Linear Perspective

Linear. Perspective

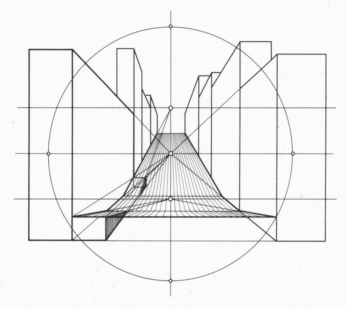

Its history, directions for construction, and aspects in the environment and in the fine arts

By Willy A. Bärtschi

Translated by Fred Bradley

VNR Van Nostrand Reinhold Company
New York Cincinnati Toronto London Melbourne

This book was originally published in Germany under the title *Perspektive* by Otto Maier Verlag Ravensburg.
Copyright © 1976 by Otto Maier Verlag Ravensburg.
English translation by Fred Bradley
Copyright 1981 by Van Nostrand Reinhold Company
Library of Congress Catalog Card Number 80-22296
ISBN 0-442-24344-8

Printed in Germany.

Published in 1981 by Van Nostrand Reinhold Company
135 West 50th Street, New York, NY 10020

Van Nostrand Reinhold Limited
1410 Birchmount Road, Scarborough, Ontario M1P 2E7, Canada

Van Nostrand Reinhold Australia Pty. Limited
17 Queen Street, Mitcham, Victoria 3132, Australia

Van Nostrand Reinhold Company Limited
Molly Millars Lane, Wokingham, Berkshire, England

16 15 14 13 12 11 10 9 8 7 6 5 4 3 2 1

Library of Congress Cataloging in Publication Data
Bärtschi, Willy.
 Linear perspective.
 Bibliography: p.
 1. Perspective. I. Title.
NC750.B22513 742 80-22296
ISBN 0-442-24344-8

Definitions

A vertical straight line is a line in the direction of the center of the Earth. A plumb as used by a bricklayer also points toward the center of the Earth like a line of gravity. The vanishing point of a perpendicular, on the other hand, is the vanishing point of a straight line which is at right angles to another straight line. The sides of a right angle therefore produce two vanishing points of a perpendicular, because they are at right angles to each other; this is why we also call the vanishing points of the sides of right angles the vanishing points of normals.

Designations

A′ horizontal plan or 1st projection of point A
A″ vertical plan or 2nd projection of point A
A‴ profile or 3rd projection of point A
Å central projection or perspective picture of point A
Ā point A swiveled
A† point A tilted
A° point A revolved
Â cast shadow of point A
BE picture plane
D distance
FE vanishing plane
fl vanishing line
FP vanishing point
fs vanishing ray
GE object plane
HDP horizontal distance point
HE horizontal plane
H horizon
hh auxiliary horizon
LF foot of a perpendicular
MP measuring point
MS central visual ray
OP check point
PZ center of projection
RP space point
Sa sagittal
SaE sagittal plane
StE ground plane
StL ground line
StP station point
TE receding plane
TR receding direction
UM generatrix
VDP vertical distance point
ZP center of perspective

Contents

Preface

I taught students of architecture and interior architecture the principles of constructed perspective at the Zurich College of Arts and Crafts. My aim was to make the students also aware of the practical applications of perspective as a creative medium and to show them what can be achieved with it.

To this end I used mainly the little-known method of the circle of view, which permits the drawing of a perspective picture without horizontal, vertical, profile, and plans; that is, it produces a direct perspective representation and is therefore also well suited for freehand drawing and sketching. Obviously, this does not imply that the other methods based on plans are of no importance. Their combination with the circle of view method extends the possibilities of solving many kinds of problems raised by perspective.

When I established the theoretical principles of the circle of view method, I was unable to make use of any literature on the subject. I therefore tried to set up these principles, to a certain extent in collaboration with the Zurich mathematician Hermann Holliger, eventually to work them out on my own, and to establish them more firmly. Teaching descriptive geometry had accustomed me to derive and to understand the laws on which the methods of construction are based from the demonstration of a model. Conversely, I endeavored to translate the abstract geometric images into lucid drawings. Here, too, I therefore attempted to establish the laws of perspective on the study of the "perspective model."

Constructed perspective represents a geometric discipline characterized by its logical structure. The forms and theorems of geometry are therefore laid down by definition and conceptual abstraction. According to the mathematician Ostrowski, one must never rely on visual perception because this can never be a complete substitute for clear, logical proof. Unlike Ostrowski, the mathematician Lietzmann accepts visual perception as a heuristic means of searching for and testing mathematical facts.

In constructed perspective, visual perception is of fundamental importance. Its laws are deduced from visual perception with the aid of the perspective model. Such a procedure is justified in that the student, according to Drenckhahn, is able to abstract from a concrete and therefore tangible object, or to arrive at abstraction by way of visual perception. In constructed perspective the direct connection between visual perception and abstraction becomes evident in that we obtain or aim at obtaining clear pictures by means of abstract geometric construction. The essence of constructed perspective as a central projection is that it results in pictures of concrete objects which, though not identical with the images on the retina, approximate them. The connection between visual perception and abstraction is revealed in constructed perspective also in the execution of the task of reconstructing a constructed perspective based on a photograph and capable of being regarded as its mathematical structure. We thus do not consider visual perception and abstraction mutually exclusive opposites but accept them as being interdependent, interpenetrating, in a relation of correspondence and conformity. The study of constructed perspective therefore demands that we exercise and train our powers of visual perception and abstraction.

This is the approach I employed not only as a teacher but also in presenting the subject matter in this book. I have chosen my concrete examples mainly from the fields of architecture and interior architecture for good reasons.

On the one hand, I had to adapt my teaching to the needs of future architects; on the other, perspective distortion can be experienced only in architectural objects of large dimensions. In a matchbox we hardly notice perspective distortion; it is clearly evident in a building that is 1000 times larger.

The illustrations in the theoretical section of this book are based on fair drawings executed to my designs by several draftsmen. This accounts for the fact that the lines and line widths are not uniform. All illustrations marked "B" are by myself. The architect Bruno Rey is the author of Figs. 192 and 206; Figs. 139, 141, 316, and 380 are the work of architect Ronald Schertenleib, Figs. 225 and 229 of the architect Fritz Schmocker. The photograph Fig. 35 was taken by Veronika Breu. My thanks are also due to Manfred Bingler for kindly making the photograph Fig. 34 of New York City available to me and to Roger Tittel for the drawings in Figs. 334 and 335.

Zurich, October 1975 Willy A. Bärtschi 7

Various Aspects of the History of Perspective

Max Bense in his *Outline of a History of Mathematical Thought* (Hamburg, 1949) calls the reciprocal effect of mathematics and art a most important subject of the history of thought. This chapter deals with the special significance of the development of *linear perspective* as a *means of creativity,* on the one hand, and as a *mathematical discipline* on the other. We can trace a parallel development of linear perspective—aerial and color perspective has been treated more intuitively by painters—and of anatomy insofar as artists, especially during the Renaissance, played a prominent part in laying the foundations of this science. They conducted original research into anatomy; working closely with anatomists, they produced some superb illustrations for textbooks of anatomy; lastly, we must not forget the expansion and deepening of anatomical knowledge through its application to artistic creation. Although anatomy was also a concern of artists, it evolved first and foremost from the interests of physicians and scientists. But perspective can be regarded as an artistic product older than science. Its mathematical aspect enabled mathematicians to tackle perspective and raise it to the status of an exact science; it also led them to establish other mathematical disciplines such as projective and descriptive geometry. Thus the twin role of perspective as an artistic means of expression and a geometric discipline requires us, if we want to trace its development, to study certain epochs of the histories of art and of mathematics.

Perspective in the History of Art

Evidence and records of art are far older than those of science. We may therefore be justified in tracing the beginnings of the development of perspective from the earliest records of art; after all, coming to grips with the problems of perspective begins with the pictorial representation of our concrete surroundings, with the solution of the problem of depicting our three-dimensional world in a two-dimensional medium. Even the authors of the paleolithic drawings and paintings of *Altamira* and *southern France* may already have been conscious of the difficulty of

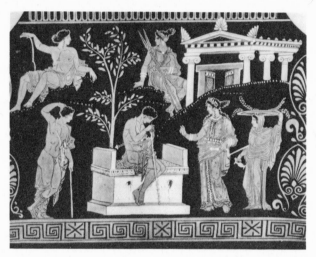

1 Orestes, Pylades, and Iphigenia, Apulian amphora, about 375 B.C., Naples. Although the figures are represented in a certain relation to each other, this impression is created mainly by gestures and the directions of the faces, not by any perspective representation of the individual figures. Only the temple and the altar are shown in spatial rendering.

solving this problem. Their pictures are linear and colored representations of animals in profile. Only occasionally do we find a part of an animal's body shown in perspective foreshortening, whose mastery is partially explained by the eidetic talent of man.

Nor has the art of both the *Babylonians and Egyptians* yet discovered perspective: Here, pictorial representations are characterized by the reproduction of objects in horizontal or vertical rows. In the Egyptian wall reliefs the human figure is shown frontally without foreshortening of the limbs, but the head and feet are in profile; one of the eyes in this profile also appears frontally. In the art of the *Persians,* too, man is reproduced en-face, but the feet are in profile. It is necessary to study the subject of perspective in greater detail in *Greek* works of art, because it was the Greeks who discovered perspective in the sixth century B.C. and because of their influence on artistic creation in the Middle East, India, the Far East, and the West, where their spadework in this field was the basis of rediscovery of perspective in the fifteenth century. The time and place of its discovery and its use for the solution of problems of space and composition was surely no accident; after all, many great earlier civilizations were unaware of perspective. In

his treatise *The Meaning of Perspective* (Tuebingen, 1953), Bernhard Schweitzer deduces that it was the Greeks who discovered perspective from a special form of conception of reality which owed its origin to a particular situation.

Schweitzer demonstrates the first phase of development using a picture of an army camp on a vase dating from the middle of the fifth century B.C. It shows some of the bodies in perspective foreshortening, but also en-face and in profile; that is, in different positions and aspects. The requirement of proper perspective rendering, that the objects (here the soldiers) should be shown from a single, fixed standpoint, which is essential to the integrated nature of perspective, has not been met in this picture. In fact, every single figure appears in its own perspective without relation to the whole and to space. No spatial effect is created by the smaller representation of the more distant figures. Schweitzer calls this first phase of development, which extends into the height of the classical period of the fifth century B.C., that of the *body perspective* and *partial perspective*. Here we can speak only of partial perspective pictorial rendering.

Unlike the first phase, in which a connection between the objects within the picture area cannot yet be said to exist, the second phase, beginning about 460 B.C., leads into *spatial perspective,* in which the pictorial elements and objects are subordinated to the perspective picture space. This kind of perspective during the second phase of development obviously cannot be measured with the yardstick of strict perspective construction, because the representations, which are wrong from a geometric point of view, create the impression that the painters were unfamiliar with the laws of perspective. According to Schweitzer, *spatial perspective* holds the balance between pure body perspective and *constructed perspective*. Schweitzer distinguishes ''visio perspectiva'' from ''ars perspectiva'' and ''scientia perspectiva.'' ''Visio perspectiva'' means a special form of perception, perspective seeing. ''Ars perspectiva'' is artistic perspective, ''scientia perspectiva'' perspective in terms of optics, geometry, and science.*

The Greek-derived word *scenography,* which really means ''stage setting'' for perspective, indicates the origin of spatial perspective, which had its beginnings neither in vase nor in mural painting but in stage setting; realistic representations of houses, façades, columns, roofs, doors, windows, and ledges are characteristic of the wings of the Greek theater. ''Scenography (perspective) is a part of optics and is concerned with how buildings must be reproduced in painting.'' This is how *Damian* explained the origin of perspective in the painting of stage settings in the second century A.D.** In 460 B.C. the philosopher *Anaxagoras* established the first scientific theory of perspective at a time when it

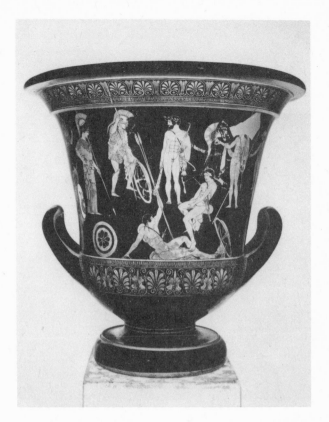

II Urn by the Niobid Painter, about 450 B.C., Louvre, Paris (photograph by Chuzeville). Example of ''body perspective''; individual figures appear in their own perspectives, and there is no fixed viewpoint.

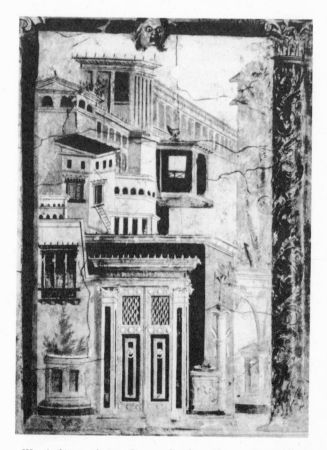

III Architectural vista, Boscoreale, about 40 B.C., New York. An architectural representation influenced by the Greek scenography of the new comedy, as evidenced by the mask top center.

**The Meaning of Perspective, pp. 8–12.*

***Quoted in Schweitzer, The Meaning of Perspective, p. 16.*

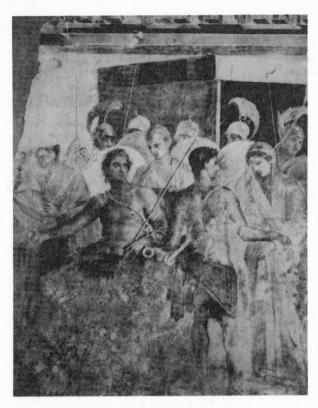

IV Achilles dismisses Briseis, mural, Pompeii, from a Greek original at the end of the fourth century B.C. Compared with Fig. I it clearly shows the difference between body and space perspective, especially in the relation of the figures to space.

began to develop from scenography. In the context of discussing the theory of light, *Democritus,* followed by *Euclid, Heliodorus,* and *Hero,* who prepared the ground for the work of *Ptolemy,* all made a study of perspective.

We have seen that learned men made perspective an object of scientific research and founded a theory of perspective which was firmly established by the fifth century B.C. This fact apparently could not induce the painters of vases and murals to apply it fruitfully to their work, because another century passed before it was accepted by the practitioners of the fine arts. Schweitzer sees the reason for this resistance of perspective on the part of the Greek artists in their view that this must be subordinate, because the painters of stage decor were able to simulate buildings and their details with the means of perspective rendering, and make-believe and simulation were alien, especially to Platonic thought. Schweitzer mentions a passage in *Sophistes,* in which *Plato* calls a work composed with the aid of perspective ''phantasma,'' an illusion. The artists' initial resistance against perspective was nevertheless unable to prevent its eventual application. Its use as a creative means was not only a revolutionary event in Greek painting; it was also of the utmost significance in the Western art of modern times.

To appreciate this, we must remember the essential properties of perspective and how Greek painting of the preperspective period differed from that in which perspective as a means of creativity had become important. Because it is the aim of a book on

constructed perspective to discuss its nature, we now describe it as a *central projection,* in which the projection or visual rays converge on, or radiate from, a center or a point. This entails the representation of objects and their relations in the field of view from a single and fixed point of view. Central projection implies subordination of the objects to a whole, the primacy of the whole over its parts, reference of the whole to the observer, who is thereby included in the picture, the realization of the ''picture space to be taken in at a single glance.''* We can demonstrate the difference between an art in which perspective is important as a means of realizing the picture space and one in which it is not, for instance in the Zen paintings of Japan and China or in the contemporary abstract art, only with the aid of suitable examples.

But here we can mention only briefly the difference between the older preperspective and the more recent Greek perspective painting. The former is characterized by a narrative picture language in which, detail is set next to detail, in isolation and self-sufficiency, without being subordinated to the whole. In perspective art, however, the whole dominates the parts, which are observed from a single point of view. We do not wish to make an artistic value judgment here. But it is important to consider whether and how perspective, a creation of the Greek intellect, represents an achievement of the arts.

The approach to Greek art from this angle is difficult, because apart from vase paintings only sparse evidence of Greek painting has come down to us. The works of the Greek colonies in *southern Italy,* in *Pompeii* and *Herculaneum,* provide us with some insight into Greek painting, offering a certain amount of information about composition and construction of mural paintings. It was the German G. J. Kern who studied the pictures at Pompeii in great detail.** He proved that the painters used ''division construction,'' named after him, until the fifth century A.D.; but it seems to have fallen into oblivion from the fifth century to the ninth, after which it again played a certain part up to the fourteenth century.

A picture based on this ''division construction'' is completely symmetrical and laid out so that the receding lines coming from the left and right intersect on a vertical representing the axis of symmetry of the picture. Although this is the most important axis of the picture, the painters of such pictures cannot have been completely unfamiliar with the rendering of the horizon, because the receding lines ascend in the lower part of the pictures but descend in the upper. This rule entails a zone in which the receding lines

*Schweitzer, *The Meaning of Perspective,* p. 19.

**G. J. Kern, ''The Development of Central Perspective Construction in European Painting,'' in *Forschungen und Fortschritte* 13, 1937, pp. 18ff.

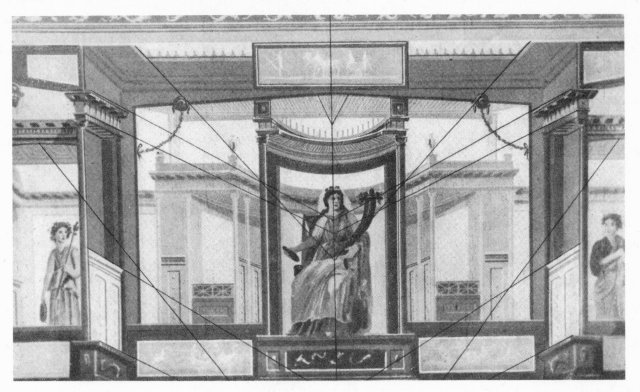

V Mural, Pompeii. Representation of the three-dimensional figure in three-dimensional space begins with the mural paintings at Pompeii; it is typical of Western painting from Giotto to Cubism. Figure III shows the relation between Pompeian mural painting and Greek scenography; representation in frontal perspective of the architectural space is typical of both. The reconstruction and production of the receding lines in Fig. V indicate the efforts of the Pompeian painters to come to grips with the laws of perspective. It also reveals their ignorance of the law that there is only one vanishing point for the horizontal receding lines at right angles to the picture plane, because we can see that only those receding lines which are at the same level have the same vanishing points; these do not lie on the horizon but on the median line of the picture.

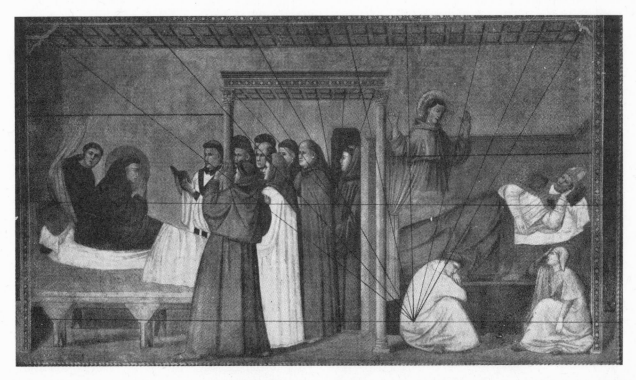

VI Giotto, Vision of St. Augustine and the Bishop, Cappella Bardi, S. Croce, Florence. Giotto stands at the point of transition from the nonperspective to the perspective painting of the early Renaissance, in which a new awareness of space becomes evident. As in Greek scenography and the Pompeian murals, in Giotto's painting the architectural frame or space is rendered in frontal perspective. But whereas in Fig. V architecture is the dominant element, in Giotto space takes second place and the figures become prominent. But even Giotto was ignorant of the law of the single vanishing point, identical with the center of perspective; the receding lines have two vanishing points, which produce two horizons. This prevented him from using perspective construction as a means of composition, for instance, from arranging the focus of pictorial appreciation close to the center of perspective or from using the receding lines as elements to guide the viewer's eye. (With acknowledgment to G. Wolff: Mathematik und Malerei (Mathematics and Painting), B. G. Teubner, Leipzig, 1925²) for the reproductions in Figs. V, VI, VII)

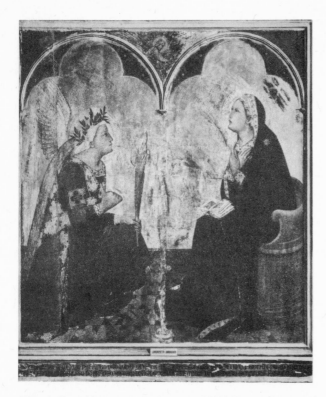

VII Ambrogio Lorenzetti, Annunciation of 1344, Sienna. The spatial impression of this painting is due solely to the construction of the floor, correct even in detail.

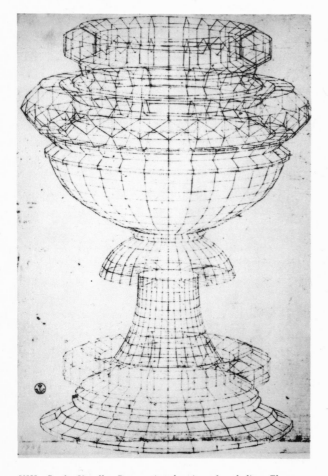

VIII Paolo Uccello, Perspective drawing of a chalice, Florence, Gabinetto Disegni e stampe degli Uffizi n. 1758A. This drawing shows Uccello's wrestling with the perspective of the circle. The wreathlike structures with the hexagonal and octagonal cross sections on the base and upper part of the chalice are Mazzocchio renderings.

run horizontally, thus forming the horizon. We can well demonstrate vanishing points for two receding lines each in those pictures, all of which would have to intersect in a single vanishing point, because they are parallel receding lines. The errors of construction in these pictures raise the question whether the Greek artists knew the concept of the vanishing point at all. *Vitruvius,* the architect of the emperor Augustus (31 B.C.–14 A.D.), thought this to be true of *Anaxagoras* and *Democritus.*

The book *De Architectura* by Vitruvius exerted a lasting influence on the artistic output of the Romans and of the succeeding epochs. His indication of the importance of the problem of proportions in man and in animals induced Dürer, who had also studied Euclid, to investigate proportion. Vitruvius also reported that the ancients already knew to a certain extent what we call the horizontal plan, vertical plan, and perspective projection of an object. He wrote that a design (*species dispositionis,* ideai) requires *ichnography,* (ichnos = footprint, graphein = to scratch, write, draw) horizontal plan, *orthography* (orthos = upright), vertical plan, and *scenography* (skene = stage, tent). Ichnography is the picture on the ground, orthography the upright picture of the front, and scenography gives the contour of the front and the vanishing sides. As late as the eighteenth century, descriptive geometry and perspective were referred to as ichnography.

The development of perspective did not take place in a continuous evolution; it passed through a transitional period lasting from Antiquity to the early Renaissance, when artists rediscovered and reestablished perspective. During this period of transition, perspective either had been completely forgotten or had become irrelevant to artistic creation. A case in point is *Romanesque* or *Byzantine* painting, in which artists sometimes improvised by using oblique *parallel projection.* It has already been pointed out that the principle of "subdivided construction" was used as an aid to composition in painting from the ninth to the fourteenth centuries, which reveals the efforts of the artists to master space and the perspective arrangement of it.

At the time when perspective was not a topical feature in art, it was not a subject of theoretical discussion for scholars either. The fact that in the eleventh century the Arab Alhazen, influenced by Euclid, wrote a book on optics which discussed the problems of perspective and was translated into Latin and enlarged by the German-Pole *Vitellio* could perhaps be interpreted as a symptom of the impending reintroduction of perspective at the time of the painter *Giotto* (1266–1337), who, according to Bense, "began to see space again in its depth as the true problem of pictorial construction."*

Lorenzetti, one of Giotto's pupils, is considered the first to have constructed the vanishing point of the receding line of the horizontal single plane. In his picture *Annunciation* the vanishing point can be

*Max Bense, *Outline of a History of Mathematical Thought.*

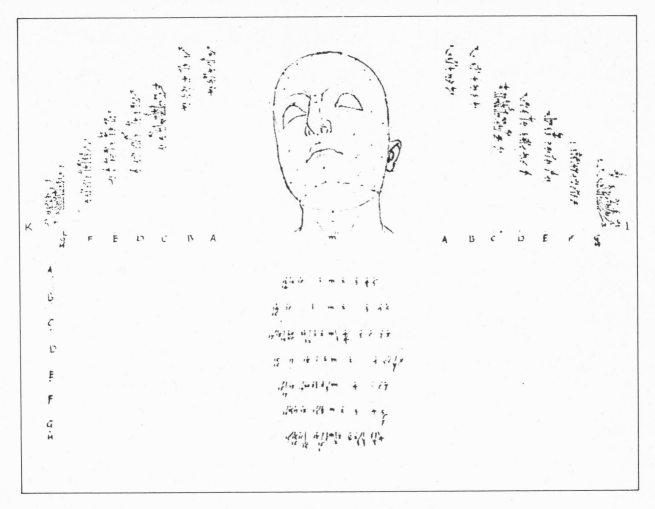

IX *Illustration from* De Prospectiva Pingendi *by Piero della Francesca. When Piero della Francesca established the principles of perspective he wanted to learn and teach the perspectively correct drawing not only of regular geometric forms but also of irregular, free ones. This drawing demonstrates how the human head can be perceived and represented constructively and in perspective.*

shown as the point of intersection of the receding lines of the tiled floor in the picture.

Filippo Brunelleschi (1377–1446), architect and builder of the dome of Florence Cathedral, is regarded as the true founder of modern perspective. He knew the vanishing point, the horizon, and probably also the distance between object and picture plane. The important painter *Masaccio* (1401–1428) put his theory into practice. He was the first to present an oblique aspect in perspective.

The versatile architect and scholar *Leon Battista Alberti* (1401–1472) earned a great reputation as one of the pioneers of perspective with his book *De Pictura,* which was published in Latin in Nuremberg in 1511 and not translated into Italian until 1804. Alberti explained the origin of the perspective picture as the intersection of the pyramid of visual rays with the picture plane. He invented a grid to determine size ratios and spatial depth in drawing and also established a method of determining the distance point.

One of the most eminent protagonists of perspective in the fifteenth century was *Paolo Uccello* (1396/97–1475), although he excelled more in the perspectively correct rendering of pictorial details than in the integrated composition of the whole picture. Uccello was the first to draw plants from nature and leaves in perspective foreshortening. His mazzocchio representations are well known. A mazzocchio is an annular wire frame which, wrapped in wool and cloth, was worn on the head. Uccello, who succeeded in drawing a polygon in perspective, made attempts to teach perspective with the example of the mazzocchio representation.

The brilliant painter and mathematician *Piero della Francesca* (1416–1492) is the author of a treatise entitled *De Prospectiva Pingendi,* which made him an even more outstanding pioneer of perspective than Alberti. Della Francesca worked with the visual point which we call the center of perspective. This is the point of intersection of the central visual ray with the picture plane. He knew the distance points and the vanishing points of any horizontals. He also worked on the perspective representation of the human head and of the coffered dome. *Sandro Botticelli* (1446–1500) must be mentioned on account of the ellipse constructed in his painting *Madonna and Child* as a circle in perspective, which hitherto had been drawn freehand.

The work of the greatest northern Italian painter of the fifteenth century, *Andrea Mantegna* (1431–1506), appears to us an outstanding expression of the fascination the Renaissance artists experienced as they wrestled with perspective as a means of composition; some of it is characterized by the bold

13

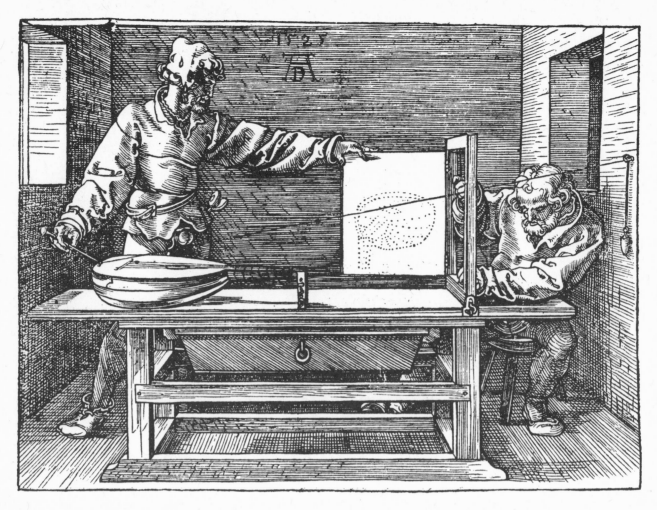

X *"The Drawing of a Lute," a page from "Vnderweysung der messung mit Zirckel und richtscheyt in Linien ebnen und gantzen corporen" (how to measure with a pair of compasses plane lines and whole bodies), Albrecht Dürer, Kunsthalle, Bremen. The example of the lute gives us an idea of Dürer's efforts to demonstrate the point-by-point production of the perspective picture. A projection ray is represented by a thread coming from an original point on the lute; it produces a picture point of the lute where it pierces the picture. This explains the principle according to which the picture of the lute is composed of points in the picture plane, which here appears rotated from the frame through 90°.*

presentation of markedly foreshortened bodies, such as his painting *The Dead Christ,* in the Brera Gallery, Milan, and the painted ceiling of the Camera degli Sposi in the Castello di Corte at Mantua. In his *Christ on the Mount of Olives,* in the National Gallery, London, the main figure appears too large compared with those in the foreground; but this very feature makes it the intellectual focus of the picture. Whether the disregard of perspective scale expressed in Mantegna's work is the result of artistic intention or of failure to master the "ars perspectiva," the painting would be inconceivable without the spadework done by the precursors and contemporaries of the artist in the field of perspective. From Italy, the country in which it had been rediscovered, perspective found its way through Burgundy to the Netherlands, where above all *Vredemann de Vries* greatly advanced its development. From here it proceeded to influence German painting before Albrecht Dürer (1471–1528).

Even in a very brief history of perspective the names of the greatest artists of the Renaissance, *Leonardo da Vinci* (1452–1519), who in his *Treatise on Painting* wrote an essay on perspective, *Raphael* (1483–1520), and *Michelangelo* (1475–1564) have an essential place. Their works, too, would be inconceivable without the contemporary cultivation of the "ars perspectiva."

In this context the chapter "Perspective Construction as a Means of Composition in Painting" must be mentioned; it shows, among other achievements, what Raphael and Leonardo da Vinci were able to do with the aid of perspective construction.

Albrecht Dürer's treatise on perspective in his "Instruction How to Measure, with a Pair of Compasses and a Straight Edge, Lines, Planes, and Whole Bodies" is the first work in German on perspective. The scholar and artist Dürer, who adopted the theory of perspective from Piero della Francesca's treatise *De Prospectiva Pingendi,* explained the perspective picture in terms of the intersection of the pyramid of visual rays with the picture plane, as Alberti had done before him.

Dürer constructed the perspective picture of an object from its horizontal and vertical plan, a principle he also used for the construction of shadows. Dürer's very lucid illustrations to explain the formation of the perspective picture of an object in the picture plane are famous (Fig. X).

In the field of planimetry, too, Dürer's achievements were outstanding; he invented the "spider line" and studied the problems of descriptive geometry. His importance as a geometrician caused

Moritz Cantor to devote ten pages to him in his *History of Mathematics,* where he observes, "The fact that in other cases he distinguishes so clearly between features that are inherently correct and those that are merely of practical use elevates him to a scientific plane hardly reached by any other geometrician in the sixteenth century."

In this context *Dürer's Formal Theory of Mathematics and of the Fine Arts,* by Max Steck, must be mentioned; this publication also emphasizes the importance of Dürer as a theoretician of geometry.

During the late Renaissance *Daniel Barbaro* and *Barozzi da Vignola* acquired a reputation with works on perspective. The architect Vignola (1505–1573) introduced the vertical distance points. The work *Perspectiva Pictorum et Architectorum* by the scene painter *Andrea Pozzo,* published in 1693, also deserves mention.

Perspective in the History of Mathematics

Up to this point we have dealt with the history of art as we traced the development of linear perspective. We have seen that it was artists, mainly painters and architects, who established and developed perspective. We must now concern ourselves with those mathematicians who treated perspective as a mathematical discipline, put it on a scientific basis, and through it progressed to the foundation of projective and descriptive geometry. However, it is of great interest to examine the development from the aspect of the interrelation between the arts and mathematics in the Baroque age and to debate the question whether the new knowledge that mathematicians acquired in the field of perspective, the science in its own right that they established, was able to influence creative activities, above all in the field of architecture, which gained ascendancy over the other fine arts. To discuss this question would be a subject for a separate monograph, such as the previously mentioned book by Max Bense and Karl Menninger's essay *Mathematics and the Arts* (Goettingen, 1959).

Max Bense writes in his work on Bernini: "It was Bernini, the exponent par excellence of the classical Baroque in Italy, who put the Renaissance artists' experiences and theorems of perspective completely into practice. The semicircular colonnades of St. Peter's Square in Rome are a masterpiece of perspective order, which only a first-class theoretician in this field can have created." And Menninger speaks of an all-pervading feeling of perspective as expressed in the unity and grand design of the Baroque church interior, in park landscapes blending into infinity, in the flight of apartments, rows of pillars and windows, in the succession of rooms leading into one another.

Perspective took a considerable step forward with the publication of *Perspectiva,* by the outstanding mathematician *Guido Ubaldi* (1545–1606). He constructed the vanishing point of random straight lines, calling it *punctum concursus* (point of convergence), in the same way as we normally do it today, by the construction of parallels to the length lines through the center of projection.

The Dutchman *Simon Stevin* also made an important contribution to the theory of perspective with his mathematical work, published at Leiden in 1605.

From Italy, with which we were mainly concerned up to now as the country where perspective was rediscovered, let us now turn our attention on France, where it was the painter J. Cousin who in 1560 published the first book on perspective.

The Lyons architect and civil engineer Girard Désargues (1593–1662) is important because his study of perspective—he wrote the monograph *Universal Method of Putting Objects into Perspective*—led him to new ideas about conics and to the foundation of projective geometry, a concept that can be traced to the work by *Poncelet* (1788–1867) *Treatise on the Projective Properties of Figures.* Poncelet proceeded from Désargues' idea of transferring properties of the circle to any conics through central projection. Projective geometry can be separated neither from descriptive geometry nor from perspective.

In conjunction with Désargues we must mention *Bosse* (1611–1678), copper engraver and teacher at the Academy of Arts in Paris, who was an ardent advocate and propagator of Désargues' theory of perspective. The engineer *Alleaume* and the mathematicians *Migon* and *Vaulezard* also made very useful contributions to the theory of perspective, and *Battaz* deserves to be mentioned on account of new additions with which he enriched and promoted the theory of his work *Reduction of the More Difficult Operations of Practical Perspective,* published in 1644. To Battaz we also owe the introduction of the circle of view, or distance circle. *Curabelle* and *Huret* became known through their pamphlets against Désargues; *Niceron,* on the other hand, agreed with him in his *Thaumaturgus Opticus,* published in 1646.

In Nuremberg in 1671 the German *Andreas Albert* published a work on perspective entitled *Two Books, the First About Perspective Established Without the Aid of Arithmetics, the Second About the Shadows Belonging to It.* The Dutchman Gravesand and the Englishman Taylor are considered important promoters to the development of perspective.

Gravesand (1688–1742), Professor of Mathematics in Leiden, wrote at the age of 19 a textbook on perspective which, because of the simplification of constructions discussed in it, was acclaimed by the Basle mathematician Johann Bernoulli.

Brock Taylor (1685–1731), well known for the theorem bearing his name, was the author of the work *On the Principles of Linear Perspective;* its

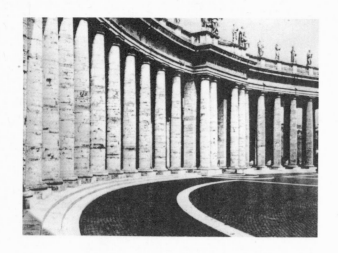

XI The colonnades of St. Peter's, Rome, 1667, designed by Giovanni Lorenzo Bernini. An example of the expression of the "perspective awareness of the world" in architecture.

XII Pilgrimage church at Steinhausen, South Germany, built by Dominikus Zimmermann 1727–1733, ceiling painting by Johann Baptist Zimmermann. The force of the "perspective awareness of the world," demonstrated here in the blending of architecture, sculpture, and painting, found its expression in the Baroque style. The "ars perspectiva" culminates in paintings that create the illusion of space. This photograph, even more than the real painting, impressively conveys the unity of painting, sculpture, and architecture. The edges of the columns as receding lines of frontal perspective guide the eye from architecture and sculpture as the temporal space and framework to the spiritual realm of painting, the focus of pictorial appreciation of the work of art in its entirety.

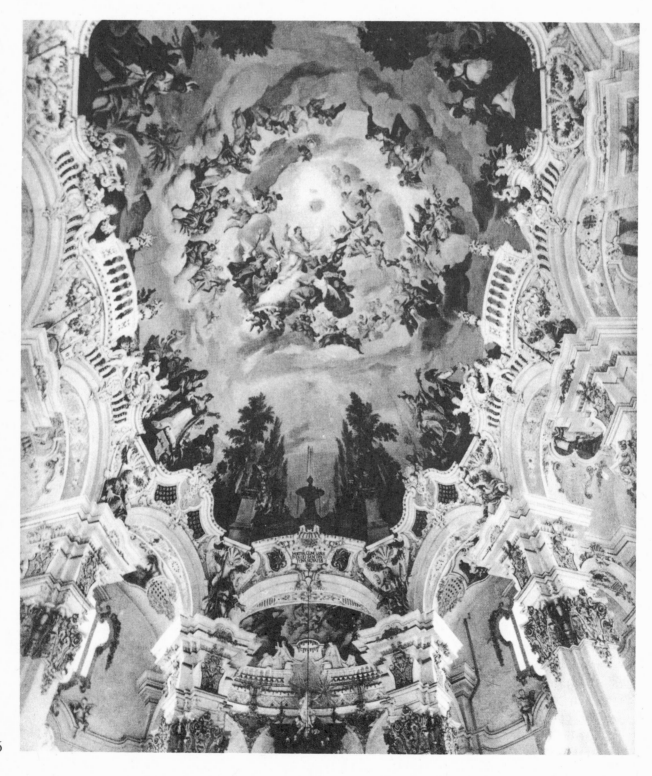

revised second edition, entitled *New Principles of Linear Perspective,* by Hamilton included an addition about aerial perspective. Max Bense has called this work by Taylor, who was not only a mathematician but also a legal expert, natural scientist, philosopher, painter, and musician, a milestone in the history of perspective. Taylor discussed in it a method of constructing a cube in a random position and summarized all contemporary knowledge of perspective. Two works on perspective, whose results had been found by means of both calculation and construction, were written by the Frenchman *La Caille* and the German *Kaestner.* The former is the author of *Traité d'Optique et de Perspective* (Paris, 1750), the latter of *Projectionum Theoria Generalis Analytica* (Leipzig, 1752). In his textbook of descriptive geometry Mueller-Kruppa calls the Swiss mathematician and physicist *Johann Heinrich Lambert* a "main promoter of perspective" and counts his book on this subject among "the most outstanding works on this phenomenon." Its second edition appeared in Zurich in 1759. The self-taught Lambert wrote it at the age of 24 and entitled it *Free Perspective or Directions How to Produce Any Perspective Elevation by Freehand and Without Horizontal Plan.* Lambert's subject in this title was not altogether new in that two years previously La Caille had taught a method of construction based on it. Perhaps because he was also a physicist, Lambert wrote a fundamental work on photometry as well as monographs on aerial and color perspective and on other problems of physics. He must also be mentioned as the inventor of instruments to make perspective construction easier, such as the "perspectograph." The Italian astronomer *Zanotti* (1709–1728) in his *Trattato Theoretico-Pratico di Prospettiva* (Milan, 1825) pursued a line similar to Lambert's.

In nineteenth-century France both mathematicians and numerous painters and architects emerged as authors of works on perspective. The mathematicians increasingly treated perspective in the context and as part of descriptive geometry. This appears to indicate that perspective, projective, and descriptive geometry are of a kind. This connection is also established by the fact that we can regard perspective as the basis of projective geometry, which was initiated by Poncelet and others and in turn exerted a fruitful influence on descriptive geometry.

At the beginning of the nineteenth century the mathematicians *Cousinery, Adhémar,* and *De la Gournery* also wrote books on perspective. Cousinery published *Geometrie Perspective* in Paris in 1828. Adhémar wrote *Perspective Linéaire* and De la Gournery *Traité de Perspective Linéaire.* The work *Eléments de Perspective Linéaire* (Paris, 1847) by the mathematician *Auguste Guyot* must not be ignored.

Of the many books on perspective by creative artists we are listing only a few, because they are

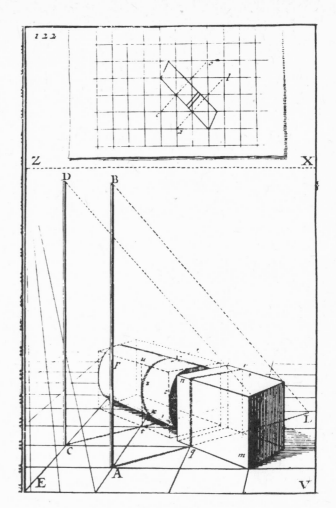

XIII Illustration from Maniere Universelle de Mr. Désargues pour Pratiquer la Perspective, *by Abraham Bosse (1611–1678).*

XIV The perspectograph. Illustration from Die freye Perspektive, oder Anweisung, Jeden perspektivischen Aufriss von freyen Stuecken und ohne Grundriss zu verfertigen (*Free perspective, or how to produce any perspective plan free-hand and without horizontal plan*), by Johann Heinrich Lambert (1728–1777), 2 ed., Zurich, 1759.

characterized not by any radically new theories but by their object of pointing at new ways of the practical application of perspective to artistic creation.

Chapuis must be mentioned among the painters who are authors of works on perspective for artists. He edited a book on the theory of his teacher *Thibault,* Professor in the Paris Academy of Fine Arts, published in Paris in 1828. Other prominent writers on this subject were the Belgian *Bossuet* and the Frenchmen *Olagnon, Cloquet,* and *Chevillard.* Bossuet was professor in the Brussels Academy of Fine Arts and wrote *Traité de Perspective Linéaire.* The painter Olagnon published *Méthode Très Simple de Tracé Perspectif,* Cloquet *Traité de Perspective Pittoresque, Perspective du Trail,* and Chevillard, also professor in the Paris Academy of Fine Arts, *Leçons Nouvelles de Perspective.*

Architects and civil engineers, too, played a prominent part as authors of practical textbooks on perspective, such as the architects *Duclos, Durand, Guadet, Gromort, Sonrei* and the engineer *Bricard* in France, the architect *William Ware* in the United States, who published *Modern Perspective* in Boston in 1883, the Englishman *Frank Medworth,* the Italian *Alberto Maso Gilli,* who wrote *La Prospettiva dei Piani Inclinati e dei Corpi Liberi nello Spazio* in Rome in 1887. Among the latest literature on perspective we must mention the two volumes *Perspective Artistique* by *Pierre Olmer* (Paris, Plon, 1949) and *Architectural Graphics* by *Leslie Martin,* a special publication for architects which appeared in New York (Macmillan Company) in 1952 as well as *Perspective, A New System for Designers* by *Jay Doblin* (Whitney Publications, New York, 1956), a textbook for designers as the title indicates.

Like perspective, descriptive geometry has grown from the needs of artistic architectural creation. Even in the Middle Ages the horizontal and vertical plan method developed from the increasingly complicated problems of stone cutting in the construction of arches and vaults. *Frézier* in 1738 was the first to divorce this horizontal and vertical plan method from practical application and to conceive and describe it as constructive geometry of space. But it is *Gaspard Monge* (1746–1818) who is considered the true founder of descriptive geometry with a textbook on this discipline published in 1798. Monge also was one of the co-founders of the Ecole polytechnique in Paris. The first comprehensive and science-based work on descriptive geometry in Germany was written by *Guido Schreiber,* the author also of a textbook on *Perspective for Painters,* published in 1828.

Perspective Now

With the advent of abstract painting around 1900—the German *Adolf Hoelzel* painted the first abstract pictures even earlier—perspective in painting became increasingly irrelevant. Painters no longer wanted to create spatial or perspective effects; paintings should be two-dimensional like the canvas that supported them, not like mirrors simulating space. It is easy to understand why, with the reduced importance of perspective in modern painting, the publication of textbooks on this subject for artists gradually ceased.

To the architect perspective is a means of visualizing the appearance or optical effect of his projects; it is the purpose of perspective to represent the objects as they appear to the observer. Parallel projections or plans have a different task to fulfill. Even a small model cannot convey the impression of the perspective effect of the completed project. Where architectural work aims at perspective effects and at the realization of perspective arrangements as in the Baroque, perspective can be a creative means also for the architect. In his work *Origins and the Present Time* (Stuttgart, 1953) *Jean Gebser* placed perspective in the larger context of the history of thought. He claimed that development progressed from the archaic through the magical, the mythical, and the mental or *perspective* to the current *aperspective* phase. In significance this phase of revolution, but also of integration and mutation, is comparable with the Renaissance, in which perspective played a prominent part as a medium of opening up space and of understanding its three-dimensional world. Gebser calls the epochs immediately preceding the Renaissance and the earlier ones preperspective and nonperspective. The aperspective age interprets all the fields of force of the previous stages in its own terms and integrates them. By "aperspective" Gebser means neither the opposite to nor the rejection of perspective; rather he chose the term to characterize the sphere of consciousness of present-day man. Gebser's book, too, makes us aware of the complex and the multitude of problems covered by the word "perspective."

Whether the age in which a man lives is aperspective or nonperspective, he will always encounter difficulties presented by the fact, above all in drawing and in the pictorial representation of objects, that he does not see them as they are in reality. He will always have to tackle in one way or another the timeless problem of the discrepancy that exists between the objective shape of things and the subjectivity of his perception. Constructed perspective attempts a solution of this problem by aiming at creating pictures, with the aid of geometry or geometric constructions, which, although they do not agree with the associated images on the retina of the human eye, approximate them closely. In this sense constructed perspective may be of timeless topicality.

Perspective Construction as a Means of Composition in Painting

Generalities

We will demonstrate with the example of works by Leonardo, Raphael, Lucas Cranach the Elder, Canaletto, Goetz, Kelterborn, and Escher how painters and draftsmen from the Renaissance onwards used perspective construction as a means of composition.

The works of Leonardo, Raphael, Cranach, Canaletto, and Goetz aim at representing the three-dimensional figure in space. "Figure" denotes the human form, "space" mainly an interior or exterior such as a section of road.

The works by Kelterborn and Escher, Figs. XXXIX and XL, do not have the representation of figures in space as their object; but we can draw a parallel between the objects of Kelterborn's still life, the sphinxlike birds and horns in Escher's woodcut, and figures in that the problem of representing non-human objects in space must be solved in basically the same way as that of representing figures in space. When an interior architect wants to find out by means of a drawing how he should furnish a room, he therefore will not draw first the furniture and then the room; because, after all, the given quantity is the room, which is to receive the furniture and other objects. It represents the framework to which the objects to go into it have to be adapted or subordinated. The solution of the problem of drawing figures that have to fit into the overriding dimension of the room is no different. This requirement can be met more easily when pieces of furniture are drawn inside a room, because it is possible to develop the various items from geometric forms so that their exact perspective construction does not involve the difficulties encountered in the corresponding representation of the figure. It was perhaps these very difficulties that induced artists as long ago as during the Renaissance, particularly Albrecht Dürer, to try to develop the human figure from geometric forms to master the problem of their spatial and perspective rendering.

Even when composing a picture that is not based on perspective construction, the artist must make it his aim to create it as an integrated whole into which the parts fit organically. This demand is met when the perspective construction determines the overall composition of a picture as in the works to be discussed here. It is the essence of central projection that in a perspective picture the whole overrules the detail; because compared with visual perception, central projection amounts to "seeing," and therefore to the reproduction of, the objects from a fixed point of view. This fact explains the demand for the essential unity of a perspective picture, that in a perspective picture everything should appear to be represented from one and the same viewpoint. It also explains why perspective means "objectivization of the picture space that can be taken in at a glance."

We can compare the perspective construction on which a picture is based to the skeleton of an animal. As this skeleton contributes to the establishment of the outward appearance of the animal, so the appearance of a picture is determined by its underlying perspective construction, which can be reconstructed like the skeleton from the shape of an animal.

Because perspective construction is a mathematical discipline we can, where it forms the substrate of the composition of a work of art, call it the mathematical structure of this work. It represents the part of a picture created by way of mental activity and on the basis of theoretical knowledge of perspective construction, which at Leonardo's time was, like that of arithmetic and its rules, not yet extensive and widespread.

The Frontal Representation of Space

The interiors shown in the pictures by Leonardo, Raphael, and Cranach are reproduced in the frontal perspective. Traditionally the only known frontal representation of interiors, encountered already in the murals of Pompeii, was the frontal one.

In Leonardo's time, likewise, the only vanishing points known were those of horizontals which pierce the picture plane either at a right angle or at an angle of 45°. This indicates that the painters of the period lacked the knowledge of representing interiors in any other than the frontal perspective. This did not, however, prevent them from presenting certain objects in interiors shown in frontal perspective in a diagonal or any random position which obviously requires the

knowledge of two-point or three-point perspective. It is thus likely that such objects as the perspectively foreshortened figures were reproduced mainly in an empirical and pragmatic way.

To explain the meaning of frontal perspective and the frontal aspect of an interior it is useful to interpret the word "frontal" in etymological terms. "Front" is derived from the Latin "frons, frontis," the forehead. The primary connotation of "frontal" is therefore human. In anatomy, for instance, a frontal plane means a plane "in the direction of the forehead." Here we speak also of the frontal aspect of man. It is the view from the front, of his forehead.

What we call "frontal perspective" and "frontal position of an interior" can also be associated with the concept of confrontation, with the frontal plane, as Fig. XV illustrates.

XV There are six frontal aspects of the cube or cuboid from six opposite viewpoints.

XVI Frontal perspective of a cubic interior or a hollow cube open to the front, from six opposite viewpoints.

We "humanize" the cube or cuboid in that we speak of the frontal aspect also in the context of these geometric bodies. We see a cube or cuboid frontally or in the frontal position when its front is face to face with us, as two soldiers "confront" each other when fighting. But the picture plane on which, after all, the frontal perspective pictures of those bodies are to be formed must be included for a more accurate determination. As shown in Fig. XV, a cube, and,

analogously, a cuboid, is in the frontal position when its frontal aspect is parallel to the picture plane. Of the twelve edges of the cube, eight will then be parallel to the picture plane, whereas the four cutting the picture plane at right angles produce the single vanishing point and thereby the one-point perspective. Figure XV enables us to understand the fact explained below. A cube standing on a sheet of glass can be seen and reproduced frontally from six opposite points of view, so that each time a different side becomes the front, to which the picture plane is parallel. These six possible frontal aspects of the cube produce the only or identical perspective picture of Fig. XVI. Conversely, Fig. XVI must be interpreted as the picture of the cube from one of the six possible points of view. All works reproduced here can therefore be traced to frontal perspectives.

A corresponding situation exists in a cubic or cuboid interior: All one has to do is imagine the cuboid or cube to be hollow and with the front face missing. The side opposite the front of the cube will then be parallel to the picture plane.

The properties of an interior represented in frontal perspective are briefly discussed with the aid of Figs. XVIIa and b, XVIII, and XIX. Figs. XVIIa and b show a hollow cuboid open to the front or an interior in frontal perspective. In Fig. XVIII only the floor of an interior and two of its walls in the diagonal position are reproduced. Like Fig. XVIII, Fig. XIX shows only the floor and two walls of an interior but in a random position or in three-point perspective.

These illustrations demonstrate that the frontal perspective representation of an interior is further characterized by its vanishing point ZP as the center of perspective. In Fig. XVII attention is drawn to the

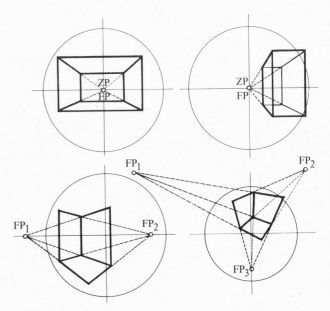

XVIIa, b Two different aspects of a hollow cuboid or interior open to the front in frontal perspective.

XVIII Only the floor and two walls of an interior are rendered in the diagonal position or two-point perspective.

XIX The same object, but in random position or three-point perspective.

picture by Cranach, Fig. XXV, where the vanishing point ZP lies outside the perspective of the interior. If we disregard this case, we can say that it is possible only in the frontal perspective representation of interiors to use the length lines converging in ZP as elements directing the eye to enhance the depth-of-space effect and to establish the center of a picture, which can be done by placing the foci of pictorial appreciation of a picture in the area of the vanishing point ZP.

XX Sketch of the mural The Last Supper *by Leonardo da Vinci 1496–1497, S. Maria delle Grazie, Milan, with construction lines.*

XXI Drawing to demonstrate the static figure of Christ in the center of the perspective construction, in contrast with the dynamic movements of the disciples.

The Wall Painting *The Last Supper* by Leonardo da Vinci

The Last Supper represents the moment at which Christ addresses His disciples with the words "one of you shall betray me."

Let us first look only at the composition of the figures in this picture, reproduced here as a copy drawing, Fig. XX. The main figure of Christ is shown in the midst of his twelve disciples, assembled to the left and right of him in equal numbers in groups of three figures each at a long table.

Let us further compare the appearance of Christ with that of his disciples. A contrast exists between Christ, who is shown in an attitude of modest ges-

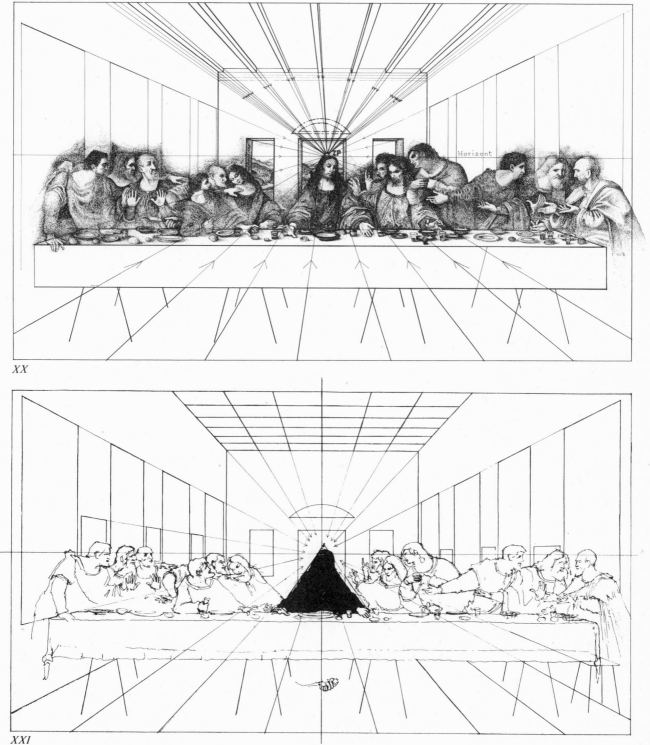

XX

XXI

ture, and his disciples, with expansive movements and emotional expressions. A kind of contrast is intended between static and dynamic attitudes in that the figure of Christ in *The Last Supper* optically has the effect of a silhouette that can be reduced to a triangle (Fig. XXI) and of a point of rest in the tumult of his agitated disciples. Christ—also as the center—is thereby contrasted with and emphasized against the other figures shown in *The Last Supper*. In other words, he personifies the center of passionate appeal, on which the painting is focused.

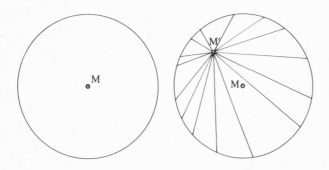

XXII and XXIII Straight lines as elements that direct the eye.

Leonardo achieved the centration on Christ and the emphasis on His person compared with the other figures in *The Last Supper* by means of perspective construction, which is made evident in Fig. XXI, showing the room of *The Last Supper* with the projected length lines and edges of the ceiling, the table, the floor, and the stool in frontal or one-point perspective. We must now view the figures in the context of this room to realize that Leonardo placed the head of Christ near the vanishing point of the length lines. We have already indicated, in the preceding chapter, the possibility of using the length lines as a means of guiding the eye in the frontal perspective

representation of an interior. Leonardo made use of this possibility in that the length lines reconstructed in Figs. XX and XXI direct the observer's eye toward Christ, who has been located in the center of the perspective.

Figures XXII and XXIII illustrate how lines can function as elements directing the eye and converge on a figure.

The circle in Fig. XXII is centered in M, unlike the circle in Fig. XXIII, which is centered in M′, because the relevant straight lines deflect the observer's eye toward it and away from M. The circle in Fig. XXIII can also be interpreted as a frontal perspective representation of a hollow cylinder, into which the observer looks, with generatrices. Even so, this figure is centered in M′, the vanishing point of the generatrices.

Sketch for *The Adoration of the Magi* by Leonardo da Vinci

Figure XXIV, the reproduction of a drawing of a cartoon for Leonardo's painting *The Adoration of the Magi,* which was never executed, clearly reveals pictorial composition by means of perspective construction. This cartoon affords particular insight into Leonardo's method of pictorial composition, in which perspective construction is of central importance. Close inspection of the cartoon for this picture is convincing evidence that the construction of the interior was the first step in Leonardo's drawing, into which the figures, the horses, and the camel in the foreground were composed only at a later stage.

XXIV Drawing after Leonardo da Vinci (1452–1519), study for The Adoration of the Magi, *Uffizi, Florence. Accurate construction of the interior with a pair of compasses and a ruler.*

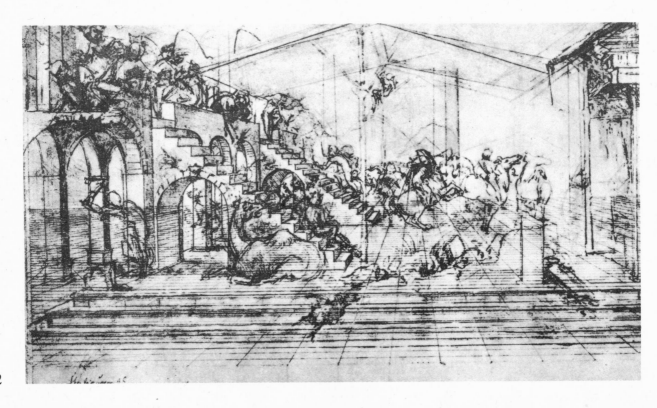

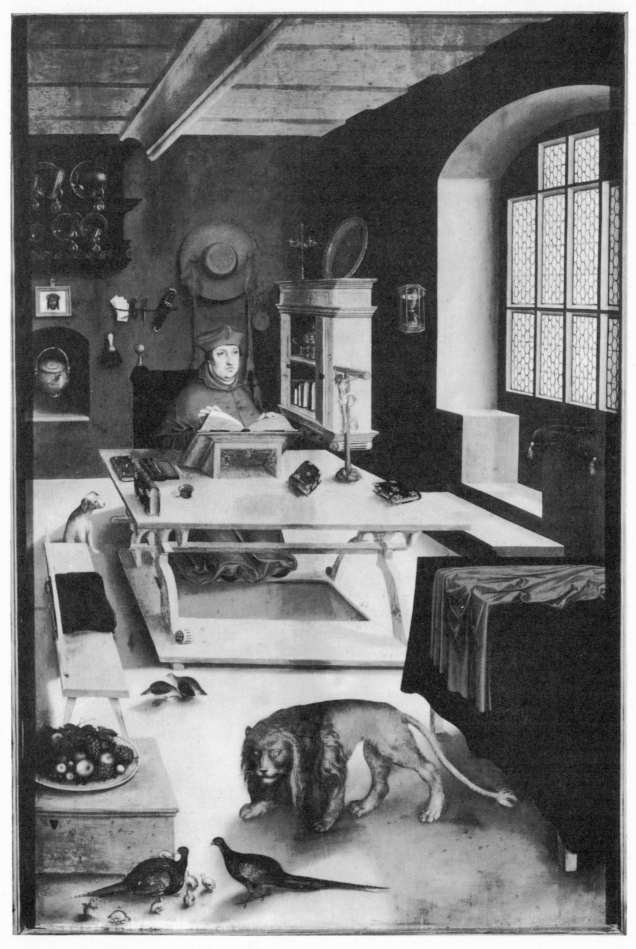

XXV Lucas Cranach the Elder (1472–1553), St. Jerome in His Study,
with the Features of Cardinal Albrecht von Brandenburg, *Hessisches
Landesmuseum, Darmstadt.*

This study also reveals how pictures were painted at the time of Leonardo: Their composition required a cartoon, which was subsequently transferred to the support. Obviously such a cartoon, executed with a rough pencil or brush, cannot be compared with that for the painting *Adoration of the Magi,* which was of course constructed to the last detail with the aid of compasses and scales; the many construction lines, which would have been covered by paint had Leonardo completed this work, betray this.

The perspective construction of the interior in the cartoon for *The Adoration of the Magi* breaks up and thereby dominates the picture area. It thus constitutes an integrating element of the pictorial composition. In contrast with *The Last Supper,* the main figures or the main event, the adoration, have not been placed near the vanishing point. But here, too, the many length lines draw the observer's eye toward the horseman and his rearing mount and thus toward a dramatic accent as if by suction.

The Panel Painting *Cardinal Albrecht von Brandenburg as St. Jerome* by Lucas Cranach the Elder

The subject of this painting, too, is the representation of a figure in space, in an interior in frontal perspective, which is characterized by the high level of the horizon. As a result, the ceiling of the room does not take up much space. In contrast, the floor is large so that Cranach was able to furnish the room adequately and enliven it with pheasants, a small lion, quails, and a small dog (Fix. XXV).

Another typical feature of the perspective of the interior of Cranach's painting is that the center of perspective is, as Fig. XXVI shows, outside the picture space. The intellectual focus of the painting, the cardinal, is thus not placed at the center of per-

XXVI Construction of the visual point, the distance points, and the edges of the pieces of furniture, the ceiling, and the horizon with the aid of the square tabletop, after Georg Wolff.

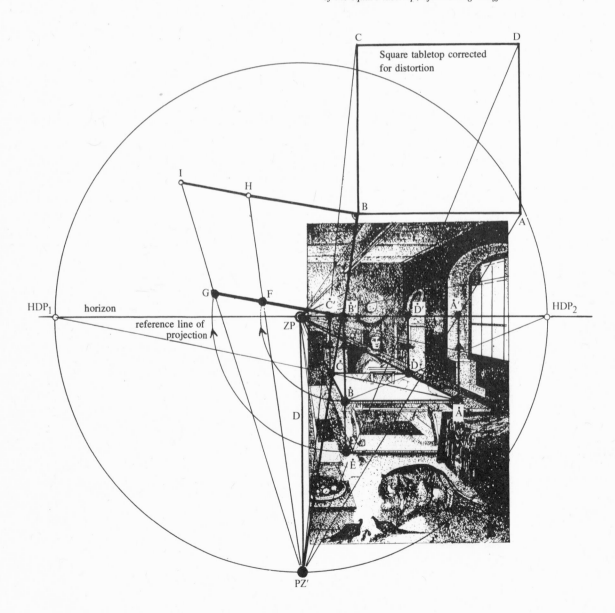

spective, although not far from it.

Mastery of perspective construction as a means of composition also becomes evident in the way a painter solves the problem of reproducing the figure in space, how he relates it to the structure of a space. The solution of this problem in Cranach's painting has been influenced also by Dürer's copper engraving *St. Jerome in His Study* insofar as Cranach, like Dürer, placed the figure of St. Jerome, alias the cardinal, in the background and thereby in the depth of the interior. Because the cardinal's figure constitutes the most important pictorial element in this work, we are able to speak of a background composition. This would become a foreground one if it began, say, with the front edge of the table at which

the cardinal is sitting and the foreground were cut off there. With the removal of the foreground and middle ground a new picture would be created, whose effect we can simulate by covering this position, for instance with a sheet of paper. This would demonstrate that without the foreground and middle ground and its emphasis by inanimate objects and animals there would also be no spatial stages which would lead us indirectly to the figure of the cardinal. In other words, the observer, to arrive at the picture of the cardinal, the focus of pictorial appreciation of the painting, must mentally progress through the interior from the foreground to the background as he traverses these spatial stages. The tension this creates enhances its effect.

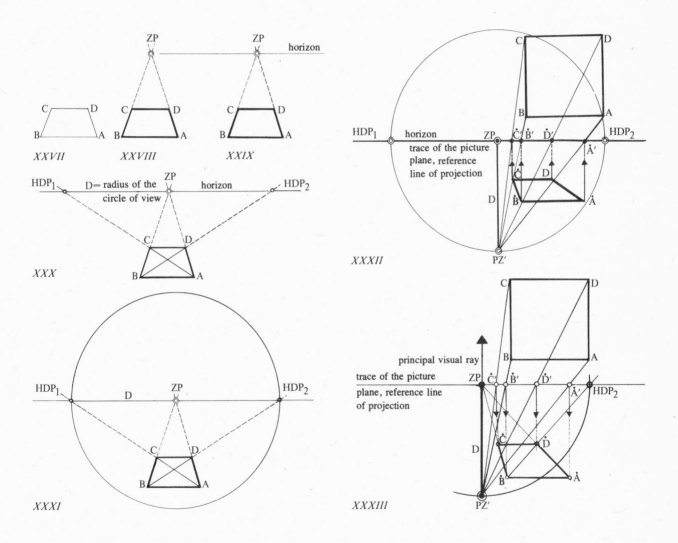

XXVII XXVIII XXIX XXX XXXI XXXII XXXIII

We can use the example of this painting to show how the perspective can be reconstructed.

Let us begin with the table top $\mathring{A}\mathring{B}\mathring{C}\mathring{D}$, which from a planimetric point of view appears as a trapezoid but in reality is a square. We want to prove in this context by means of the illustrations that it is possible to construct the circle of view and, furthermore, the square corrected for distortion from any trapezoid that is a square in perspective.

Figure XXVII: The trapezoid is given as the perspective square ABCD. Required are the circle of the horizon and the square corrected for distortion.

Figure XXVIII: The intersection between the produced sides AD and BC results in ZP, the center of the perspective and of the circle of view.

Figure XXIX: We draw a parallel to AB through Z. This gives us the horizon.

Figure XXX: From the intersection with the horizon of the produced diagonals of the square in perspective we obtain the two horizontal distance points HDP$_1$ and HDP$_2$ and the radius D of the circle of view, which is the distance between the center of projection and the picture plane.

Figure XXXI: Because we obtain the radius of the circle of view from the straight lines HDP$_1$–ZP and HDP$_2$–ZP, we are now able to draw this circle.

Figure XXXII: We can prove that the trapezoid ABCD is a square in perspective by correcting its perspective distortion as follows: We interpret the drawing Fig. XXXII both as the vertical—primarily—and as the horizontal plan of the perspective model. In the vertical plan the picture plane coincides with our sheet of drawing paper, and the distance D has shrunk to a point. In the horizontal plan, however, the picture plane is reproduced in the form of its (now horizontal) trace, which coincides with the horizon of the vertical plan, so that this can be used as the reference line of projection. The distance between the center of projection and the picture plane can be drawn as a straight line at right angles to the trace of the picture plane. In Fig. XXXII the horizontal defines the axis or trace of the picture plane, and the straight line ZP–PZ at right angles to it the distance D and the center of projection.

Figure XXXII shows the transferring of the corners ABCD of the perspective square into the horizon or axis, where they reproduce their perspective aspect in the horizontal plan. With the aid of the projection rays radiating from PZ′, which pass through $\mathring{A}′\mathring{B}′\mathring{C}′$ and $\mathring{D}′$, we can construct the square ABCD with its distortion corrected. It is best to begin with a horizontal above the horizon and to enter the points A and B of this square.

Figure XXXIII represents the inversion of the method just described. It demonstrates the solution of the problem of constructing the square $\mathring{A}\mathring{B}\mathring{C}\mathring{D}$ in perspective from the given square $\mathring{A}\mathring{B}\mathring{C}\mathring{D}$. To do this, we draw the axis of the trace of the picture plane parallel to AB. We then determine PZ′ at right an-

gles to it by constructing the distance D. From PZ′ the points ABCD of the square can be centrally projected onto the trace of the picture plane. From here the points $\mathring{A}′$ and $\mathring{B}′$ are translated into a horizontal resulting in \mathring{A} and \mathring{B}. These points are joined to ZP. The corners \mathring{D} and \mathring{C}, also obtained with perpendiculars from the correlated points, are located on the connecting lines A–ZP and B–ZP. The circle of view can be described around ZP at the radius D, which is associated with the square $\mathring{A}\mathring{B}\mathring{C}\mathring{D}$. But both circle of view and square must be perceived in connection with the picture plane, which coincides with our sheet of drawing paper.

The square tabletop in Fig. XXVI was corrected for distortion according to this method. The same illustration also shows how the height of the table can be found in proportion to the dimensions of the tabletop. We are following here Georg Wolff's suggestion in his book *Mathematics and Painting* (Leipzig/Berlin, 1925).

In Fig. XXVI the vertical \mathring{B}–\dot{E} is the height of the table. This height is marked from $\mathring{B}′$ on the side of a right angle erected there on the projection ray PZ′–B, resulting in FG. Through projection rays from PZ′, F and G are transferred to the side of the right angle erected in B. H–I will then correspond to the height of the table in proportion to the tabletop.

The Wall Painting *The School of Athens* by Raphael

Everything we have said about perspective construction as a factor determining the entire composition of *The Last Supper* and of the study for *The Adoration of the Magi* applies also to Raphael's painting, reproduced here as a drawing (Fig. XXXIV).

This painting contains an anachronism in that it shows eminent representatives of ancient Greek philosophy and history of thought of several centuries assembled in a templelike hall.

The figures are distributed throughout the foreground, middle ground, and background of the hall so that those on the left and right of the steps lead to the background figures, who with a single exception are shown standing. The figures in the left foreground take up the space to the center of the picture, whereas the group in the right foreground appears to have been pushed into the right-hand corner. A gap opens up between the two groups, which exposes to view the two main representatives of Greek philosophy, Plato and Aristotle. These two figures form the intellectual center of gravity, the focus of pictorial appreciation of *The School of Athens*. As in *The Last Supper,* this center is located near the vanishing point ZP, on which the length lines converge, functioning here, too, as a means to direct the eye to the two principal figures of the painting.

Vasari, an Italian biographer of artists, claims that the architect Bramante constructed the interior of *The School of Athens* and its perspective. If this

is true, it by no means detracts from Raphael's achievement, the less so as the way in which the figures and the interior blend into an integrated whole must be regarded as brilliant. The unity of figures and space in *The School of Athens* is also expressed in that the figures are represented on the same perspective scale as the interior. In other words, they become progressively smaller as they recede into the background.

We can also speak of an interplay of figures and space in *The School of Athens,* because the verticals of the architecture are repeated in the upright bodies of the standing figures in the background, producing a harmonious effect. These verticals are contrapuntally opposed to the horizontals of the steps in the middle ground. But the relation between interior and figure is also expressed in the way Raphael related the two principal figures of *The School of Athens* to the architecture.

The artist could have established the focal point of *The School of Athens* supplied by these central figures equally well by placing them in the foreground, that is, by emphasizing their size. But he employed different, we may say more ingenious, means. We have already mentioned the method of using the length lines of the interior, at right angles to the picture plane, as elements to direct the eye. We have also drawn attention to the gap in the foreground as a means not only of directing the eye but also of creating tension.

XXXIV Raphael (1483–1520), The School of Athens, *1508–1520, wall painting in the Stanza della Signatura, Vatican, Rome. Copy, with the receding lines of the perspective construction added.*

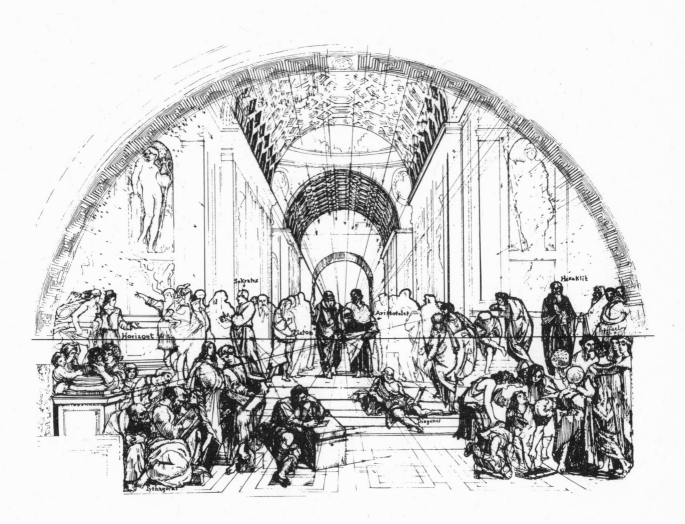

27

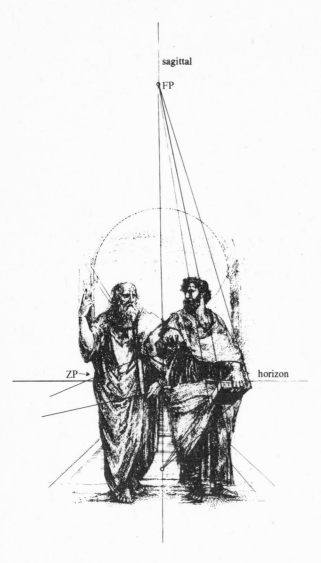

sagittal

FP

ZP→

horizon

XXXV Although at the time of Raphael only the vanishing points of horizontal straight lines which intersect the picture plane either at right angles or at an angle of 45° were known—the vanishing points ZP, HDP₁, and HDP₂—the problem of the perspective rendering of oblique lines had to be solved in the representation of the books held by Plato and Aristotle.

This empty space in the foreground of *The School of Athens* near the central axis forms a kind of counterpoint to the arches in the upper portion of the picture. Four arches of different shapes lend the painting its character. The first and largest arch does not form part of the architecture of the interior. It is, in fact, the same kind of frame that Raphael used in another fresco of the Stanze, namely, *The Divine Revelation* or *La Disputa*. This arch is followed by three successive arches of the interior architecture. Two of them are characterized by a complex spatial and ornamental structure. Because the horizon in *The School of Athens* is comparatively low, the underside of the arches is clearly revealed to view, and this causes the ceilings of the passages to dominate the scene.

In the context of the emphasis on Plato and Aristotle in *The School of Athens* these arches are significant in that they encircle these principal representatives of Greek philosophy as if they were halos. This is also brought out in Fig. XXXV, which shows Plato and Aristotle in isolation.

Their hands point at the core of their theories. The right hand of Plato, to whom Raphael gave the features of the aged Leonardo, indicates his realm of ideas, which ranks above the material world, whereas Aristotle's right hand is turned toward the Earth as if blessing it as the place where the ideal exists only in unity with reality. Figure XXXV also demonstrates the problem mentioned in the introduction, that in the frontal representation of space at a time when only two vanishing points were known, certain objects were nevertheless reproduced in the diagonal and in a random position. The block in the foreground of *The School of Athens,* for instance, which supports one of the figures, is shown in a diagonal position.

San Marco from the Arcades of the Procuratie Nuove by Canaletto

It is no accident that "ars perspectiva" developed mainly in architectural representation, because scenography began with the reproduction of frontal architectural vistas. The highly developed "ars perspectiva" as expressed by Canaletto in his paintings of cities and in the drawing, Fig. XXXVI, has on the one hand been founded on a tradition that goes back to Antiquity. On the other hand, the high standard of "ars perspectiva" Canaletto observed can be explained by the fact that his father was a scene painter, from whom he received a thorough training in perspective. During the late Baroque, scene painting called for comprehensive knowledge of perspective. The camera obscura must be regarded as another of Canaletto's teachers in perspective; he made use of it in his artistic work.

The major part of architecture drawn by Canaletto is represented both in frontal perspective and from the frog's-eye view because of its low horizon, on which the monumental effect of this kind of perspective is based. The shift of the center of gravity to the right is due above all to the arcades with the long, structured ceiling, which owes its prominence also to the low horizon. Although the two sitting figures in the right foreground attract the observer's eye because they are located near the center of perspective—here, too, the lines of length function as guides for the eye—the figures throughout the picture are on the whole little more than accessories. They also serve the purpose of enhancing the perspective effect by being distributed singly as well as in groups from the foreground to the background in the square. In addition they are employed to provide an idea of scale.

When we compare Canaletto's drawing with Raphael's *The School of Athens,* we find that the two works have in common a low horizon, which places appropriate emphasis on the architecture. However, whereas in Raphael's painting the many figures counterbalance an otherwise dominant architecture (all the more so because, as individuals and repre-

sentatives of the Greek world of thought, they rivet the observer's attention), in Canaletto's drawing it is the architecture which dominates and the less prominently shown figures are of secondary significance, although they enhance the perspective effect of the picture and demonstrate the human scale.

Sketch for a Ceiling Fresco by Gottfried Bernhard Goetz

The cartoon for a ceiling fresco (Fig. XXXVII), even more than the impact of the finished work in a Baroque church, makes us aware of the ultimate flowering of "ars perspectiva," the use of perspective as an artistic means of composition of the Baroque style, because here it finds expression in a blending of architecture, sculpture, and painting into an integrated whole.

The drawing shows us architecture combined with sculpture as a weighty and powerful framework which not only encloses, but also directs the eye to, the heavens with their scenery; this is illustrated by Fig. XXXVIII, which, to enhance the perspective effect, is hatched in the direction of the length lines.

A comparison with Fig. XV reveals that this drawing, too, has been executed in the appropriate frontal perspective, whose specific feature is the suggestiveness of the length lines in directing the observer's eye.

XXXVI *Juan Antonio da Canal, called Canaletto (1697–1758),* San Marco from the Arcades of the Procuratie Nuove, *pen drawing in black ink, Royal Library, Windsor Castle, England (reproduced by gracious permission of Her Majesty Queen Elizabeth II).*

The Panel Painting *Still Life in Puzzle Perspective* by Ludwig Adam Kelterborn

Here the frontal perspective resulting from a horizontal picture plane and a vertical visual ray appears only within limits (Fig. XXXIX). The special feature of this picture is the so-called puzzle perspective, in which the objects of the still life are reproduced in inverted perspective. For a better understanding of the term "puzzle perspective" we might look at a puzzle picture which deceives us or sets us a puzzle.

Kelterborn's *Still Life* conforms to the frontal perspective with a horizontal picture plane in that the rims of the glasses, the bottle, the cup, and the coffee pot appear as circles and the top surfaces of the dice as squares, that is, without perspective distortion. The convergence of the longitudinal or body axes of the objects, which are parallel to the principal visual ray, on a vanishing point outside the picture area also agrees with this kind of perspective. The paradox or inverted feature of the perspective in Kelterborn's *Still Life* is the fact that his objects do not, as they should, become shorter in depth but are, on the contrary, elongated. This is most evident in the dice: Their edge length is that of the sides of their square top surfaces. The edges of the dice, and therefore the dice themselves, should become shorter in depth. In fact, they grow to double their length. We clearly see a corresponding paradox in the orange in the top right-hand corner of the picture; the longitudinal axis

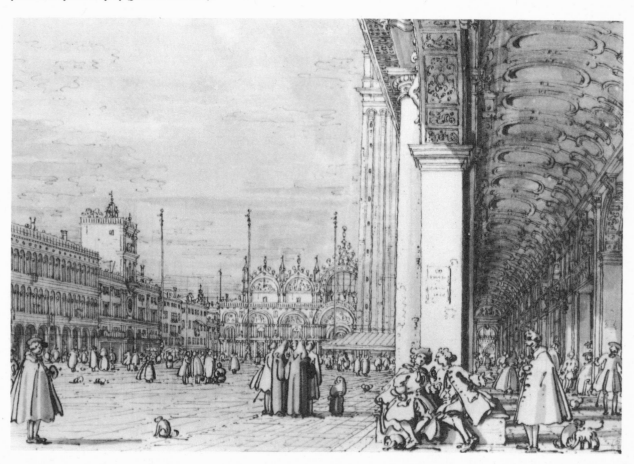

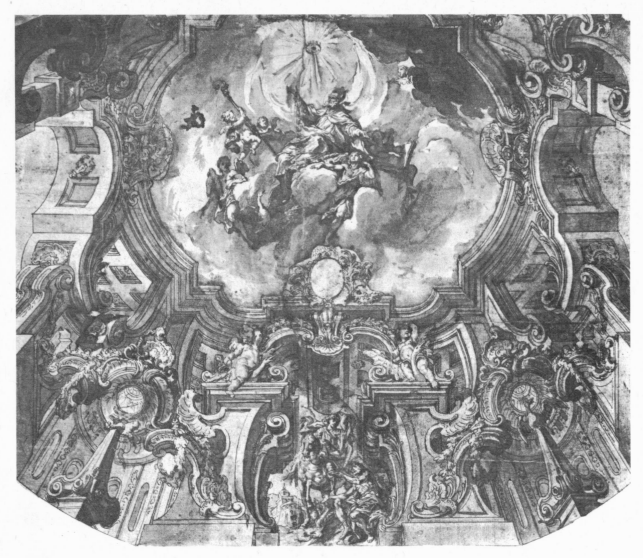

XXXVII *Gottfried Bernhard Götz (1708–1774), design for a ceiling fresco, pen and ink with water colors, private collection.*

is elongated instead of shortened: Kelterborn has thereby achieved what we have come to call "alienation of the object" also in the other objects of his *Still Life;* this work therefore appeals to contemporary taste and is felt to be "modern."

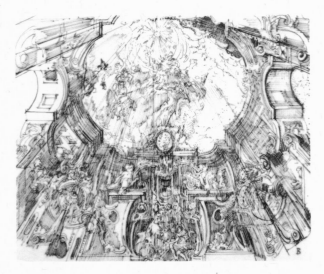

XXXVIII *Design for the ceiling fresco, with perspective construction lines added.*

The Woodcut *Another World*
by M. C. Escher

This picture shows how a modern Dutch artist makes use of perspective as a means of composing a surrealist work (Fig. XL).

Here, too, frontal perspective is employed which is the source of the initial confusion but also attraction of the spatial effect. It is based on the ambiguity of the frontal perspective representation of a cube or cuboid and correspondingly of a cubic or cuboidal interior, as illustrated in Figs. XV and XVI.

In this picture the aspects of the same interior from three different visual points—from below, from above, and from the front—are combined.

The vista of the lunar surface with its craters appears as if seen from above. The central visual ray would be perpendicular or like a gravitational line being directed toward the center of the Earth. This impression is created by the bird standing on the ledge below the top of the picture as well as by the horn hanging above the other ledge at right angles to the first.

XXXIX Ludwig Adam Kelterborn (1811–1878), Still Life in Puzzle Perspective, *water color, Basle.*

XL M. C. Escher, Another World, *woodcut.*

In the central part of the picture the vista opens onto a horizontal lunar surface, from which we can see the Earth; Escher placed it in the region of the vanishing point ZP, the center of perspective. Let us again look at the sphinxlike bird on the ledge of the window through which we view the lunar landscape as from a familiar room. To be able to obtain a view of the universe as afforded from the bottom-most portion of the picture, we would have to be able to take up a viewpoint from which we could look steeply upwards and thus see the interior from below.

The realization of the perspective of a certain view is made easier if the other possibilities of view are concealed.

Problems and Importance of Perspective Construction

We must distinguish between free perspective and perspective construction. What are their differences?

The usual procedure of constructing a perspective picture of an object requires the horizontal and the vertical plan, and sometimes also the profile of the object. To the mathematician *Johann Heinrich Lambert* (1728–1777) "free perspective" meant a method of constructing a perspective picture without horizontal plan; but we classify this method as "linear perspective" because, like the circle of view or distance circle method, it is based on a strict geometric construction. *"Free perspective"* requires no knowledge of the relevant geometry, whereas drawing according to the categories or definitions of linear perspective demands such theoretical knowledge. Free perspective and linear perspective are therefore opposites although there is an interrelation between them. We speak of free perspective when someone draws, for instance, a group of buildings only on the basis of acute observation, without knowledge and use of linear perspective. Such a picture may well be correct also according to linear perspective, because we see objects not as they really are but in perspective distortion. All that is therefore required for their correct perspective reproduction is accurate observation.

However, in this process certain laws of perspective can be understood empirically, for instance, that horizontal length lines below eye level seem to ascend and above eye level to descend. The perspective law which states that parallel length lines intersect in a point, their vanishing point, can be proved empirically also by means of photography: If parallel length lines such as the edges of buildings or the sides of roads are produced with a ruler until they intersect, their point of intersection is the vanishing point.

A wide range of creative work is characterized by the conscious or subconscious application of the empirically understood laws of perspective, that is, by what we call free perspective.

But free perspective also governs representations produced through eidetics or through the eidetic gift of the draftsman.

Eidetics is the science of imagery. In our context, however, eidetics defines the ability to reproduce and to present, i.e., to draw and to paint from memory, on the basis of an "after-image" of what was seen. Persons who have this gift are therefore called "eidetic." Experiments have shown that they are capable of drawing from memory, after only 20 seconds of looking at the original, a picture which agrees with it even in detail to an astonishing extent.

This eidetic gift can be strongly evident in young people but usually regresses later. Even when it is present in artists, it is no criterion of artistic talent, because reproductions drawn by an eidetic person from an "after-image" often look like carbon copies. This suggests that the eidetic brain and eye function like a projector, which produces an "after-image" on a sheet of paper so that all the eidetic person has to do is trace the lines he sees.

But pictures from the earliest period of prehistory, such as the cave paintings of Altamira and Lascaux, are evidence that works of art can be produced through the medium of eidetics.

It is assumed that primitive man was eidetic. His faithful yet extremely expressive representations of animals, which he produced in caves dimly lit by fires, can probably be explained in terms of a dynamic intensity of "after-images."

We are all to varying degrees eidetics, because we heavily depend on our ability to reproduce after-images of the objects of our natural environment. Good examples are a suddenly extinguished light in a room, where from the after-image we can roughly visualize our situation, and our recognition of a person or of an object, impossible without any previous visual encounter and without the "after-images" this produces.

Because these "after-images" are constructed by means of central perspective, their structure can be described as perspective. This is also clearly evident in drawings by eidetic persons. "Free perspective," too, is therefore embodied in eidetics, because like everybody else the eidetic person sees his or her surroundings and its objects not as they really are but in perspective distortion. A discrepancy therefore exists between the objective shape of things and the subjectivity of perceiving them.

Kant, too, mentions this discrepancy; he contrasts

the concept of appearance with that of "things in general," which he defines as things independent of a perspective subject and therefore of our subjectivity. In other words, the object of free perspective is the appearance of things as perceived and pictorially reproduced by the eidetic person.

The perception of the (perspective) appearance of objects and accordingly their pictorial reproduction can be defined by the so-called *esthetic-physiognomic concept of form,* which must be separated from the *mathematical concept of form,* which characterizes perspective construction. Briefly, this is the difference between the two concepts of form.

When looking at architecture, at a Gothic cathedral for instance, we can try to become aware of the structural principles on which it is based or of its geometric-mathematical structure. We must use an analytical and categorical mode of approach, which is a process of the intellect and of the mathematical concept of form. The situation is altogether different when, rather than an "intellectual appreciation," it is a "visual experience," for instance of a Gothic cathedral, to which a person is able to surrender in profound emotion and awe. The esthetic-physiognomic concept of form valid in such a case is not analytical and categorical but integrating. The impression of the cathedral as a whole is the basis of the emotion-charged "visual experience."

Geometric figures, too, can be viewed in accordance with the esthetic-physiognomic concept of form, as may occur above all with a child or a person unfamiliar with geometry. Thus Emil Strauss in his novel *Freund Hein* writes of Heiner, its hero: "These acute triangles caused him physical discomfort, as if he had to play with the splinters of a glass pane." The schoolboy Heiner saw in the acute triangles on the blackboard images of glass splinters, so that he was unable to find the necessary objective, matter-of-fact approach to them that the mathematical concept of form in which a pupil is to be trained demands. Instead, his emotionally affected and esthetic-physiognomic manner of perception of the triangles could not but jeopardize his success in the subject of geometry.

It is thus an esthetic-physiognomic way of looking at things when we see images of concrete objects in geometric forms and figures: In a circle, for instance, the image of the sun, in a rectangle the silhouette of a modern building, or in a trapezoid the image of a roof.

Geometric forms and figures can thus be looked at in purely esthetic terms, i.e., from the point of view of their beauty or ugliness. However, this does not apply in geometry, where it is irrelevant whether a theorem is discussed in conjunction with a beautiful figure or an ugly one. This is not to belittle the esthetic assessment of geometric figures, because in modern design and composition such figures occupy the foreground of interest. But the designer must above all aim at a discriminating feeling for the esthetic quality of a geometric form, on which he depends, for instance, for the distinction between well- and badly proportioned rectangles.

In his book *Architecture* Walter Gropius discusses the contrast between esthetic-physiognomic and mathematical concept of form as it affects the experience and representation of space. However, without using the words which characterize the contrast between free perspective and linear perspective in this context, he writes: "We have all at some time or other tried lying on our backs to fathom the infinity of the distant sky only to realize that we are denied comprehension of infinite space. It is true that mathematicians have established the terms of infinitely large and infinitely small units and used symbols for them; but these symbols remain abstract and cannot convey a senuously tangible impression of infinite space. We comprehend only finite space in its measurable three-dimensionality. Limited space, whether open or closed, is the artistic means of creation in architecture."

Even if according to Gropius we are denied comprehension of infinite space, we can yet experience it in esthetic-physiognomic perception and above all in awe, because "infinite space" means "infinity" which someone may experience as he faces such a space.

Infinite space cannot be represented by means of linear perspective, because this is restricted to the line. But the line is not the only means of objectivizing perspective space effects. Other such media are colors and tone values. A landscape fading into infinity can be represented by tonal gradation.

Although the laws of intensity of illumination, reflection, and optics of the colors must be followed in the creation of *color perspective, tone perspective,* and *aerial perspective,* they cannot be applied scientifically as those of linear perspective can. When we create color, tone, and aerial perspective, we are forced to use our sense of vision, our feelings, emotions, and intuition and to proceed according to our own discretion and independent judgment. We therefore categorize color, tone, and aerial perspective as free perspective, which we compare with perspective construction, a matter of the intellect, logic, and discursive thinking. We therefore list all—even linear—perspective renderings that do not strictly comply with the laws of perspective construction under the heading of free perspective.

The construction of shadows calls for the simultaneous use of tone and of linear perspective and thereby for a merger of free and linear perspective. The contours, which are lines, of the cast and body shadows can be determined with mathematical precision by means of linear perspective, and the cast and body shadows themselves represent tone values which (even according to Lambert's Law about intensity of illumination) can be determined only approximately.

For knowledge of the law formulated by Lambert, 33

that the intensity of illumination of parallel planes is inversely proportional to the square of the distance from the light source, is not by itself enough to determine the tone gradations in the representation of cast and body shadows in all possible types of illumination at the same degree of accuracy as their contours or shapes. Rules cannot be laid down for all possible types of natural or artificial illumination. The concept of perspective therefore does not encompass only what can be precisely constructed on the basis of mathematics; it is free and linear perspective which together constitute the whole concept of perspective.

Only geometric shapes and bodies can be drawn accurately according to the laws of linear perspective. However, we must also represent irregular shapes and structures in correct perspective. In other words, linear perspective must be restricted to the representation only of geometric or regular shapes and bodies. In actual fact we want to make use of it for the representation of any types of object and living being. We reach this goal by drawing the geometric structure or mathematical shape of an inanimate or of a living thing according to the laws of linear perspective and everything else according to the principles of free perspective.

As in descriptive geometry, we can thus construct only the geometrical structure of a landscape in linear perspective. Everything else, the individual shapes of hills or mountains, the fine structure of a landscape, the plants, trees, and woods, must be represented by means of free perspective and free-hand drawing.

We can arrive at a synthesis between free and linear perspective in the reproduction of the "figure in space" if it meets the requirement of the unity of perspective: All the contents of a picture—figures and space—must appear to be seen from one and the same point of view, projected from one and the same center of projection. Meeting this requirement demands that we come to grips with the perspective construction of the figure itself; here the study of anatomy will be helpful because it explains the basic structure of the body, which can be constructed; flesh and blood, hair and clothes cannot be constructed and must therefore be represented by means of free perspective.

The perspective reproduction of plants and animals, too, requires knowledge of their basic geometric structure. Nature, in the vegetable kingdom and particularly in that of the primitive animals, offers many shapes whose geometric structure is obvious. Seashells and snail shells come to mind, as do primitive marine animals such as phaeodaria, whose external shapes are octahedral, dodecahedral, and icosahedral. In certain flowers and plants, too, the geometric structure is immediately evident. An example is the sunflower, whose seeds are arranged in logarithmic spirals.

does not call for the study of their basic geometric structure. But linear perspective is based on it and therefore is also valuable in that it develops our *conceptual differentiation of objects.*

Everything that we can perspectively represent at our discretion, empirically, and mainly on the basis of intuitive methods comes under the heading of free perspective, whereas linear perspective is a matter of the intellect and of deductive methods, which means that it is part of geometry, whose reliability is founded on the fact that all but its basic structures are precisely laid down by definition and conceptual abstraction.

The mathematical concept of form is the subject of the conceptual structure of geometry and of perspective construction, whereas in free perspective the esthetic-physiognomic concept of form is the dominant factor.

Linear perspective is based on *central projection,* in which the visual or projection rays converge in a center or point or, conversely, radiate from it (Figs. XLI and XLII). This point, called the center of projection, is, as it were, the single eye of linear perspective.

The assumption of a single center of projection, from which we proceed when constructing a picture of an object, constitutes, in contrast with the very complicated binocular visual process, a simplification or restriction.

Our moving eyes in a moving head, attached in turn to a moving trunk, produce stereoscopic individual pictures, whose sum total makes up the picture we see. Binocular vision (with two eyes) conveys a picture of our surroundings and the objects they contain; it differs slightly from that produced by central projection, which we can compare with, and regard as a parallel to, monocular (one-eyed) vision. For if we view an object binocularly, we move the eyes so that our glance takes it in from all possible directions; the image we obtain of this object must therefore be understood as a composite of many separate stereoscopic images. The visual process is even more complicated when we look at a space; here we move not only our eyes, but also our head and sometimes even our whole body.

Monocular vision corresponds to the rigid, fixed glance: The eye is confined to a certain point which, once fixed, must not be changed. But with the rigid, fixed glance we actually see only a very small portion of the surface of an object; in fact, we see only a single point of this surface, the so-called fixation point, in sharp focus. This is where the main visual ray meets the surface of the object seen. Anything outside this point is seen a little out of focus and with increasing distance from it becomes increasingly blurred. The angle of vision within which objects appear in focus is about 10°.

Here are two examples to illustrate the problems of central projection or the reproduction of objects from a single point, which we compare with the

Simple representation of the appearance of objects

XLI The perspective picture of an object will be larger than life when the object is situated in front of the picture plane.

XLII The perspective picture of an object will be reduced when the object is situated behind the picture plane.

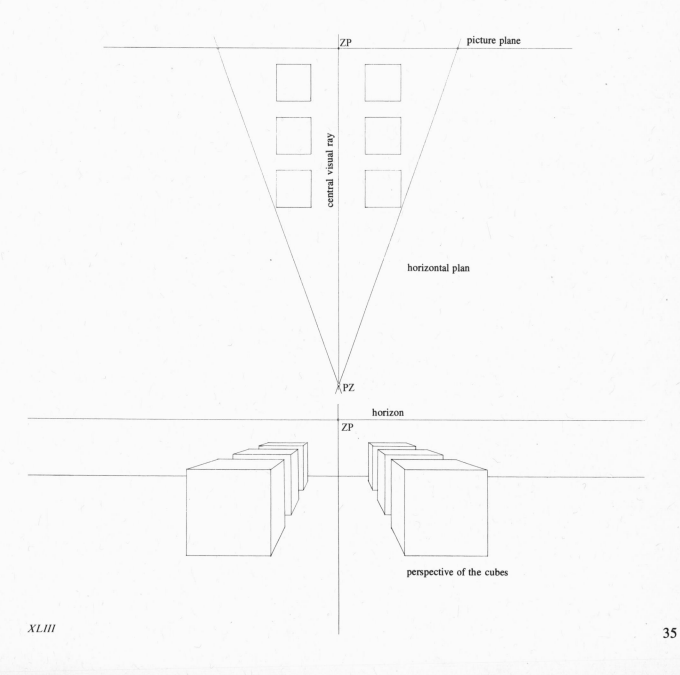

rigid, fixed, monocular vision.

Figure XLIII top shows cubes in horizontal plan. PZ is the center of projection, where the rays that are to project or to form a picture of the cubes in the picture plane BE converge. We have said that we can compare this center of projection to the single eye of perspective, which takes in the objects—here the cubes—with a rigid, fixed glance.

Provided that the cubes are situated within an angle of vision of 40° formed by the outermost projection rays or visual rays, the principal visual ray does not touch the cubes at all but passes them by. This ray meets the picture plane in the previously mentioned fixation point, called the center of perspective ZP. Here the rigid, fixed glance is directed not at the cubes at all but at the center of perspective. So that it can take in each of the cubes discretely, it must be directed at each of them. The perspective picture of the cubes we obtain by the appropriate construction method therefore cannot conform to our perception, because the lateral faces parallel to the picture plane appear as squares and the edges of the cubes vertical to it have their vanishing point in the center of perspective ZP (Figs. XLIII and XLIV).

In the perspective construction of several spheres, too, we do not obtain a picture that conforms to our perception; in other words, we achieve our aim of perspective construction, of representing the objects as we see them, only within limits.

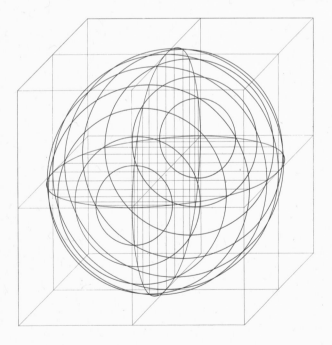

XLIV Construction of a sphere from a cube rendered in parallel perspective. The sphere is developed from the three median planes of the cube, from which circles are drawn. The circle from the frontal median plane, unlike those from the other median planes, does not become an ellipse. Nor does it correspond to the contour of the sphere, which is an ellipse, as this drawing shows. For the further construction of the sphere from the cube, planes parallel to the frontal median plane and intersecting the sphere in front circles are assumed. The diameters of these circles are in the horizontal and in the sagittal median plane. The elliptical contour of the sphere, which in the drawing has not been traced, is partly derived from the frontal circles. Cube and sphere can be simultaneously rendered both in top and underside aspect.

Let us assume that a class is given the task of drawing the globular lamps suspended from the classroom ceiling from the frontal aspect. If they are to be drawn freehand from observation, this should present no difficulties to pupils after a certain amount of practice. Everyone can see the circular outlines of the globes and draw them correctly.

The situation is different if the pupils are asked to represent the lamps strictly according to the rules of perspective construction. It is true that, provided we proceed from the right conditions, we can construct a picture of the classroom that corresponds to that produced by our eye. As regards the pictures of the lamp globes, however, only the lamp whose center coincides with the center of perspective will become circular in outline. The outlines of the other lamps will become elliptic.

Why? In geometry we develop the round forms from angular ones, the circle from the square, ellipses from rectangles, parallelograms, or trapezoids, the sphere from the cube. We can construct a sphere that is to be circular in contour only from a cube whose contour is either a square or a regular hexagon. If we now examine the cubes from which we are about to develop the lamps and whose contours correspond to the perspective of the classroom, we find that none of these will form a square or a hexagon. Only the cube whose center coincides with the center of perspective would have a square contour. We would therefore be able to draw a circular lamp only from this cube. All the others would produce elliptic contours. Because the same conditions as in perspective construction prevail in photography which corresponds to monocular "vision" (we can compare the camera lens to the single eye, the center of projection), photographic pictures correspond to those of perspective construction. The photograph of a classroom with globular lamps in Fig. XLV confirms this. The lamps appear to be ellipsoids.

We may ask to whom perspective construction is still important today. Although in the past perspective played a prominent part in painting and the graphic arts for the benefit of pictorial composition and objectivization of the picture space, it has become irrelevant in modern abstract painting. But until we know of a more satisfactory method of convenient representation of objects than central projection, it will continue to be of interest to engineers, architects, industrial designers, and graphic artists, who in their work depend on spatial and perspective rendering of their objects.

Is parallel perspective inadequate for this purpose? In our opinion it is, because the parallel perspective picture of an object is limited to a certain size beyond which it will appear unacceptably distorted.

Because the drawing can be regarded as the language of the engineer, the architect, the designer, and the graphic artist, everyone who uses it daily

XLV Photograph of a classroom with globular lamps.

and wants to master it should know the possible modes of representation and projection. None of them is without its drawbacks. Precisely for this reason the draftsman must have at his disposal a repertory of modes and methods of representation with whose advantages and disadvantages he is familiar; he must be able to illustrate a given object by means of different modes of representation. As to the knowledge of perspective construction, its defects and limitations are an additional reason for studying it, because we can overcome the pitfalls and difficulties of a problem only if we know them thoroughly. Knowledge of central projection also leaves us free to use it where we believe it achieves our aim, and alternatively allows us to use our discretion by adopting free perspective where the other method would fail. We have described linear perspective as pure geometry. Every branch of geometry is concerned with the laws that govern space. The study of geometry, especially the geometry of perspective, is an excellent means to develop the perception of space. It will be an essential element of this study that the perceptual and discursive methods and thought should interact in that we must try to make results obtained in a purely discursive way as capable of visualization as possible; problems we cannot solve by means of perception we should solve discursively, and vice versa. Thus, where we cannot accomplish the aim of perspective construction, which is to reproduce the objects as they appear to us, we should take such measures as we feel conform to our optical sense and perception. This means that we draw the lamp globes, which we cannot construct perspectively as we see them, as circles, disregarding the accuracy of the perspective construction.

We can call the geometric shapes elementary, regular ones. They are the simplest shapes in existence. It is the object of geometry to investigate the origin, generation, transformation, and reproduction of these regular shapes. It develops methods that help us determine a shape, for instance, that of an intersection curve. It shows us what the characteristic shape of such a curve should be. Because both geometry and perspective construction concern the origin, generation, and transformation of shapes, we may regard these faculties as a kind of *morphology*. This makes them meaningful and topical to all those who encounter the problem of giving shape to objects in any field of the arts or technology.

However, we must bear in mind that geometry, by virtue of obtaining its results discursively (that is, by making use of intellect and logic), does not assign esthetic values to its shapes but perceives them as measurable, constructible dimensions or quantities. In contrast the eye, our visual faculty, perceives shapes and relations between them everywhere and experiences, unlike the tangible faculty of geometry, the quality of a shape. "To see means to see shapes," according to H. Friedmann.

We have mentioned that the discursive method in linear perspective constitutes both its strength and its weakness. We have already discussed its weakness; what constitutes its strength?

The discursive method and the arithmetical procedure enable us to solve problems incapable of solution by means of perception and imagination. An example may briefly illustrate how limited our imagination is. On the strength of his imagination a pupil with some knowledge of geometry will find the answer to the question how many points of inter-

37

section will be produced by three intersecting straight lines. This may be possible if he sees the straight lines as thin rods before his mind's eye and mentally counts their points of intersection. He will soon arrive at the answer to the question that there must be three if he remembers that the three rods or straight lines form a triangle whose sides may be produced beyond its corner.

The imaginative solution to the problem of determining the number of spaces or regions between three intersecting straight lines or rods will be more difficult for the pupil. However, it is possible to determine the number of points of intersection and of regions between intersecting and tangent straight lines with the aid of formulas and therefore by purely arithmetical means.

The formula for calculating the points of intersection is $\frac{n(n-1)}{2}$, where n is the number of straight lines. If we want to find the number of intersecting points of 10 straight lines according to this formula, we can, by substituting the number 10 for n, easily solve the problem by mental arithmetic:

$$\frac{10(10-1)}{2} = \frac{10(9)}{2} = \frac{90}{2} = 45$$

Thus 10 intersecting straight lines produce 45 points of intersection. This formula is valid also for the calculation of the number of clinks when glasses are touched: When 10 people touch glasses, there will be 45 clinks.

For the number of regions between lines the formula is

$$1 + n + \frac{n(n-1)}{2}$$

We let $n = 10$ if we want to find the number of interspaces produced by 10 intersecting straight lines. This results in the following equation:

$$1 + 10 + \frac{10(10 - 1)}{2} = 11 + 45 = 56$$

Thus 10 intersecting straight lines enclose 56 regions.

We see that this formula enables us to say at once that 10 intersecting straight lines produce 45 points of intersection and 56 regions. It is formalism, then, which is at the root of an achievement of which our imagination is simply not capable. We must therefore employ reflection, logic, or discursive thinking here, as we do in the derivation and use of formulas.

The limitations of our spatial imagination are also brought home to us when we attempt to solve problems of linear perspective. A parallel can be drawn between the operation with formulas and algebraic and arithmetical rules and the formalism founded on the use of construction methods from which we proceed when solving such problems.

This formalism constitutes the strength of linear perspective, because it enables us to tackle problems and to realize achievements impossible with free perspective, where we rely mainly on spatial imagination. This is also evident in the teaching of linear perspective, in which students making use of formulas are soon able to solve quite difficult problems, such as the perspective drawing of carpets with complicated geometric ornaments (Fig. LXVI). These students would probably be overchallenged if they were to tackle this problem with the aid of their spatial imagination by freehand drawing or according to the method of free perspective. They would either need a vast amount of time and extreme effort or fail altogether.

In summary we can say that free and linear perspective are interdependent insofar as we must rely on both types in the practice of the draftsman; this and artistic creation present problems which cannot be solved by relying on one to the exclusion of the other. Both types have their strengths and weaknesses, and their careful balance is one of the aims of this discussion.

The School of Athens by Raphael (Fig. XXXIV) represents a synthesis between free and constructed or geometric perspective in that the space in this picture has been constructed strictly according to the laws of perspective construction, but the figures follow the principle of free perspective; both space and figures nevertheless appear to be presented and seen from the same point of view. This also applies to the examples in Figs. XX, XXIV, XXV, XXXVI, and XXXVII.

The Circle of View Method of Construction of Perspectives

In this book three different methods of constructing perspectives are explained. Two of them are characterized by requiring projections of the objects whose perspective pictures are to be drawn. Such pictures must be developed from their horizontal, vertical, and sometimes even profile plans. The circle of view method discussed here does not require this. The mathematician Johann Heinrich Lambert therefore called the perspective construction based on it "free perspective." This can be combined with the two other methods, which extends the means to the solution of problems of all kinds of perspective.

The principle of every method of constructing perspective pictures is founded on central projection, in which the projection rays converge on or radiate from a point or center. The only other method is parallel projection, in which, as the name implies, the projection rays are parallel.

Photography, too, is based on a kind of central projection and therefore produces the same kind of picture as this. All the basic terms explained below in the context of the circle of view method apply to all methods of perspective construction. In the circle of view method the perspective pictures of objects are drawn on the basis of a circle through whose center pass a horizontal and a vertical.

Basic Concepts of Perspective

Visual Rays

To be able to see, we need light. We therefore call light rays reflected by illuminated objects, entering our eyes, and producing images of these objects on our retina visual rays.

Projection Rays

The projection rays in perspective construction, which produce the perspective picture of an object in the picture or projection plane, are the equivalent of the visual rays in the process of seeing.

Perspective tries to reconstruct the visual process by way of geometric construction. The pictures of concrete objects it produces approximate the images of these objects formed on the retina.

The process of seeing and perspective construction share the straight-line progression of the visual

or projection rays, because both these rays are reproduced in a drawing as straight lines. In the same way as we can see only along straight lines (that is, not around corners), we can project only with the aid of straight lines, not around corners.

The Concept of Projection and of Projecting

"Projection" and "projecting" are derived from the Latin *projicere,* "to throw forward." But "projecting" can also be translated as "forming an image." A certain relationship exists between "forming an image" and "throwing forward" if we consider the fact that a projector "throws at," or projects on, the image screen the image on a transparency. The picture on the transparency—in turn the outcome of a projection—can therefore be called the original, its image on the screen its reproduction or projection. In perspective, too, we distinguish between an original or an original figure and its projection.

As an image or a reproduction is the result of forming an image, so projection is the result of projecting. However, the concept of projection is applied both to the process of projecting and to its product.

The Picture Plane, or Projection Plane

The picture, the reproduction, the plan, or the projection of an object is produced in the picture plane, or projection plane, where the projection rays pierce or are incident on it. All planes on which pictures are formed can be called picture planes: They may consist of canvas, drawing paper, film, projection screens, and so on.

The Center of Projection

The point from which a picture is projected or on which the projection rays converge is called the center of projection, PZ. To demonstrate the process of central projection and associate it with seeing, let us assume the center of projection to be in the observer's head. Figure 25 shows how and where it is located and indicates that it is not an eye, but only a point which in central projection we can imagine independent of and therefore without the observer's head. For better understanding we imagine the center of projection moved to infinity; this makes the

projection rays parallel, and central projection becomes parallel projection.

Projection of a Point

When a projection plane PE and a point P outside it are given (Fig. 1a), we find the picture or projection of P as follows: We draw a straight line which represents a projection ray through P. The picture or the projection P is formed (Fig. 1b) in the point of intersection between this line and the projection plane.

Projection of a Figure

A "figure" can be a flat, two-dimensional structure or a three-dimensional structure. To project it, important points (for instance, the corners of polygons, cubes, and cuboids) are projected individually.

Because the contours of a polygon represent the connections of its corners, we obtain the projection of a polygon by joining the projections of its corners according to the original figure, as illustrated in Figs. 2–5. Figures 2 and 3 show the parallel projection of the triangle ABC. The projection rays are parallel to each other and are either oblique, as in Fig. 2, or at right angles, as in Fig. 3, to the projection plane. The triangles A'B'C' correspond to the pictures of the triangles ABC obtained by way of parallel projection.

In Figs. 4 and 5 the triangles ABC are reproduced by central projection in the picture or projection plane. If the original triangle ABC is located between the center of projection and the projection plane (Fig. 4), the perspective picture ÅB̊C̊ will be larger than the original triangle; if the original triangle ABC is below or behind the projection plane (Fig. 5), the perspective picture ÅB̊C̊ will be smaller than the original triangle ABC.

Central Projection with Vertical Picture Plane and Including the Observer

The position of the picture plane is irrelevant in projection. In Figs. 1–5 it is horizontal. When we explain, with the aid of Figs. 6–9, the central projection of a point, a line, a plane, and a body on a vertical picture plane, we do this to relate it to the upright observer with the center of projection PZ in his head. Here the objects to be projected are located behind the center of projection and the picture plane, so that the perspective pictures will be smaller than the original objects.

Figure 6 shows the central projection of the original point A. Its perspective picture is formed where the visual or projection ray proceeding from A to the center of projection or in the opposite direction pierces the picture plane.

Figure 7 illustrates the central projection of the vertical AB, determined by joining the endpoints A and B. The perspective picture of AB is the connection between the picture points Å and B̊.

Figure 8 explains the central projection of the plane or the rectangle ABCD. The perspective picture is the result of the appropriate connection of the picture points Å, B̊, C̊, and D̊.

Figure 9 illustrates the central projection of a cube or of a body. The perspective picture is produced by the connection of the picture points Å B̊ C̊ D̊ and E̊ F̊ G̊ H̊ corresponding to the corners ABCD and EFGH.

The Perspective Model

We derive the laws of perspective construction from a model, called a perspective model and best made of Plexiglass, of four planes which enclose the space to enable us to understand its laws.

In theory we assume the faces of the perspective model to be infinitely large; in fact, they are rectangular cutouts of these faces.

The setup of the perspective model, explained in detail in Figs. 10–14, conforms to the nature of the visual process of a person standing upright.

We begin the construction of the perspective model with its foundation, the ground plane StE (Fig. 10). The station point of the observer StP is the point of intersection between the ground plane and the perpendicular we drop to it from the center of projection PZ.

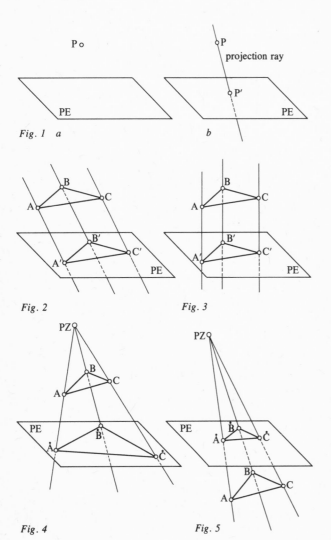

Fig. 1 a　　　　*b*

Fig. 2　　　　　*Fig. 3*

Fig. 4　　　　　*Fig. 5*

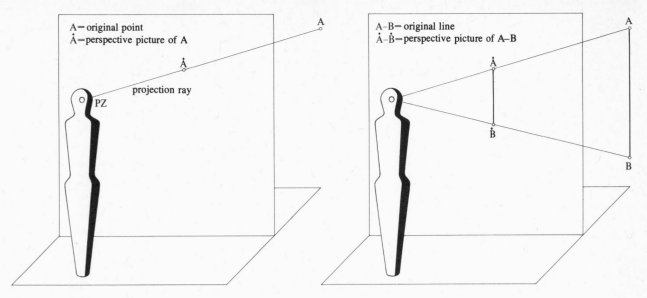

Fig. 6 Central projection of a point.

Fig. 7 Central projection of a line.

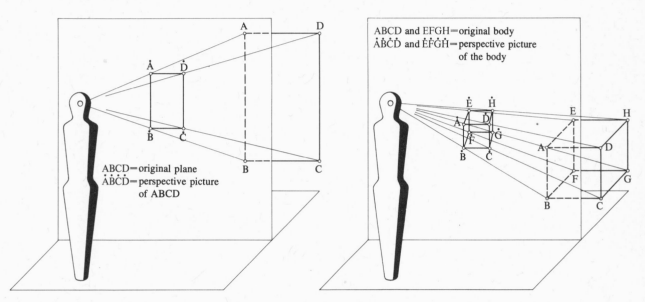

Fig. 8 Central projection of a plane.

Fig. 9 Central projection of a body.

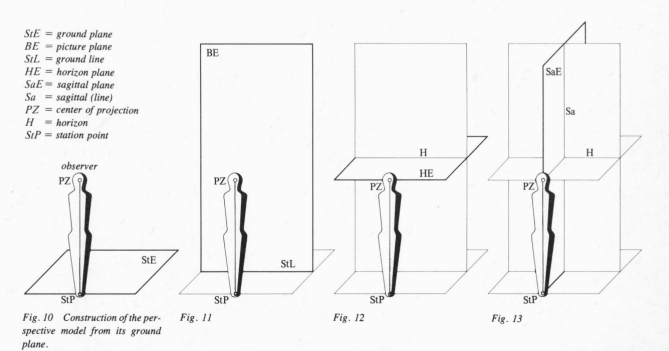

StE = ground plane
BE = picture plane
StL = ground line
HE = horizon plane
SaE = sagittal plane
Sa = sagittal (line)
PZ = center of projection
H = horizon
StP = station point

Fig. 10 Construction of the per-
spective model from its ground
plane.

Fig. 11

Fig. 12

Fig. 13

The picture plane BE (Fig. 11) is perpendicular to the ground plane. The line of intersection between these planes is the ground line StL. (Two planes intersect in a straight line, the line of intersection, which is common to both planes.)

The horizon plane HE (Fig. 12) passes through the center of projection; it is horizontal, as the name implies, and therefore parallel to the ground plane. The intersection of horizon plane and picture plane is the horizon H. The distance between the horizon plane and the ground plane indicates the eye level as defined by the line between the center of projection and the station point (center of projection = eye level).

The *sagittal plane* Sa E (Fig. 13) is vertical to both the ground plane and the horizon plane and cuts the picture plane at right angles in the sagittal line Sa. The sagittal plane divides a person into two mirror-symmetrical halves (Fig. 14); for the observer it could also be called the plane of symmetry. The arrows in this plane (Latin *sagittae;* the term is borrowed from anatomy) point at the median line of the body. The straight ground, horizon, and sagittal lines are the intersections of two planes each of the perspective model, which, however, also has corners produced by the intersection of three planes each. Thus the ground, picture, and sagittal planes intersect in a point; but this is less important than that produced by the intersection of the horizon, picture, and sagittal planes, the center of perspective ZP (to be explained later).

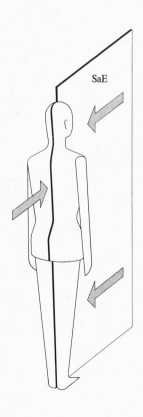

Fig. 14 Sagittal plane, which divides the person into two symmetric halves. The arrows (sagittae) in this plane point at the median line of the body.

42

The Establishment of the Circle of View

Figure 15 shows the establishment of the circle of view GK on the picture plane with the example of a mountain landscape which as seen by the observer is situated behind the picture plane and whose perspective picture is to be constructed.

By the "shape" of an object we mean its visible surface; the picture of the mountain landscape is therefore obtained from the central projection of its surface, which we imagine to be composed of an infinite number of points. From these original points we let visual or projection rays diverge. Here it is above all the mountain tops from which the projection rays radiate to converge in the center of projection. Where the projection rays pierce the picture plane on their way to the center of projection, they produce individual picture points, and together the outline of the mountain landscape. This circle is the circle of view (Fig. 15).

All the visual rays together form a cone, the visual cone, whose apex is the center of projection. The intersection is the visual cone with the picture plane produces the circle of view, which limits the field of view.

If the mountain landscape includes a cloudless sky and a sheet of water (in the form of a lake, for instance), these gaseous and liquid components must also be projected. This raises the question of how to project objects which, unlike a mountain landscape, have no surface and therefore no shape but, like the air, are invisible.

Because water, in the form of a lake, does have a surface, it can be projected according to the same principle as the surface of the mountain landscape, which we treat as a complex of points, so that we can reproduce it point by point. A cloud, something intermediate between water and air, is also characterized by a surface and therefore a shape which must be projected as a collection of original points.

Any section of a cloudless sky is an air-filled space, whose original points could be based on molecules. The fact that these are invisible does not imply that they cannot be projected, because in the strict geometric sense points and lines are also invisible and can only be imagined. Drawn points and lines are therefore only symbols of what they signify in geometry. The same applies to the original points of the air molecules which, although invisible, can be conceived as symbols when represented as points in a drawing. The central projection of these points would produce the circle of view or the picture of the cloudless sky in the picture plane. Here, too, the circle of view would correspond to a picture.

The Circle of View as the Picture of a Space

Let us assume a vacuum instead of a space filled with air as the subject of central projection. The molecules of air must now be replaced by spatial points, which in projection are important as original

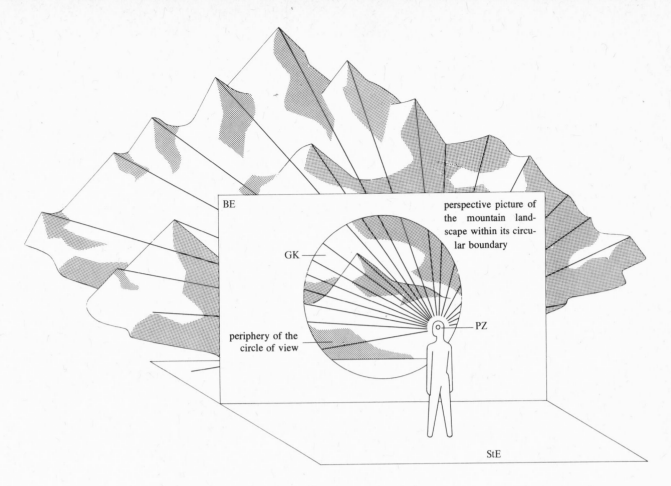

BE

GK —

perspective picture of
the mountain land-
scape within its circu-
lar boundary

PZ

periphery of the
circle of view

StE

*Fig. 15 The origin of the visual cone from visual rays proceeding
toward the center of projection from points of a landscape situated
behind, next to, and on top of each other and forming the picture of the
landscape in the picture plane.*

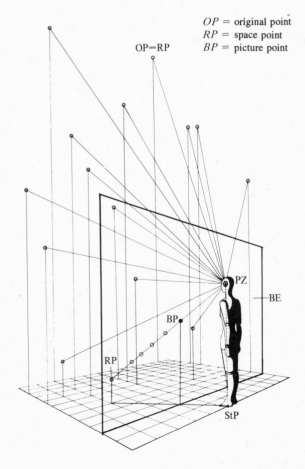

OP = original point
RP = space point
BP = picture point

OP=RP

PZ

BE

BP

RP

StP

*Fig. 16 Visual rays of spatial points situated next to, on top of, and
behind each other proceeding toward the center of projection.*

points, to be correlated with the associated picture
points in the picture plane. This picture points thus
produce the circle of the horizon as the picture of a
space.

Because all the objects to be projected point by
point occupy space, all original points can ultimately
be regarded as spatial points. Any projection is
therefore a reproduction of such spatial points. This
makes the point not only the basic, original element
but also the simplest and most elementary represen-
tative of space.

This is probably what Dürer had in mind when he
wrote, "Points are the beginning and end of all
things." Leibniz's definition of the point as the
"metaphysical basic form par excellence," too,
reinforces its significance.

The Circle of View as Spatial Picture, Picture
Space, and Field of View

Figure 16 shows original or spatial points arranged in
front of, on top of, and next to each other, from
which visual rays converge in the center of projec-
tion PZ. Where they pierce the picture plane, they
produce the pictures of the original or spatial points;
their precise construction is possible with the aid of a
vertical plane determined by the spatial point and the
eye of the observer.

Each point in three-dimensional space is therefore
correlated with one on the two-dimensional picture
plane. This also applies to the many spatial points on
the same visual ray, which, however, together pro-

43

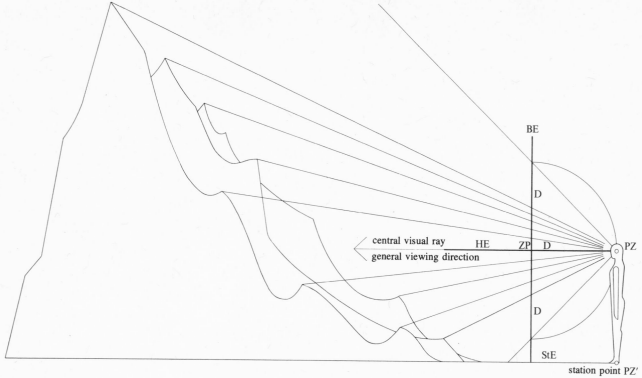

central visual ray
general viewing direction

HE ZP D PZ

BE

D

D

StE

station point PZ'

Fig. 17 Origin of the visual cone and of the circle of view, lateral aspect.

duce only one picture point. Here, too, we can say that each picture point can be associated with one original point or with an infinite number of spatial points.

Up to now we have discussed those visual rays which form the visual cone, produce the circle of view on the picture plane, and proceed from the original or spatial points. However, we can treat the visual cone also as originating in the observer, comparable to the cone of light of a searchlight. In exactly the same way as the rays of a light cone touch or sweep a three-dimensional landscape, the visual rays of the visual cone touch or sweep the space of a landscape to be projected. They produce the circle of view or the picture of the space in the picture plane. Accordingly, the circle of view corresponds to a spatial picture which can, however, also be conceived as a plane or two-dimensional picture space, also called a field, field of vision, or field of view.

Determination of the Circle of View

Figure 17 represents the perspective model with the observer and the landscape to be projected in profile. We now look at that part of the visual cone which is situated between the picture plane and the observer; it is circular. The circle of view outlines the base area of this cone, whose apex is the center of projection. The cone is represented here as a right isosceles triangle; the apex of the right angle is the center of projection. The right angle is also the angle of aperture of the visual cone and the visual angle in the sagittal plane, within which the observer sees the landscape to be projected. The height of the triangle is the same as that of the related circular cone. In addition, however, it also represents the part of the horizon plane situated in the picture to the right of the

picture plane and that section of the principal visual ray which coincides with the distance D.

The Central or Principal Visual Ray

This is that ray of the visual cone which pierces the picture plane at right angles. It also represents the general viewing direction.

The Center of Perspective ZP

This is the point where the principal visual ray pierces the picture plane and also the center of the circle of view or of the perspective picture.

The Distance D

This is defined by PZ–ZP, the distance between the center of projection and the picture plane. It is the radius of the circle of view, which is therefore also called distance circle. This makes the interdependence between the length of the distance and the radius of the circle of view evident: The longer the distance, the larger the circle of view.

The Visual Angle

Figure 18 illustrates the origin of the circle of view as the intersection between the convex surface of the cone and the picture plane. We can treat those rays of the visual cone which form its convex surface as the generatrices of a cone. Two diametrically opposed rays of the convex surface of the visual cone always form a visual angle of 90°. "Diametrically opposed visual rays" are rays of the convex surface of the visual cone such that the points at which they pierce the picture plane are also endpoints of a diameter of the circle of the horizon.

To the infinite number of diametrically opposed visual rays as sides of right angles corresponds an

44

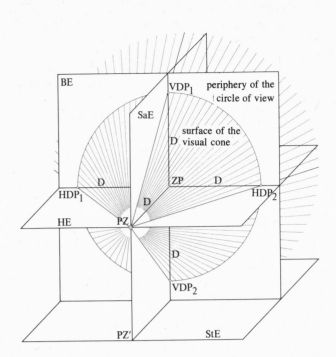

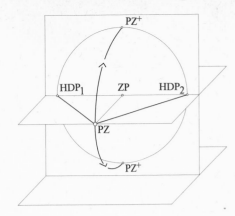

Fig. 19 Turning the horizontal angle of view into the picture plane.

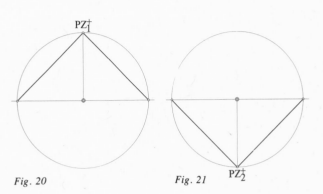

Fig. 18 Origin of the circle of view as the intersection of the visual cone and the picture plane.

Fig. 20 Fig. 21

infinite number of visual angles. Of these we must emphasize those whose sides are in the horizon plane and in the sagittal plane to align them with the upright stance of the observer, from which we proceed as a first step in projection. We call these two angles the horizontal and the vertical visual angles. We have already encountered the latter in Fig. 17, where it refers to the observer in profile. The former is shown in the horizontal plan of the observer, as illustrated in Fig. 25.

The Horizontal Distance Points HDP₁ and HDP₂

These are not only the points of intersection between the horizon and the circle of view; they can also be regarded as the points where the sides of the horizontal visual angle pierce the picture plane, with which they form an angle of 45°.

The Vertical Distance Points VDP₁ and VDP₂

These points result from the intersection between the sagittal and the circle of view; they can also be regarded as the points where the sides of the vertical visual angle pierce the picture plane.

Folding Over the Horizontal Visual Angle

Figure 19 shows that we can rotate the triangle PZ–HDP_1–HDP_2 around its side HDP_1–HDP_2 as the axis of rotation, so that it will be in the picture plane. We call such a movement through 90° folding over and indicate it by a plus sign: $PZ^+ = PZ$ folded over.

If we fold the triangle upwards, then the center of projection folded into the picture plane, which constitutes the apex of the visual angle, will be PZ^+2 in the picture plane. Figures 20 and 21 show the visual angles folded into the picture plane.

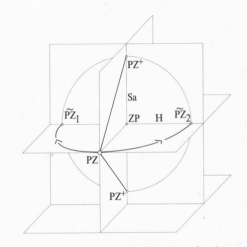

Fig. 22 Turning the vertical angle of view into the picture plane.

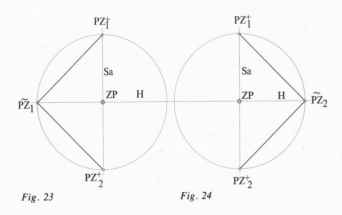

Fig. 23 Fig. 24

Rotating the Vertical Visual Angle

If we rotate the triangle PZ–VDP_1–VDP_2 around its side VDP_1–VDP_2 to the left or right into the picture plane, then the center of projection as the apex of the visual angle will coincide with the points which we have known up to now as HDP_1 and HDP_2. This rotation or movement of the vertical visual angle is

45

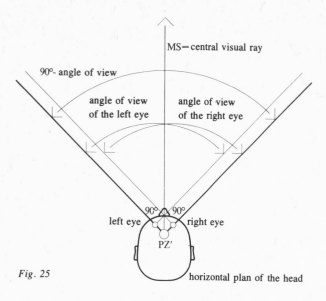

MS = central visual ray

90°- angle of view

angle of view
of the left eye

angle of view
of the right eye

90° 90°

left eye right eye

PZ′

Fig. 25

horizontal plan of the head

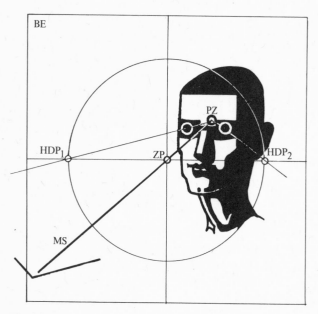

BE

PZ

HDP₁ ZP HDP₂

MS

Fig. 26

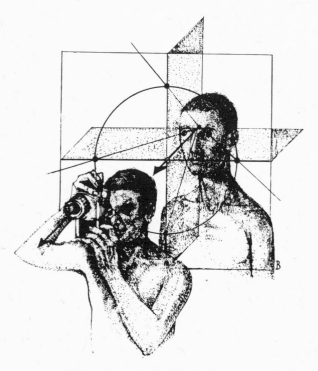

B

Fig. 27 Perspective model and camera as instruments of central projection.

called "turning" (Fig. 22) and is indicated by a tilde: $\tilde{P}\tilde{Z}_1$ = "PZ turned 1," and $\tilde{P}\tilde{Z}_2$ = "PZ turned 2." Figures 23 and 24 show the vertical visual angle turned to the left and right into the picture plane.

Locating the Center of Projection in the Observer's Head

Figure 25 shows the head of the observer with the horizontal visual angle in horizontal plan, in parallel projection from above. The center of projection is in the head, so that the visual rays or sides of the visual angle radiating from it pass through the centers of the observer's eyeballs, represented as spheres or circles. We can imagine the centers of projection of the observer's eyes in the centers of these spheres, which we regard as the apices of 90° visual angles. One side of each of these angles corresponds to the side of an angle whose apex is PZ′. These sides therefore enclose the visual angles of both eyes. We need not consider the visual angles of both eyes for the construction of perspectives. Of sole importance is the visual angle whose apex is in the center of projection.

Figure 26 is a very instructive drawing of these conditions, with one side of the visual angle of each eye omitted. The observer's forehead is diagrammatically represented as a rectangle; the position of the head relative to the picture plane thus corresponds roughly to the posture during photography (Fig. 27).

The Use of the Perspective Model in Drawing

A perspective model made of Plexiglass can be used like a camera in drawing. If such a model is not available for the drawing of, say, a landscape with buildings, we can nevertheless visualize its definitions, for instance, the picture plane, horizontal plane, object-picture plane distance, and circle of view. This categorical seeing and drawing is seeing and drawing with the aid of the orders of constructed perspective.

Establishing the Circle of View for the Construction of Perspectives

We said at the beginning that for the construction of perspectives we make use of a circle with a horizontal and vertical passing through its center (Fig. 33).

How to produce this drawing on the picture plane was the subject of our previous discussion, where we always perceived the circle of view in conjunction with the perspective model represented in parallel perspective and therefore graphically and spatially. But Fig. 31 raises the question of the true nature of the relation between the perspective model and the circle of view required for the construction of perspectives.

To answer this question we must refer to Figs. 28, 29, and 30, which represent the perspective model with the observer in the horizontal, vertical, and profile plans. In descriptive geometry the horizontal plan is called the first, the vertical the second, and

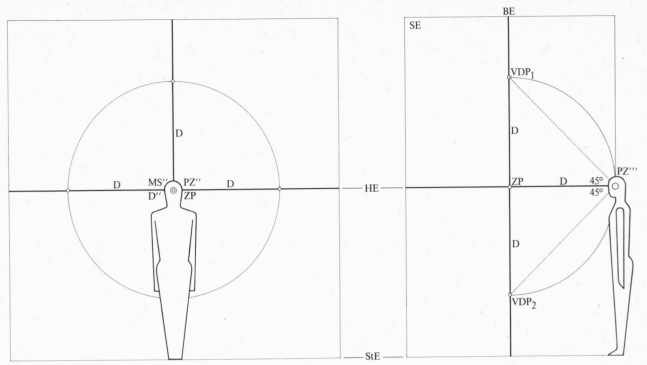

Fig. 28 Vertical plan of perspective model.

Fig. 29 Profile plan of perspective model.

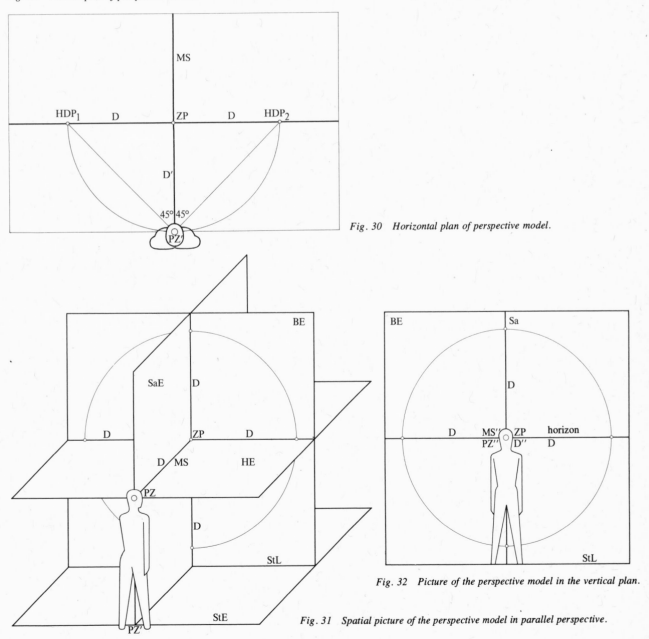

Fig. 30 Horizontal plan of perspective model.

Fig. 32 Picture of the perspective model in the vertical plan.

Fig. 31 Spatial picture of the perspective model in parallel perspective.

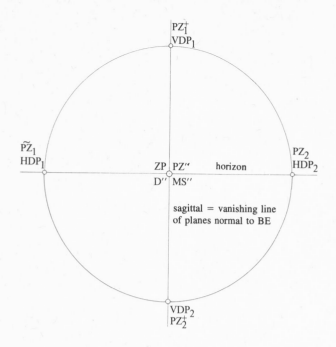

the profile the third projection. Accordingly, one, two, or three primes are added to the letter denoting the projection of a point: PZ′, PZ′′, PZ′′′.

It is the *vertical plan* of the perspective model, as shown in Fig. 28, which yields the circle of view required for construction.

Looking at Figs. 31 and 32 together facilitates understanding of how the circle of view originates and the interpretation of the point which is the center of perspective or of the perspective picture, and also represents the vertical plan or second projection of the distance D, the central visual ray MS, and the center of projection PZ. Because the circle of view is in the picture plane, which coincides with our draw-

Fig. 33 To begin with, the perspectives are constructed with the aid of this simple figure, called the circle of view. Because this figure is in the picture plane and the sheet of drawing paper is regarded as such, the picture plane need not be indicated. The margins of this book may serve as its outline.

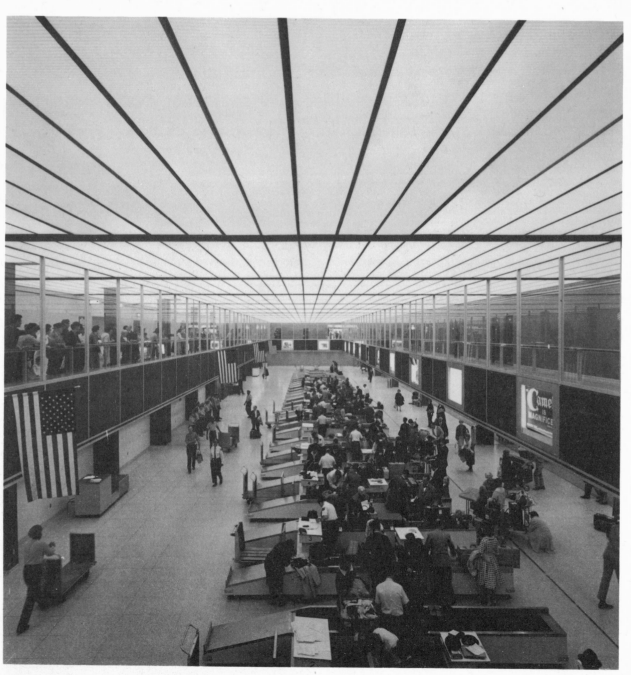

Fig. 34 Kennedy Airport, New York (photograph by Bingler, Swissair)

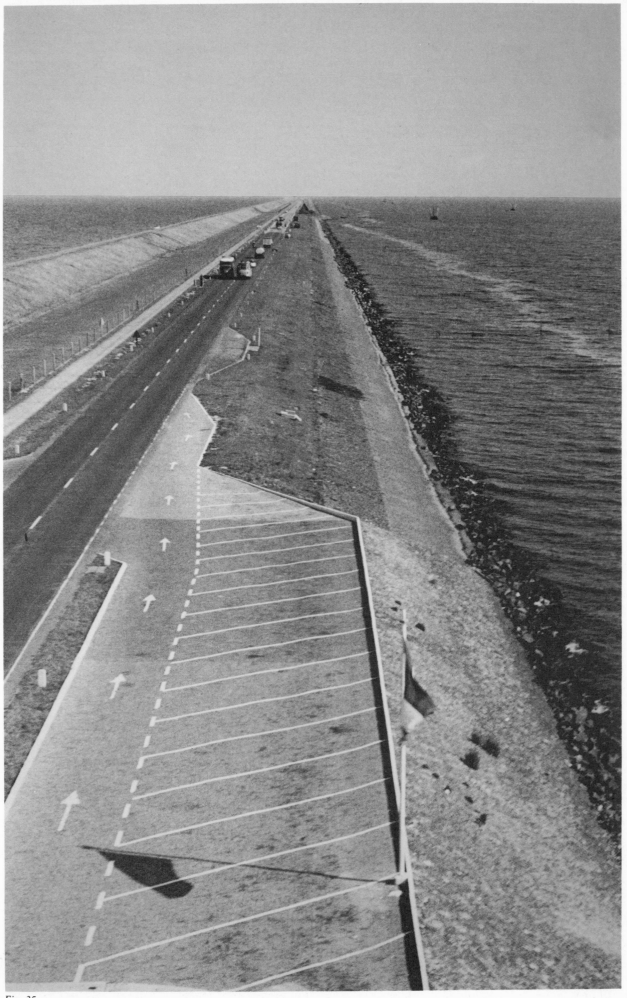

Fig. 35

ing plane or the page of this book, it will not be necessary to draw the edges of the picture plane around it in the form of a rectangle as has been done in the vertical plan in Figs. 28 and 32. The edges of the book page or of the sheet of paper on which the circle of view is shown can thus be regarded as the boundary of the picture plane.

In Fig. 33 the ground line or the trace of the picture plane has been omitted, although this horizontal, too, is important, as will be shown later.

The Vanishing Point

Observation of the Vanishing Point

To observe the vanishing point, let us step between the rails of a long, straight railway track and follow them in depth with our eyes. Although they are parallel, they seem to intersect or converge in a point in the distance.

We call this the "vanishing point of sight," because we see how it originates. We compare it with the vanishing point of the mathematical discipline of constructed perspective and call it "vanishing point of the formal concept of mathematics."

Even in a photograph such as shown in Fig. 34, the vanishing point of sight can be seen as a point of convergence; the parallel strips on the ceiling of the hall as shown in the picture appear to converge in a point. This, the vanishing point of the edges of the strips (to be treated as straight lines), can be constructed with a ruler: We extend the edges of these strips until they intersect; their point of intersection is their vanishing point.

The same method can be used in Fig. 35, which shows a dam in Holland with banks across the sea. Although the edges of this dam and the banks are not sharply defined straight lines, they nevertheless show the same properties when we extend them with a ruler to their point of intersection or vanishing point.

The Vanishing Point of Constructed Perspective

Unlike our vanishing point of sight, which is perceived by the visual sense, the vanishing point of the mathematical formal concept or of constructed perspective can be grasped only mentally, because it defines the *vanishing point as the perspective picture of the infinitely distant point of a straight line.*

Sensory perception suggests that for the establishment of the vanishing point two or more straight lines are necessary, to see it as a point of convergence. However, in constructed perspective only one straight line is mentioned, on which the definition of the concept of the vanishing point must be based. We must therefore associate a vanishing point with a single straight line here, which is the perspective picture of its infinitely distant point; this has no equivalent in the real world.

In spite of this contrast between the vanishing point of sight and that of constructed perspective, a relative correspondence must exist between them. This will become clear when we explain the origin of the vanishing point of a straight line in the context of the perspective model.

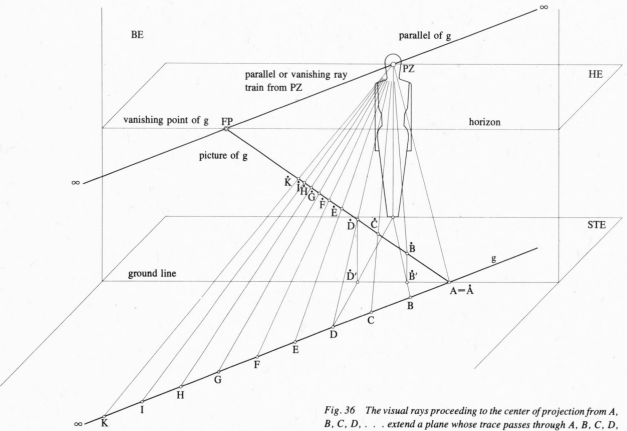

Fig. 36 *The visual rays proceeding to the center of projection from A, B, C, D, . . . extend a plane whose trace passes through A, B, C, D, . . . and which intersects the picture plane in A–FP.*

The Infinitely Distant Point of a Straight Line

The mathematician Walter Lietzmann (in *Visual Introduction to Multidimensional Geometry*) writes about this point: "An infinitely distant point, which can also be called an ideal point, is coordinated with the straight line. This is done although the straight line extends into infinity in both directions, and in the interest of symmetry we ought to expect not one, but two infinitely distant points. The reason for this is that we want the law stating that two straight lines intersect in a point to remain valid even when the straight lines are parallel, when they obviously share their infinitely distant point.

"This, by the way, ensures the validity of the axiom that any two points determine a straight line even when one of them is infinitely distant; here the straight line is defined just by one point and its direction. In fact, a statement about the infinitely distant point of a straight line is nothing but an indication of its direction. 'Straight lines pass through the same infinitely distant point' means simply that they have the same direction."

Lietzmann thus expands the concept of the infinitely distant point of a straight line to include the direction of the line. This becomes evident when we imagine that the straight line as a series of points originates in a point moving in a straight line perpetually, and in the same direction; in other words, there is no end to the point's movement into infinity, or no last point in the sequence. Yet it is useful to imagine this point in a conceivable or relative "infinity," for instance, as the center of the sun when we attempt to identify the direction of the straight line with its infinitely distant point. It also makes it easier to grasp that parallels intersect at a distance which, although not infinite, can still be imagined.

Construction of the Vanishing Point of a Straight Line

The construction of the vanishing point of a straight line consists of drawing from PZ a parallel or vanishing ray to it; this pierces the picture plane in the vanishing point, which we have already encountered as the picture of the infinitely distant point of this straight line. According to the principle that "parallels travel in the same direction," a straight line g and the vanishing ray parallel to it travel in the same direction and pass through the same infinitely distant point.

In Fig. 36 the straight line g proceeds from a point A on the ground line along the ground plane into infinity. If we treat the straight line g as a row of points and assume its points A, B, C, D, and so on, as being equidistant and project them centrally, we obtain its picture in the picture plane. The original point A on the straight line need not be projected, because it coincides with its perspective picture: A = Å. Both the original straight line g and its perspective picture therefore proceed from this point. By projecting more than the necessary two points of the straight line g here, we can demonstrate the behavior of the visual or projection rays between the center of projection and the original straight line in a drawing. We note that the projection rays of the points on line g located further in depth approach it, progressively approximating parallelism. Were we to continue this central projection indefinitely, we would obtain a projection ray which is virtually parallel to g.

Such a projection ray parallel to a length line is called a *vanishing ray*. This shows how to draw the vanishing point of a length line: All we have to do is construct a ray parallel to this length, or receding, line from PZ. This pierces the picture plane in the

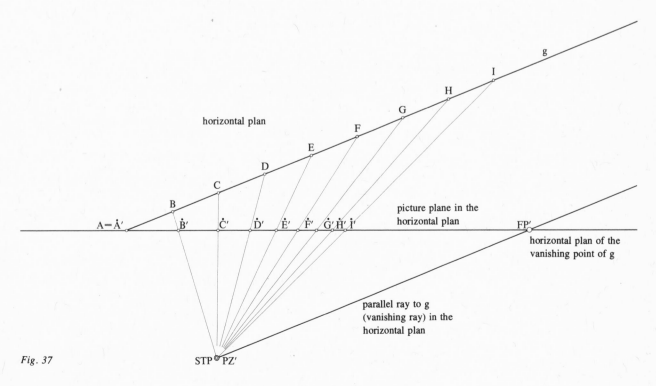

Fig. 37

horizon

$\infty \leftarrow$ ——— ——— $\rightarrow \infty$

Fig. 38

vanishing point of the line. The parallel or vanishing ray of g can now also be constructed (Fig. 36). The visual rays passing from A, B, C, D, and so on, to the center of projection define a plane whose trace passes through A, B, C, D, . . . and which intersects the picture plane in A–FP.

Line g is horizontal. Its vanishing point must therefore be located on the horizon. We obtain this vanishing point FP by intersecting the perspective picture of g starting from Å with the horizon. When we join FP to the center of projection, this connecting line must be parallel to g, as Fig. 36 shows.

Figure 37 illustrates how simple it is to construct the vanishing point of a given length line with the aid of a parallel ray which pierces the picture plane. This piercing point of the vanishing ray is the vanishing point of the straight line.

Vanishing Lines

In perspective the concept of the vanishing line is no less important than that of the vanishing point. Yet the vanishing line is not as widely known as the vanishing point, and "vanishing line" is often confused with what is called "length line."

Let us first explain the origin of the horizon and of the sagittal as vanishing lines of horizontal and vertical planes from a visual aspect. Vanishing lines are thus shown to be associated with planes; as straight lines have vanishing points, planes have vanishing lines.

Perception of the Vanishing Line of a Plane

We have seen that it is possible to experience the vanishing point perceptively or sensually. But the visual proof of the vanishing line of a plane in the real world would require an infinitely large horizontal plane, which does not exist, to be viewed in

depth. We can take as a substitute, the ocean, which, although it is not a plane, can appear to us optically as such an infinitely large plane, limited in depth by the horizon. With this proviso we can regard the horizon of the surface of the sea as the vanishing line of the infinitely large plane, despite the fact that in reality it is evidence of the spherical nature of the Earth (that is, of its curvature).

When we look a great distance across the sea, its surface appears to rise toward the distance; at the same time we cannot see it in the infinity of its expanse because it appears cut off in depth, limited by a horizontal line. With the sensual perception of this line we can graphically experience what we call the vanishing line or the horizon of an infinitely large horizontal plane.

Figure 38 illustrates the *horizon as vanishing line* of such a plane, which is represented by progressively thinner horizontal lines more and more closely spaced in depth like the waves of the sea. That a horizontal plane below eye level appears to rise toward the distance, as shown here, can also be confirmed by looking at the floor of a large hall.

The Importance of the Horizon as Locus of the Vanishing Points

The importance of the horizon as locus of the vanishing points of horizontal lines that are not parallel to it is demonstrated in Fig. 39: All straight lines in a plane have their vanishing points on its vanishing line. In other words, the horizon can also be seen as the vanishing line of a horizontal field of straight lines or rays whose vanishing points are located on its vanishing line. The rays or straight lines of a horizontal plane below eye level ascend toward the distance but descend toward it when the plane is above eye level. The vanishing points of the straight lines that are parallel to the horizon lie at infinity.

FP FP FP HDP$_1$ FP FP FP ZP FP FP HDP$_2$ FP FP FP FP

Fig. 39 Horizontal plane below the observer's eye level as a field of
rays or of straight lines.

vanishing line of the sagittal

Fig. 40 A plane parallel to the sagittal plane; it is formed by verticals
at perspectively foreshortened distances to the left of the observer.

The Origin of the Sagittal as the Vanishing Line of a Vertical Plane Normal to the Picture Plane

This is illustrated by Fig. 40. Like the horizontal plane in Fig. 38, this plane is represented by straight verticals, which can be regarded as marking stages in space toward infinity.

This vertical plane, too, would not be seen as it really is, i.e., infinitely large, normal to the picture plane, and parallel to the sagittal plane. Optically it creates the impression of being directed toward the right, and in depth it appears to be limited by a vertical, which is none other than the sagittal or the vanishing line of the vertical plane. That this plane to the left of the observer appears to be directed toward the right can be confirmed in a large rectangular hall. Here it would appear as if the wall on the left, which is in fact parallel to the one on the right, points toward the right, and the right-hand wall toward the left.

The Sagittal as Locus of the Vanishing Points of Straight Lines in a Vertical Plane Normal to the Picture Plane

Like the horizontal plane, this vertical—or any other—plane can be regarded as a field of rays or straight lines, as illustrated by Fig. 41. Their vanishing points lie on the vanishing line of the plane to which they belong.

The Vanishing Line of the Horizon as Line of Intersection of Horizontal Planes

Let us attempt to see the floor and ceiling of a large hall as horizontal planes. Let us look at the floor first: It appears to rise toward the back. In contrast, the ceiling creates the impression of sloping downwards.

Let us further imagine the floor and ceiling as infinitely large planes; this should have the result of

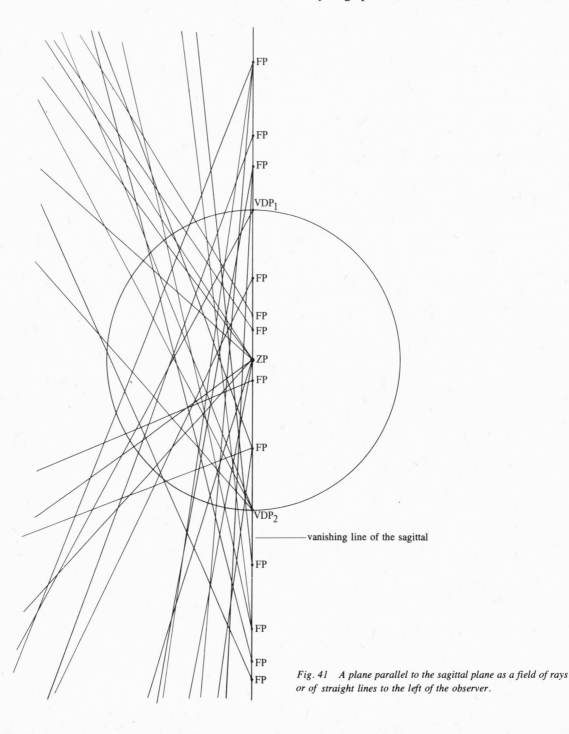

Fig. 41 *A plane parallel to the sagittal plane as a field of rays or of straight lines to the left of the observer.*

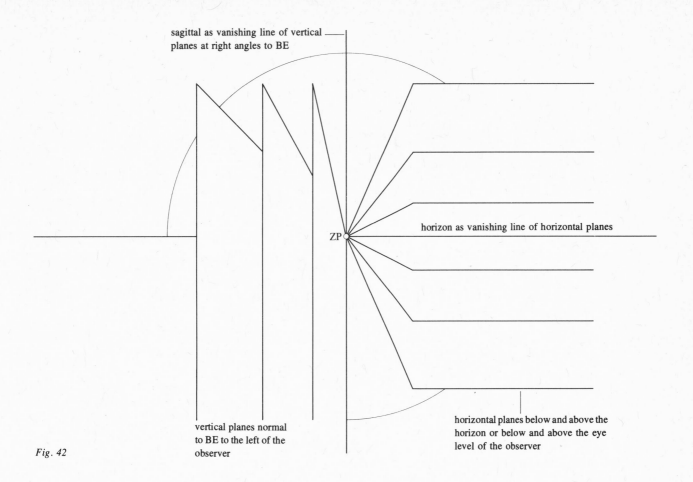

sagittal as vanishing line of vertical planes at right angles to BE

horizon as vanishing line of horizontal planes

ZP

Fig. 42

vertical planes normal to BE to the left of the observer

horizontal planes below and above the horizon or below and above the eye level of the observer

these planes intersecting in a horizontal straight line, the horizon or the vanishing line of the horizontal plane (see Fig. 42).

The right half of Fig. 42 illustrates the vanishing line of the horizon as the line of intersection between horizontal planes, some of which are below and others above eyelevel. It also shows how the horizontal planes below the horizon rise and those above the horizon slope downwards, the more steeply the higher they are above the horizon. We must correspondingly imagine the optical behavior of all the floors and ceilings of a building.

The Vanishing Line of the Sagittal Plane as Line of Intersection between Vertical Planes Normal to the Picture Plane

The left half of Fig. 42 shows the vanishing line of the sagittal plane as the line of intersection between vertical planes normal to the picture plane which, because they are to the left of the observer or of the sagittal plane, appear to point to the right.

The Mathematical Formal Concept of the Vanishing Line

In addition to the visual aspect of the concept of the vanishing line dealt with so far, the aspect of the mathematical concept of form must now be discussed.

The Infinitely Distant Straight Line of a Plane

By the vanishing point of a straight line we understand the picture of the infinitely distant point of this line. Accordingly, we are now introduced to the vanishing line of a plane as the picture of the infinitely distant straight line of this plane. This raises the question of the nature of this line.

In the same way as a straight line is defined by two of its points, a plane is defined by two intersecting lines, even when one of these lines is at infinity. Because parallel lines intersect at infinity, we can also say of two parallel lines that they determine a plane.

As draftsmen we can regard the origin of an infinitely large plane bounded by parallel lines (Fig. 38 illustrates a section of it) as follows:

If we move a piece of chalk on a blackboard in the direction of its long axis, we obtain a straight line of finite length; but if we move the chalk at right angles to its long axis, we draw a plane which we can conceive as consisting of parallel straight lines. If we were able to continue the movement of the chalk on the blackboard infinitely in the same direction, we would obtain an infinitely large plane.

Even if we assume the location of the last straight line of this plane to be at an only relative infinity, passing, for instance, through the center of the sun, we could say that a plane is defined by two lines also when one of them is located at infinity, which is then called its infinitely distant line.

Analogously to the law that a line is defined by a point and a direction, a plane can be produced from a straight line and its direction, in that the concept of the infinitely distant line of a plane also includes the position of this plane.

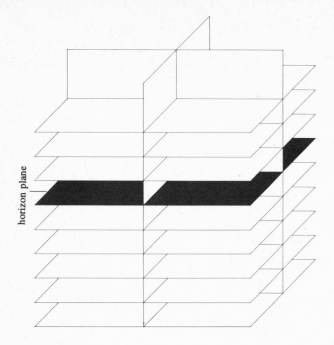

Fig. 43 Horizon plane as vanishing plane of horizontal planes.

Fig. 44 Sagittal plane as vanishing plane of vertical planes normal to the picture plane.

The Vanishing Line in Its Correlation with Two and More Planes

If two lines intersect even when they are parallel, two parallel planes will also do so. Two intersecting planes will then share a line, i.e., the line of intersection as locus of their shared points. We therefore ascribe an ideal or infinitely distant line of intersection not only to the individual plane but also to two parallel planes and to all others parallel to them.

The Vanishing Line as an Image of the Infinitely Distant Straight Line of a Plane and of all Planes Parallel to It

"Image" in this context is the perspective rendering of an object obtained in the projection plane by means of central projection. We must therefore clearly distinguish the infinitely distant line of a plane from its image in the projection plane, which we correlate not only with a simple plane but with all planes parallel to it. For the construction of the vanishing line of a plane and all planes parallel to it we need to introduce the new concept of the vanishing plane.

The Vanishing Plane

To determine the vanishing line of a plane or of parallel planes, we require the vanishing plane. This is constructed, parallel to the plane whose vanishing line is required, through the center of projection so that it intersects the picture plane. The resulting line of intersection is the vanishing line of the plane.

Construction of the Vanishing Lines of the Horizon and of the Sagittal

Figure 43 demonstrates the origin of the vanishing line of the horizon. It shows the perspective model with horizontal planes above and below eye level. As already pointed out, the vanishing line of parallel planes is produced when we place a plane parallel to them through the center of projection and intersecting the picture plane. The vanishing plane of the horizontal planes, which is shown in black here, is the already familiar horizon plane HE. This intersects the picture plane in the vanishing line of the horizon.

Figure 44 shows the origin of the vanishing line of the sagittal plane, correlated with vertical planes which are normal to the picture plane. The black vanishing plane among the white parallel planes is the sagittal plane. It intersects the picture plane in its vanishing line.

Construction of the Square in Perspective

The position of the square in which we want to draw it must be determined with the perspective model Fig. 45. To do this, we need to introduce a new plane, which we call the object plane.

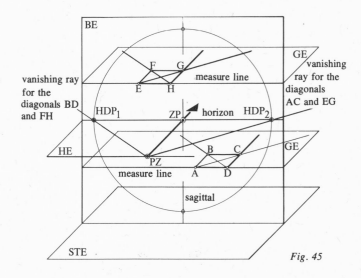

Fig. 45

56

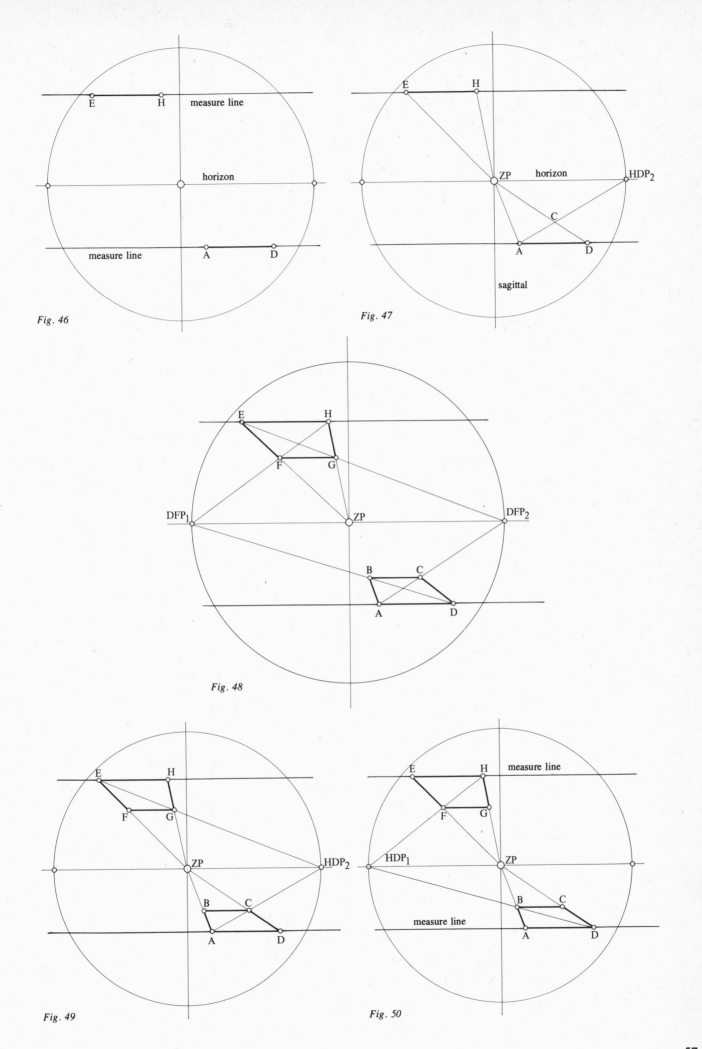

Fig. 46

Fig. 47

Fig. 48

Fig. 49

Fig. 50

We assume the object we wish to draw to be in the object plane GE, which is parallel to the horizon plane. Its intersection with the projection or picture plane results in a line we call the *measure* or *dimension line*. This contains all the points common to the picture plane and to the object plane. On the measure line we mark the dimensions of a figure to be drawn and translate them into perspective. Conversely, we correct perspective dimensions for distortion with the aid of the measure line, on which they appear in their true lengths.

Determination of the Positions in the Squares ABCD and EFGH on the Basis of the Perspective Model in Fig. 45

This model shows two object planes, one of them below the horizon plane, the other above it. Therefore the observer sees the object plane with the square ABCD below the horizon plane from the top, the one above it with the square EFGH from below.

For further definition of the position of the squares we must now look at the progression of their sides; their sides AD and EH are on the measure lines and therefore in the projection plane, and the sides BC and FG are parallel to it. Therefore the square edges in and parallel to the picture plane have practically no vanishing points, because they are located at infinity.

Sides AB and CD of the square ABCD and the sides EF and GH of the square EFGH differ in this respect because they are normal to the picture plane. Their vanishing point is therefore the center of perspective ZP. A parallel or vanishing ray from the center of projection pierces the picture plane in ZP.

Because in perspective we can draw the square in the position described with the aid of its diagonals, as illustrated in Figs. 46–50, we must also examine their progress. The diagonals of squares ABCD and EFGH enclose an angle of 45° with the picture plane.

Figure 45 shows them extended to demonstrate the determination or construction of their vanishing points. The parallel or vanishing rays of these extended diagonals pierce the picture plane in HDP$_1$ and HDP$_2$ in the vanishing points of all horizontals that cut the picture plane at an angle of 45°.

Figure 45 also shows that the horizon is the vanishing line of the squares ABCD and EFGH. To determine this, we must place a parallel or vanishing plane of these squares through the center of projection. This vanishing plane, which is the horizon plane, intersects the picture plane in the vanishing line of the squares; this coincides with the horizon. In the perspective construction of a square as represented in Figs. 46–50 we start with those sides of the squares which, coinciding with the dimension line, appear in their true dimensions.

If we join, as in Fig. 47, A and D, as well as E and H to the center of perspective, we obtain not only the corners A and B as well as E and H of the squares, but also the straight lines on which the other corners B and C as well as F and G are located. From the square ABCD in Fig. 47, which is to be constructed, we see that we can do so with the vanishing point of a single diagonal, that is, with either HDP$_1$ or HDP$_2$ only. Joining A to HDP$_2$ thus produces corner C of the square through its intersection with the line from D to ZP. Point B, still to be found, is the result of a line parallel to the side AB of the square passing through C and intersecting the line joining A and ZP.

In Fig. 48 the squares ABCD and EFGH were both constructed with the aid of the vanishing points DFP$_1$ and DFP$_2$ of the two diagonals. The line from B to C turns out to be parallel to the side AD of the square ABCD. Analogously, the line from F to G must be parallel to the side EH of the square EFGH.

Figures 49 and 50 show how squares located above and below eye level can be constructed from the same vanishing point of a diagonal.

Optically the square ABCD, below eye level, appears to ascend and the square EFGH, above eye level, to descend toward the background.

The Perspective of the Vertical Square Normal to the Picture Plane

This is explained initially with the aid of Fig. 51. Here the squares ABCD and EFGH are represented in the context of the perspective model so that their position can be determined. Square ABCD stands on an object plane below, square EFGH on one above eye level.

The positions of those squares are also characteristic in that their sides AB and EF lie in the picture plane and the corners A and E on the measure lines from which the squares are to be drawn. The sides CD and GH are parallel to the picture plane, and in perspective they remain perpendicular. The sides normal to the picture plane have their vanishing point in the center of perspective, that is where their vanishing ray pierces the picture plane.

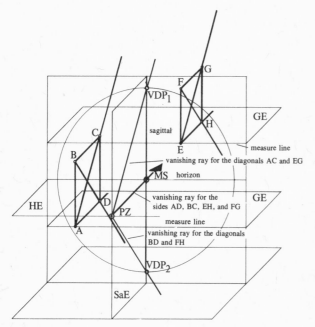

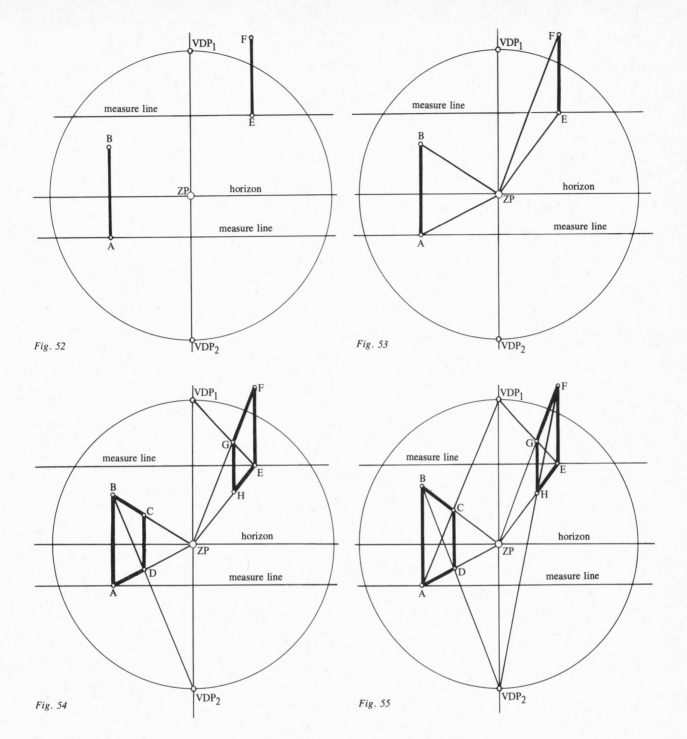

Fig. 52

Fig. 53

Fig. 54

Fig. 55

We also draw the squares normal and perpendicular to the picture plane with the aid of the vanishing points of their diagonals VDP₁ and VDP₂, where the vanishing rays of the diagonals of the squares ABCD and EFGH pierce the picture plane (Fig. 54).

The vanishing rays of the diagonals establish the sagittal plane (SaE), the vanishing plane of the squares ABCD and EFGH. They intersect the picture plane along the vanishing line of the squares, which is the sagittal.

Perspective Construction of the Vertical Square Normal to the Picture Plane with the Aid of the Circle of View

We start from the measure line and from the vertical side of the square that lies in the picture plane. Thus in perspective we also draw perpendiculars from the measure line.

The two vertical sides AB and EF, lying in the picture plane, of squares ABCD and EFGH in Fig. 52 were thus erected on the corresponding measure lines.

The sides normal to the picture plane of the squares to be constructed originate in A and B, and in E and F. Their vanishing point is in the center of perspective. By joining A and B as well as E and F to the center of perspective, as in Fig. 53, we obtain the corners of the squares ABCD and EFGH.

In Fig. 54 these squares were each constructed with only one vanishing point of a diagonal, that is, with either VDP₁ or VDP₂ only.

The situation is different in Fig. 55, where the squares ABCD and EFGH are both determined by means of the two vanishing points VDP₁ and VDP₂ of the diagonals. This shows that the points C and D (as well as G and H) determined by the diagonals are

59

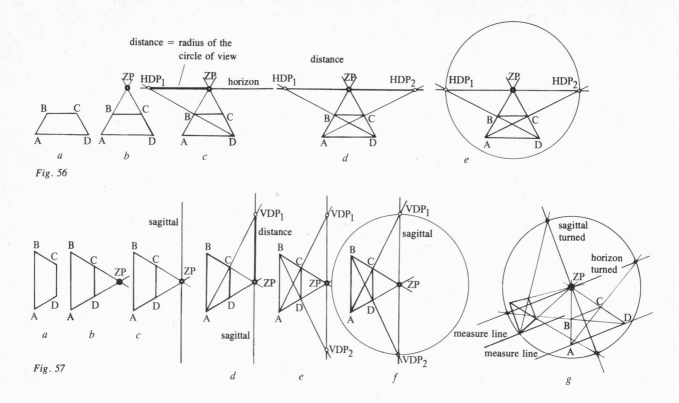

distance = radius of the
circle of view

Fig. 56

Fig. 57

vertically above one another and must result in a vertical when joined.

Because the sagittal is the vanishing line of the squares ABCD and EFGH, the vanishing points of all straight lines of these squares are located on it.

The upper portion of square EFGH protrudes beyond the circle of view, so that it becomes more distorted, because perspective distortion of a figure increases the further outside the circle of view the figure is situated.

The Square in Perspective as a Trapezoid

Figures 50 and 55 illustrate that in perspective the square becomes a trapezoid, a quadrangle in which two sides are parallel. Conversely, Figs. 56 and 57 show that we may see a square in perspective in every trapezoid; here the circle of view is to be constructed from the given trapezoid or squares in perspective. The trapezoid in Fig. 56 is a horizontal square in perspective in such a position that the sides AD and BC are parallel to the picture plane. However, the trapezoid in Fig. 57 corresponds to a vertical square in perspective normal to the picture plane. As Fig. 57g shows, the circle of view can also be drawn from a trapezoid as a square in perspective whose side AB is inclined rather than horizontal or vertical. Because in this construction the horizon must be drawn parallel to the side AD, it will also be inclined according to its transformation or rotation, to be dealt with in the appropriate chapter. Analogously, the side EF of the square EFGH must be parallel to the sagittal.

Figures 56d and 57c also demonstrate that to determine the radius of the circle of view or the distance between the object and the center of perspective, the production of only one diagonal of the trapezoid, with which we intersect the horizon or the

sagittal, is enough; this provides one of the distance points and thereby the radius of the circle of view, which is the distance between the distance point and the center of perspective.

Use of the Construction of the Square

Geometric patterns or structures of all kinds can be drawn from the square, and the ellipse or the circle in perspective developed from it.

Geometric Structures, Patterns, or Ornaments Derived from the Square

In this context "structure" means the pictorial representation of an arrangement strictly according to rule. Even a net of squares as used here for the development of certain formal figures can thus represent a "structure." In this sense a structure can also be called a "pattern," which finds its concrete expression in, for instance, the herringbone design of a fabric or in the cobblestones of a street (where, however, the stones need not be arranged in a strictly regular design). "Ornament" defines something created as a feature of a work of art, such as the tracery in a Gothic cathedral.

This does not imply that creative imagination is not required, as it is in the design of a work of art, for the development of the most varied patterns from a net of squares.

If, as in Fig. 58, we want to draw a net of squares from a square in perspective so that we can develop a pattern from it, we must first understand the method of construction with the aid of planimetric squares (Figs. 58a–d). These drawings show that we will obtain a net from a square by means of its diagonals and by drawing parallels to its sides through the point of intersection between the diagonals. This produces four new squares with one diagonal each. If we now

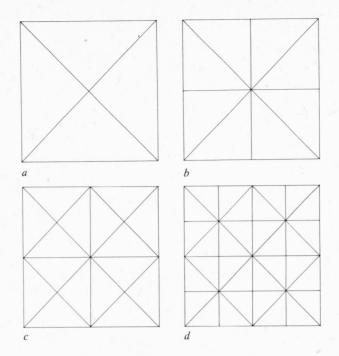

a

b

c

d

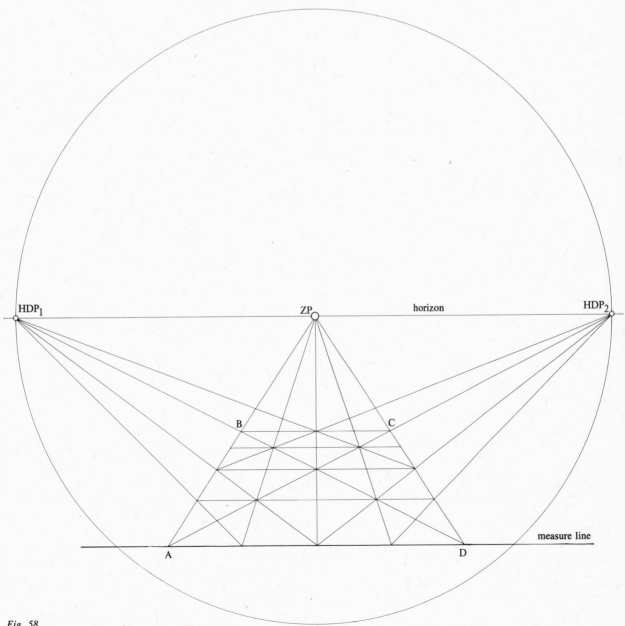

HDP₁ ZP horizon HDP₂

B C

A D measure line

Fig. 58

61

Fig. 59

Fig. 60

Fig. 61

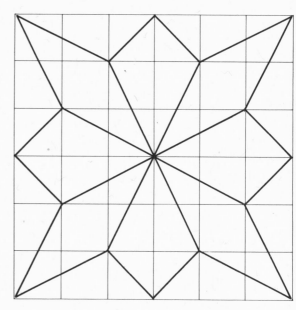

Fig. 62

Fig. 63

Fig. 64

Fig. 65

a

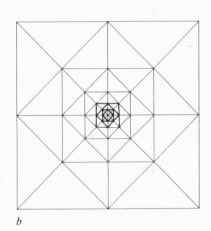

b

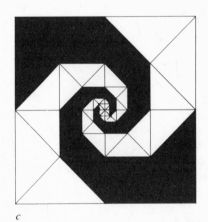

c

add the missing diagonals in each square and again draw parallels to the sides of these squares and of the original square through the points of intersection of the diagonals, we obtain a net of sixteen squares. It is obvious that, as we continue to use this method, we obtain nets of progressively smaller squares. The number of new squares is 4 times the previous number.

The same procedure as for drawing the planimetric net is adopted for drawing the net in perspective, as shown in Fig. 58. We determine the side AD of the square, from which we construct the perspective net on the measure line, which, after all, lies in the picture plane. Points HDP$_1$ and HDP$_2$ are the vanishing points of the diagonals of all the squares produced.

Figures 59–63 offer suggestions for creating patterns from nets of squares and for translating them into perspective.

When drawing the figure in Fig. 65, we also start from a square, which we divide as in Fig. 65a and b. We accordingly draw parallels to the sides of the square through the point of intersection of the diagonals, which bisect these sides. By joining the midpoints of the sides of the square we obtain an inscribed diagonal square in the original square. One of its diagonals is horizontal, the other vertical. By joining the midpoints of the sides of the inscribed square we obtain another square inscribed in the first inscribed square, with horizontal and vertical sides.

It is possible to draw any number of inscribed and circumscribed squares whose sides are bisected by the diagonals and the parallels to the sides drawn through the intersection point of the diagonals of the original square. But joining the centers of the new squares produces not only new squares but also isosceles right triangles; from these we can form four "snail's shells," starting from the corners of the original square, as Fig. 65c illustrates. Obviously, many other configurations can be drawn from this division of the square.

Figure 66 suggests the design of a carpet from a square, its composition in various colors, and its translation into perspective.

The square ABCD in perspective (Fig. 66) has two different structures, a halftone one and a graphic

63

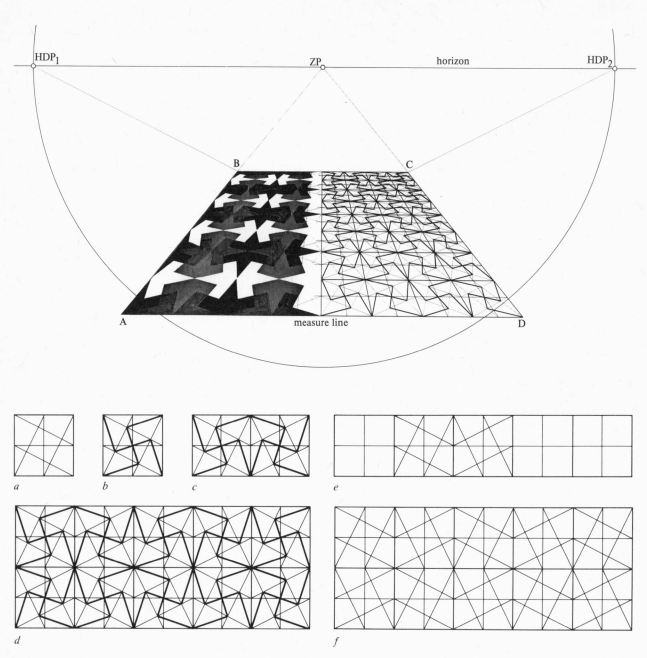

Fig. 66 *The left half of this illustration shows the development of a possible two-dimensional structure from the linear structure on the right.*

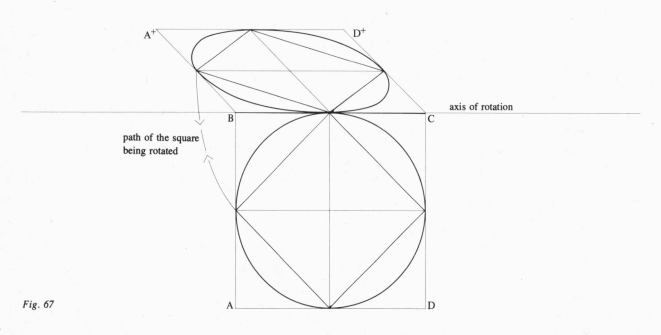

Fig. 67

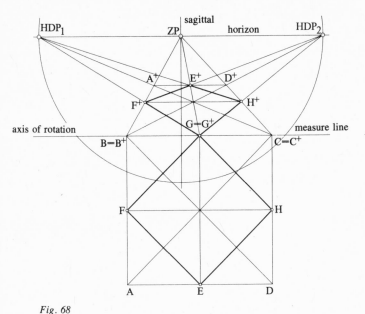

Fig. 68

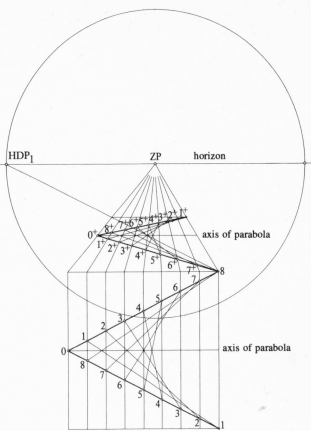

Fig. 69　Construction of a parabola from straight lines and their perspective rendering.

one; the halftone pattern was created from a linear sketch.

The structure shown in Fig. 66f is based on the perspective drawing in Fig. 66, a Moorish pattern of the Alhambra in Granada. It is developed from the square through which the center lines bisecting the sides of the square are drawn. According to Fig. 66a, the midpoints of the sides are joined to the corresponding corners of the square. This connection is established in two adjacent squares, so that a mirror pattern is created. Now the diagonals of the small second diagonal square inside the first square are drawn and the corners of both squares joined.

Perspectives from Rotating a Square

Figure 67 shows a vertical square and a horizontal one adjoining it represented in parallel perspective. Both squares contain an inscribed square and an inscribed circle.

We can interpret the vertical square ABCD as the front face and the horizontal square A+BCD+ as the top face of a cube. Both squares, which are normal to each other, share, the side BC.

If we rotate the square ABCD in Fig. 67 through 90° toward the back and top with BC as the axis of rotation, it will appear in perspective. For the better demonstration of this process the square has a square and a circle inscribed in it.

When the square A+BCD+ is returned to its original position, it will appear corrected for distortion with its inscribed square and circle.

If we assume the vertical square to be part of an infinitely large vertical plane and the horizontal square part of an infinitely large horizontal plane, this rotation will also include these infinitely large planes. Their line of intersection includes all points common to them; it becomes the axis of rotation, which we can also use as the measure line.

Transposition of Angular Figures into Perspective with the Aid of a Square and of Rotating the Square

Figure 68 shows the transposition of the frontal inscribed square of a frontal vertical square into central perspective by rotating the latter. In fact, we can draw an inscribed square in perspective directly by joining the midpoints of the sides of a square in perspective. Cumbersome construction by way of rotating a square with its inscribed square is therefore unnecessary; however, this simple example should be used to practice this method of construction.

Square EFGH is the square inscribed in square ABCD (Fig. 68). Square E+F+G+H+ is the rotated and inscribed square in perspective of the rotated square A+B+C+D+ in perspective.

When the square ABCD is rotated, B, C, and G on the axis of rotation remain in position; B = B+, C = C+, and G = G+.

The inscribed square E+F+G+H+ in perspective has been rotated through 45° with reference to the axis of rotation or measure line. Points HDP₁ and HDP₂ are therefore the vanishing points of its sides.

Transposition of a Parabola into Perspective

The same method of construction can be applied to the transposition of a parabola into perspective (Fig. 69). For this purpose the parabola is generated from intersecting straight lines. The two sides of the angle and the points of the straight lines are rotated; the　65

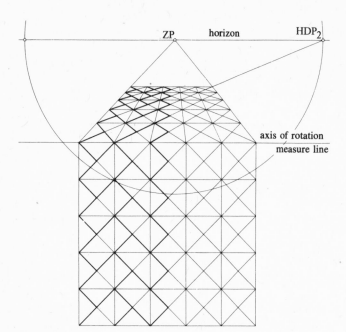

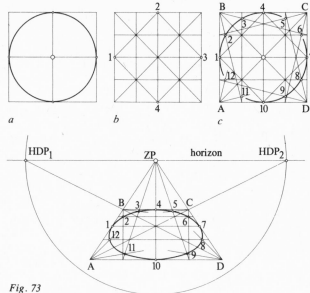

Fig. 70 Structure of a parquet floor composed of squares.

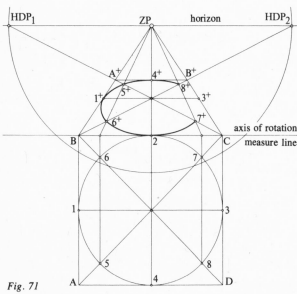

Fig. 71

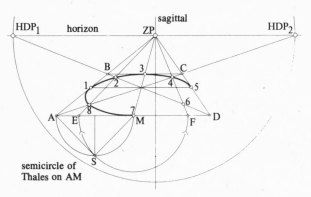

Fig. 73

points of intersection of the straight lines drawn from the rotated points produce the perspective picture of the parabola.

The apparent kinks in the actually smooth curve of the parabola in the drawing are due to its construction from only a few points; the larger the number of points, the smoother the shape of the parabola.

The transfer of the pattern of a parquet floor consisting of squares into central perspective (Fig. 70) can be based on the same method.

Transposition of a Circle into Perspective

In perspective the circle becomes an ellipse, so that the perspective drawing of a circle amounts to the construction of the latter. We start from the square, into which we inscribe its circle.

For the construction of the circle in perspective as shown in Fig. 71, we need at least eight points on the inscribed circle. Figs. 71a–d illustrate how they are found.

The sides of the square are interpreted as tangents of the circle. The points of tangency, 1, 2, 3, and 4, are important because they are common to the square and its inscribed circle. We obtain points 5, 6, 7, and 8 from the intersections of the diagonals of the square with the circle.

Figure 72 shows how to find directly in a square ABCD in perspective the eight points for the construction of an ellipse as a circle in perspective.

Let us construct an isosceles right triangle on the bisected side AD with the aid of the semicircle of Thales. We now draw a circle of radius MS centered at M. This circle intersects side AD in E and F, which we join to the center of perspective. These connecting lines intersect the diagonals of the square in perspective in 2, 4, 6, and 8. The tangent points 1, 3, 5, and 7 are obtained with parallels drawn to the sides of the square through the point of intersection of the diagonals.

66

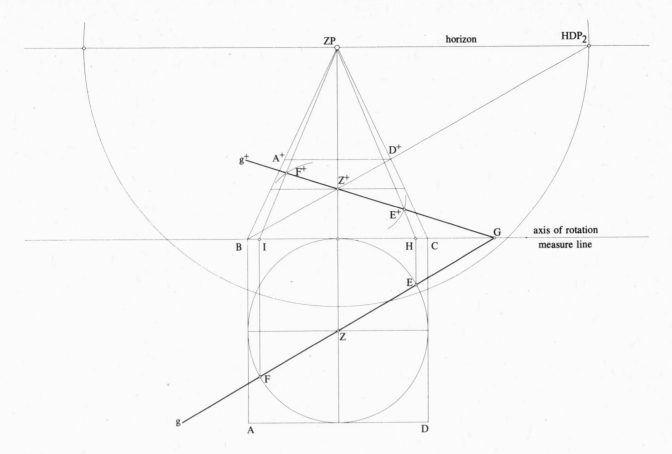

Fig. 74

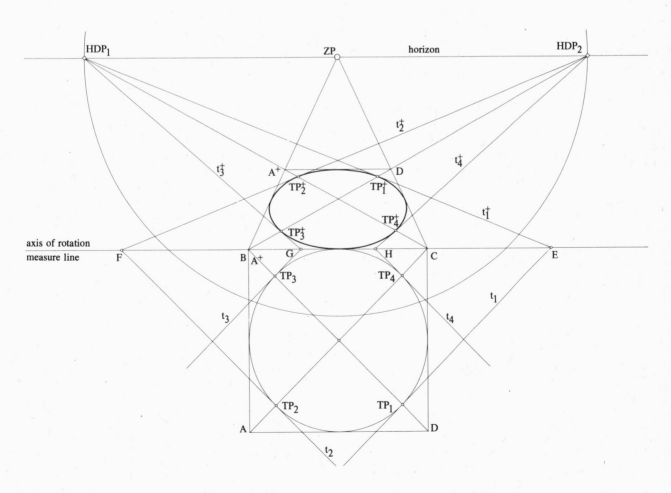

Fig. 75

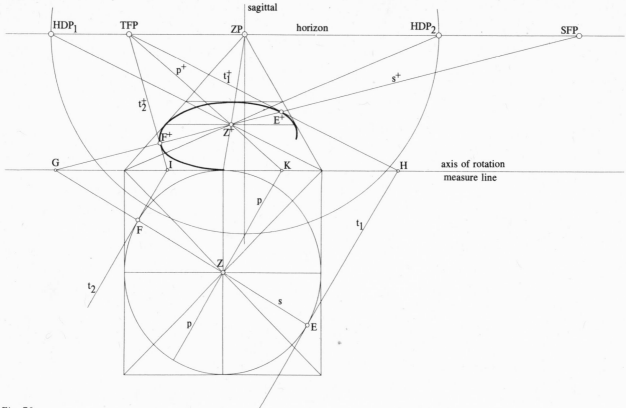

Fig. 76

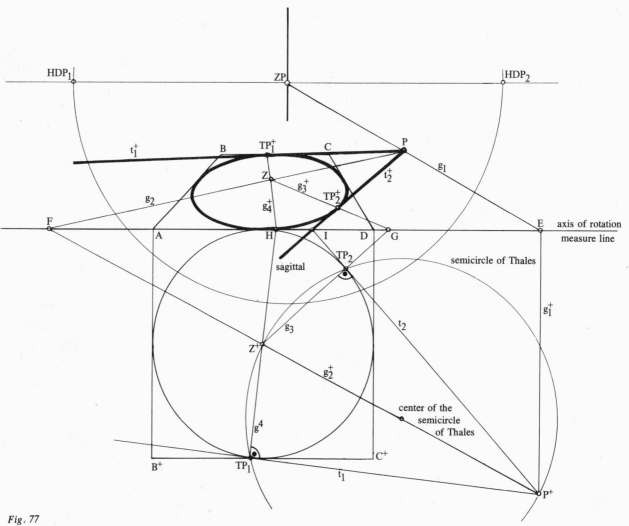

Fig. 77

Another Method of Direct Construction of an Ellipse

Another method of direct construction of an ellipse as an inscribed circle of a square in perspective is illustrated in Fig. 73. Figures 73b and c show how within a square the twelve points on a circle—a curve—are established by the intersection of straight lines.

On the center lines of the square we obtain the points of tangency 1, 2, 3, and 4 (Fig. 73a). Connecting these points results in an inscribed square whose sides also form one diagonal each of the four sub-squares produced by the center lines. The second diagonals are entered and parallels to the sides of the square ABCD drawn through the points of intersection (Fig. 73b). We obtain the other points of the circle by drawing from the corners of the original square the diagonals of the rectangles, each consisting of four squares. These diagonals intersect the sides of the rectangles in the other eight points.

The same method is used for the determination of the points of the ellipse within the square in perspective.

It is advisable to learn this method by heart, because it enables us to construct an ellipse from any parallelogram, rectangle, or trapezoid. It probably is also the simplest method of constructing an ellipse.

Transposition of Random Points on the Inscribed Circle of a Square into Perspective

Let us assume E in Fig. 74 to be such a random point. We draw a line g through E and through the center of the inscribed circle of the square ABCD, so that g intersects the inscribed circle as a secant and intersects the axis of rotation, producing G. But this secant also results in F on the inscribed circle, which is diametrically opposite E, because EF is a diameter of this circle.

When the line g is rotated, G as the point of rotation remains stationary and is therefore common to the line g and the rotated line g^+; the construction of these lines must therefore start with G. Line g^+ must also pass through Z^+ and must be extended until it becomes a secant of the circle in perspective.

But to establish points on the circle or to translate E and F into perspective also requires lines that must intersect g^+. They are perpendiculars to be erected at E and F so that they intersect the axis of rotation. This produces H and I, to be joined to the center of perspective. The connecting lines intersect g^+ in the required points E^+ and F^+. By this procedure any number of points on the circle in perspective can be found. The circle will become more accurate as more points are constructed.

Construction of the Tangents of the Circle in Perspective

The first requirement is to draw the tangents to the circle in perspective in Fig. 75 where the diagonals of the square ABCD intersect the inscribed circle. This produces the points of tangency TP_1, TP_2, TP_3, and TP_4. The tangents t_1, t_2, t_3, t_4, which intersect the axis of rotation and therefore the picture plane in E, F, G, and H at an angle of 45° in perspective, have their vanishing points in HDP_1 and HDP_2. All we have to do then to obtain the tangents in perspective (or when rotated) is connect E, F, G, and H with HDP_1 and HDP_2. This produces the rotated tangents t_1^+, t_2^+, t_3^+, and t_4^+.

Figure 76 shows the construction of a certain point on the circle in perspective corresponding to a random point E on the inscribed circle of square $A^+B^+C^+D^+$. If we draw through E the secant s so that it passes through Z and intersects the axis of rotation, then F is produced diametrically opposite E on the inscribed circle, and G on the axis of rotation. From here the rotated secant s^+, which passes through Z^+, must be drawn. By extending it so that it intersects the horizon we obtain its vanishing point SFP. But s^+ also provides the rotated tangent points E^+ and F^+, in which the tangents in perspective t_1^+ and t_2^+ must be drawn with the aid of the tangent vanishing point TFP, which is constructed as follows: A parallel P passing through Z is drawn to the tangents t_1 and t_2; it intersects the axis of rotation in K. From here p^+, the rotated parallel to t_1 and t_2, passes through Z^+; through its intersection with the horizon it produces the vanishing point of the tangents, TPF. The connection of H and I to TFP results in the tangents t_1^+ and t_2^+.

Figure 77 illustrates the solution of the problem of drawing the tangents of the given inscribed circle in perspective of the square ABCD from a random point P. We fold down the square ABCD in perspective with its inscribed circle and P, to construct the tangents from P^+ (P rotated) to the inscribed circle of square AB^+C^+D. This produces the tangents t_1 and t_2 and the tangent points TP_1 and TP_2, which must be transferred to the inscribed circle in perspective of the square ABCD through folding them upwards. This gives us the tangent points TP_1^+ and TP_2^+. The tangents t_1^+ and t_2^+ at these points are rotated tangents t_1 and t_2.

To obtain P^+, the rotated point P, line g_1 is drawn through P and ZP; it intersects the axis of rotation in E. The vertical dropped from E is g_1^+, g_1 rotated. To establish P^+, we need line g_2^+, which intersects g_1^+. Line g_2^+ is g_2 rotated, which passes through P and Z and intersects the axis of rotation in F. With the aid of the semicircle of Thales constructed on P^+-Z^+ we determine the tangent points TP_1 and TP_2 to draw the tangents t_1 and t_2 to the inscribed circle of the square AB^+C^+D from P^+. These tangents make right angles with the sides g_3 and g_4, with which we intersect the axis of rotation in G and H. By drawing through these points and Z lines intersecting the inscribed circle in perspective of square ABCD we obtain the tangent points TP_1^+ and TP_2, to which we draw the tangents from P. Tangent t_2^+ can also be drawn as the

69

line joining I and P, resulting in t_2^+, the rotated tangent t_2. Tangent t_1^+ can be constructed analogously provided there is sufficient space to do so.

The Cube

For a better understanding of the nature of the cube we must briefly study its properties, illustrated in Figs. 78–80.

A cube has eight corners, six faces or sides representing equivalent squares, and twelve equivalent edges. Three edges and three planes meet at each corner; the three edges of a corner are normal to each other. There are only three directions for the edges, because four each of the twelve edges of the cube are parallel to each other. Three faces of the cube intersect in three edges, two faces each produce a line of intersection, and three edges intersect in a corner, which is shared not only by the three edges but also by the faces (Figs. 78 and 79). We distinguish between face diagonals and spatial diagonals of the cube. Each face has two face diagonals, so that there are twelve for the entire cube.

Diagonal planes are produced by two opposite parallel plane diagonals and two related edges of the cube, which therefore has six diagonal planes. These intersect in four lines, the spatial diagonals, which in turn intersect in the center of the cube (Fig. 80a). A spatial diagonal joins two spatially opposite corners of the cube; there are, accordingly, four spatial diagonals. Three planes can be placed through each spatial diagonal (Fig. 80b).

The Cube in One-Point or Frontal Perspective

Because the frontal position of the cube in perspective has only one vanishing point, frontal perspective is also called one-point perspective (Fig. 81). The frontal position of the cube is characterized by the fact that its front and rear faces are parallel to the picture plane. Its lateral, top, and bottom faces, on the other hand, are receding planes intersecting the picture plane at right angles.

The vanishing line of the horizontal top and bottom faces is the horizon. The sagittal is the vanishing line of the side faces, perpendicular and normal to the picture plane, of the cube from the frontal aspect. The edges of the cube in this position align only once. Eight of its twelve edges are therefore parallel to the picture plane and accordingly do not recede. The parallel horizontal edges at right angles to the picture plane are different in that they do recede. As a result, only one vanishing point, ZP, the center of perspective, exists for the edges of the cube in the frontal position. Figure 81 explains the origin of this vanishing point: It is the point where the vanishing ray of the receding edges of the cube in the frontal position pierces the picture plane.

The Vanishing Points of the Plane Diagonals of the Cube in the Frontal Position

The diagonals of the front and rear faces of the cube in the frontal position have virtually no vanishing points, because these are at infinity.

Because the bottom and top faces of the cube are horizontal squares, the vanishing points of their diagonals lie on the horizon at HDP$_1$ and HDP$_2$. By joining these two points we obtain the horizon or the vanishing line f_1 of the planes whose horizontal diagonals intersect the picture plane at an angle of 45°.

Let us consider the diagonals of the side faces of the cube in the frontal position: From the observer's aspect one diagonal ascends, the other descends

Fig. 78 The corner of a cube as point of intersection of three edges.

Fig. 79 The corner of a cube as point of intersection of three planes.

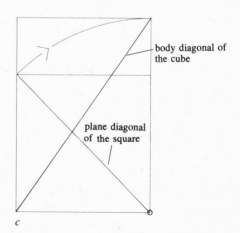

a

b

c

Fig. 80 a The body diagonals of a cube.
b Three diagonal planes can be placed through each body diagonal.

c Rectangle as a diagonal plane of a cube, corresponding to the normal format to be constructed from the diagonal of the square. The diagonal of this rectangle corresponds to a body diagonal of the cube.

70

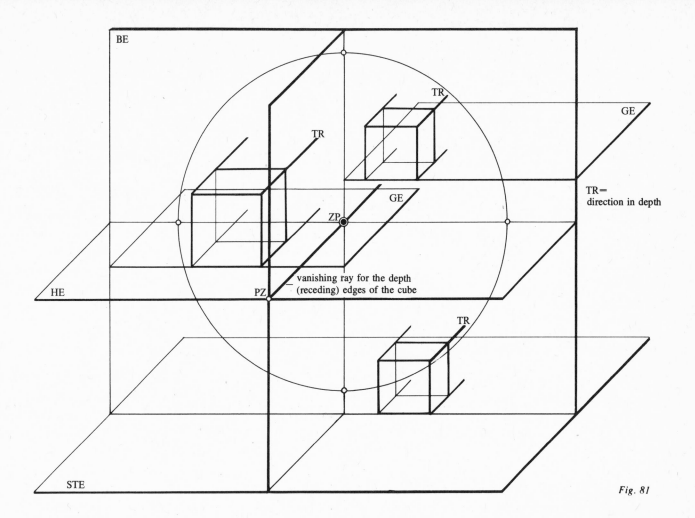

Fig. 81

Labels in figure: BE, TR, GE, TR=direction in depth, ZP, GE, TR, HE, PZ, vanishing ray for the depth (receding) edges of the cube, STE, TR

toward the rear at an angle of 45°. The vanishing point for the ascending diagonal is thus VDP₁, for the descending diagonal VDP₂. Figure 82c shows the aligning plane diagonals of the cube in the frontal position as they converge on the vanishing point.

The Vanishing Lines of the Sides of the Cube in the Frontal Position

The front and rear faces of the cube in the frontal position are parallel to the picture plane. Their vanishing lines are therefore at infinity. The sides, which are not parallel to the picture plane, constituting receding planes (TE) of the cube in Figs. 82a and b, are hatched. The horizon and sagittal planes of the perspective model (Fig. 82) are also partly hatched to distinguish them as vanishing planes (FE) of the receding faces of the cube. Because the horizon plane and the sagittal plane intersect the picture plane in the horizon and in the sagittal, the horizon and the sagittal are the vanishing lines of the related faces of the cube.

Construction of the Cube in One-Point Perspective or Frontal Position

If by the shape of an object we mean its visible surface, the drawing of a geometric solid must represent its surface. Because the surface of a cube consists of six squares, its construction can be based on any one of these and the rest connected to it.

Before drawing the cube we must decide whether it should be represented from the worm's-eye or

from the bird's-eye view or, alternatively, so that its top face is viewed from below and its bottom face from the top (Fig. 83). Here the cube is built up from the bottom face, the usual procedure for drawing geometric solids.

Perpendiculars can be erected at the corners ABCD from which the top edges of the cube can be developed. From the top edges, which outline the front face AEHD, AEHD itself can be drawn. By joining the corners of this front face of the cube to the center of perspective we obtain not only the bottom edges of the cube; in addition, the intersections of E–ZP and H–ZP with the perpendiculars erected at B and H result in the top edges B–F and C–G, which outline the rear BFGC of the cube; the drawing is complete when F is joined to G.

If we interpret the perspective picture of the cube in Fig. 83e in purely planimetric terms, we can say that it is characterized by two concentric squares. The diagonals of the small square coincide with those of the large one and intersect in the center of perspective.

Spatially Fig. 83e represents the drawing of a model showing only the edges of a cube rather than the aspect of a compact cube, which in this particular presentation would show only its front face, a square.

But the perspective picture of the cube in Fig. 83e appears as if its front face were missing, so that we can look into it as if it were hollow. We find that its top and bottom as well as its side faces are equiva-

71

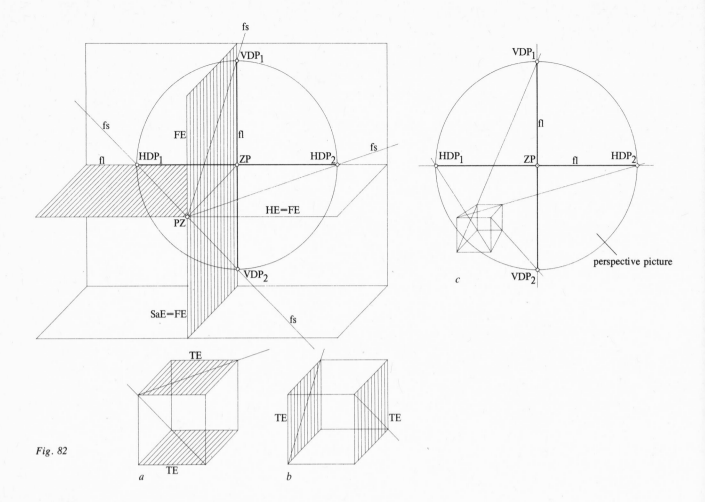

Fig. 82

lent. The bottom face appears to ascend, the top face to descend toward the rear. The left face appears to point toward the right, the right face toward the left.

Figure 84 proves through the central projection of planes below and above the horizon that to the observer the former appear to ascend and the latter to descend toward the rear. This illustration shows the projection of the perspective model's receding lines normal to the picture plane above and below eye level, which results in right triangles. In the region of the triangles the visual rays become hypotenuses. The longer legs of these triangles are the horizontal plans of sections of the visual rays. The hypotenuse of the triangle whose perpendicular proceeds from the center of perspective is the related section of the central visual ray.

This illustration represents the perspective model in true perspective. The ground plane on which the observer stands is below his eye level and therefore below the horizon. The question arises how the observer sees the edges spanning the ground plane. We find the answer by centrally projecting them: From A and B we mark on the edges of the ground plane points 1, 2, 3, . . . at equal distances, which foreshorten progressively in perspective. To find the projections of these points on the picture plane, we also require the horizontal plans of the projection rays on the ground plane. We now erect perpendiculars at 1, 2, 3, . . ., that is, at the points where the projection rays in the horizontal plan intersect the ground line. The projections of the points 1, 2,

3, . . . are the points where these perpendiculars intersect the projection rays; by joining the points 1, 2, 3, . . . we produce the perspective of the edges of the horizontal plan viewed from A and B. The perspective of the edges of the ground plane from A and B corresponds to the lines A–ZP and B–ZP, which ascend as seen by the observer. Because a straight line is defined by two points, there is no need for the complicated drawing in Fig. 84 to project the edges of the ground plane from A and B; this projection quite simply results from the connection of A and B with ZP.

We must determine the projection of the plane above the horizon and the observer's eye level, defined by the edges C–FP and D–FP, from this point of view: We obtain the central projection of C–FP by joining C to ZP; the central projection or perspective picture of D–FP is the result of joining D to ZP.

In Fig. 84 triangles are constructed from the projection rays, their horizontal plans on the ground plane, and the perpendiculars erected at the points 1, 2, 3, . . . which demonstrate how the projection rays toward increasingly distant points on A–FP tend to become parallel to the vanishing ray PZ–ZP.

Figure 85a shows the cube in top or bird's-eye view, Fig. 85b in underside or worm's-eye view, and Fig. 85c so that its bottom face appears to be seen from the top and its top face from below. In Fig. 85d we see the cube with one cross section each below, on, and above the horizon. This illustrates that cross sections of a cube or cuboid below the

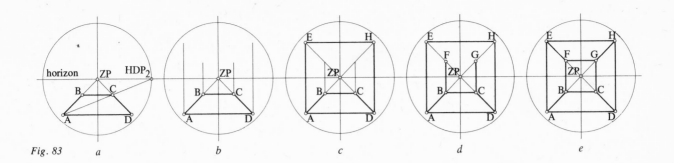

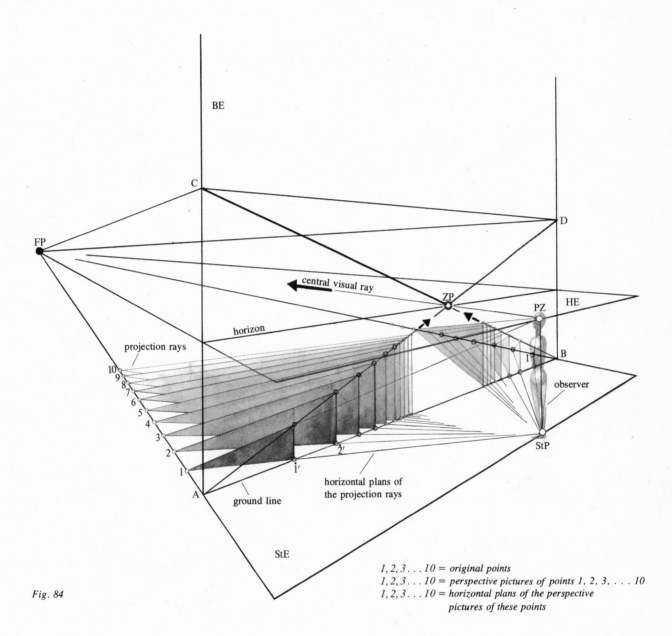

Fig. 83 a b c d e

Fig. 84

1, 2, 3 . . . 10 = original points
1, 2, 3 . . . 10 = perspective pictures of points 1, 2, 3, . . . 10
1, 2, 3 . . . 10 = horizontal plans of the perspective
pictures of these points

horizon produce top, and above the horizon under-side views, and that the cross section at the level of the horizon and therefore at eye level narrows to a horizontal line.

In contrast with the picture of the cube in Fig. 83e, of which we see only the front and therefore only one side face, its representation in top view (see Fig. 85a) reveals three side faces. The same number of visible side faces of the cube is produced by its representation in underside view, as in Fig. 85d. The cube in the perspective of Fig. 85c produces only two visible side faces.

The Vanishing Lines of the Diagonal Planes and the Vanishing Points of the Spatial Diagonals of the Cube in the Frontal Position

A diagonal plane of the cube can be drawn from two of its plane diagonals and two of its edges. Of the six diagonal planes of the frontal cube two are vertical, the others inclined. The diagonals of the diagonal planes are solid diagonals of the cube.

Figures 87–90 prove that the vanishing lines of the diagonal planes of the cube in the frontal position are the sides and the diagonals of a circumscribed square

73

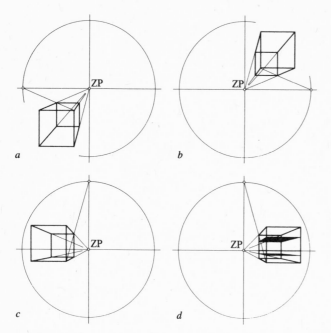

Fig. 85

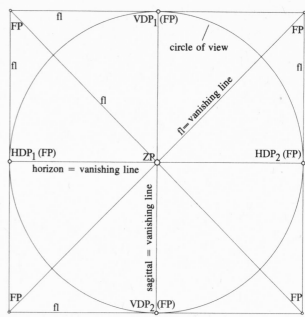

Fig. 86 The circle of view as the circle inscribed in a square.

of the circle of view. This is illustrated by Fig. 86, which shows the circle of view as the inscribed circle of a square, the sides and diagonals of this square as vanishing lines of the diagonal planes of the cube, the corners of the square as vanishing points of the body diagonals of the cube, and the center lines of the square as vanishing lines of horizontal and vertical planes normal to the picture plane.

This shows the many possible interpretations in perspective of which the planimetric figure of a square with its diagonals, center lines, and inscribed circle is capable. Figures 87–90 show the generation of the top and the bottom side of the square as vanishing lines of the diagonal planes of the cube, one of them ascending at an angle of 45°, the other descending at the same angle toward the back. Obviously, the vanishing planes of these diagonal planes also ascend and descend to produce, where they intersect the picture plane, the vanishing lines of the diagonal planes, as shown in Figs. 87 and 89.

In Figs. 88 and 90 the diagonal planes and their diagonals, which are body diagonals of the cube, are represented in perspective.

Figures 91–94 demonstrate the development of the vanishing lines of those diagonal planes of the cube in the frontal position which join the bottom left to the top right and the bottom right to the top left receding edge of the cube. The diagonals of the circumscribed square of the circle of view are shown to be the vanishing lines of the related diagonal planes.

Figures 95–98 illustrate the generation of the vanishing lines of the vertical diagonal planes of the cube in the frontal position. The vertical sides of the circumscribed square of the circle of view are the vanishing lines of these diagonal planes.

In Figs. 99–104 the diagonal planes of the cube in the frontal position are represented perspectively and synoptically. The illustrations show that the corners

of the circumscribed square of the circle of view are the vanishing points of the diagonals of the diagonal planes and of the body diagonals of the cube.

Development of a Paraboloid from the Cube

Figures 105 and 105a demonstrate how we can draw from a cube a curved surface that is exclusively developed from straight lines. This curved surface is called a saddle surface or a paraboloid. The procedure is as follows: In any two opposite faces of a cube, a diagonal each is drawn so that it is not parallel but skew to the other. These skewed diagonals are then divided into a number of equal parts. Figure 105 shows such a division into eight parts. The diagonals in perspective in the cube in perspective are divided on the same principle. The division points are numbered 0–8 so that points 0 and 8 of both diagonals are corners of the same squares. By joining the points bearing the same numbers we obtain a paraboloid. That it is a curved surface is not necessarily evident from Fig. 105. Only in a model in which the straight lines that connect the division points are represented by rubber threads can the curved surface of the paraboloid be tangibly and optically perceived.

Development of Structures from the Cube

Figures 106–121 show the development from the cube of structures that are outlined by horizontal, vertical, and inclined planes. It is a useful exercise to translate these structures, represented in parallel perspective, into real perspective, or to invent other structures that can be developed from the cube. The cubes in Figs. 106–109 are divided into subcubes from which other shapes are constructed.

The structures in Figs. 110–112 are produced by the connection of midpoints of the edges of the cube.

The tetrahedron in Fig. 113 can be drawn from the

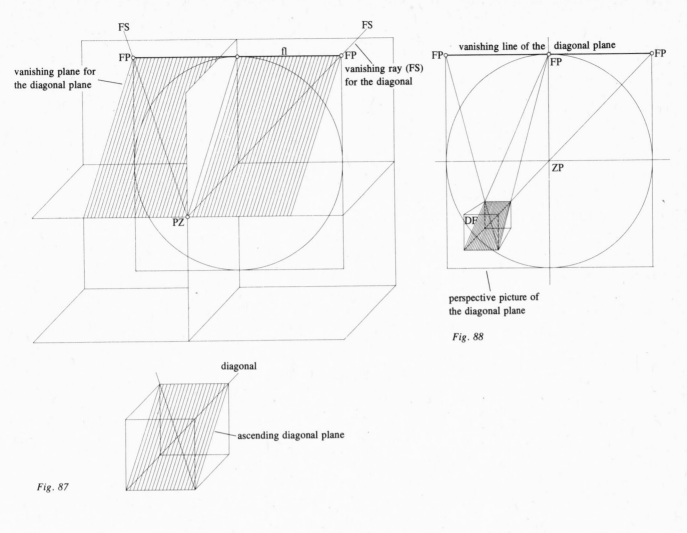

FS FS fl

vanishing plane for
the diagonal plane

FP

vanishing ray (FS)
for the diagonal

PZ

vanishing line of the | diagonal plane

FP FP FP

ZP

DF

perspective picture of
the diagonal plane

Fig. 88

diagonal

ascending diagonal plane

Fig. 87

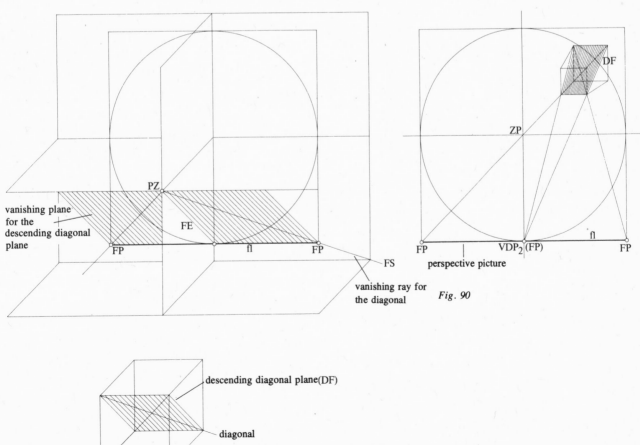

vanishing plane
for the
descending diagonal
plane

FP

PZ

FE

fl FP

FS

vanishing ray for
the diagonal

DF

ZP

FP VDP$_2$(FP) fl FP

perspective picture

Fig. 90

descending diagonal plane(DF)

diagonal

Fig. 89

75

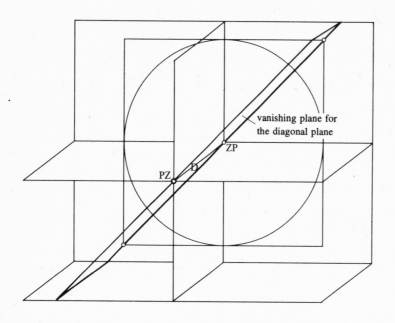

vanishing plane for
the diagonal plane

ZP

PZ D

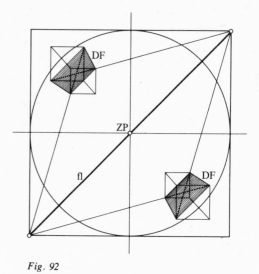

Fig. 92

fl

diagonal plane

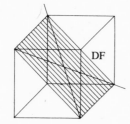

Fig. 91

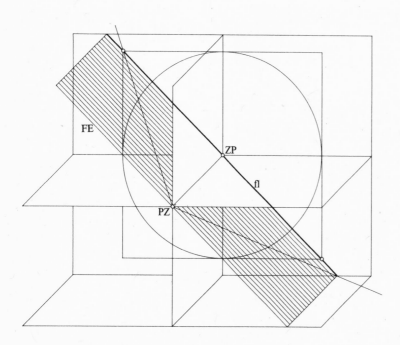

FE

ZP

fl

PZ

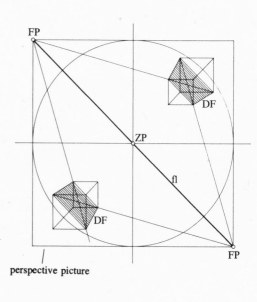

FP

DF

ZP

DF

fl

FP

perspective picture

Fig. 94

DF

Fig. 93

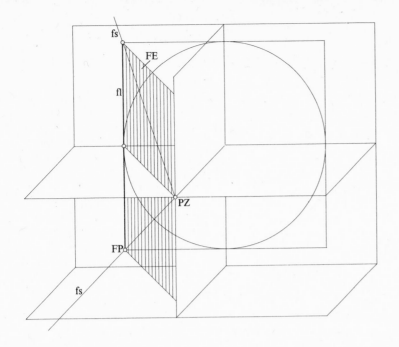

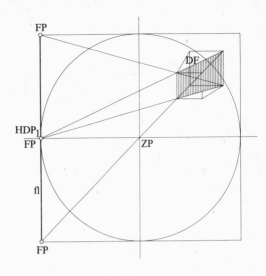

Fig. 96

Fig. 95

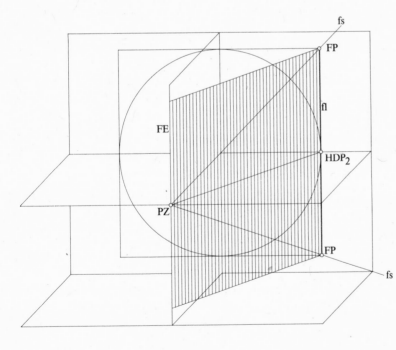

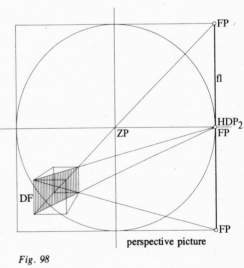

perspective picture

Fig. 98

Fig. 97

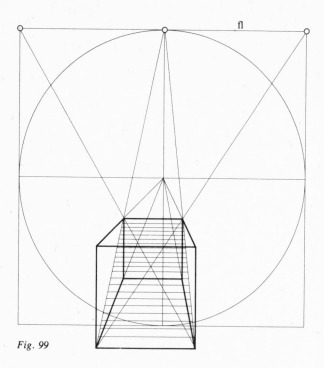

fl

Fig. 99

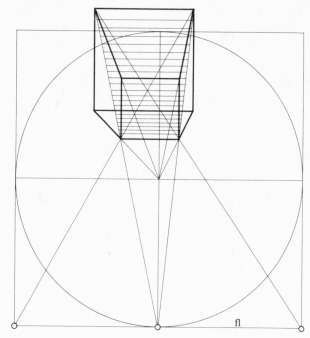

fl

Fig. 100

plane diagonals of the cube that are skew to each other in the opposite faces.

How types of roofs can be drawn from the cube is illustrated in Figs. 114–121.

The Measuring Point (in One-Point Perspective)

The measuring point serves for the transfer of linear segments and angles into perspective. Conversely, it can be used to correct the distortion of lines and angles in perspective. Here we will discuss the measuring point only with a view to its use in the transfer of linear segments into perspective and for the correction of distortion of linear segments in perspective.

The measuring point is the vanishing point of measure lines, which are illustrated in Fig. 122. Figure 122a shows the horizontal and vertical sides of a right angle with apex 0. In Fig. 122b the points 1, 2, and 3 are marked at equal distances on the horizontal side. As shown in Fig. 122c, they can be transferred to the vertical side by means of quarter-circles as 1', 2', 3'. Because the points limit segments, equivalent segments are transferred from one side to the other with the equidistant points. Obviously, the points can also be entered at different distances. As in Fig. 122d, we can replace the quarter-circles with straight lines to transfer the points from one side of the right angle to the other. This produces measure lines, which together with the sides of the right angle form isosceles right triangles or half-squares. We can produce these also by drawing from 1', 2', and 3' horizontals to intersect with the measure lines, which enclose angles of 45° with the horizontal and vertical sides of the right angle.

Let us now look at the position and directions of the sides of the right angle with the points and mea-

sure lines in perspective (Fig. 123). These sides extend a plane whose vanishing line is the horizon. One side is parallel to the horizon and to the picture plane; indeed, it can be assumed to lie in the latter. We may therefore also interpret it as a measure line, on which we determine the lines to be transferred into perspective. Because the other side of the angle is normal to the picture plane, it has its vanishing point in the center of perspective. The measure lines starting at points 1, 2, 3 form an angle of 45° with the picture plane. Points HDP_1 and HDP_2 are therefore their vanishing points. We are thus introduced to HDP_1 and HDP_2 as measuring points, as we have called the measuring point the vanishing point of measure lines.

The vanishing point of the measure lines or the measuring point and the vanishing point of the line onto which the lines are transferred in perspective are mutually dependent. Therefore from a certain vanishing point we can construct its corresponding measuring point. This procedure will be demonstrated in the next chapter.

Construction of the Measuring Point for a Given Vanishing Point

In the perspective model in Fig. 124 the side of the right angle with the points 1, 2, and 3 entered from 0 is the ground line, which can also represent the measure line. From this side, which also lies in the picture plane, the previously mentioned points have been transferred by means of quarter-circles and lines to the other side of the right angle, which has its vanishing point in the center of perspective because it is normal to the picture plane. The vanishing ray to the measure lines, to be drawn from the center of projection, pierces the picture plane in the vanishing point of the measure lines and therefore in the measuring point to be correlated with the vanishing point ZP. Thus if a straight line has its vanishing

78

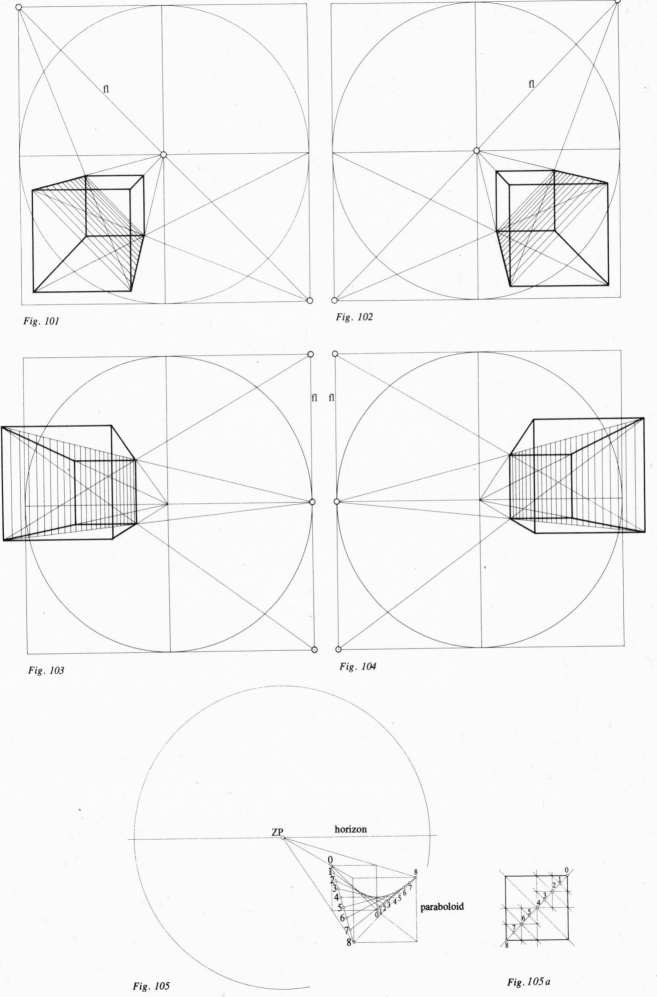

Fig. 101

Fig. 102

Fig. 103

Fig. 104

ZP horizon

paraboloid

Fig. 105

Fig. 105a

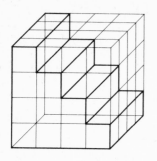

Fig. 106

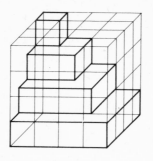

Fig. 107

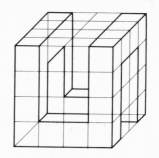

Fig. 108

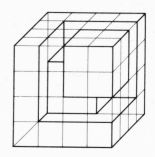

Fig. 109

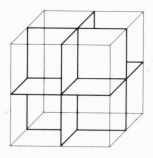

Fig. 110 The three median planes of a cube.

Fig. 111 Cubic octahedron.

Fig. 112 Hexagonal plane of section through a cube.

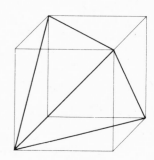

Fig. 113 Tetrahedron.

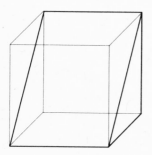

Fig. 114 Shed roof.

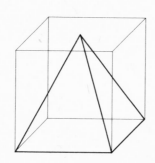

Fig. 115 Tent roof.

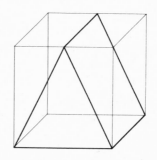

Fig. 116 Saddle roof.

Fig. 117 Cross gable-end roof.

Fig. 118 Hip roof.

Fig. 119 Curb roof.

Fig. 120 Truncated tent roof.

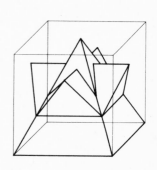

Fig. 121 Freely designed roof.

80

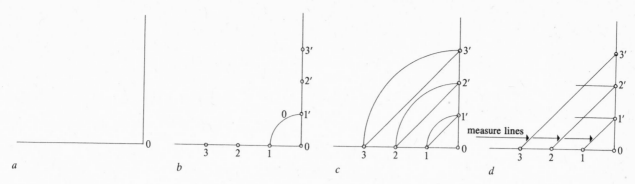

a　　　　　　　　*b*　　　　　　　　*c*　　　　　　　　*d*

Fig. 122

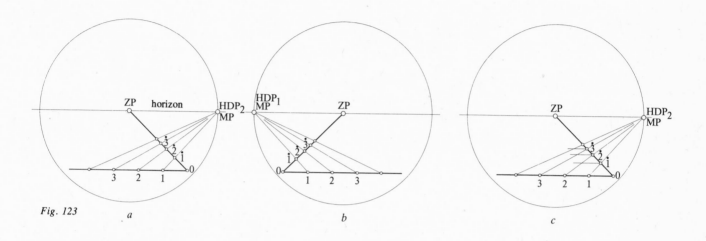

Fig. 123　　　*a*　　　　　　　　　　*b*　　　　　　　　　　*c*

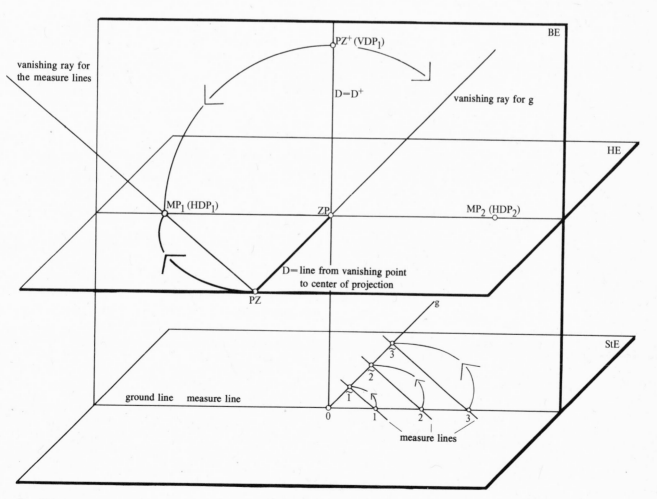

Fig. 124

point in ZP, either its distortion can be corrected with the aid of measuring point HDP_1 or HDP_2 or it can be perspectively subdivided. Therefore HDP_1 and HDP_2 become the vanishing points of the measure lines, because these form an angle of 45° with the picture plane. We consequently speak of HDP_1 also as measuring point 1 or MP_1, and of HDP_2 as measuring point 2 or MP_2. Figure 124 shows in addition how to find the rule for determining the measuring point of a certain vanishing point: It is necessary to rotate the line between this vanishing point and the center of projection PZ into the horizon. This line represents the distance D between the vanishing point and the center of projection, which in Fig. 124 is folded into the picture plane and becomes D^+. But together with D the center of projection is also turned, producing PZ^+. In other words, to find the measuring point for ZP, we insert the compasses in this vanishing point and open it through the distance ZP–PZ, so that we obtain the measuring points MP_1 and MP_2 from the intersection of the quarter-circles with the horizon. Figure 124 shows the determination of MP_1 only. Obviously, MP_2 can be found in an analogous way with a quarter-circle of radius $ZP–PZ^+$.

Construction of Nets of Squares

Figure 125 explains the construction of a net of 5×5 squares from the measure line with the aid of the measuring point MP_2. Measuring point MP_1 could equally well be used for this purpose. As shown in Fig. 125a, five equal parts are plotted and points 0–5 obtained; these are joined to the center of perspective. The resulting lines are intersected with a straight line drawn through 0 and MP_2. This produces a figure in perspective that is represented planimetrically or undistorted in Fig. 125e; it is half a square or an isosceles right triangle, whose hypotenuse is the diagonal of the half-square. Figure 125c illustrates the generation of the net of 25 squares which is itself a square, where parallels to the measure line are to be drawn through the points of intersection between the diagonals and the related receding lines. Figure 125f shows the procedure to be adopted if we want to add to this square further nets of squares toward the rear; square nets can equally well be drawn toward the front.

Construction of Verticals in Depth

Figure 126 shows how to draw, for instance, equidistant telegraph poles. These poles, initially represented by verticals, must stand in a receding plane whose trace has its vanishing point in the center of perspective. If this trace is situated to the right of the sagittal, as in Fig. 126, the problem can be solved with the aid of MP_2. A horizontal and a vertical measure line must be used. The distances between the poles from point 0 must be marked on the horizontal measure line to be translated from here into perspective on the related trace.

The height of the poles must be based on the horizontal measure line, which, after all, lies in the picture plane. If the first pole in the foreground is assumed to stand precisely on the measure line, this would determine the height of all the other poles. We therefore erect the vertical measure line on the horizontal one.

We use a corresponding method for drawing a

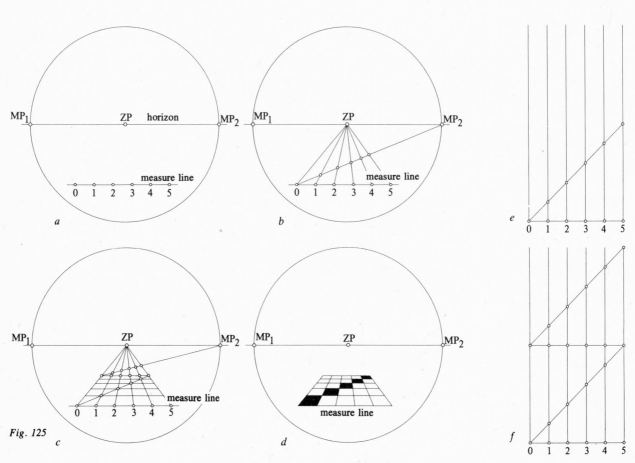

Fig. 125

82

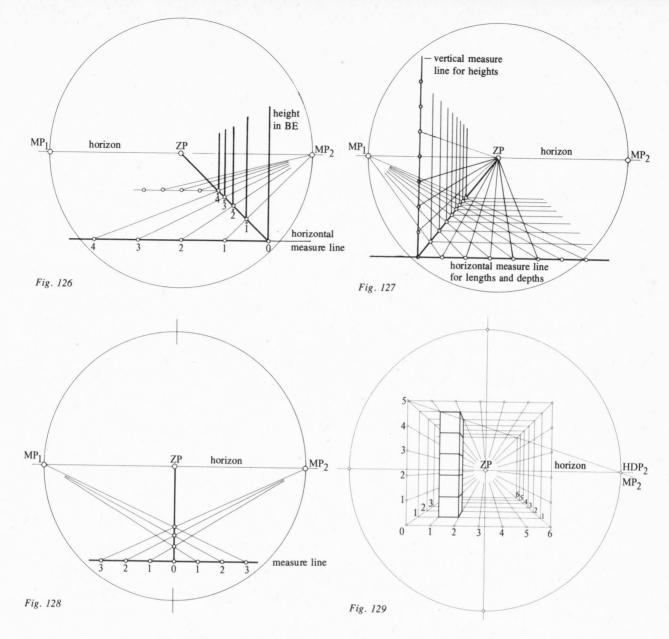

Fig. 126

Fig. 127

Fig. 128

Fig. 129

horizontal and a vertical net of squares according to Fig. 127. The sides of the squares must then be plotted from 0 both on the horizontal and on the vertical measure line.

If, as in Fig. 128, the receding line to be subdivided coincides with the sagittal, we are free to use either MP_1 or MP_2 as measuring point to subdivide it perspectively into the appropriate sections. This raises the question how to draw heights on a receding line that coincides with the sagittal, because all these lines will coincide with the sagittal. Because in the practice of the draftsman such an assumption is rarely used, we will say only that we begin with the procedure shown in Fig. 126 and continue by transferring the points of the distances and heights into the trace of the height plane, which is in the sagittal, by means of horizontals.

Construction of Interiors According to a Given Length, Height, and Depth Scale

The longitudinal dimension of a cuboid interior, as shown in Fig. 129, measures 6 scale units or sides of a square, equivalent to the dimension of the depth, so that the floor of the interior is a square. But its height

measures only 5 scale units, so that the room would have a volume of $6 \times 6 \times 5 = 180$ cu m at the scale unit of 1 m. This means that we can interpret the interior of the solid in Fig. 127 as consisting of 180 cubes of 1 m edge length each. We can use the edges of the cubes as coordinates for marking certain points within the interior, as we have done in drawing the column in the room (Fig. 129).

The room in Fig. 130, too, is based on the square and therefore the cube as the scale unit. This interior has no ceiling or front wall in order to reveal the partitions, whose proportions are also determined by the standard of the square. The floor is not a square but a rectangle, which can, however, easily be constructed from a square by cutting off the desired number of squares of the net.

It is best to begin by acquainting ourselves with the layout of an interior by means of a horizontal plan (which, however, provides only its length and depth, as shown in Fig. 130a, but not its height, which is plotted in a vertical plan). How the perspective plan of an interior can be drawn from its horizontal and its vertical plan will be explained later.

The interiors with the corners ABCD and EFGH

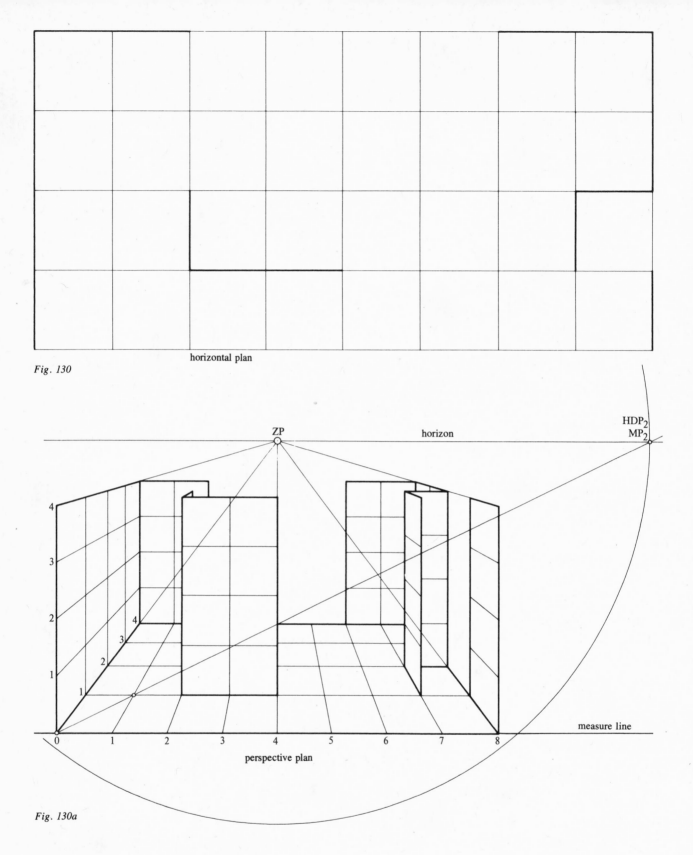

horizontal plan

Fig. 130

Fig. 130a

HDP₂
MP₂

horizon

ZP

measure line

perspective plan

(Figs. 131 and 132) are constructed not on the basis of square nets but from the dimensions of length, depth, and height determined on the measure lines. If we treat the interior of Fig. 131 as a cuboid, its bottom front edge coincides with the measure line where this becomes the longitudinal dimension of the interior or cuboid. The depth dimension can be marked off on the measure line from either corner A or corner D, so that it can be transferred into perspective with the aid of the measuring points MP₁ or MP₂. The height must be erected as a perpendicular somewhere on the measure line after determination

of the edge AE or DH unless these are also to serve as the height scale.

As Fig. 132 shows, an interior or cuboid can also be drawn so that it is removed from the measure line. The distance between this and the cuboid to be constructed is determined in perspective from the measure line, where it is marked off in its true dimension, with the aid of MP₁ or MP₂. In Fig. 132 this distance also corresponds to the depth of the cuboid ABCD and EFGH displaced from the measure line.

Figure 132 can also be interpreted as the solution of the problem of drawing the true, undistorted

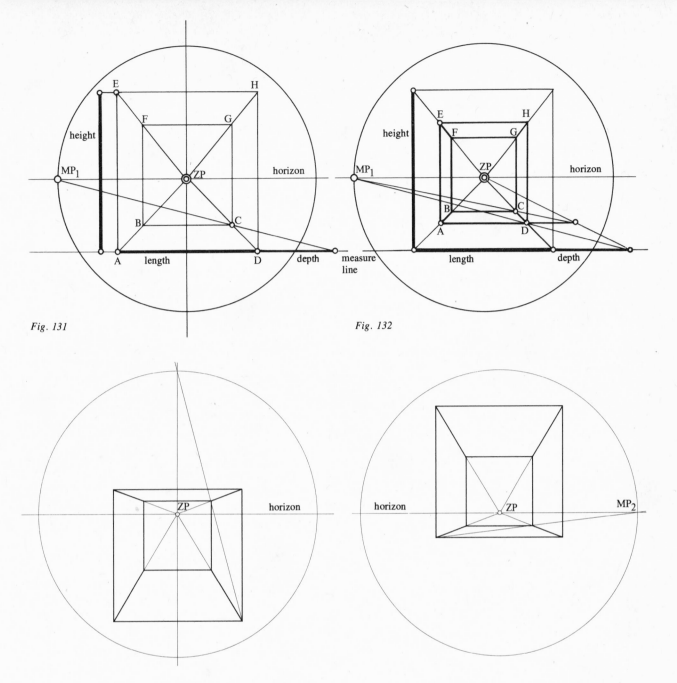

Fig. 131

Fig. 132

Fig. 133 *Spatial effect of high horizon: bird's-eye view.*

Fig. 134 *Spatial effect of low horizon: worm's-eye view.*

length, depth, and height of a given cuboid displaced from the measure line, with its distance from it. In other words, it is necessary to understand a method of construction also when it is inverted and to apply it by using measure lines and measuring points not only for transferring lines into perspective but also—in reverse—for correcting them for distortion.

Level of the Horizon and Spatial Effect

When, as in the interior of Fig. 133, the level of the horizon is high, we speak of a bird's-eye view. When it is low, as in Fig. 134, we call it a worm's-eye view.

Rooms in a perspective with a low horizon appear larger and more monumental than in one with a high horizon. This is evident not only from a comparison between Figs. 133 and 134 but also when we look at a picture such as *The School of Athens* by Raphael.

Yet the representation of a room with a high horizon is preferable when a good view of the furniture or the appointments is essential, as Figs. 135 and 136 illustrate.

In Fig. 136 three tables are represented in depth in the perspective of an interior, offering a good view. The situation is different in the perspective of a room with a low horizon, as shown in Fig. 137. Here the three tables are strongly foreshortened and therefore less prominent than in Fig. 136.

A clear view is also obtained of tables or other pieces of furniture represented as cubes in perspective with a high horizon (Fig. 135).

A new problem of the perspective of an interior with a high horizon arises when the floor gives the impression of being an inclined plane, as appears to be the case in Fig. 138: The cuboid on the floor seems to be sliding off it. To bring out the furniture in a room prominently and without crowding, the horizon must be reasonably high (Fig. 139).

On the right the interior has been drawn comparatively far beyond the circle of view, which results in 85

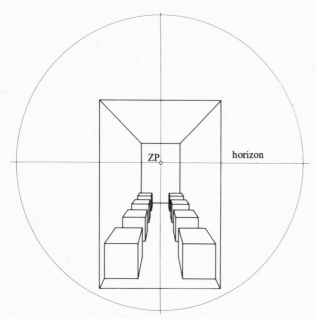

Fig. 135 Unobstructed view above pieces of furniture in an interior in frontal position with a high horizon.

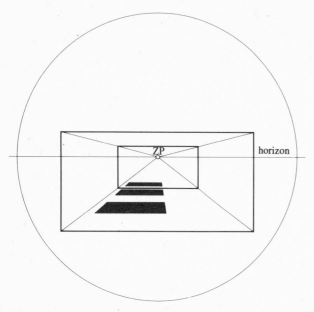

Fig. 136 Table tops, with high horizon, in an interior in frontal position.

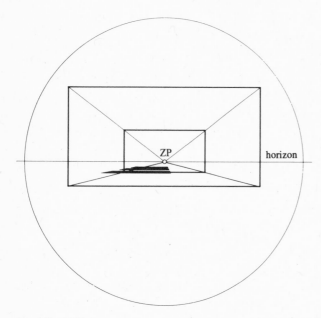

Fig. 137 Tabletops, with low horizon, in an interior in frontal position.

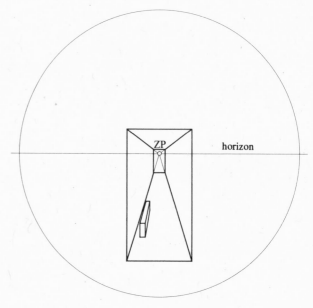

Fig. 138 The high horizon makes the floor of this narrow room look like an inclined plane.

strong perspective distortion; this is not as disturbing in frontal as in two-point perspective. Moderate perspective distortion is welcome where it enhances the tension in a drawing and therefore heightens its impact.

The length and depth dimensions of the furnished room were laid down in a horizontal plan, from which they were translated into a perspective plan on whose measure line the height scale or height measure line was erected.

Perspective horizontal plans of cuboids can be developed from a net of squares in perspective drawn in the form of the floor of a room. As Fig. 140 shows, it is possible to draw structures consisting of cuboids whose position always presents frontal perspective.

The strong spatial effect and tension of the drawing in Fig. 141 is to some extent based on the fact that parts of the dwellings in the row protrude far to the left and right of the circle of view. To avoid grazing intersections, measure line 2 has been displaced parallel downwards through a randomly chosen distance.

Figure 142 illustrates that the arrangement of buildings in an urban street can be represented as cuboid structures in frontal perspective. In other words, it is advisable to reduce the more complicated features of buildings to cuboids in the drawing of an urban landscape. Figure 142 is also intended to promote the understanding of Fig. 143, a view in frontal or one-point perspective of a scene in New York.

Perspective of Inclined Planes and Oblique Lines

We start our discussion of this subject with the four diagonal planes of the frontal cube, which are inclined.

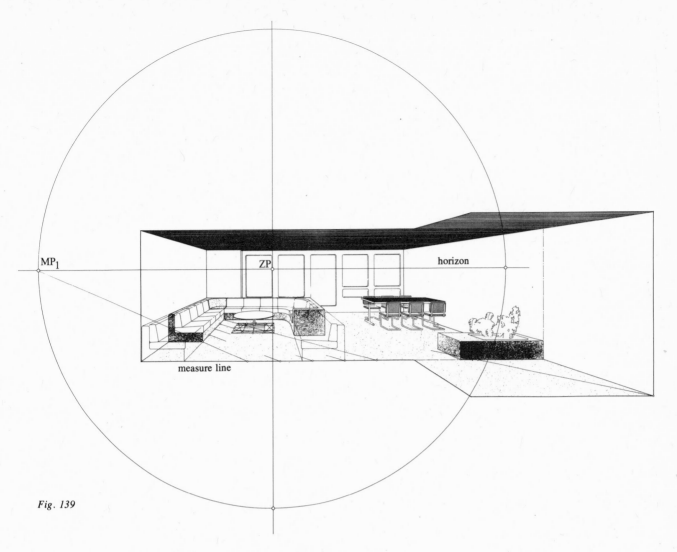

Fig. 139

A diagonal plane divides the cube into two halves called ramps. The diagonal plane of the cube becomes an inclined ramp at angles of 45° with the bottom and top faces of the cube.

Figures 144–146 show both the generation of the vanishing lines of the inclined diagonal planes and the distortion correction of the angles of inclination of these planes.

In the cube in Fig. 144 the diagonal plane ascends as seen by the observer. Its vanishing plane forms with the horizon plane an angle of 45°, which is therefore the same as the angle of inclination of the diagonal plane of the cube. This angle of inclination has a horizontal and an inclined ray as its sides. We will presently explain the perspective of the inclined ray in terms of its relation to the horizontal ray.

Distortion Correction of the Angle of Inclination

To correct the angle of inclination ϕ for distortion, we assign it to the right triangle PZ–VDP$_1$–ZP, which we rotate with its side VDP$_1$–ZP as axis of rotation into the picture plane either to the left or to the right. If we rotate it to the right as in Fig. 144, the rotated PZ will coincide with HDP$_2$, becoming \widetilde{PZ}, which is the apex of the corrected angle of inclination ϕ. But HDP$_2$ is also the measuring point of the horizontal side of the angle of inclination ϕ with ZP as its vanishing point, with which the measuring point MP$_1$ or MP$_2$ is associated.

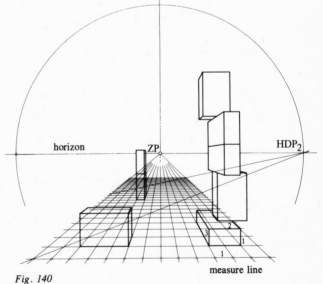

Fig. 140

It is important that a measuring point can serve to correct not only lines but also angles for distortion and to represent them in perspective.

The possibility of using the measuring point of the horizontal side of an angle for both its distortion correction and its distortion is based on the following consideration:

An angle can be defined as the difference between the directions of the starting and end positions of a rotating ray. We can therefore interpret the horizontal side of the angle of inclination ϕ as the ray in

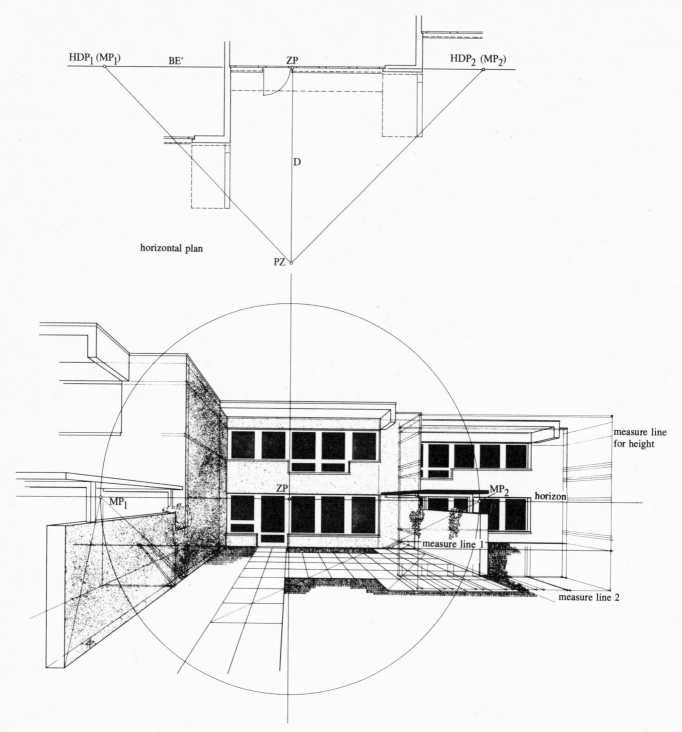

HDP₁ (MP₁) BE' ZP HDP₂ (MP₂)

D

horizontal plan

PZ

measure line for height

MP₁ ZP MP₂ horizon

measure line 1

measure line 2

Fig. 141 Frontal perspective of terraced houses.

the starting position and the inclined side as the ray rotated to its end position. The point of rotation is the measuring point of the horizontal side, around which the other side is rotated through 45° in the plane extended by the two sides. The vanishing line of this plane is the sagittal, on which the vanishing points of the sides of the angle of inclination are located vertically above one another.

In summary, the vanishing line of the ascending diagonal of the cube in the frontal position passes horizontally through VDP_1. This is the vanishing line on which lie the vanishing points of the lines in the diagonal plane that are not parallel to it.

The apex of the corrected angle of inclination ϕ coincides with the measuring point of the horizontal

side of this angle. A measuring point serves not only for the correction of angles for distortion but also for their transposition into perspective, which we call their distortion. The inclined side of the angle of inclination ϕ at 45° has its vanishing point in VDP_1, the point of intersection of the vanishing line of two planes to which the inclined side of the angle of inclination (that is, the inclined plane and the triangle $PZ–VDP_1–ZP$) belongs. This triangle can be called the supporting triangle of the inclined plane.

Perspective of the Oblique Straight Line

With the perspective of the inclined diagonal plane and its angle of inclination we have also been introduced to that of the inclined straight line, because we

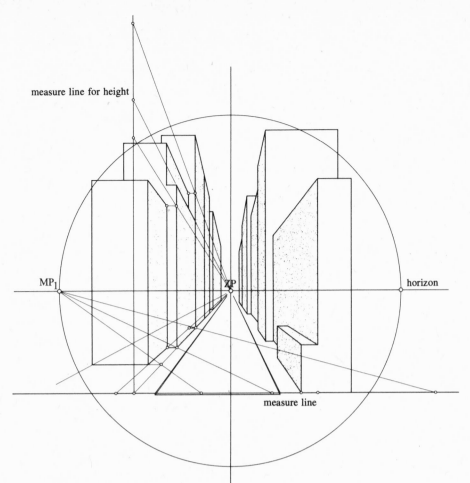

Fig. 142 Frontal perspective of cuboidal buildings.

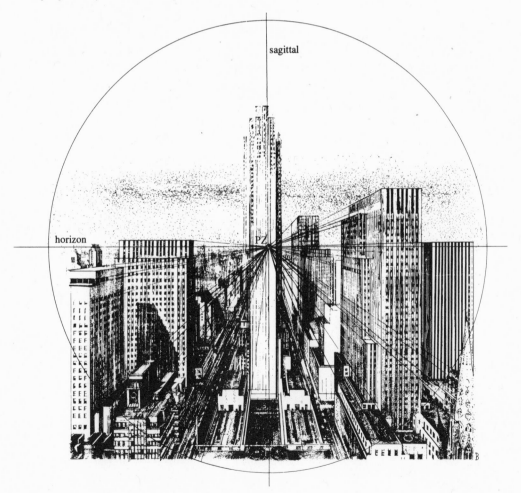

Fig. 143 Appearance of a frontal or one-point perspective (New York City).

can interpret the inclined side of this angle of inclination as an inclined straight line, which can be understood only in conjunction with a horizontal with which it forms the angle of inclination.

Perspective of the Angle of Inclination of the Descending Diagonal Plane of a Cube in the Frontal Position

Figure 145 illustrates the generation of the vanishing line and the distortion correction of the angle of inclination of the descending diagonal plane of the cube in the frontal position. To correct this angle for distortion, the triangle $PZ–VDP_2–ZP$ is rotated into the picture plane with its side $VDP_2–ZP$ as axis of rotation. The center of projection will coincide with HDP_2 if the triangle is rotated to the right, where the corrected angle of inclination $\tilde{\phi}$ is produced, whose apex coincides with measuring point MP_2 of the horizontal side of the angle of inclination of the descending diagonal plane. As the vanishing line of this plane, which passes horizontally through VDP_2, is located below the horizon, so its corrected angle of inclination is located below it.

The angle of inclination of the descending plane in turn is the angle of inclination of the inclined straight line with which the inclined side of the angle of inclination can be identified. The inclined and the horizontal side form an angle of 45°; the inclined side has its vanishing point in VDP_2, the horizontal one in the center of perspective, to which we assign measuring point MP_2. As we use this measuring point for correcting and distorting angles of inclination of inclined planes, so it can serve for the correction and distortion of angles of inclination of inclined straight lines.

Perspective of an Angle of Inclination, Parallel to the Picture Plane, of an Inclined Diagonal Plane

This diagonal plane of the cube in the frontal position is the third of its four mentioned inclined diagonal planes. The plane shown in Fig. 146 joins the top left to the bottom right rear edge of this cube. The fourth inclined diagonal plane is its counterpart and therefore does not need to be treated separately; its properties are the same as those of the third plane. Figure 146 shows that the angle of inclination formed by the diagonal plane and the base is not distorted. This is evident from the vanishing line of this diagonal plane, which forms an angle of 45° with the horizon. This also explains the perspective of the inclined line parallel to the picture plane, which we can always see in conjunction with a plane as represented by a supporting triangle or as the line of intersection of a vanishing plane with the picture plane.

Perspective of the Inclined Plane of a Ramp Obtained from a Cuboid in the Frontal Position

The inclined planes of a cube, like its diagonal planes, are inclined at an angle of 45°. Such planes can also be drawn in cuboids, but here their inclination can be steeper or flatter than 45°; the inclination of the ramp planes in Figs. 147 and 148 is more than 45° and that in Fig. 149 less than 45°.

Figure 150 shows the generation of the vanishing lines of the ascending and descending ramp planes of the cuboids in Figs. 147 and 148. The illustrations demonstrate that the vanishing line of an ascending plane whose angle of inclination is greater than 45° is *horizontal and above* the point VDP_1 and that of a similarly descending plane *below* that point.

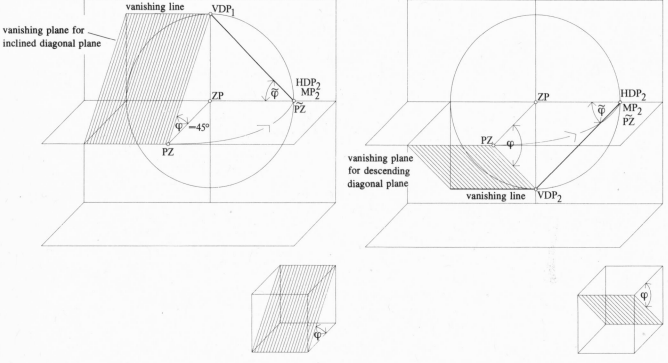

90 *Fig. 144 Vanishing plane for inclined diagonal plane.*

Fig. 145 Vanishing plane for descending diagonal plane.

Figure 150 also explains the distortion correction of the angles of inclination of the ascending and descending ramp planes through rotating the triangles PZ–FP$_1$–ZP and PZ–FP$_2$–ZP into the picture plane. The apices of the corrected or rotated angles of inclination α and β are located in the measuring points MP$_1$ or MP$_2$ of the horizontal sides of these angles.

Figure 151 reproduces the vanishing planes of inclined ramp planes whose angles of inclination are less than 45°. The vanishing line of the ascending ramp plane is below VDP$_1$, that of the descending plane above VDP$_2$.

Ramps in Frontal Perspective

A ramp can be drawn without the cube or cuboid from which it is developed. To determine its position, however, it is best to treat it as one half of the cube or cuboid in order to determine the position of the whole structure through the addition of the other half, because a ramp can, after all, be drawn from any position of the cube or cuboid. In other words, if the cube or cuboid is in the frontal position, so is the ramp developed from it; if the cube or cuboid is in the diagonal position, the ramp will be the same. Thus

the ramps shown in Figs. 152–154 are in the frontal position because so are the cuboids to which they add up.

The inclined plane of the ramp in Fig. 152 ascends. It can be drawn from the angle of inclination whose apex is either in MP$_1$ or in MP$_2$. If we draw the inclination of the inclined plane at a random angle, we can determine this subsequently by joining the vanishing point FP to MP$_1$ or MP$_2$, which produces the angle ϕ. If we treat the inclined ramp plane as a field of rays or straight lines, the vanishing points of these lines are located on its vanishing line.

If, as in the ramp in Fig. 153, the supporting triangle of its inclined plane is in the frontal position, or parallel to the picture plane, then the angle of inclination of this plane will not be distorted and is therefore a priori given. The vanishing line of the plane is parallel to the inclined side of the angle of inclination ϕ and passes through the center of perspective.

Figure 154 shows two ramps of different proportions with planes descending toward the back. However, these have the same angle of inclination and therefore the same vanishing line, on which the vanishing points of the lines of the inclined planes lie, except for those of the lines parallel to the vanishing line.

Inclined Planes in the Draftsman's Practice Related to Ramps in the Frontal Position

Figure 155 illustrates the constructive-perspective solution of the problem of drawing a road in a terrain first descending from the foreground toward the background, then level, and finally ascending.

The vanishing point of the edges of the vanishing line of the descending section of the road are below the horizon, those of the ascending section above it. The vanishing point of the edges of the level section is the center of perspective, its vanishing line the horizon.

The angles of inclination of the descending and ascending sections of the road can be determined either first, with the aid of measuring points MP$_1$ and MP$_2$, or subsequently, in case the inclinations were chosen at random. All we have to do here is join the vanishing point of the edges of the descending and ascending sections of the road to MP$_1$ or MP$_2$.

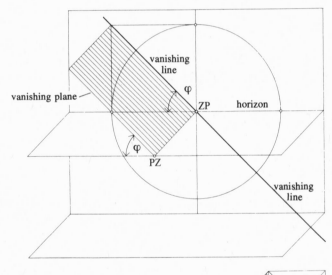

Fig. 146 *Perspective of the inclined plane of a ramp, obtained from a cube in the frontal position.*

Fig. 147

Fig. 148

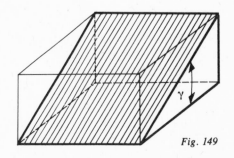

Fig. 149 91

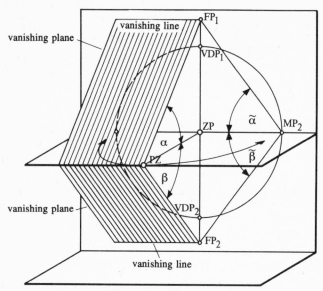

Fig. 150

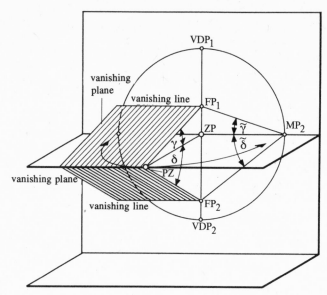

Fig. 151 Inclined planes in drawing practice, referred to ramps in the frontal position.

Figure 155 explains Fig. 156, which shows a road in a landscape with two descending sections in the foreground. The inclinations of the various descending as well as ascending sections were drawn at random. You should construct their angles of inclination.

The edges of the receding descending, level, and ascending sections of the road run from bottom to top in the picture. To become instantly aware of this, all we have to do is extend the various sections to form arrows or triangles. These will all point upwards. Only when a road is embedded in the landscape will it create the optical impression of descending, being level, and ascending.

Urban Roads

Before an urban road similar to the one in Fig. 157 is drawn, it is essential to find the position of the inclined planes and the direction of inclined lines compared with horizontal planes and lines with the aid of a parallel perspective drawing of cuboids and ramps, as shown in Fig. 158. This considerably facilitates the grasp of the situation to be drawn in perspective.

The addition of people and cars on an urban road and airplanes in flight as in Fig. 157 enhances the perspective impression of the picture.

Figure 159 shows Lindenhof, a street in Zurich, descending toward the background with steps on the left leading into an alleyway. The construction of stairs, which calls for knowledge of the construction of inclined planes, will be explained in the chapter "Stairs."

An Underpass

Before an underpass, as shown in Fig. 160, is drawn, it is also advisable to make a parallel perspective drawing of the kind illustrated in Fig. 158 at the left to determine the position of the inclined planes with reference to the horizontal and vertical planes.

Figure 160 presents the new problem of drawing two equivalent verticals, which can be interpreted as

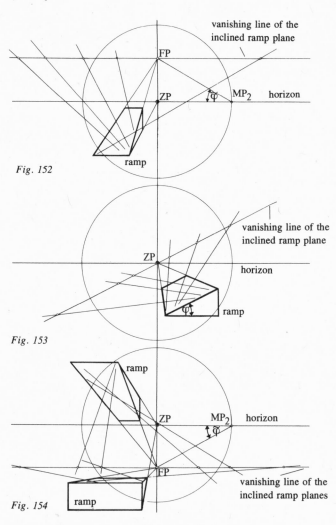

Fig. 152

Fig. 153

Fig. 154

body axes of figures, in two different sections of the sidewalks of the descending part of the road. This problem can be solved as follows:

We first erect one vertical on one sidewalk and determine the foot of the other anywhere on the other sidewalk. We now draw a line through the feet of the two verticals so that it intersects the vanishing line of the surfaces of the sidewalks. This produces the vanishing point FP of the line passing through the feet of the two verticals. By joining FP to the top end of the first vertical we obtain a parallel to the line

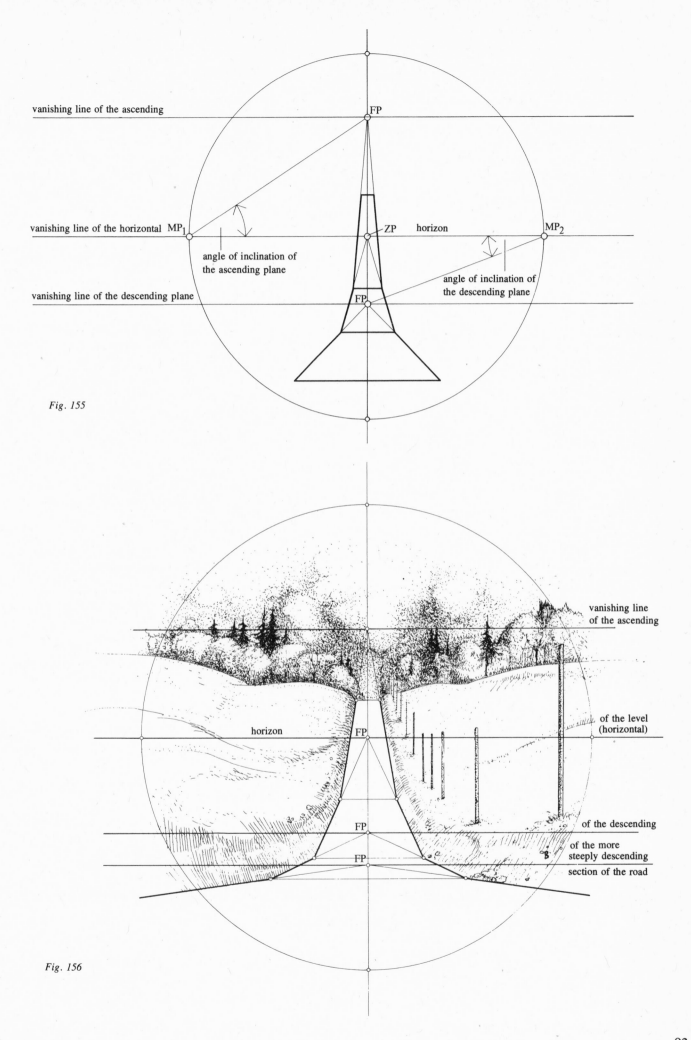

vanishing line of the ascending ——————————————— FP

vanishing line of the horizontal MP₁ ——— ZP horizon ——— MP₂

angle of inclination of
the ascending plane

angle of inclination of
the descending plane

vanishing line of the descending plane ——— FP

Fig. 155

vanishing line
of the ascending

of the level
(horizontal)

horizon FP

FP

of the descending

of the more
steeply descending

FP

section of the road

Fig. 156

93

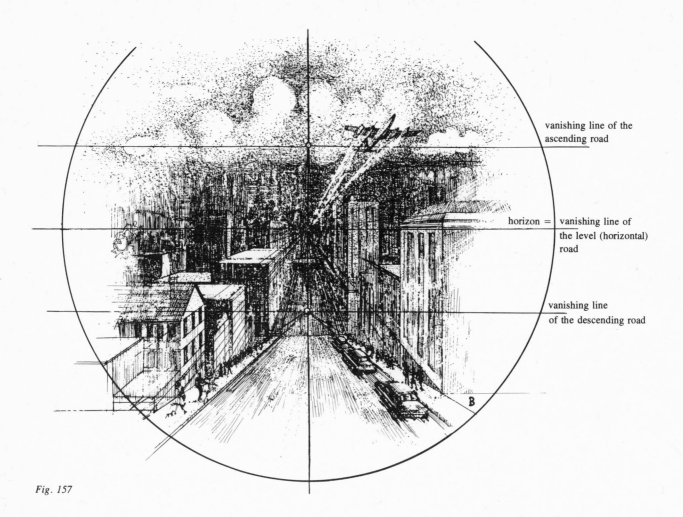

vanishing line of the
ascending road

horizon = vanishing line of
the level (horizontal)
road

vanishing line
of the descending road

Fig. 157

passing through the feet of the verticals. Because the distance between parallels is constant, the line joining FP to the top of the vertical is the upper limit line of the vertical we erect in the other foot. If the foot were on the roadway instead of the sidewalk, the height of the latter would have to be taken into account for the vertical to be erected there.

A Simple Chair with Inclined Back and Seat

When a simple chair, as in Fig. 161, is to be drawn, the angles of the inclined planes it includes, such as those formed by the seat and the back, can be determined with the aid of the corresponding measuring points. Conversely, we can use the measuring points to correct these angles of inclination for distortion when the inclinations of the planes had been drawn at random.

Three Houses with Sloping Roofs along a Village Street

The roofs of the houses in Fig. 162 are of the saddle and shed varieties. Interpenetrations of saddle roofs therefore occur in the first houses to the left and right of the sagittal. We have shed roofs on the lean-to of the house to the left of the sagittal as well as on the second house on the right. The inclinations of the roofs of the houses in Fig. 162 differ. Their angles can be determined either first, with the aid of measuring point MP_1 and MP_2, or at a later stage.

In Fig. 162 a new problem is presented by the drawing of the dormer windows whose roofs pene-

trate or intersect the large roofs of the houses. For the solution of this problem, which will be discussed in a separate chapter, lines of intersection of inclined planes must be constructed. Here we need only say that the line of intersection of two planes contains all the points common to both planes and therefore results from the connection of two points belonging to these planes. In the first house on the right they are A and FP_1, which are part of the roof planes to be intersected. Point FP_1 is the point of intersection of the vanishing lines of these roof planes, whose line of intersection AB is produced by connecting A with FP_1. The vanishing point FP_1 is the result of the intersection of the vanishing line of the roof AEFG with that of the roof ABC. We obtain this vanishing line with a parallel drawn to the edge of the roof through the center of perspective.

The construction of the dormer window of the house to the left of the sagittal in Fig. 162 should now be clear. However, we must take note that the roof IKLM of the dormer window has been produced from the guttering of the roof NOPQ to obtain H (that is, the point common to both roofs), which must be joined to FP_2 to produce the line of intersection IK between the small and the large roof.

A Downward-Sloping Bridge with Railings

Figure 163 (Manhattan, New York City) shows that planes to convey the pictorial impression of descending toward the back must be drawn exactly like ascending planes. If we examine the edges of the

94

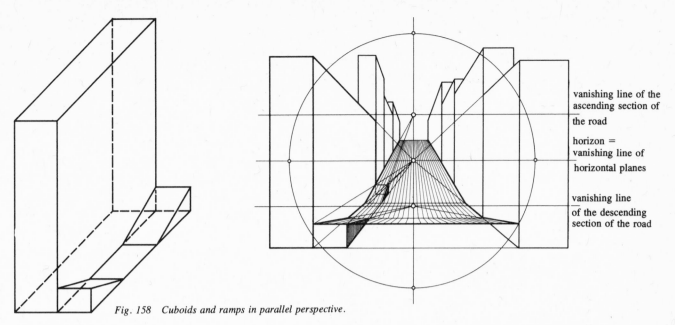

Fig. 158 Cuboids and ramps in parallel perspective.

vanishing line of the
ascending section of
the road

horizon =
vanishing line of
horizontal planes

vanishing line
of the descending
section of the road

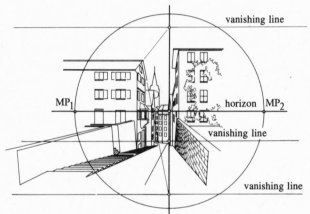

vanishing line

MP₁ horizon MP₂

vanishing line

vanishing line

Fig. 159 Lindenhof, in Zurich.

sloping bridges in Fig. 163 for this condition, we therefore find that they ascend in the picture or run from bottom to top in the drawing. This is borne out by Figs. 165 and 166; Fig. 165 represents three ascending squares, Fig. 166 a descending one. If we add to these squares to make them triangles or arrows, both arrows will point upwards.

The drawing of the distances, progressively diminishing toward the background, between the vertical posts of the railings on the downward-sloping bridge presents a new problem of perspective. Figures 167 and 168 explain the construction of these distances and the measuring points this calls for; it involves the construction of measuring points of vanishing points on the vanishing lines of ascending and descending planes.

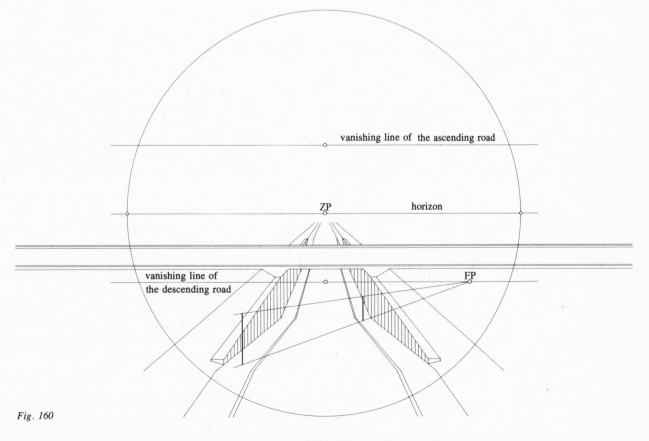

vanishing line of the ascending road

ZP horizon

vanishing line of
the descending road FP

Fig. 160

95

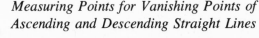

vanishing line of the back of the chair

FP

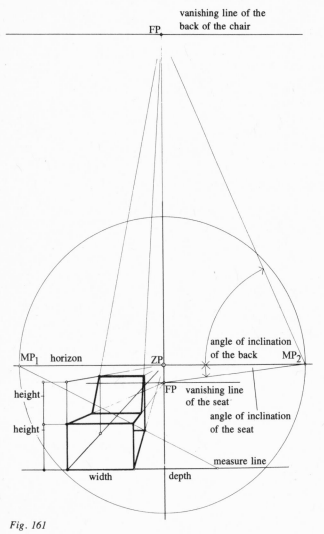

Fig. 161

Measuring Points for Vanishing Points of Ascending and Descending Straight Lines

The perspective model in Fig. 164 serves to explain the construction of measuring points for vanishing points of ascending and descending straight lines.

In Fig. 164, FP_1 is the vanishing point of ascending lines, FP_2 that of descending or skew lines. Points MP_1 and MP_2 are the measuring points for FP_1, MP_3 and MP_4 for FP_2.

The measuring points MP_1 and MP_2 for the vanishing point FP_1 are found as follows, according to the already discussed rule: We turn the line joining the vanishing point to the center of projection or FP_1–HDP_1 and the line FP_1–HDP_2 into the vanishing line on which the vanishing point for which we require the measuring point is located. In other words, we take FP_1–HDP_1 or FP_1–HDP_2 as radii of arcs of a circle drawn around FP_1 and FP_2. The arcs intersect the vanishing lines on which FP_1 and FP_2 lie at the measuring points MP_1, MP_2, MP_3, and MP_4.

FP_1–HDP_1 and FP_1–HDP_2 correspond to FP_1–PZ, if we treat them as the hypotenuse of the triangle PZ–FP_1–ZP, which we rotate around FP_1–ZP into the picture plane. In Fig. 164 the arrow left of the center of projection indicates only the rotation to the left. The triangles HDP_1–FP_1–ZP and HDP_2–FP_1–ZP correspond to the triangle PZ–FP_1–ZP rotated to the left and to the right. This will also explain FP_2–HDP_2, with which we construct the measuring point MP_3, in terms of FP_2–PZ corrected for distortion if we treat it as the hypotenuse of the rotated triangle PZ–ZP–FP_2.

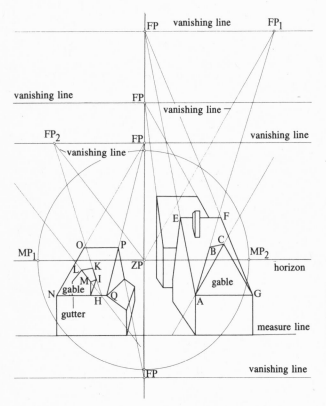

96 Fig. 162

Fig. 163 Manhattan (New York City).

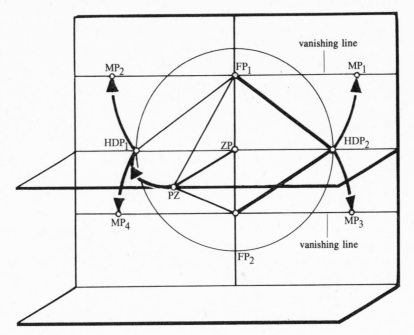

Fig. 164

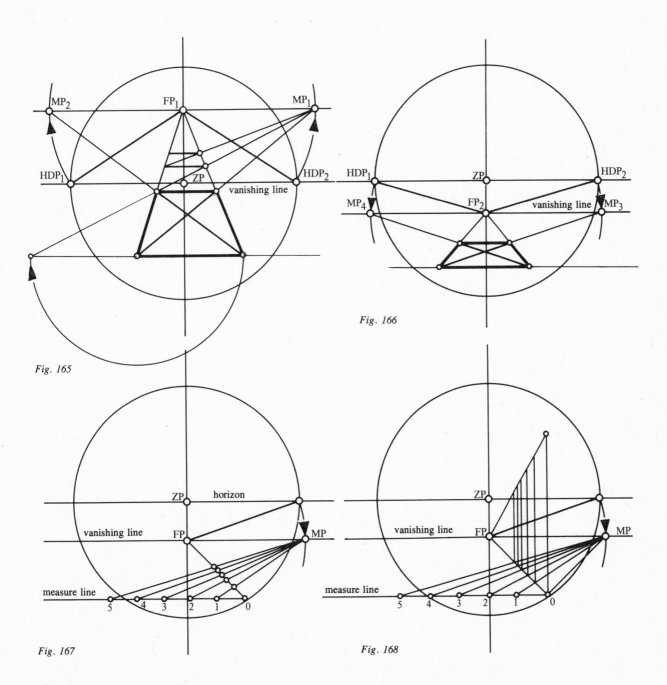

Fig. 165

Fig. 166

Fig. 167

Fig. 168

Construction of Squares as Inclined Planes

The squares in Figs. 165 and 166 have been constructed with the aid of their diagonals. Figure 165 shows the construction of a net of ascending squares, Fig. 166 a square descending toward the rear. These squares can also be drawn with measure lines on which the length of the square is defined.

Construction of a Circular Cylinder from a Cuboid in the Frontal Position

In a circular cylinder the top and base planes (as distinct from its convex surface) are circular. We can obtain such a circular cylinder from a cuboid of square cross section as shown in Fig. 169. Its base plane appears in top view, its top plane in underside view. The cross sections of the cuboid above the horizon or eye level appear from the underside, those below it from the top aspect. The same conditions apply to the cylinder in Fig. 170, whose cross sections have been drawn from the square ones of the cuboid.

The circular cylinder can be interpreted as being composed of its cross sections seen as circular discs stacked on top of each other.

Because we can treat the base and top planes as cross sections also forming part of the cylinder, we can use the square base and top planes of the cuboid for drawing from them ellipses as circles in perspective and, finally, the cylinder. However, it is advisable to draw several cross sections above and below the horizon or eye level to see how these ellipses become progressively thinner toward it and thicker away from it. This drawing of the cross sections is important to the understanding of the perspective of the cylinder.

To obtain the cylinder from a cuboid, we first draw its elliptical cross sections from the square ones of the cuboid and then its contour generatrices. The term "contour generatrix" should be self-explanatory.

All lines of the convex surface of the cylinder, including the contours of the cross sections of the cylinder, can be called generatrices. However, it must be stressed that the generatrices both of the circular cylinder and of the circular cone are straight lines from which one can imagine the convex surfaces of these forms to have developed. We can realize this by joining thin rods so that they form a square or a rectangle, which we can regard as a development of the convex surface of a cylinder.

The convex cylindrical surface is a curved structure that can be completely generated from straight lines. The contour generatrices are those lines of the convex cylindrical surface which produce the picture of the side contour of the cylinder. The construction of the contour generatrices both of the cylinder and of the cone is a separate problem, to be dealt with in its own chapter. However, we can draw the contour generatrices empirically as tangents of the ellipses of the perspective cross sections of the cylinder, as in Fig. 170.

Construction of a Water Wheel from a Circular Cylinder

Figure 172 explains how to draw the geometric perspective structure of the water wheel shown in Fig. 171 from a cuboid in the frontal position. The representation of the shaft, the spokes, and the thickness of the various parts such as the blades in the form of boards has been omitted from the drawing.

The structure of the water wheel can be developed from a hollow cylinder to be constructed from the cuboid. The blades and the rims on which they are mounted can therefore be drawn from the hollow cylinder.

The water wheel in perspective is constructed as follows according to Fig. 172:

The cuboid from which we draw the cylinder of the water wheel is produced in vertical plan when it appears as a square; from this we construct the vertical plan of the water wheel. Rotating this square through 90° around a vertical axis of rotation enables us not only to draw the cuboid in perspective but also to construct the perspective vertical and horizontal plan of the water wheel, from which its perspective picture can be developed.

The Hyperboloid of Revolution

After the perspective representation of the cylinder let us draw a hyperboloid of revolution. We develop it, like the previously mentioned forms, from the top and base plane of a cylinder based on a cuboid of square cross section.

However, we must first clearly understand the generation of a hyperboloid of revolution with the aid of a three-dimensional model, which we can build of wood, cardboard, and elastic thread.

Let us assume the top and base plane of a cylinder to consist of thin disks joined by an axis, which in our model can be a cylindrical rod, around which they can rotate. These disks are now joined with parallel and vertical elastic threads representing the generatrices. This real or imaginary structure corresponds to the model of a cylinder shown in Fig. 173. Here the circumferences of the top and base planes are each divided into twelve equal parts. The dividing points numbered 1–12 in the top and base planes should at first be vertically above each other, so that the lines with which we join them represent generatrices. If we now rotate the top disk of the cylinder, which in the drawing is shown as a circle in perspective, clockwise and the base disk counterclockwise, the convex surface of the cylinder will become constricted toward the midpoint of its long axis. The form of this constriction is a hyperbola, and the structure a hyperboloid of revolution; the previously vertical and parallel elastic threads are skew to each other. A hyperboloid is also produced when only one disk is rotated. The degree of rotation

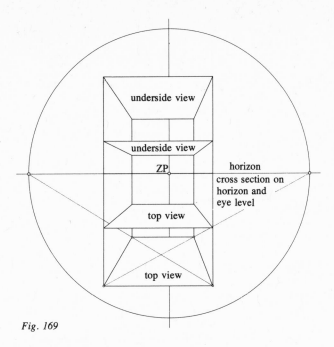

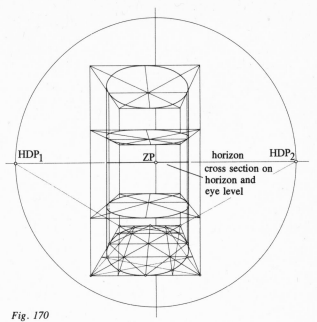

Fig. 169

Fig. 170

determines that of the constriction and the shape of the hyperboloid. If we counterrotate the disks through 180°, so that the dividing points of the top and base disks are diametrically opposed to those bearing identical numbers, we obtain a figure of maximum constriction, corresponding to a double cone. Theoretically, the site of maximum constriction is a point at which the generatrices of the double cone intersect (Fig. 174).

The reproduction of a hyperboloid of revolution and thereby of a complex curved area is illustrated in Fig. 175. To obtain the hyperboloid shown in Fig. 175, the top and base planes of the cylinder with numbers 1–12 are mutually rotated through 150°. Try to draw hyperboloids in which the top and base planes of the cylinder had been counterrotated through less or through more than 150°.

Fig. 171 Hallwil (Switzerland).

Stairs

In the context of the drawing of stairs, problems other than purely perspective ones arise, and we will discuss them on the basis of Franz Schuster's arguments on the subject in his book *Treppen* (Stairs) (Julius Hoffmann Verlag, Stuttgart, 1943). The main problem is the slope of the stairs, which is determined by the ratio of riser and tread of the step.

The angle of slope is determined by a horizontal and the line of ascent (see Fig. 176). The line of ascent of a flight of stairs is produced when the front edges of the steps are joined. The ratio of riser to tread determines the steepness of the stairs.

On the basis of investigations by Drs. C. Lehmann and W. Doell, the most favorable ratio of rise to tread is 17 : 29 cm.

A graphic representation enables us to determine the rise-to-tread ratio constructively for a certain rise; we can also construct it with the aid of the angle of slope of the stairs to be drawn.

The graphic representation for the construction of stairs is based on the following considerations, illustrated by Figs. 177–179.

The movement of a person on stairs consists of a horizontal and a vertical direction. We can therefore draw the graphic representation for the construction of stairs from a horizontal and a vertical symbolizing these directions. In geometry, the horizontal is called the abscissa, the vertical the ordinate.

If a person moves in a straight line on a horizontal plane, we can assume that he is walking on stairs of 0° angle of slope. Because the length of step differs from person to person, we have to know the average length of step of a person of normal build; Drs. C. Lehmann and W. Doell arrived at 63 cm. If we regard walking on a horizontal plane as movement on theoretical stairs of 0° angle of slope, we can say that the width of tread of the stairs has reached its maximum of 63 cm. If the riser determines its angle of slope, it will be zero when the angle of slope is

99

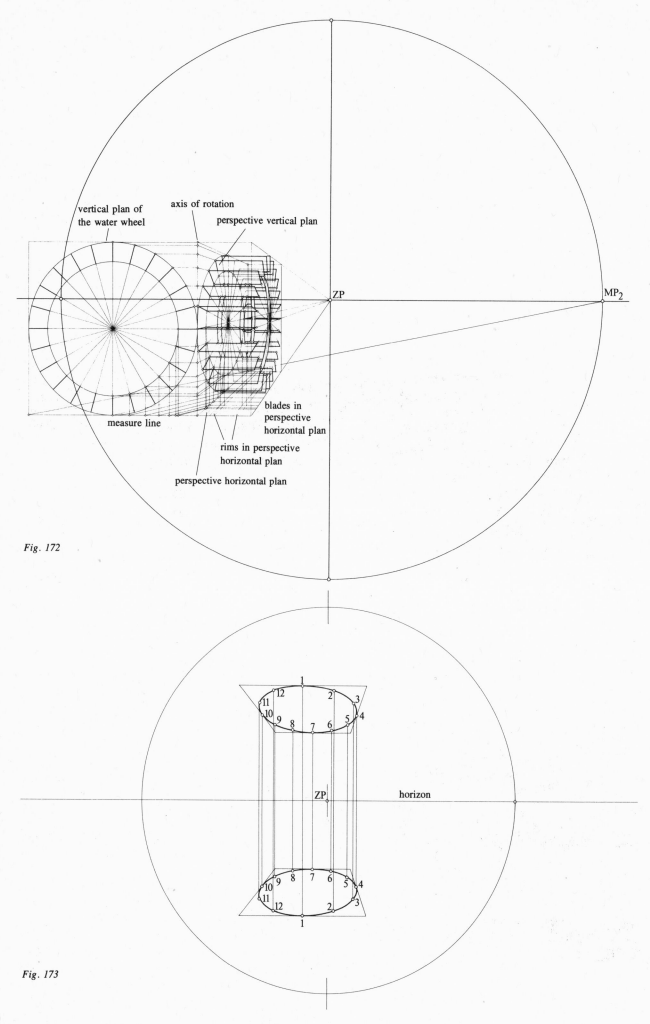

vertical plan of
the water wheel

axis of rotation

perspective vertical plan

ZP

MP₂

measure line

blades in
perspective
horizontal plan

rims in perspective
horizontal plan

perspective horizontal plan

Fig. 172

horizon

ZP

Fig. 173

100

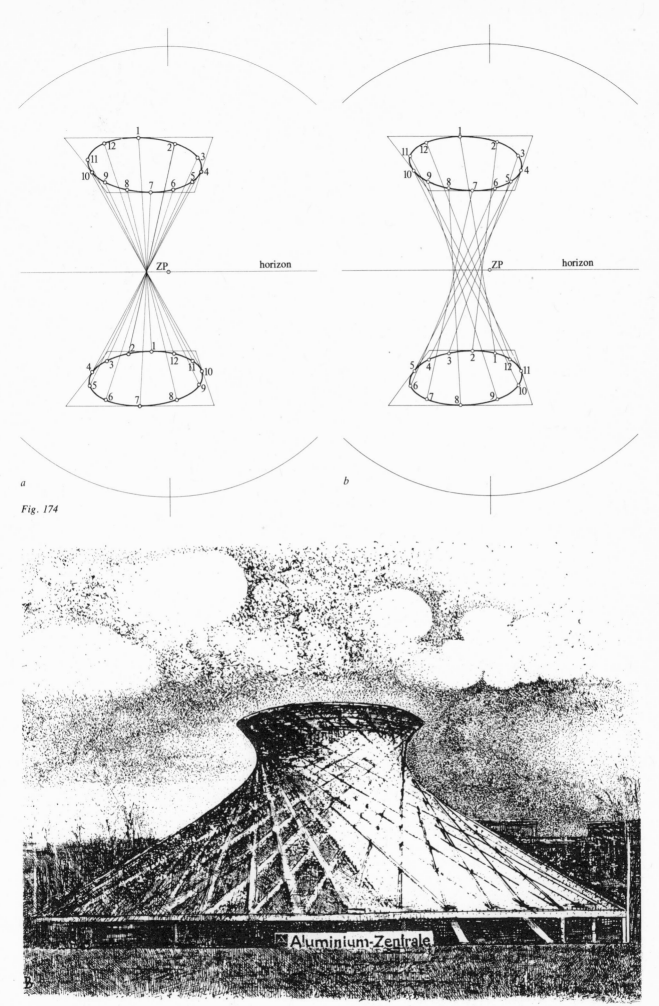

a

b

Fig. 174

Fig. 175 *Hanover, hyperboloid building structure.*

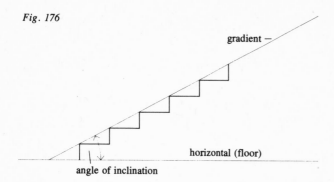

Fig. 176

gradient —

horizontal (floor)

angle of inclination

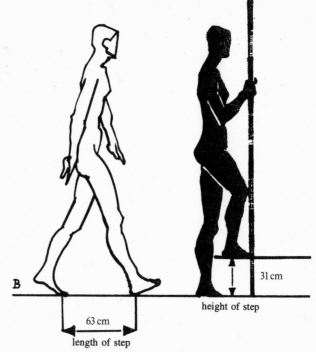

B

63 cm

length of step

31 cm

height of step

Fig. 177

zero. The length of 63 cm can be marked off to scale on the abscissa for the construction of the graphic representation (Fig. 177).

If the person moves vertically upward on a vertical ladder, which we can treat as stairs of 90° angle of slope, the necessary lifting of a thigh calls for twice the effort required for walking on a horizontal plane; it shortens the length of the step by about half. We therefore assume 31 cm for the height of such a step, which we mark off on the ordinate. If we regard the vertical ladder as vertical stairs with steps of negligible tread width, we can say that the maximum riser has been reached (Fig. 177).

The dividing points on the abscissa and on the ordinate as marked off in Fig. 178 are now joined to each other; this results in inclined lines, which are important to the construction of stairs of a certain angle of slope or of a certain riser. To determine the corresponding tread width, we start from the required riser, which we mark off on the ordinate. If the riser is 15.5 cm, we can draw from the midpoint of the line representing the maximum riser a horizontal, which we intersect with the inclined connecting line; the distance from the midpoint to this line will now correspond to the tread of the stairs to be drawn. If we thus know riser and tread of the stairs, we can draw its profile with the aid of the inclined connecting lines in the graphic representation. But to obtain this profile, we can also start from the inclined side of the angle of slope of the stairs to be drawn; from the points of intersection between this side and the inclined connecting lines we draw horizontals and verticals so that they intersect. These points of intersection correspond to the front edges of the treads in profile.

We can now directly use the graphic representation described for the construction of stairs in perspective. Figure 179 shows the parallel perspective aspect of a ramp developed from its supporting triangle.

We interpret the inclined connecting lines of the graphic representation in Fig. 178 as vertical plans of imaginary planes through that ramp. The longest inclined connecting line will then be the vertical plan of the inclined plane of the ramp. We can, if we want to draw stairs in perspective, proceed from the perspective representation of a ramp whose form and arrangement are determined by the graphic represen-

tation. With the aid of the perspective rendering of the ramp, stairs of a certain angle of slope can now be drawn. The size of the ramp depends on that of the stairs to be drawn.

The ramp from which we want to draw stairs as shown in Fig. 180 contains the graphic representation in its planimetric form, that is, as we first encountered it. We can therefore draw the stairs directly from this graphic representation. Both the angle of slope and the angle of inclination of the inclined plane of the ramp from which we can construct the stairs are 45°.

The angle of slope of the stairs, as shown in Fig. 181, is also 45°. We can mark off the vertical dimension for constructing the profile of the ramp, which now appears in perspective, on the perpendicular we erect at 0; this is also the origin of the abscissa on which we mark the length of the step to be transferred to the line which has its vanishing point in the center of perspective; the length diminishes progressively toward the back.

If we want to draw stairs that slope downwards away from the observer, as shown in Fig. 182, we must start from a ramp with a downward slope. The profile of this ramp, from which we construct these stairs, must be drawn so that we have to transfer not

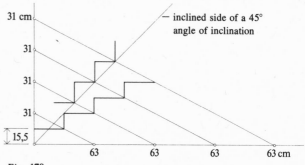

31 cm

31

31

31

15,5

— inclined side of a 45° angle of inclination

63 63 63 63 cm

Fig. 178

102

Fig. 179

only the tread but also the riser into perspective. We must also note that the vanishing point of the inclined side of the 15° angle of slope is on the sagittal below the horizon.

Figures 183–185 demonstrate practical examples. Figure 183 shows an interior in frontal perspective with stairs rising with respect to the observer.

Figure 184 illustrates two stairs. One slopes upwards, the other downwards as seen by the observer. Two persons at the bottom end are ascending, two at the top end descending them. When figures are shown on stairs, not only must the perspective scale be maintained, but the height of the figures should also be commensurate with the riser, which may vary.

Figure 185 shows a kind of staircase with descending and ascending stairs, whose construction should be understood in view of what has just been explained.

The Spiral Staircase

Here we can discuss only the geometric problems of representing spiral staircases, not those of constructing individual ones. However, a basic understanding of the nature of a spiral staircase is necessary if such an object is to be drawn.

A spiral staircase consists of a newel, constituting a cylindrical column, and the steps; in the absence of a newel the steps are built around an open well.

Figure 186 shows the horizontal plan of a spiral staircase with an open well, Fig. 187 that of one with a newel. These horizontal plans are based on two concentric circles, the smaller one representing either the open well or the newel.

The horizontal plan of the treads is drawn by dividing the larger circle into as many parts as treads are planned. The dividing points are now joined to the center of the two circles. This is the horizontal plan of a spiral staircase in which the treads taper to points which coincide with the center of the circles. It is suitable for the construction of a spiral staircase with either an open well or a newel. In modern spiral staircases (for instance, of swimming pool diving boards) the newel supports the mostly trapezoidal treads.

The line of ascent in the midline of the treads as shown in Figs. 186 and 187 is a spiral, whose origin on a helicoid or screw surface we can imagine as follows:

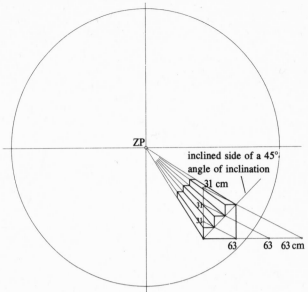

Fig. 180

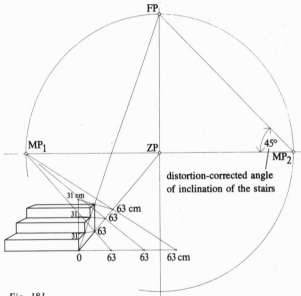

Fig. 181

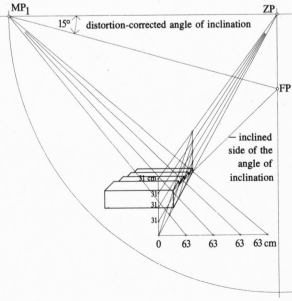

Fig. 182

103

Let one side of a right angle be horizontal, the other vertical. Let the vertical line be the axis around which the horizontal side rotates while moving vertically along it. This horizontal side thus generates a screw surface. Every point on this surface describes a helix.

In other words, the motion of the horizontal side of the right angle is both rotary and vertical. The line of ascent as represented in Figs. 186 and 187 shows only the rotation. The vertical plan demonstrates the vertical motion of the point.

Figure 188 illustrates seven stages of this motion. For constructing the drawing in Fig. 188 we first draw a cuboid in the frontal position, from which we obtain a cylinder with six equidistant cross sections, three of which are below, two above, and one at the level of the horizon or eye level.

The cylinder in Fig. 188, developed from a cuboid of square cross section, was constructed from its base plane. The base of the cylinder, an ellipse as a circle in perspective with four diameters, was produced from the two center lines and the diagonals of the base of the cuboid. The base of the cylinder with the four diameters (eight radii) can also be treated as a perspective horizontal plan of the cylinder from which its cross sections are constructed. These cross sections contain the seven stations of the path of the horizontal side of the right angle, which simultaneously rotates and moves vertically, thereby generating a helix. It is obvious that the horizontal side always remains normal to the central axis of the cylinder, representing the vertical side of the rotating and vertically moving right angle, as it rotates around it. Therefore Fig. 188 illustrates not only the generation of a helix but also the geometric perspective structure of the spiral staircase.

Figure 189 represents only the skeleton, as it were, of a spiral staircase, whose newel and treads

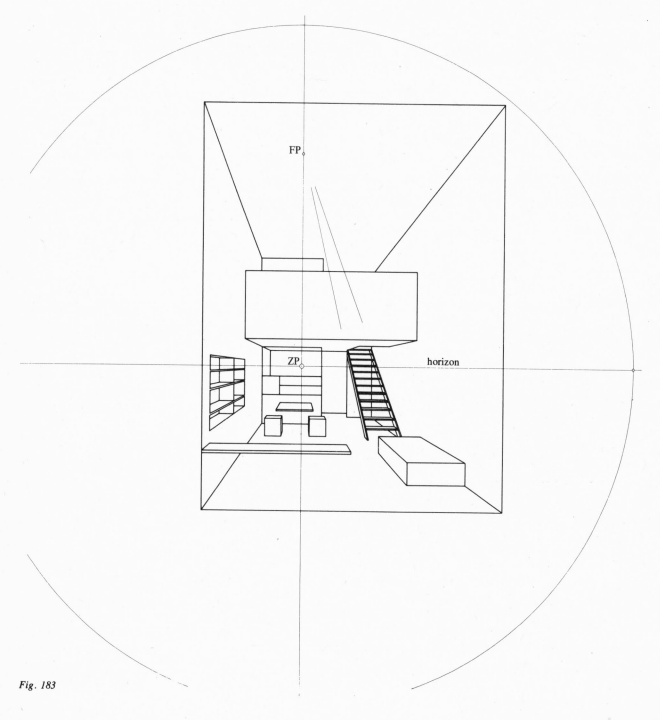

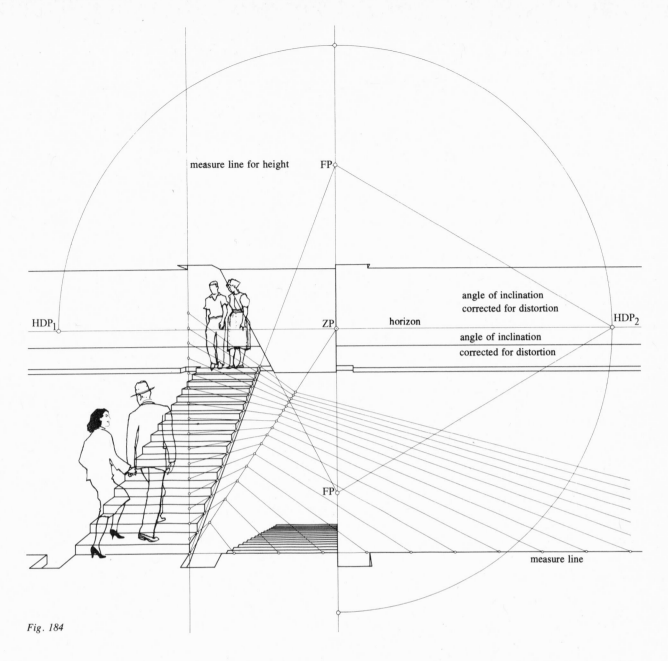

measure line for height

FP

angle of inclination
corrected for distortion

HDP₁

ZP

horizon

HDP₂

angle of inclination
corrected for distortion

FP

measure line

Fig. 184

we can imagine to consist of thin rods. The illustration shows how to develop the frame of a spiral staircase from the base of a cylinder. From the four diameters of this plane we obtain the eight radii as horizontal plan of the horizontal steps, from which we can draw the eight treads. The vanishing points of these treads in the form of lines can also be determined from the perspective horizontal plan of the spiral staircase. We have only to extend the horizontal plans of these steps until they intersect the horizon to obtain the vanishing points.

The newel with two treads of a spiral staircase in Fig. 190 has been constructed on the same principle as in Fig. 189: On a perspective horizontal plan which in turn had been constructed on a horizontal plan proper of a spiral staircase. Here the treads 1 and 10 to be drawn have been rendered in bold lines. The staircase can be of the newel or the open well variety. The measure line for its height and for that of the treads can be drawn from a vertical front edge of the cuboid from which we develop the cylinder of the spiral staircase. In Fig. 190, too, the vanishing points of the width edges of the treads can be con-

structed on the perspective horizontal plan of the spiral staircase. One of a total of five vanishing points is in the center of perspective.

The spiral staircase of Fig. 191 has been drawn from its perspective horizontal plan and profile. The perspective profile of the staircase can be obtained with the aid of its perspective horizontal plan and of one aligned side of the cuboid from which we construct the cylinder of the spiral staircase.

The spiral staircase in Fig. 192 differs from those previously discussed in that it has a bannister and its treads are wedge-shaped boards supported by the newel instead of blocks. Half of its structure was determined in a horizontal plan proper, on which the perspective horizontal plan of the spiral staircase was constructed. The perspective horizontal plan can be used also for setting up the perspective profile of the staircase; this can, in addition, be constructed on an aligned side of the cuboid from which the cylinder of the spiral staircase can be drawn. The bannister, parallel to the treads, is based on a helix whose points are equidistant from the treads.

The figures on the spiral staircase in Fig. 192 must

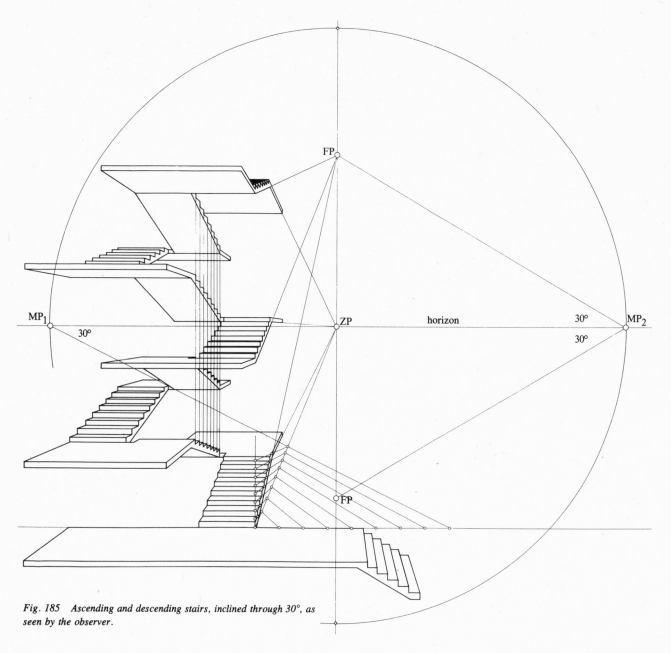

Fig. 185 Ascending and descending stairs, inclined through 30°, as seen by the observer.

be drawn so that their dimensions conform to the rise and so that they meet the requirements of the perspective consistency; that is, figures and stairs must appear projected from the same center of projection or be seen from the same point of view.

Transformation of the Horizon

The original position of the circle of view for the construction of perspectives is characteristic in that the horizon is level (horizontal) and the sagittal perpendicular. Transformation of the horizon enables us to solve problems arising when the infinity line is not horizontal and the sagittal not perpendicular but both are sloping as a result of what we call transformation.

Figure 193 explains the establishment of the transformation of the horizon and of the sagittal through a clockwise or counterclockwise rotation of the perspective model around an axis that coincides with the line of intersection between the horizon and the sagittal plane or the central visual ray.

Figure 193 shows the model in parallel perspective with the observer in the initial position and after clockwise rotation around this axis; the planes of the perspective model with the observer assume an inclined position indicated by the dotting of the horizon plane and the sagittal plane.

Figure 194 shows the clockwise rotation of the perspective model and thereby the planimetric establishment of the transformation of the horizon and of the sagittal.

Figure 195 explains the transformation of the horizon from a possible movement of the observer, whom we can treat as the pilot of a small aircraft with a fuselage of circular cross section. The illustration shows four stages of a counterclockwise rotation around the long axis of the fuselage. These four stages produce four different inclined positions of the observer and of the perspective model, of which Fig. 195 shows only the picture plane represented by the circle of view.

A sailing ship assuming an inclined position also illustrates a motion causing a transformation of the horizon. We can imagine the observer sitting or standing in it with a camera, which we compare to

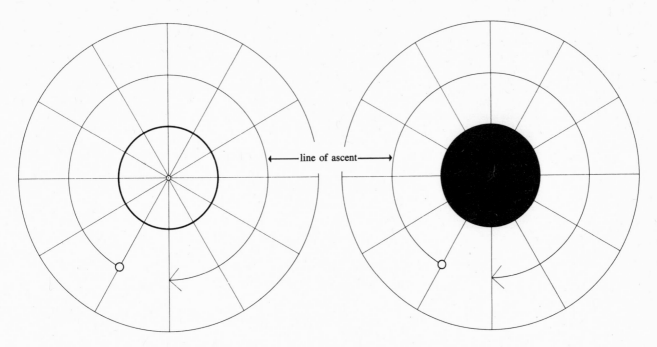

Fig. 186 Well hole. Fig. 187 Newel.

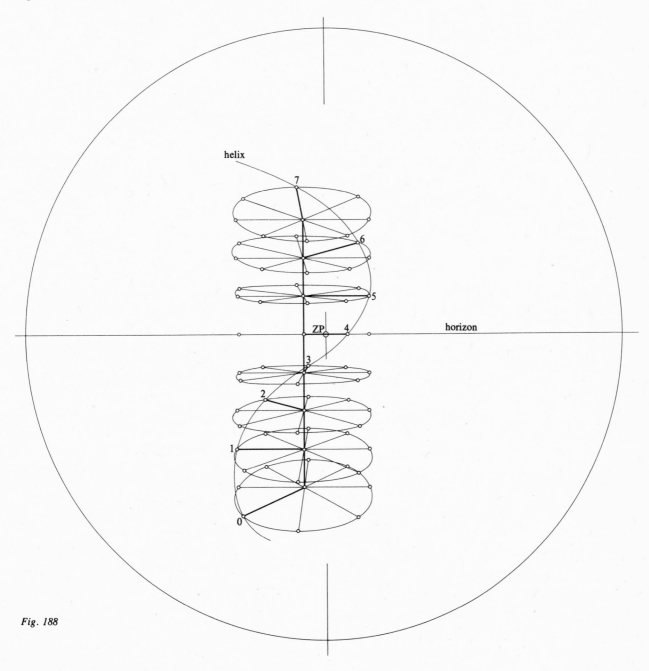

Fig. 188

107

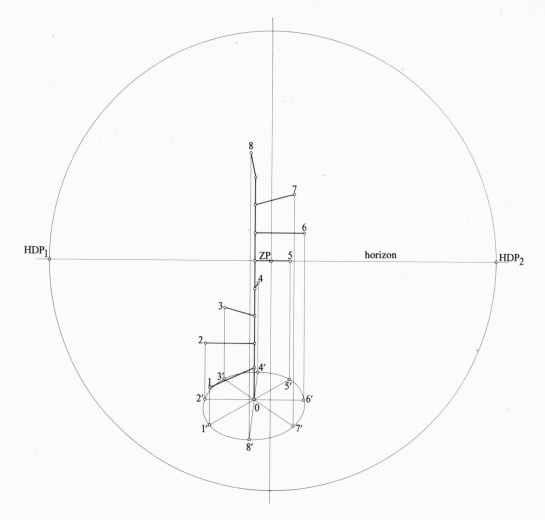

Fig. 189 Perspective horizontal plan of the frame of a spiral staircase.

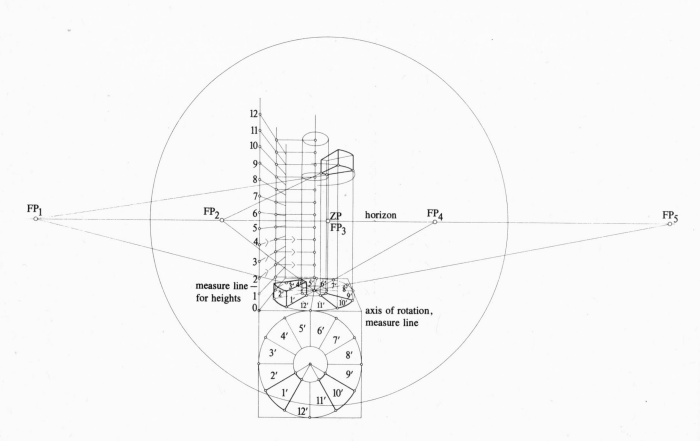

Fig. 190

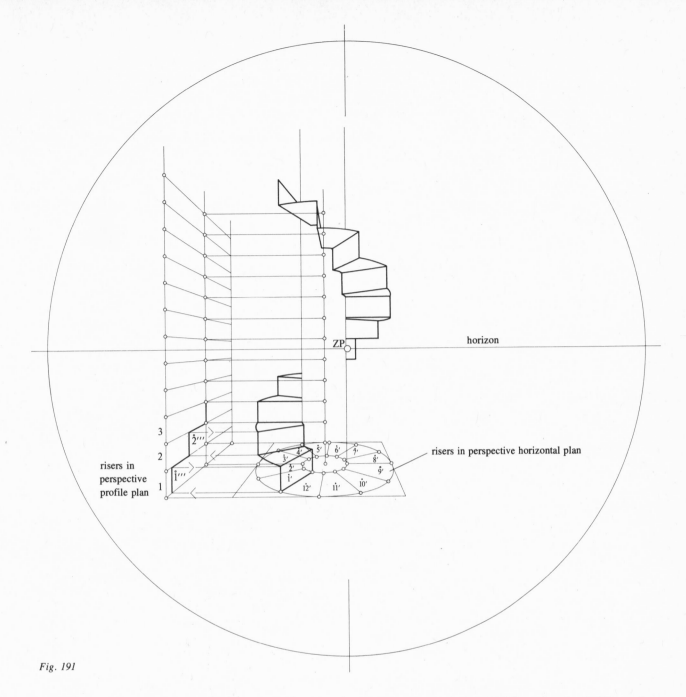

risers in perspective profile plan

risers in perspective horizontal plan

horizon

ZP

Fig. 191

the perspective model, in front of his eyes. If he photographs the sailing ship in an inclined position, its perspective can be explained from the transformation or inclination of the horizon.

Whatever the motion we think has caused the transformation of the horizon, the axis around which the perspective model with the observer rotates must always be normal to the picture plane.

Figure 196 illustrates a counterclockwise rotation of picture plane and observer as the cause of the transformation of the horizon. The axis of this rotation is the central visual ray, which passes through the center of perspective. Like the true horizon, any transformed horizon must therefore pass through the center of perspective. We can consequently regard any straight line through the center of perspective as a transformed horizon or even as an "auxiliary horizon."

When the picture plane is rotated as in Fig. 196, the points on the horizon, on the sagittal, and on the circle of the horizon describe arcs of circles; HDP$_1$ is

displaced downwards, HDP$_2$ upwards, VDP$_1$ to the left, and VDP$_2$ to the right. The situation is reversed when the transformation of the horizon is clockwise.

A transformed dimension is indicated by the addition of "t" to the designation; for instance, HDP$_1$ t means "HDP$_1$ transformed."

Solution of Problems through Transformation of the Horizon

The square ABCD in Fig. 197 is to be drawn through the transformation of the horizon after a 30° rotation around AB, as illustrated in Fig. 198. It would be possible to construct the square ABC-tD-t in Fig. 198 without transformation of the horizon by using 30° arcs of circles from A and B, as shown in Fig. 198. But this construction requires the drawing of the square ABCD, from which the inclined square can be determined. The solution of this problem by means of transformation of the horizon makes this unnecessary, because here we can start with AD-t, which must make an angle of 30° with a horizontal.

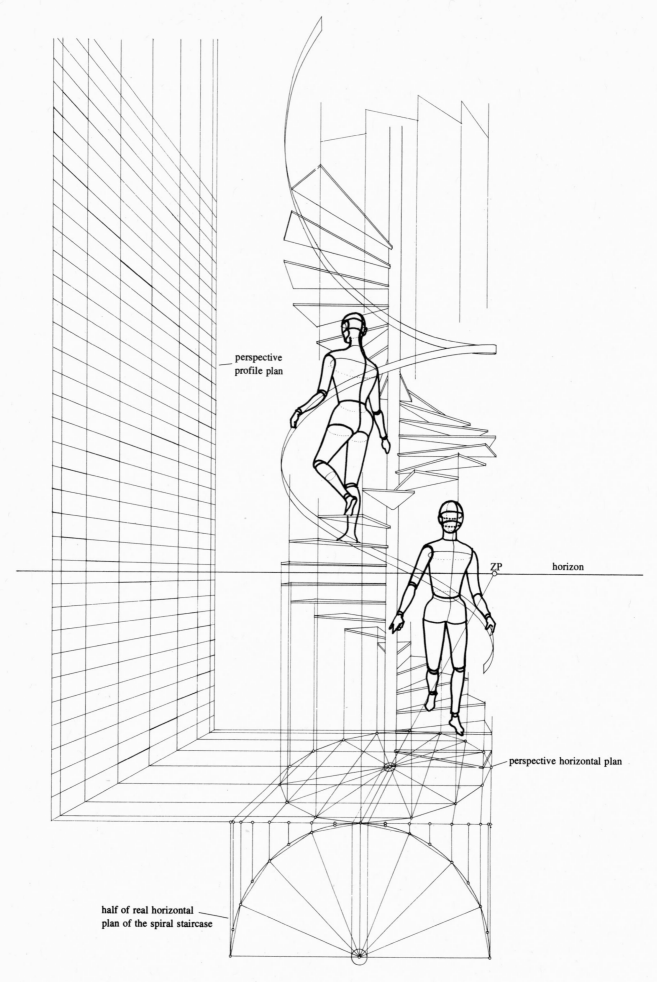

perspective
profile plan

ZP horizon

perspective horizontal plan

half of real horizontal
plan of the spiral staircase

Fig. 192

110

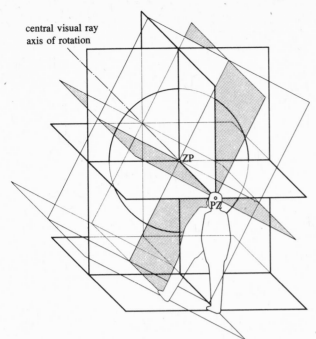

Fig. 193 Clockwise transformation.

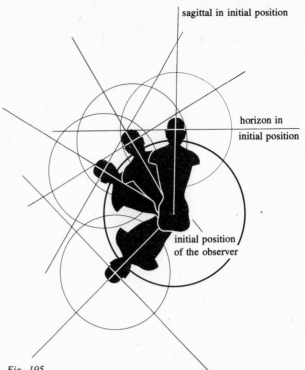

Fig. 195

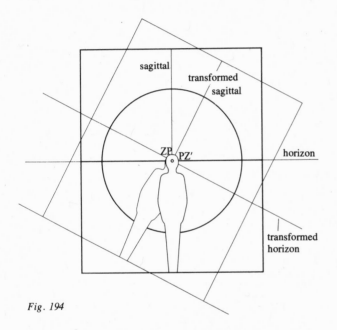

Fig. 194

A parallel to AD-t, which must pass through the center of perspective, produces the transformed horizon. Its intersection with the circle of view produces HDP_1 t and HDP_2 t, with which the square ABC-tD-t can be constructed.

The Inclined Frontal Position of a Cuboid

Figure 199 explains the term "inclined frontal"; it shows the square ABCD in the inclined position into which it has been rotated around DC, which is in the ground plane. Based on this square is the cuboid with the corners EFGH and IKLM, whose position we call inclined frontal. To grasp this position we must imagine the square ABCD in the original horizontal position and the cuboid based on it vertical and in the frontal position. The front and rear faces of the cuboid are parallel to, its sides EIKF and HLMG normal to the picture plane. The length edges of the cuboid are normal to the picture plane, as in the original position. Their vanishing point is therefore in the center of perspective.

Figure 199 shows the horizon plane in the inclined position of square ABCD or transformed to illustrate that the horizon plane is the vanishing plane not only of ABCD but also of the top and base planes of the cuboid and that the transformed horizon represents the vanishing line of these planes. The transformed sagittal plane, too, can be regarded as a vanishing plane, which intersects the picture plane in the transformed sagittal or vanishing line of the side faces EIKF and HLMG of the cuboid; this is indicated by the hatching of HLMG and of its vanishing plane.

As the transformed sagittal is normal to the transformed horizon, so the planes whose vanishing lines are the horizon and the sagittal are normal to each other. This must be kept in mind when a cuboid in the inclined frontal position on a plane is being drawn, as in Fig. 200. The plane is a net of squares. The base of the cuboid measures two squares. Figure 200 shows that the net of squares with the cuboid standing on it is in principle constructed in the same way whether it is in the inclined-frontal position or with horizontal horizon and vertical sagittal.

One-Point Perspective with Horizontal Picture Plane

Up to now we have drawn perspectives obtained with the aid of vertical picture planes, related to the observer in an upright position; we now move on to the perspective of cuboids resulting from the horizontal position of the picture plane.

We obtain this position by rotating the perspective model with the observer through 90° around the horizon as axis of rotation. This produces the situation illustrated in Fig. 201. The picture plane is horizontal and therefore parallel to the ground, to which the ground plane, the horizon plane, and the sagittal plane are normal. The body axis of the ob-

111

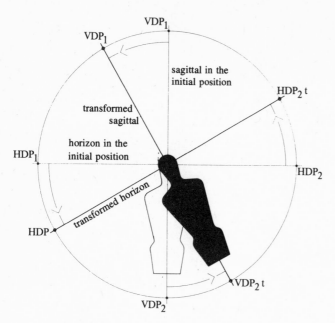

Fig. 196 *Counterclockwise transformation.*

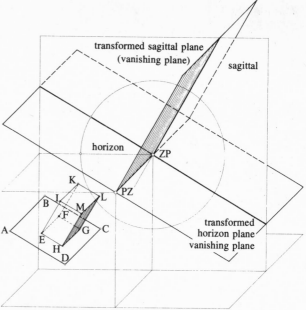

Fig. 199

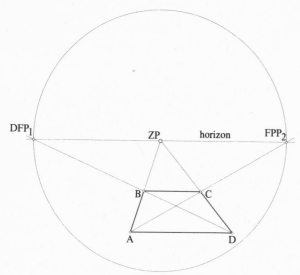

Fig. 197

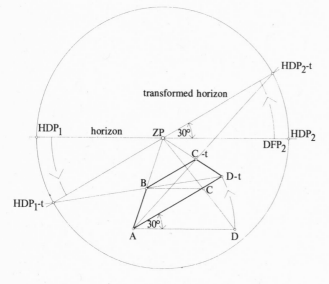

Fig. 198

server is horizontal. The horizontal position of the picture plane necessitates the horizontal position of the observer and vice versa. It is characteristic of this position that the central or principal visual ray of the observer is perpendicular and therefore normal to the ground.

Let us treat the cuboids in Fig. 201 as flat-roofed buildings to be photographed vertically from an airplane in level flight. If the film in the camera, a picture plane parallel to the photographer's forehead, is also parallel to the roofs of the houses, eight edges of a house will be parallel to the picture plane. But four edges are normal to it; to the observer in the horizontal position these recede, having their vanishing point in the center of perspective.

Figure 202 explains that the perspective construction of a cuboid building with a horizontal picture plane and position of the observer is the same as that of one in frontal or one-point perspective. Figure 202 represents an eight-story flat-roofed building of square cross section. The height of the building can be found on a measure line parallel to the horizon. One of the four height edges, which now recede, represents the height of the building. In Fig. 202 such an edge has been divided into eight parts with the aid of measuring point MP_2; as they recede, they become progressively shorter.

Transformation of the Horizon with a Horizontal Picture Plane

Transformation of the horizon is possible regardless of the position of the picture plane, that is, even when this is horizontal. Figure 201 demonstrates this clearly. Figure 203 has been drawn by means of transformation of the horizon.

The visible front of the building in Fig. 203, consisting of two squares, has been constructed from a net of squares on the ground, with which the base plane of a cuboid building can also be determined.

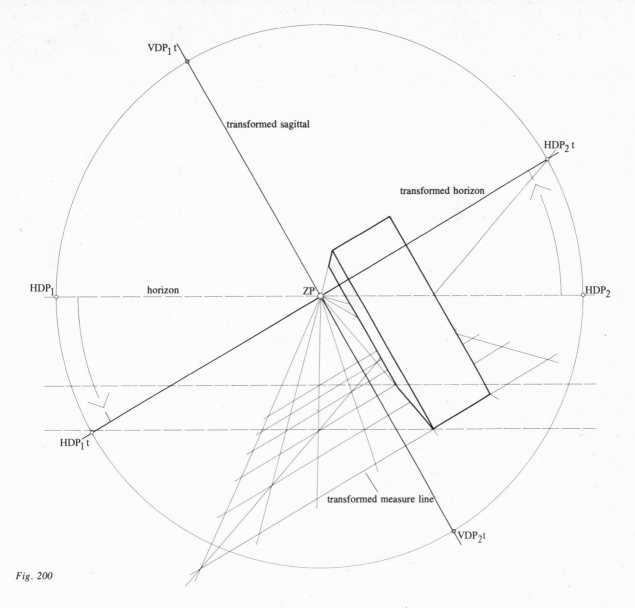

Labels in figure: VDP$_1$t, transformed sagittal, HDP$_2$t, transformed horizon, HDP$_1$, horizon, ZP, HDP$_2$, HDP$_1$t, transformed measure line, VDP$_2$t

Fig. 200

Thus a base plane of nine squares, in turn forming a large square, of a second cuboid building is shown in Fig. 203. Through the corners of this large square have been drawn lines from which the height edges and fronts of the building can be determined.

A Photograph of New York City

Figure 205 is a reproduction of a photograph of New York City, which was taken from a height of about 1200 m with a special nine-lens camera to obtain a large field of view. The extensions of those edges of the skyscrapers and of the lower buildings which seen from the ground are height edges but from the photographer's viewpoint must be treated as receding edges converge in their vanishing point, which is identical with the center of perspective. This indicates the position of the photographer at the moment of exposure, that is, vertically above the point of intersection between the vertical principal visual ray and the ground.

If we assume the picture plane of the film to be parallel to the ground, we see why the roofs of the buildings are not perspectively distorted but appear in their planimetric form as squares, rectangles, trapezoids, and polygons or—in cylindrical structures such as gasworks—as circles.

The strong impact of a city landscape in one-point perspective with a vertical principal visual ray is perhaps due to the fact that the receding lines guide the observer's eye into the depth, which is thereby seen as an abyss. As a comparison between Figs. 204 and 205 shows, the height from which a city is photographed or drawn probably also has an important influence on the perspective effect.

Both illustrations demonstrate one-point perspective with a vertical principal visual ray. But whereas the relatively few skyscrapers, cuboid or composed of cuboids, in Fig. 204 appear to have been drawn from a low height, the photograph in Fig. 205 was taken from a height at which the special camera was able to reproduce a huge area of New York City. The fact that we do not perceive the many street canyons as chasms is connected with the distance from which they were photographed. To illustrate the point, let us remember that we do not see valleys between high mountains as chasms as we fly above them at a great height; this impression is created only at lower heights. The representation in Fig. 204, which shows a street canyon from a rather close distance, gives a better impression of a chasm.

The photograph in Fig. 205 fascinates us by the enormous dimensions of the area shown, that is, by

113

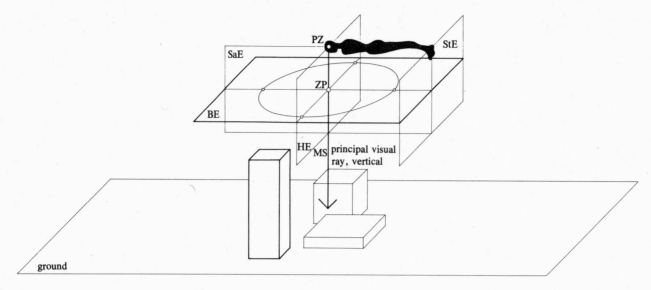

Fig. 201

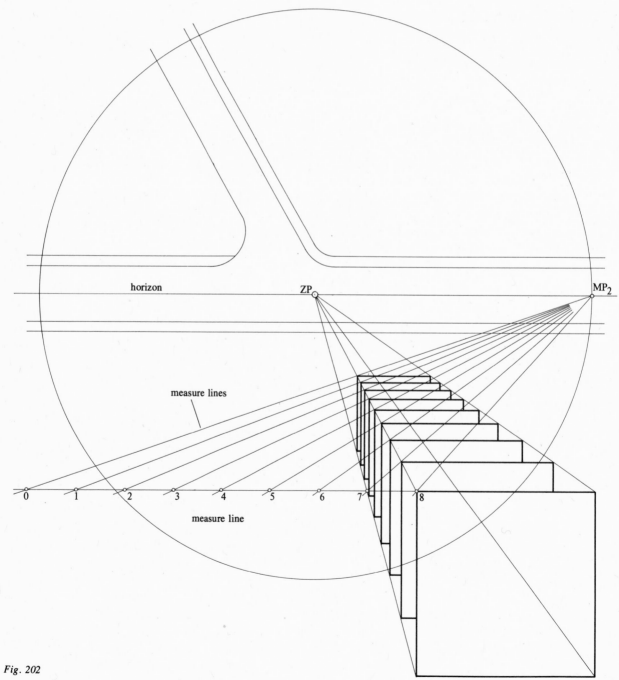

Fig. 202

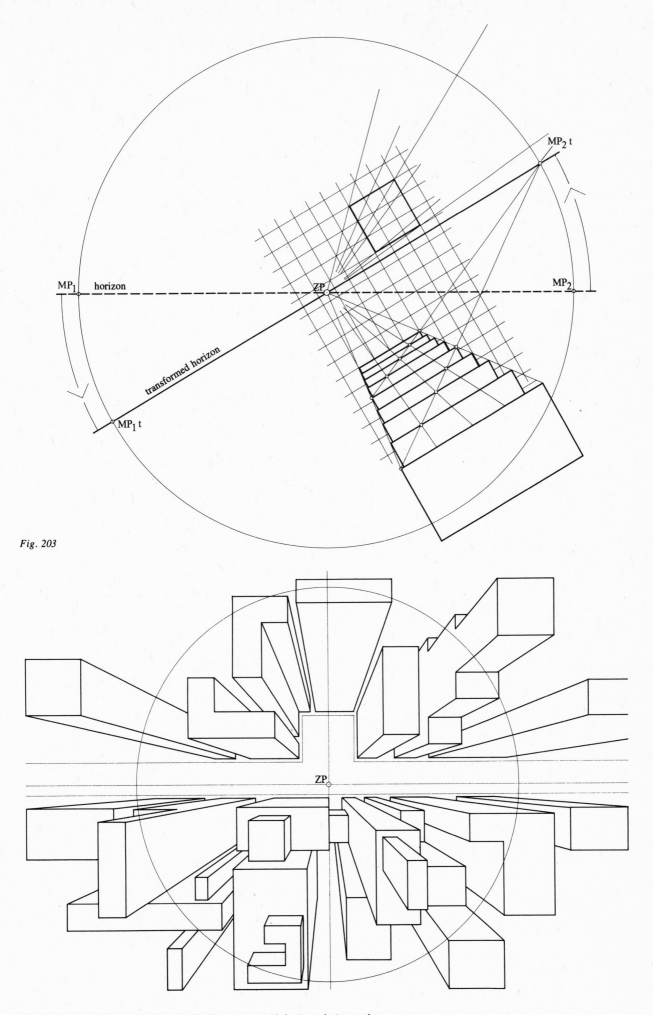

Fig. 203

MP₁ horizon

ZP

MP₂

transformed horizon

MP₁ t

MP₂ t

Fig. 204 *Perspective composition of cuboid structures with horizontal picture plane.*

ZP

115

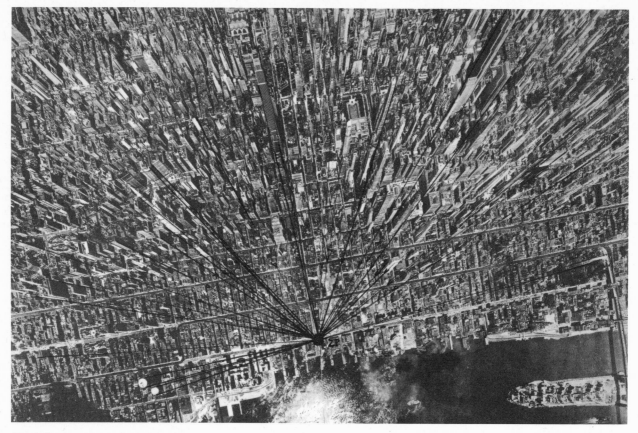

Fig. 205 *Appearance of one-point perspective (New York City).*

the strong impression of perspective created by the many receding lines. We would become even more conscious of these dimensions if we were to add the circle of view to Fig. 205, whose center we know. This would create a picture whose bottom half would consist mainly of the sea, which would not be structured by the receding lines that produce the perspective effect in the top half. This effect could therefore be enhanced in the view of a city entirely consisting of a sea of houses. We realize this if we hold Fig. 205 in front of a mirror so that the sea of houses is duplicated by the reflection, which also duplicates the receding lines of the buildings.

This is not to detract from the quality of the photograph in Fig. 205, whose tension is based partly on the contrast between the sea of houses and the real sea.

Perspective of a Cylindrical Office of a Bank Manager

The optimum view of a cylindrical interior is perhaps obtained only with one-point perspective and a perpendicular visual ray, as shown in Fig. 206. All that need be said about its construction is that its hollow cylinder can be developed from a cuboid of square cross section.

Two-Point Perspective

Cube and Cuboid in the Diagonal Position

The perspective of a cube or cuboid in diagonal position, which produces two vanishing points, is called two-point perspective.

As shown in Fig. 207a, we obtain the diagonal position of a cube or cuboid from its frontal one by rotating it around AE as axis of rotation, which remains stationary, from this position so that its base remains in contact with the ground plane.

At each stage of this rotation the cube or cuboid is in the diagonal position (Fig. 207b).

Looking at the corner A of the cube in Fig. 207b, we find that it is not only the point of intersection of three edges but also that of three faces or sides of the cube.

We must now examine the direction of the edges relative to the picture plane. This reveals that AE is not only in the picture plane but also a height edge of the cube. Like all the other height edges which are parallel to the picture plane, it is not a receding one. This means that the four height edges of the cube do not have a vanishing point at infinity.

But the edges AB and AD would, if sufficiently extended, intersect the picture plane, which makes them receding edges. Because all parallel edges have the same direction, AB and AD represent the depth directions of the cube, which we call TR_1 and TR_2. The extensions of these edges are shown as arrows in Fig. 207b. Each of the two depth directions of the edges of the cube has its own vanishing point, FP_1 or FP_2.

Central Projection of a Building in the Diagonal Position

Figure 208 illustrates the point-by-point production of the linear perspective picture of a building with a saddle roof in the picture plane. By extending the horizontal receding lines so that they intersect the

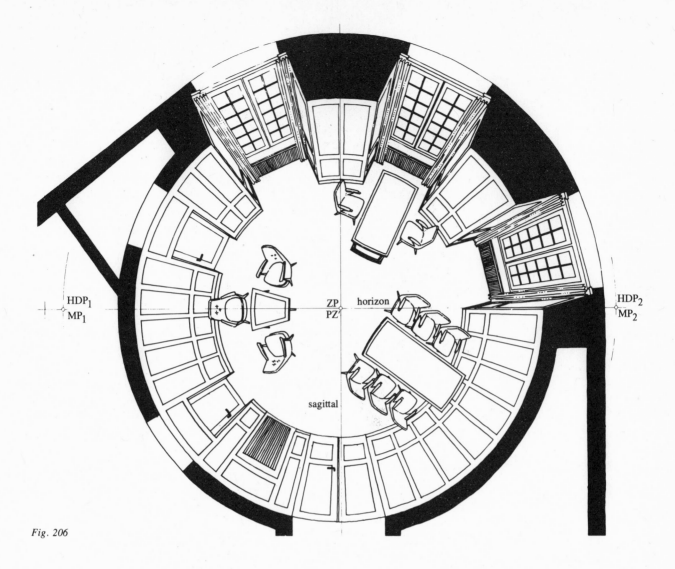

Fig. 206

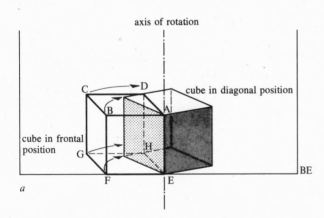

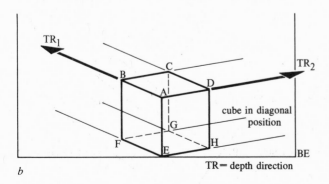

Fig. 207

horizon we obtain their vanishing points FP₁ and FP₂. But we find these points also by drawing the parallel or vanishing rays fs₁ and fs₂ of the depth directions TR₁ and TR₂ of the related horizontal edges of the building from the center of projection. These vanishing rays intersect the horizon and the picture plane in the vanishing points FP₁ and FP₂. The horizontal receding edges of the building, which can be treated as representing the depth directions of its edges, are generated where the visible fronts of the building intersect the ground plane StE. The diagonal position of the building in Fig. 208 becomes obvious when we regard it as having been developed from a cuboid in the diagonal position.

The Vanishing Points FP₁ and FP₂ of a Cuboid in the Diagonal Position in Their Relation to the Circle of View

Figures 209 and 209a show once again how to find the vanishing point of the receding edges of a cuboid in the frontal position, which are normal to the picture plane so that their vanishing point is in the center of perspective. The vanishing point of the horizontal edges, which are parallel to the picture plane, is at infinity.

Comparing Figs. 209 and 210, let us observe how by rotating the cuboid from the frontal into the 117

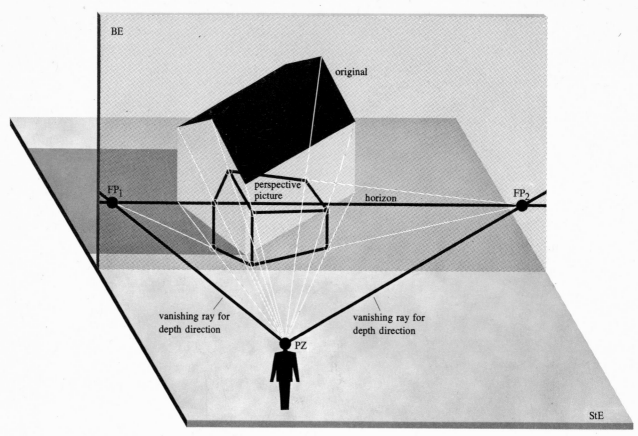

Fig. 208 Central projection of a house in diagonal position.

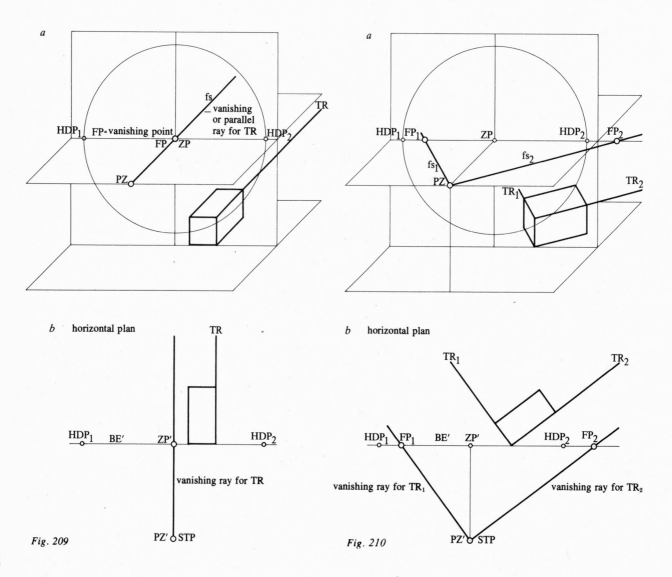

a

fs
_ vanishing
or parallel
ray for TR

TR

HDP₁ FP=vanishing point HDP₂

FP ZP

PZ

b horizontal plan

TR

HDP₁ BE' ZP' HDP₂

vanishing ray for TR

PZ' ○STP

Fig. 209

a

HDP₁ FP₁ ZP HDP₂ FP₂

fs₁ fs₂

PZ TR₁ TR₂

TR₁ TR₂

b horizontal plan

TR₁ TR₂

HDP₁ FP₁ BE' ZP' HDP₂ FP₂

vanishing ray for TR₁ vanishing ray for TR₂

PZ' ○STP

Fig. 210

118

diagonal position we obtain two vanishing points FP_1 and FP_2. One of these is located inside, the other outside the circle of view unless the position of the cuboid is such that the receding edges, which represent the depth directions TR_1 and TR_2, intersect the picture plane at an angle of 45°, in which case the two vanishing points of the cuboid in the diagonal position coincide with HDP_1 and HDP_2.

Construction of FP_1 and FP_2 of a Two-Point Perspective with the Aid of the Circle of View

In the diagonal cube or cuboid in Fig. 211 the receding edges, which can be treated as representing the depth directions of the parallel receding edges, are drawn in bold lines, extended, given arrowheads, and called TR_1 and TR_2. It is important to see the right angle formed by TR_1 and TR_2, whose apex is the corner of the cube from which the receding edges diverge, in view of the right angle formed by the vanishing rays fs_1 and fs_2, which at their intersection with the picture plane establish the vanishing points FP_1 and FP_2. The center of projection is the apex of this right angle, which lies in the horizon plane and is therefore perspectively distorted. However, this distortion can be corrected if the angle is turned into the picture plane as demonstrated in Fig. 212.

Here the procedure of rotating the right angle formed by the vanishing rays fs_1 and fs_2 is shown so that, as the angle is rotated both upwards and downwards, it is represented in an intermediate position. It is irrelevant whether it is rotated upwards or downwards. When it is rotated upwards, its apex, which of course is in the center of projection if it lies

in the horizon plane, will come to lie in the picture plane, where it becomes PZ_1^+. When it is rotated downwards, its apex becomes PZ_2^+. It should be noted that FP_1 and FP_2 remain fixed as the right angle is being rotated.

We can demonstrate the rotation of the right angle by holding a drafting triangle between index finger and thumb in the horizontal initial position so that the apex of its right angle points toward us as an arrow would. This right angle together with the rest of the set square is perspectively distorted. If we move the angle into a vertical position by rotating it 90° upwards or downwards, it and its right angle will appear undistorted. During the rotating action the points of rotation on index finger and thumb remain fixed. They correspond to FP_1 and FP_2 in Fig. 212, which of course also remain fixed as the angle is being rotated.

Figure 213, which shows the rotated right angle in the picture plane, indicates that the apices of these angles come to be either in VDP_1 or in VDP_2. This is significant in that we can draw the vanishing points FP_1 and FP_2 of a two-point perspective from these points. In VDP_1 or VDP_2 the sides of right angles must therefore be constructed with which we intersect the horizon. The resulting points of intersection are FP_1 and FP_2.

In Fig. 214a we must treat FP_1 and FP_2 as points of intersection between the sides of a right angle with its apex at VDP_1 and the horizon. This distortion-corrected right angle in the picture plane is faced by the perspectively distorted right angle with apex A. The distorted and the undistorted right angle each

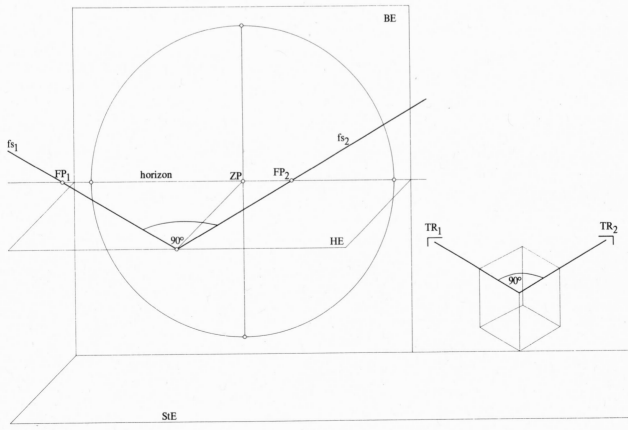

Fig. 211

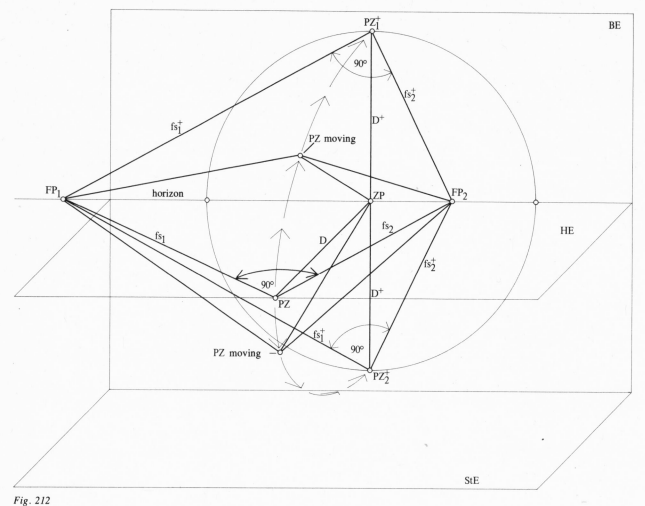

Fig. 212

span a plane whose vanishing line is the horizon.

The corners of the rectangle ABCD (Fig. 214b) in the diagonal position can also be interpreted as apices of right angles in perspective. Although these angles are equivalent, in perspective A and C (seen pictorially and planimetrically) are obtuse and B and D acute angles.

The subject of Figs. 215a and 215b is the construction of a cuboid in the diagonal position from its base plane ABCD. The perpendicular with which we determine the height of the cuboid must be erected at A.

FP_1 and FP_2 of a Two-Point Perspective as Vanishing Points of Normals

The sides of a right angle are normal to each other. Points FP_1 and FP_2, the vanishing points of the sides of a right angle, are therefore called "vanishing points of normals," as shown in Fig. 214a.

The problem of drawing the normal of A–FP_1, whose vanishing point is FP_1, so that it intersects it in A can thus be solved as in Fig. 216. For this purpose vanishing point FP_2 of the normal to FP_1 must be constructed, because all the lines that have their vanishing point in FP_2 are normal to A–FP_1. Conversely, all the lines whose vanishing point is FP_1 are normal to the line whose vanishing point is FP_2. Parts a–d of Fig. 216 show how to proceed with the construction of the normal to A–FP_1.

The Measuring Points in Two-Point Perspective

We have been introduced to the measuring point which we correlate with a given vanishing point and which serves for the perspective distortion and correction of lines and angles as the vanishing point of measure lines.

In two-point perspective there are two measuring points for the vanishing points FP_1 and FP_2. Figures 217 and 218 show how to construct them. Let us begin with the parallel perspective rendering of Fig. 217.

We see the rectangle ABCD in the diagonal position, with A in the picture plane. The sides AB and AD of the rectangle are each divided into three sections of unequal length, which have been turned with their dividing points into the picture plane, where AB and AD and their sections appear in their true dimensions. The rotation with A as the center produces arcs of circles from which measure lines can be constructed. If we draw the vanishing rays of these measure lines from the center of projection, the measuring points MP_1 and MP_2 of the vanishing points FP_1 and FP_2 will be at the intersection of the vanishing rays with the picture plane. But this is not the only method of constructing MP_1 and MP_2.

The intersection with the picture plane of the vanishing rays of the sides AB and AD of the rectangle ABCD produces the vanishing points FP_1 and FP_2 of

120

Fig. 213

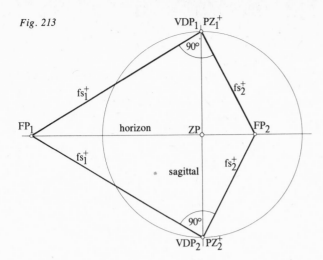

Fig. 214

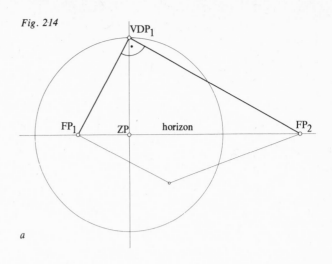

a

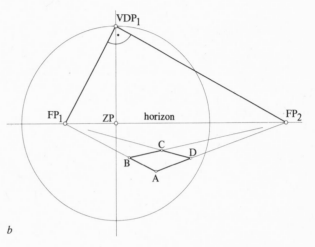

b

Fig. 215

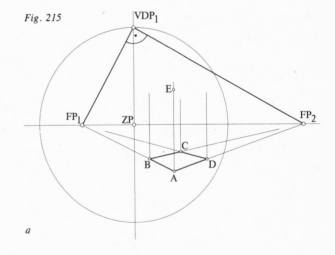

a

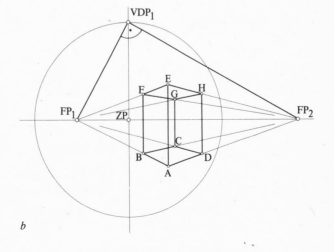

b

these sides. If we now rotate FP₁–PZ on the horizon line into the horizon or into the picture plane, we will obtain the measuring point MP₁ of vanishing point FP₁. Analogously, MP₂ results from rotating FP₂–PZ into the horizon or into the picture plane.

The measuring points of the vanishing points FP₁ and FP₂ can be constructed with a third method, as in Fig. 217: If we rotate the triangle FP₁–PZ–FP₂ around its side FP₂–FP₂ upwards into the picture plane, FP₁–PZ will correspond to FP₁–PZ⁺. It is therefore possible to draw the measuring point of the vanishing point FP₁ also with this line lying in the picture plane in such a way that we can regard it as the radius of an arc of a circle with which to intersect the horizon; this produces the measuring point MP₁. We can also call this operation "rotating the line FP₁–PZ₁⁺ into the horizon." In principle we adopt the same method of determining the measuring point of the vanishing point FP₂: We turn FP₂–PZ₁⁺ into the horizon or describe an arc of a circle of radius FP₂–PZ₁⁺ with which to intersect the horizon.

In Fig. 218 this construction of the measuring points of FP₁ and FP₂ has been represented separately, that is, in conjunction with the circle of view and therefore as it is required for work with the circle of view. In Fig. 218 the vanishing point FP₂ has been joined to PZ₂⁺ instead of to PZ₁⁺ to show that it is unimportant whether FP₁ and FP₂ are joined to PZ₁⁺ or to PZ₂⁺ to construct the measuring points and to obtain the radii of the arcs of circles. From now on we will use the measuring points MP₁ and MP₂ only for the transfer of lines into perspective. The role of these measuring points in perspective distortion and its correction is described in the chapter on inclined planes.

Construction of Squares in the Diagonal Position

Figures 219–221 show that squares in the diagonal position can be drawn in various ways with the aid of the measuring points MP₁ and MP₂. In Fig. 219 the length and width of the square ǍB̊ČĎ to be constructed have been determined on the measure line.

The length and width of the square ǍB̊ČĎ (Fig. 220) were taken from the square ABCD suspended from the axis of rotation.

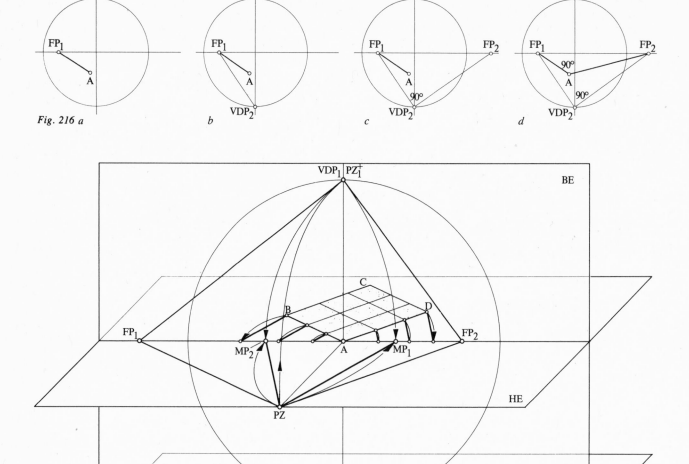

Fig. 216 a b c d

Fig. 217

Figure 221 shows that a square in the diagonal position can be drawn with the aid of its diagonal vanishing points, without its dimensions being determined on the measure line. The square $A\overset{\bullet}{B}\overset{\bullet}{C}\overset{\bullet}{D}$ illustrated has been constructed from the vanishing points DFP_1 and DFP_2 of its two diagonals, although one diagonal vanishing point is enough for the purpose. We find the vanishing point DFP_1 of the diagonal $A\overset{\bullet}{C}$ by bisecting the right angle whose apex is PZ_1^+ and with those sides we determine FP_1 and FP_2. To find the vanishing point DFP_2 of the diagonal $\overset{\bullet}{B}\overset{\bullet}{D}$, we must construct the vanishing point of the normal of DFP_1. The side $A\overset{\bullet}{B}$ of the square, whose length has been chosen at random, has only subsequently been corrected for distortion through the measuring point MP_1.

Construction of a Cuboid in the Diagonal Position

The cuboid in Fig. 222 has been drawn from its base $A\overset{\bullet}{B}\overset{\bullet}{C}\overset{\bullet}{D}$ by the erection of perpendiculars at its corners for the construction of its height edges. The dimension of these height edges must be determined from edge AE, which, of course, lies in the picture plane, because it starts from the measure line for the

length and width constituting a trace of the picture plane. Figure 222 can be regarded as the picture either of a cuboid building or of a cuboid interior. This enables us to draw both in the diagonal position.

Interior in Frontal Perspective with Two Cuboids in the Diagonal Position

The cuboids in the diagonal position in the frontal interior in Fig. 223 have been given random dimensions. The main point of the drawing was the construction of the four vanishing points FP_1, FP_2, FP_3, and FP_4 by means of right angles whose apices are VDP_1 and VDP_2 and whose sides produce these vanishing points by intersecting with the horizon.

Interiors in the Diagonal Position

Before discussing the interior perspectives in Figs. 224–226 individually we must deal with the optical effect of an interior presented in the diagonal position. How does a two-point perspective of an interior differ from a representation in frontal perspective? We obtain the diagonal position of a cuboid by rotating it out of its frontal position. Interiors in the two-point perspective therefore do not have the same

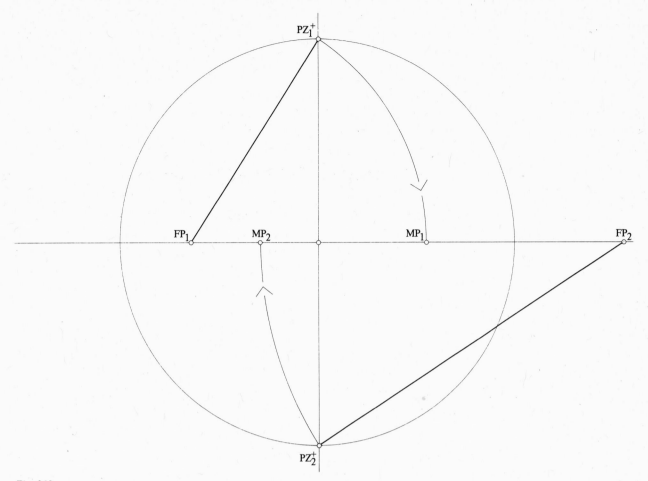

Fig. 218

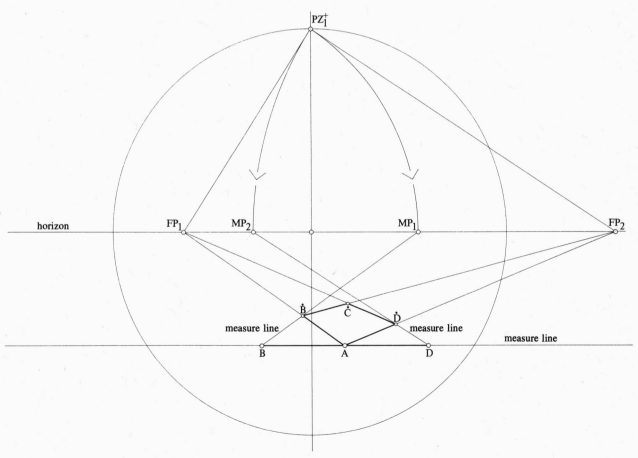

Fig. 219

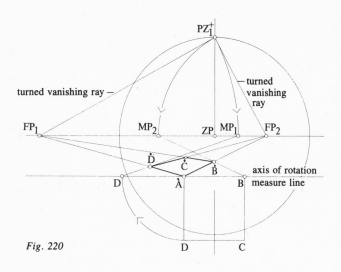

Fig. 220

impact as those in frontal perspective.

Figure 224 demonstrates that the floor and ceiling of an interior in the diagonal position readily create the impression of inclined planes. In the case of the floor this is the result both of its size and of the fact that its corner A is close to the circle of view and therefore outside the 60° sector of the horizon, the zone of least distortion.

The floor in Fig. 224 is a net of squares. Its long dimension has its vanishing point in FP$_2$, its wide dimension in FP$_1$. Consequently the measuring point MP$_2$ of the vanishing point FP$_2$ must be used for the division of the length, and the measuring point MP$_1$ of the vanishing point FP$_1$ for that of the width. The same procedure applies to the division of the wall with the windows: MP$_1$ must be used for its division, through which the dimensions determined on the measure line are translated into perspective. The vertical measure line in Fig. 224 is established when A is joined to Ė. It must be pointed out that the measure line for the division of ĖH can be drawn through Ė, in which case it will be above the horizon.

The floor of the interior in Fig. 225 does not

appear as strongly distorted as that in Fig. 224, because it is located more in the zone of least distortion. The unbiased observer may nevertheless perceive it as an inclined plane owing to the inclination of the lines with which it has been constructed.

The floor in Fig. 225 is the dominant feature because of the cuboid pieces of furniture drawn on it, whereas the ceiling has only been suggested, as it were, and is strongly foreshortened. Therefore, in the interest of a clear view of the furniture in an interior, the floor must always be represented with a sufficiently large scale.

Although we have not yet discussed the inclined plane in two-point perspective, Fig. 225 contains inclined building elements for the construction of stairs; inclined planes are produced by the appropriate connection of points on horizontals.

The horizontal plan of the interior has been drawn as a net of squares in the top right-hand corner of Fig. 225; it has no constructive relation with the perspective of the interior. Its main purpose is to unravel the spatial conditions as far as a horizontal plan can do this at all. The net of squares not only represents the horizontal plan of the tiled floor but also serves to determine the proportions of the furniture and of the building elements.

Figure 226 shows the importance of not distorting the floor too much in the perspective drawing of an interior. In other words, the observer should be able to see the furniture clearly arranged and to gain an impression of the appearance of the various pieces. The real shape of the furniture in Fig. 226 can be conveyed only by vertical plans or cross sections. The three cross sections of the seating accommodation on the measure line provide information about its profile and construction; we see, for instance, that the seats are slightly inclined and therefore represent inclined planes. One cross section would be enough to provide this information; but

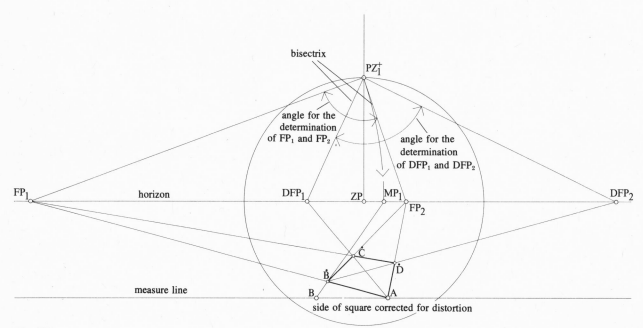

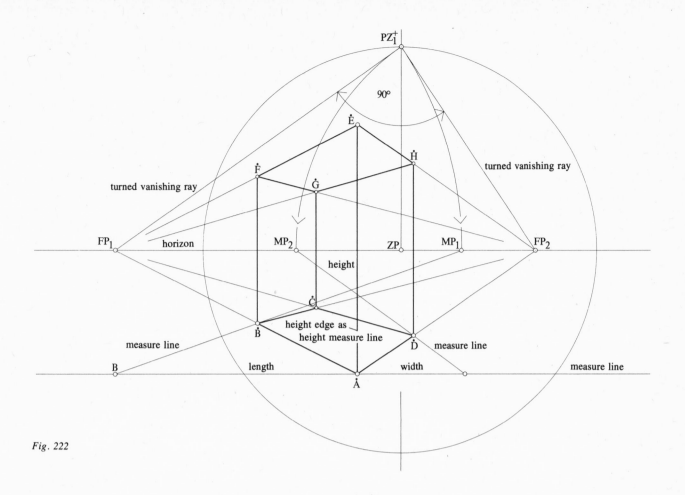

Fig. 222

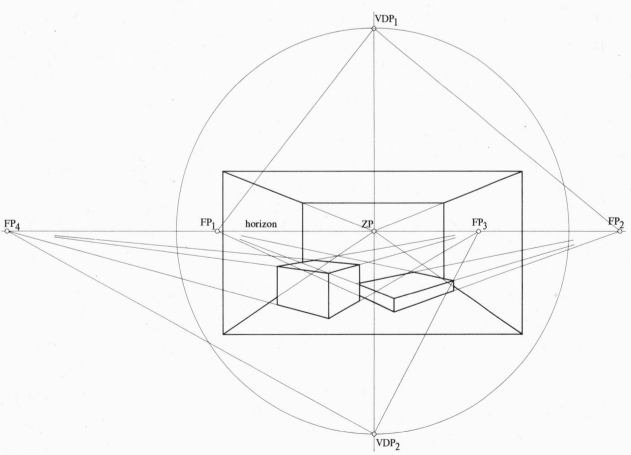

Fig. 223

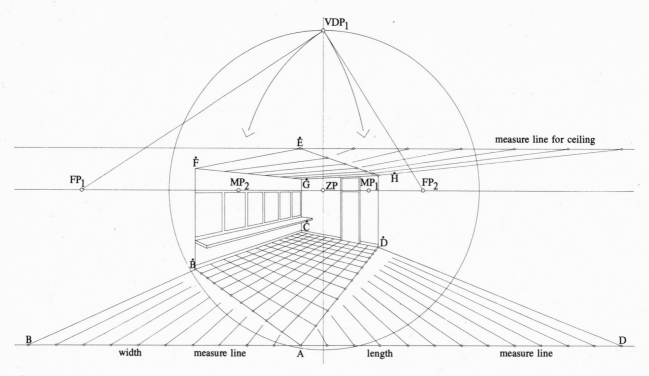

Fig. 224

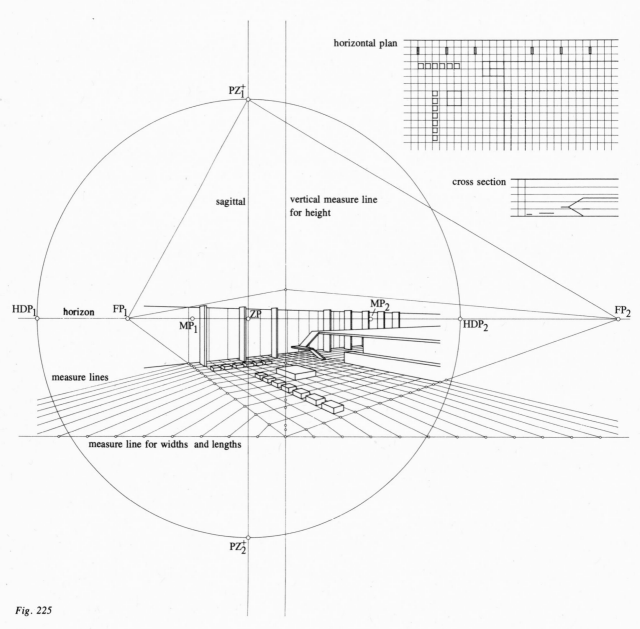

Fig. 225

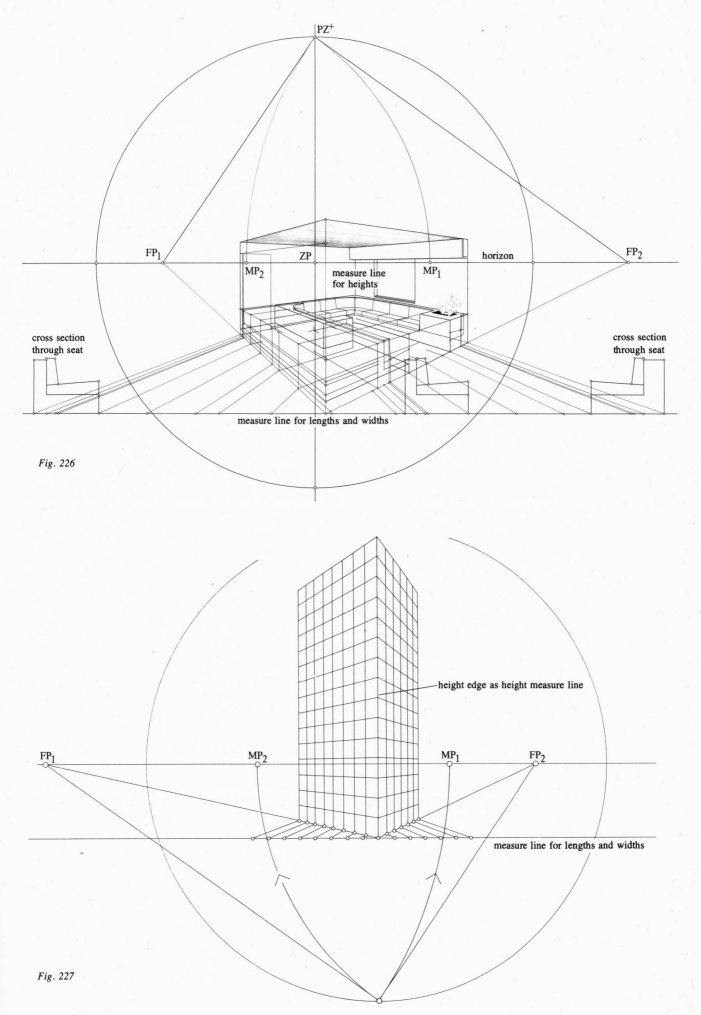

PZ+

FP₁ ZP horizon FP₂

MP₂ MP₁

measure line
for heights

cross section
through seat

cross section
through seat

measure line for lengths and widths

Fig. 226

height edge as height measure line

FP₁ MP₂ MP₁ FP₂

measure line for lengths and widths

Fig. 227

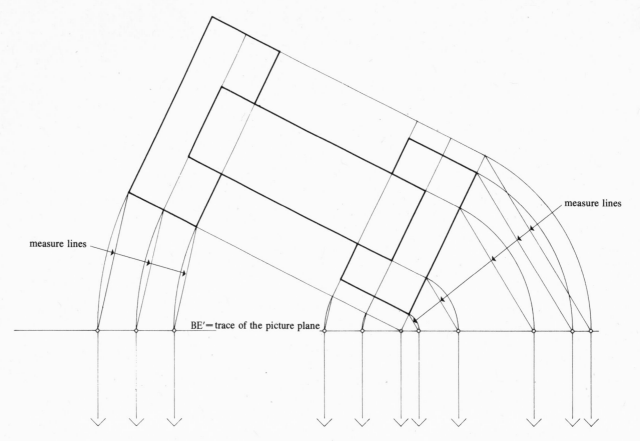

Fig. 228 a

measure lines

measure lines

BE′= trace of the picture plane

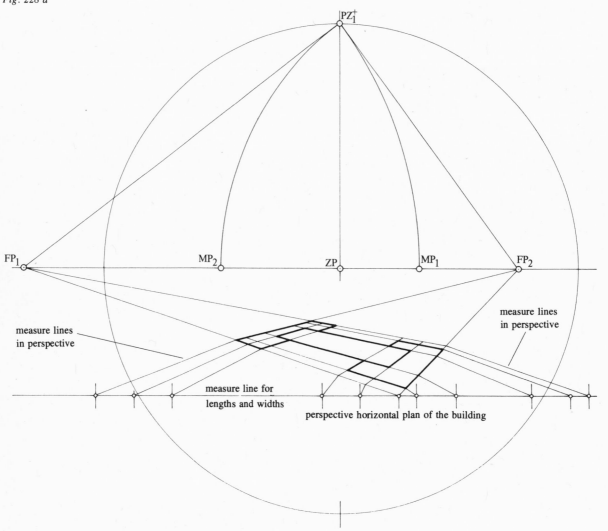

Fig. 228 b

PZ_1^+

FP_1 MP_2 ZP MP_1 FP_2

measure lines
in perspective

measure lines
in perspective

measure line for
lengths and widths

perspective horizontal plan of the building

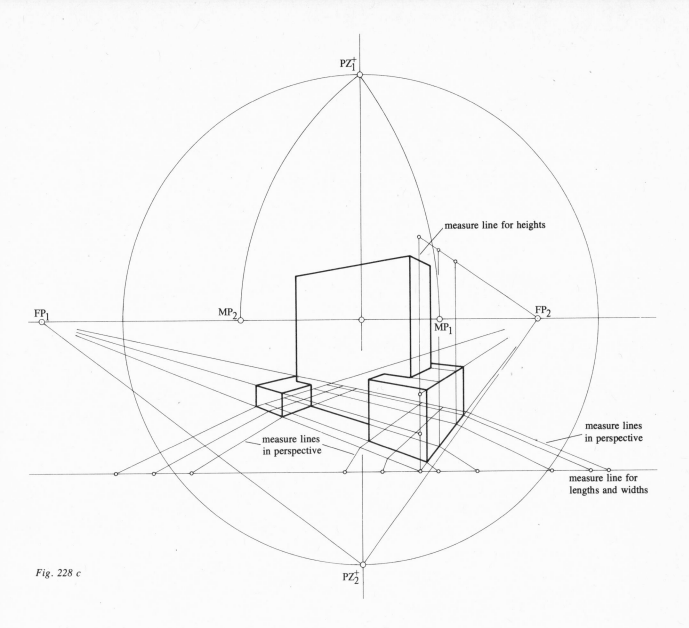

PZ₁⁺ — PZ_1^+

measure line for heights

FP₁ — FP_1

MP₂ — MP_2

MP₁ — MP_1

FP₂ — FP_2

measure lines in perspective

measure lines in perspective

measure lines in perspective

measure line for lengths and widths

PZ₂⁺ — PZ_2^+

Fig. 228 c

three cross sections are necessary for the construction of the perspective picture.

Curved shapes occur in the seating accommodations and in other details in Fig. 226; they are arcs of circles in perspective drawn from circles. Discretion has been used in the drawing of very small curved shapes, which are difficult to construct accurately.

Construction of Buildings in the Diagonal Position

The same methods are used here as for the construction of interiors, which are, naturally, features inseparable from architecture. Our comments on Figs. 227–237 can therefore be brief. The perspective effect of the building in Fig. 227, which has the geometric shape of a cuboid, is based on the fact that the horizon is low in relation to it. Its fronts have been structured from the measure lines through rectangles.

The building consisting of cuboids in Fig. 228 is more complex than that in Fig. 227. Its perspective horizontal plan as shown in Fig. 228b has been drawn partly from the true ground plan of Fig. 228a. Thus the length and width dimensions were first transferred to the trace of the picture plane with arcs

of circles, from which it was possible to construct the measuring lines; from there they were transferred to the measure line of the perspective horizontal plan of Fig. 228b. Thus only the length and width dimensions were taken from the true horizontal for the construction of the horizontal plan in perspective. The perspective was then drawn with the aid of the circle of view. On the vertical measure line (Fig. 228c) the vertical dimensions of the building were marked and translated from there into perspective.

In a perspective picture such as that shown in Fig. 229, the architect wants to present the external appearance of a house. But in the cross sections and horizontal plans, also shown in Fig. 229, he not only determines the dimensions of the building; they also convey information about its internal structure. The drawing of horizontal and vertical plans and profiles also has the added importance of directly providing a perspective picture and therefore the appearance of an object or of a piece of architecture. In Fig. 229 the plans do not have this significance. In other words, they are totally unrelated to the construction of the perspective of the house. Viewed in conjunction with its perspective picture, the plans promote understanding of the building's construction. The

129

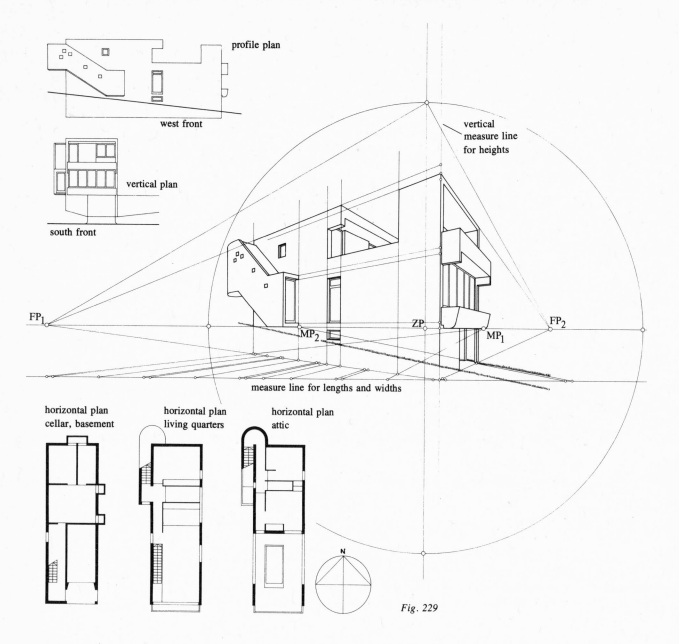

profile plan

west front

vertical plan

south front

vertical
measure line
for heights

FP₁

MP₂

ZP

MP₁

FP₂

measure line for lengths and widths

horizontal plan
cellar, basement

horizontal plan
living quarters

horizontal plan
attic

N

Fig. 229

curved features of this house have been drawn according to the principles applied to the drawing in Fig. 229.

The building structures shown in Fig. 230 are called "mushrooms." The upper portions represent pyramids whose tops are inserted in elongated, truncated pyramids or columns as the vertical plan of a "mushroom" in the top right-hand corner of Fig. 230 confirms. The first "mushroom" was developed from a cuboid. The perspective profile of the pyramid has been drawn on the left side of the cuboid, from which it was possible to develop the pyramid itself.

At first glance the building in Fig. 231 seems to have been drawn in frontal instead of in two-point perspective. This is due to the fact that the vanishing point FP₂ lies far outside the circle of view, and as a result FP₁ is near the center of perspective.

Figure 232 shows the perspective of a large city; the vertical edges of the cuboid tall buildings appear perpendicular and therefore have their vanishing points at infinity. This perspective picture (of Sydney, Australia) is characterized by the frontal and diagonal position of its architectural features.

The 60° Field of View as the Zone of Least Distortion within the 90° Field of View

The perspective distortion of objects reproduced within the circle of view increases with their distance from the center of perspective. A zone can be drawn within which such objects appear less distorted (Fig. 233). The 60° and the 90° fields of view are sectors of concentric circles. The 60° field is drawn within the 90° field as follows: A 60° angle is constructed, with its apex either at PZ_1^+ or PZ_2^+, so that it is bisected by the sagittal. The horizon is intersected with the sides of the angle, which produces A and B and thereby the radii A–ZP and B–ZP of the 60° field of view.

The Vanishing Lines of the Sides of a Cube or of a Cuboid in the Diagonal Position

As we say of parallel lines that they have the same direction, we can say of parallel planes that they have the same position. Of the six sides of the cube in the diagonal position as represented on the horizontal plane in Fig. 234, two each are parallel or have the same position. The sides A, B, and Γ of the cube in the same position in Fig. 234 represent the

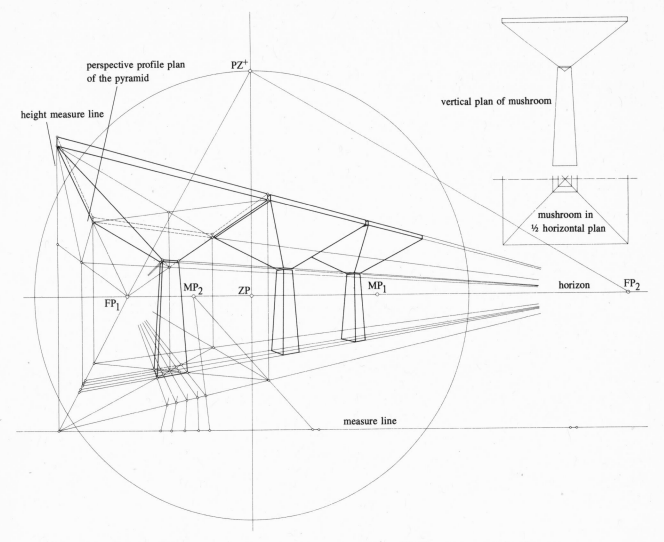

perspective profile plan
of the pyramid

height measure line

PZ⁺

vertical plan of mushroom

mushroom in
½ horizontal plan

FP₁ MP₂ ZP MP₁ horizon FP₂

measure line

Fig. 230 Use of the measuring point construction in the perspective representation of building elements called mushrooms.

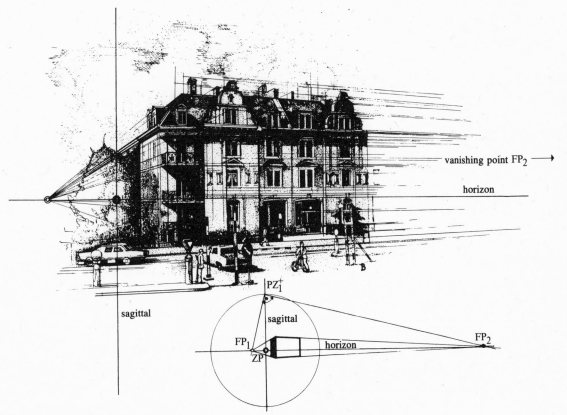

vanishing point FP₂ ⟶

horizon

sagittal

PZ₁⁺

sagittal

FP₁ horizon FP₂

ZP

Fig. 231 House in Weinbergstrasse, Zurich.

131

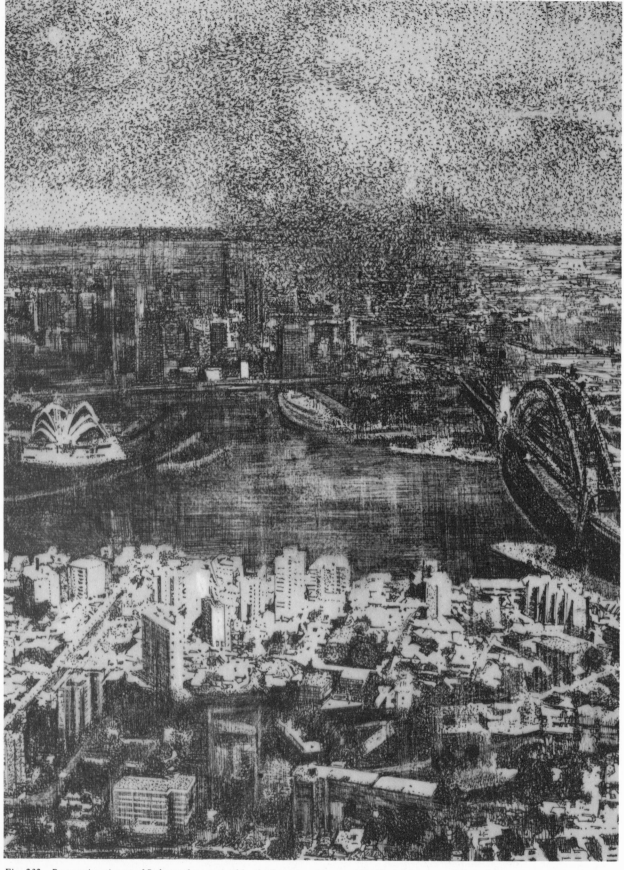

Fig. 232 Perspective picture of Sydney, characterized by the frontal position, and the diagonal aspect of the architecture.

sides constituting receding planes or planes which if extended would intersect the picture plane. Therefore no sides of the cube or cuboid in the diagonal position are parallel to the picture plane.

We find the vanishing lines of the sides A, B, and Γ by drawing their vanishing planes through the center of projection. They intersect the picture plane in the vanishing lines of the sides of the cube.

The vanishing plane of the top plane A of the cube is the horizon plane. The horizon is thus the vanishing line of the top and base planes of the cube or cuboid in the diagonal position. The vanishing lines of the sides B and Γ pass vertically through FP_1 and FP_2, respectively.

Let us now consider the eight corners of the cube and the center of projection, where three planes intersect in a point, for instance, in the corner of a room. What occurs in all the eight corners of the

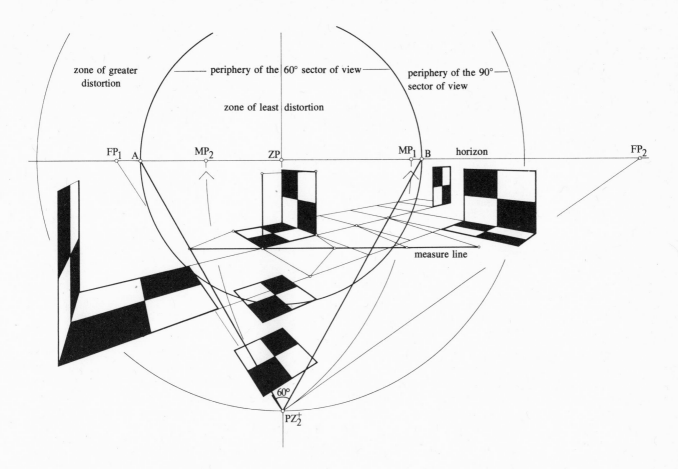

*Fig. 233 Horizontal and vertical squares in the 60° and in the 90°
sector of view or in the zone of lesser and greater distortion.*

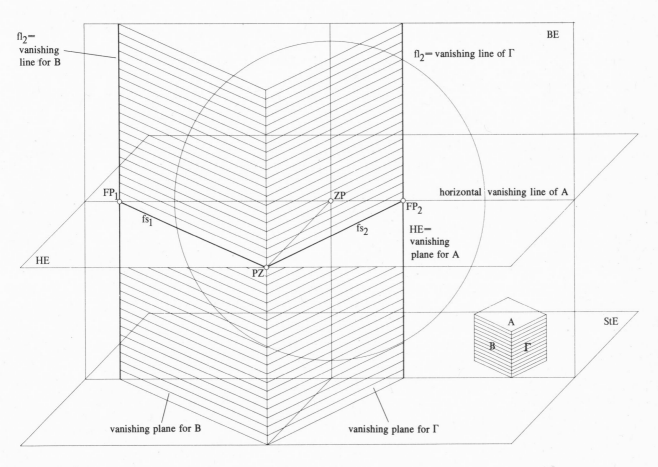

Fig. 234

133

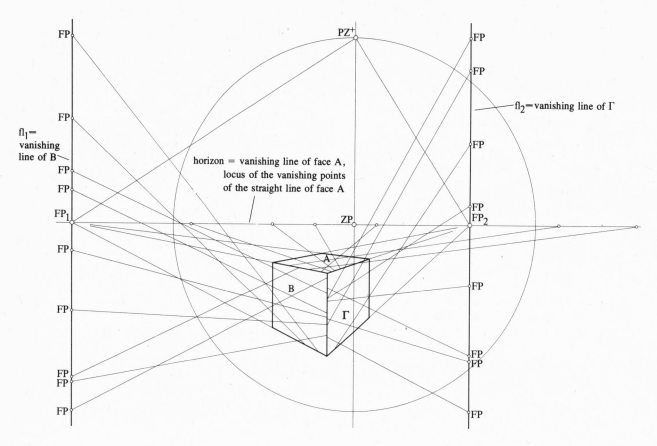

FP

PZ⁺

FP

FP

fl₂ = vanishing line of Γ

FP

FP₁

fl₁ =
vanishing
line of B

FP

FP

horizon = vanishing line of face A,
locus of the vanishing points
of the straight line of face A

ZP

FP
FP₂

FP

A

B

Γ

FP

FP

FP

FP
FP

FP
FP

FP

FP

Fig. 235 The faces of the cube and cuboid as fields of rays and straight lines. The vanishing lines of the faces are the loci of the vanishing points of the related rays.

cube, the intersection of three sides in each of them, is repeated in PZ, which we regard as the point of intersection of the three vanishing planes. Lastly, attention is drawn to the vanishing rays of the receding edges of the cube in diagonal position fs₁ and fs₂, which we can also regard as lines of intersection between the vanishing planes and the horizon plane.

Figure 235 interprets the sides A, B, and Γ of the cube in the diagonal position as fields of rays whose vanishing lines fl₁ and fl₂ are the loci of the vanishing points of these rays. Except for the horizontal all lines of side A have their vanishing points on the vanishing line of the horizon. Except for the vertical all lines of side B have their vanishing points on the vanishing line fl₁. The vanishing points of the lines of side Γ lie on the vanishing line fl₂ unless they are vertical.

In Fig. 236 fl₁ and fl₂ are the vanishing lines of planes A and B, which are normal to each other. These planes are shown as fields of horizontals, whose vanishing points are FP₁ and FP₂. The vanishing point of the horizontal of one plane accordingly corresponds to the vanishing point of the normal of the horizontal of the other plane. As we are able to construct the vanishing point of the normal for a given vanishing point, so we can draw, to a given vanishing line of plane 1, the vanishing line of plane 2, which is normal to plane 1. This is true because if we know the one vanishing point, we can find the one vanishing line using a vertical through this vanishing point, for which the vanishing point of the normal is to be found. The vertical through this point is the required vanishing line. We are now able to draw the two planes normal to each other.

Two-Point Perspective of a Cube or of a Cuboid Tilted Forward or Backward from the Frontal Position

Figure 237 shows that if we tilt a cube or cuboid in the frontal position around its rear bottom edge, which is parallel to the picture plane, it will be in a sloping position. It can be tilted forward only around its front bottom edge. In either case the relevant edge becomes the axis of rotation, and the cube or cuboid assumes a position that results in a two-point perspective.

Four edges of the cuboid in Fig. 237 are parallel to the picture plane. Their vanishing point is at infinity. The other eight edges have the receding directions TR₁ and TR₂. The vanishing rays of these receding directions produce the vanishing points FP₁ and FP₂ through their intersection with the picture plane. The right angle formed by these rays can be rotated into the picture plane, where it appears corrected for distortion.

The sides intersecting in E in Fig. 237 are the receding sides of the cuboid. Side AEHD is vertical. The sagittal plane is its vanishing plane, and the sagittal line its vanishing line. The vanishing planes of EFGH and ABFE are hatched in Fig. 237.

The intersection of these vanishing planes with the picture plane produces the vanishing lines of the hatched sides of the cuboid, which pass horizontally through FP₁ and FP₂. This should explain the perspective construction of the cuboid (Fig. 237).

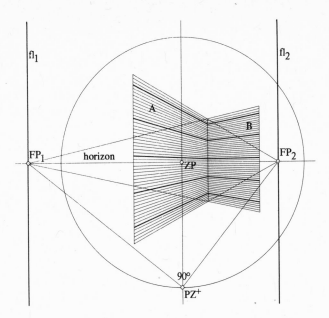

Fig. 236 fl₁ and fl₂ as vanishing lines of planes normal to each other.

Figures 238 and 239 demonstrate that this construction can also be understood through the transformation of the horizon of a perspective in which the cuboid is presented in the diagonal position. The perspective picture in Fig. 238 is thus explained by the 90° clockwise transformation of its horizon (Fig. 239). According to Fig. 237 the cuboid appears tilted backward. But by transforming the horizon in Fig. 239 counterclockwise through 90° we obtain the perspective picture of the cuboid tilted forward, as it also appears from the transformation of the horizon in Fig. 238 through 180°. There is therefore no basic

difference between the perspective drawing of a cuboid in the diagonal position and of one tilted from the frontal position.

Buildings in a Landscape with Trees

By tilting a frontal cuboid around its front edge we obtain the position from which the buildings in Fig. 240 are constructed. But these must be drawn in the context of the landscape, whose structure can be developed from basic geometric forms, for instance, by the representation of areas initially as planes, and the random introduction of irregular features, such as dips and hills, at a later stage. The area of the buildings in Fig. 240 can be compared to a riverbed or a canal. The bed of the "canal" on which the buildings stand, too, is initially treated as a plane, whose vanishing line passes horizontally through FP₁.

The banks of the canal are accordingly drawn as inclined planes. Hatching can be varied with the steepness of the banks. The figures and trees in Fig. 240 must be rendered so that their axes have their vanishing point in FP₂, for all the lines which converge in FP₂ are normal to the planes whose vanishing line is fl₂.

In the drawing of buildings in a landscape the latter should generally be the framework with which the buildings are integrated, for only the relation of the buildings with the surrounding landscape produces an organic whole which in perspective dominates the details.

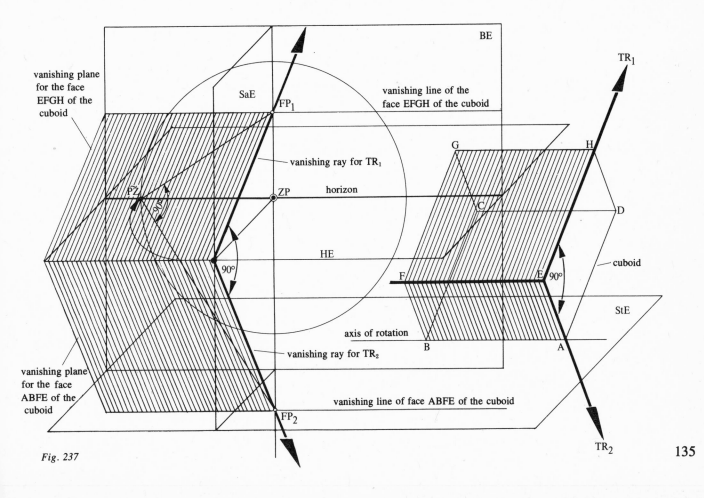

Fig. 237

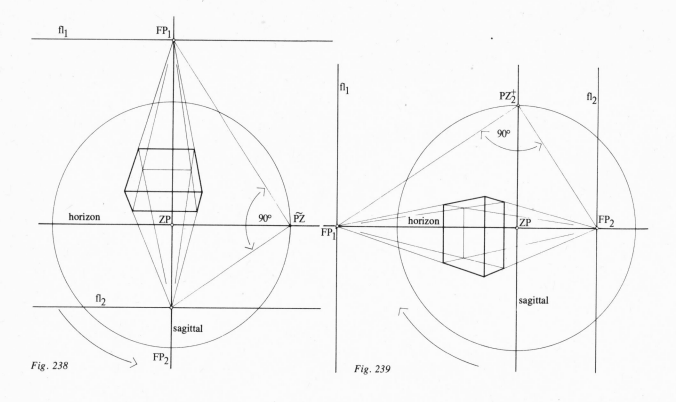

Fig. 238

Fig. 239

Perspective of the Four Inclined Diagonal Planes of the Cube in the Diagonal Position

Two of the six diagonal planes of the cube are vertical. The other four are inclined planes whose position is determined from the edges of the diagonal cube. But we also see the diagonal planes of the diagonal cube as inclined planes of diagonal ramps forming an angle of 45° with their base planes. Let us call the angle of inclination of the diagonal plane AFGD of the diagonal cube in Fig. 241 α. The vanishing plane of this plane produces its vanishing line f_1 on the picture plane of the perspective model. Because two intersecting lines produce a plane, the vanishing plane of the inclined ramp plane AFGD can also be interpreted as a plane produced by two intersecting lines, which are the vanishing rays of the sides AD and AF of the inclined ramp plane AFGD. Their intersection with the picture plane produces the vanishing points FP$_2$ and FP$_3$. The vanishing line of AFGD is shown to be also the connection between FP$_2$ and FP$_3$. If we know the vanishing points of two straight lines in a plane, we can therefore determine the vanishing line of this plane also by joining these vanishing points.

The vanishing plane of the inclined ramp plane AFGD forms the angle $\alpha = 45°$ with the horizon plane. To correct it for distortion, we rotate the triangle FP$_1$–PZ–FP$_3$, of which it is part, into the picture plane with FP$_1$ and FP$_2$ as axis of rotation, so that α becomes $\tilde{\alpha} = \alpha$ rotated or corrected for distortion. The apex of the angle $\tilde{\alpha}$ lies in \widetilde{PZ}, the center of projection rotated into the picture plane. We can therefore draw the angle of inclination of a plane using the measuring point of the vanishing point of its horizontal side. Point FP$_1$ is the vanishing point of the horizontal side of the angle α. The plane AFGD

ascends and is rendered in perspective in Fig. 243, with $\tilde{\alpha}$ above the horizon.

Figure 242 illustrates the generation of the vanishing line of the descending diagonal plane of the diagonal cube. The angle β is corrected for distortion by rotating the triangle FP$_1$–PZ–FP$_3$ into the picture plane, where the apex of the corrected angle β coincides, as in the preceding example, with the measuring point MP$_1$. Angle $\widetilde{\beta}$ is now below the horizon. The vanishing line of the inclined ramp plane EHCB is the connection between FP$_2$ and FP$_3$.

The following point should be noted in Fig. 243: An arc of a circle of radius FP$_1$–PZ$_1^+$ can be used for the construction not only of the measuring point MP$_1$ but also of FP$_3$, the vanishing point of the inclined side of the distortion-corrected angle of inclination α, through which also passes the vanishing line of the diagonal plane AFGD. We can analogously draw the measuring point MP$_1$ for the construction of the distortion-corrected angle of inclination β and of the vanishing point FP$_4$ by means of an arc of radius FP$_1$–PZ$_2^+$. Points MP$_1$, FP$_3$, and FP$_4$ can thus be formed with a semicircular arc corresponding to the Thales semicircle of diameter FP$_3$–FP$_4$. According to Thales' theorem angles inscribed in a semicircle measure 90°. Angles $\tilde{\alpha}$ and $\widetilde{\beta}$ add up to such an angle. The horizon bisects the peripheral angle of 90° over diameter FP$_3$–FP$_4$ into the two 45° angles $\tilde{\alpha}$ and $\widetilde{\beta}$. Figure 244, too, should be considered from this viewpoint: The semicircle of radius FP$_2$–PZ$_1^+$ or FP$_2$–PZ$_2^+$ was drawn with center FP$_2$. Its intersection with the horizon produces MP$_2$. Its intersection with the vanishing line passing vertically through FP$_2$ produces the vanishing points FP$_3$ and FP$_4$, with which the diagonal planes ABGH and EFCG are constructed.

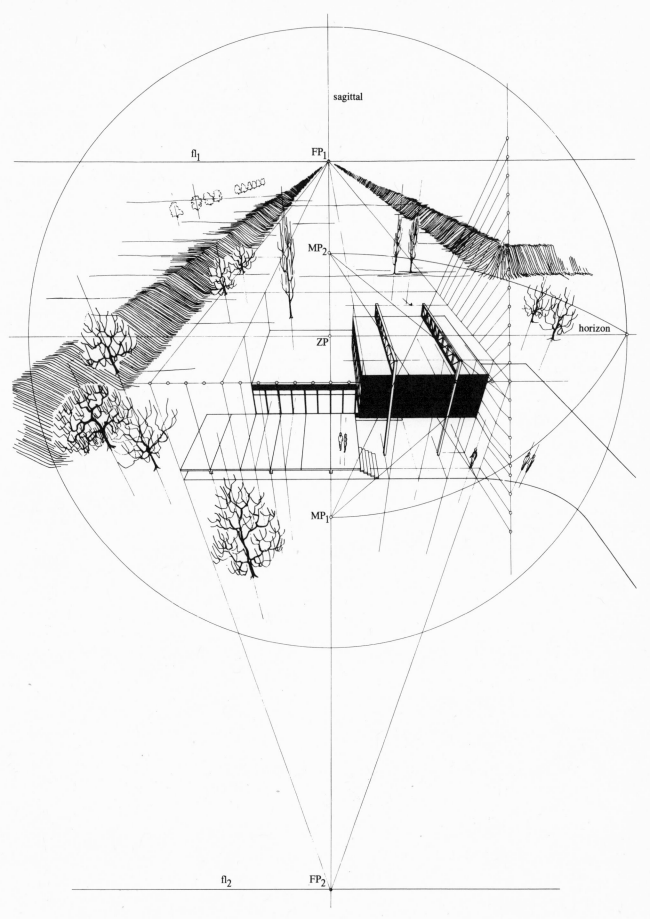

Fig. 240

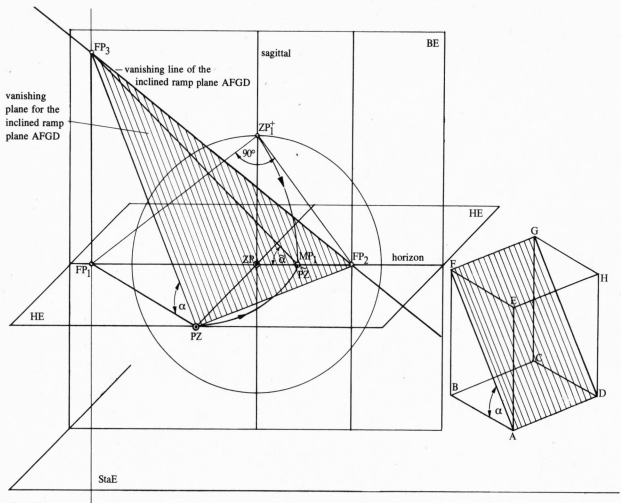

Fig. 241

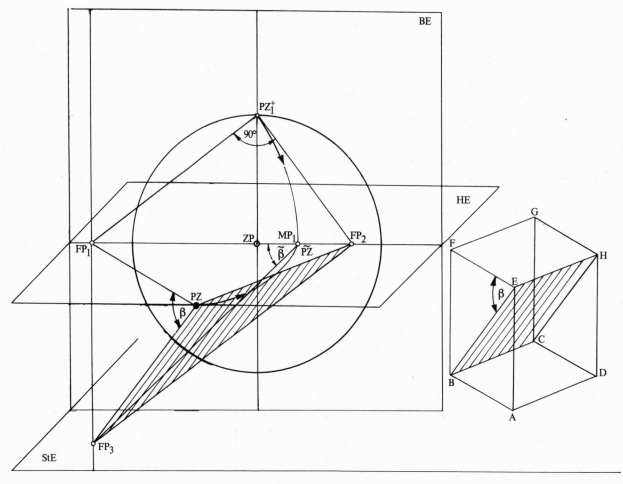

Fig. 242

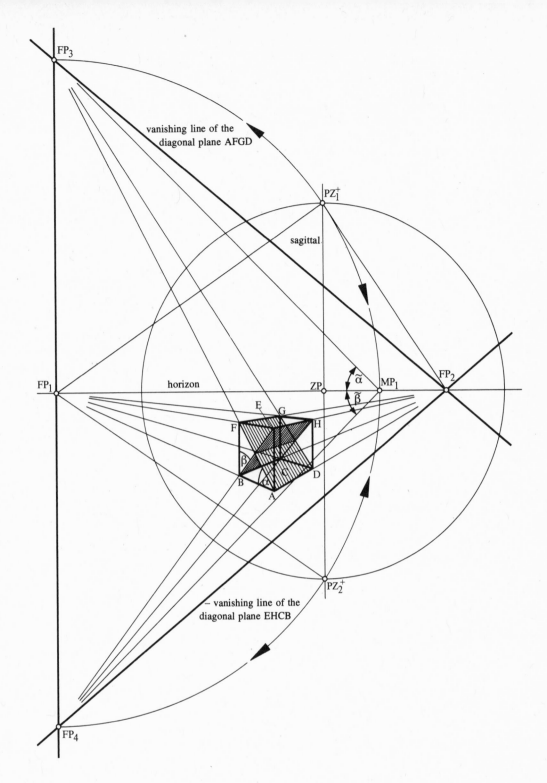

Fig. 243

Construction of a Cube Tilted from Its Frontal Position

The perspective of Fig. 245, which represents the cube tilted forward from its frontal position, is explained by the counter-clockwise 90° transformation of the horizon in Fig. 244. In other words, the construction in Fig. 245 is the same as in Fig. 244.

The cube in Fig. 245 has been constructed with the aid of the diagonals of its sides EFGH and ABFE. The diagonals of side EFGH have their vanishing points in DFP_1 and DFP_2, those of side ABFE in DFP_3 and DFP_4. We obtain these vanishing points with circular arcs of radii FP_1–HDP_1 and FP_2–HDP_2 or FP_2–HDP_1. The intersections of the arcs with the vanishing lines of sides EFGH and ABFE, which

pass horizontally through FP_1 and FP_2, produce the vanishing points DFP_1, DFP_2, DFP_3, and DFP_4.

Construction of the Line of Intersection between Inclined Planes

This construction is important because the line of intersection of two planes contains all the points common to them. In descriptive geometry the line of intersection of two planes is determined with the aid of their traces and their height lines; the height lines of both planes must be at the same level. To find the line of intersection of two planes, the point of intersection of the traces of these planes must be joined to the point of intersection of the height lines at the same level. We could use this method also in perspective (Fig. 246). But this illustration shows in 139

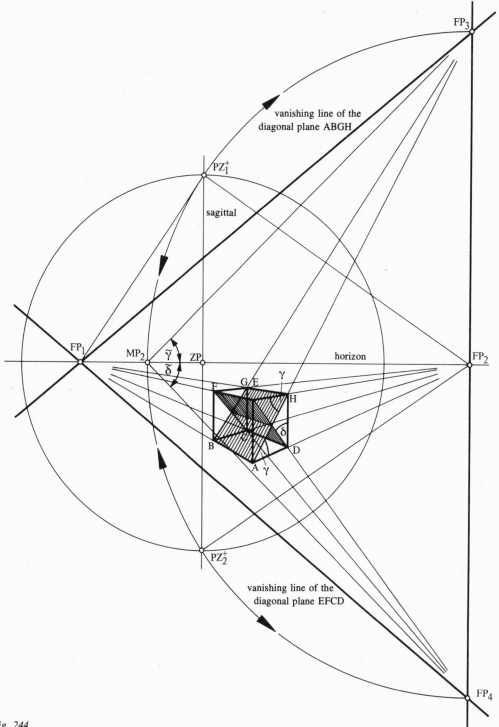

Fig. 244

addition how to construct the line of intersection in perspective by joining the point of intersection of the traces to that of the vanishing lines of the intersecting planes. However, the already mentioned rules for the construction of intersecting lines of planes become clear only when we are familiar with the nature of traces and height lines of planes; therefore this is briefly described.

Traces and height lines of planes must in turn be treated as intersecting lines of inclined or vertical planes with horizontal planes, as shown in Fig. 246. Here the cube with corners ABCD and EFGH with the inclined diagonal planes Φ and Ψ is represented in the frontal position. The intersections of Φ and Ψ with the base as a horizontal plane produce the traces of these planes. Height lines of planes are parallel to

these traces. The edge GH of the cube in Fig. 246 can thus be interpreted as the height line of the plane Φ and edge FG correspondingly as that of the plane Ψ. The edges HG and FG of the cube Fig. 246 to be interpreted as height lines can be treated as intersections of Φ and Ψ with its horizontal top plane. Corner A of the cube thus becomes the intersection point of the traces, and corner G that of the height lines of Φ and Ψ at the same level. The line of intersection of Φ and Ψ therefore results from the connection of A and G or that of the intersection points of the traces and of the height lines of the associated planes. But Fig. 246 also demonstrates that in perspective we arrive at the same result of finding the line of intersection of planes by joining the intersection point of their traces to that of the

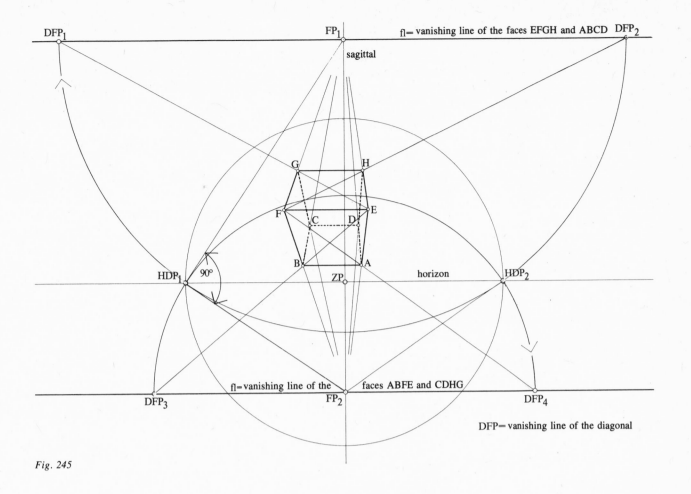

DFP₁ FP₁ fl= vanishing line of the faces EFGH and ABCD DFP₂

sagittal

G H

F E

C D

B A

HDP₁ 90° ZP horizon HDP₂

fl= vanishing line of the faces ABFE and CDHG

DFP₃ FP₂ DFP₄

DFP= vanishing line of the diagonal

Fig. 245

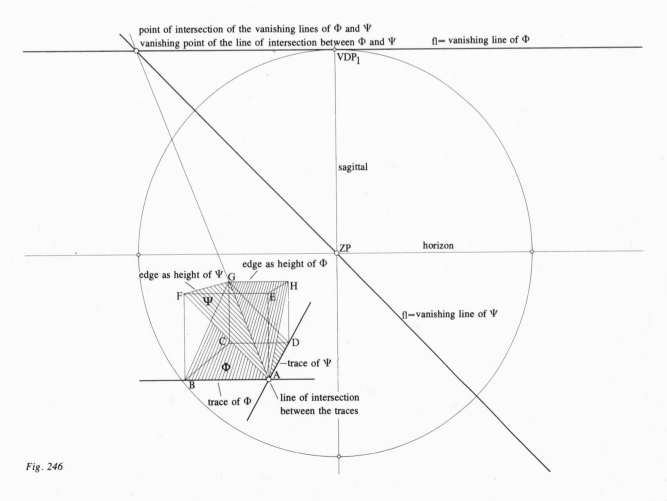

point of intersection of the vanishing lines of Φ and Ψ
vanishing point of the line of intersection between Φ and Ψ fl= vanishing line of Φ

VDP₁

sagittal

ZP horizon

edge as height of Φ

edge as height of Ψ G H

F Ψ E

fl= vanishing line of Ψ

C D

Φ

trace of Ψ

B A

trace of Φ

line of intersection
between the traces

Fig. 246

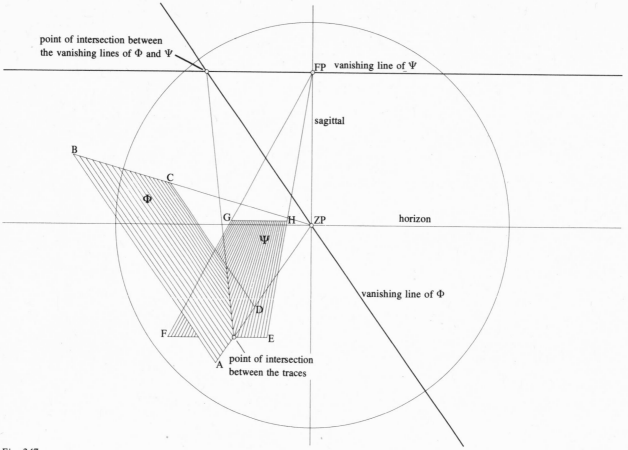

Fig. 247

vanishing lines of the planes. This rule has been applied to Figs. 247 and 248.

The vanishing line of the plane results from joining the vanishing points of the lines that enclose this plane. But Fig. 247 shows that the sides AB and AD, which enclose the plane Φ, and the sides EF and HG, which enclose the plane Ψ, each produce only one vanishing point on the vanishing lines of these planes, because sides AB and DC of plane Φ and sides EF and HG of plane Ψ have their vanishing points at infinity.

The angles of inclination of intersecting planes can either be predetermined or found at a later stage if they were drawn at random. The angle of inclination of plane Φ is thus formed by a horizontal ray proceeding to the left from A. We find the angle of inclination of plane Ψ by joining FP to HDP_1 or HDP_2.

Unlike the sides of the planes in Fig. 247, those which enclose the planes Φ and Ψ in Fig. 248 have their vanishing points on the vanishing lines of these planes. Let us look first at plane Φ. It is spanned by its trace or side AB and side AD. The vanishing point of AB is FP_1. Point FP_5 is the vanishing point of AD. By joining FP_1 to FP_5 we obtain the vanishing line of Φ.

The plane Ψ is correspondingly spanned by its trace or side F_1 and side FG. By joining their vanishing points FP_4 and FP_6 we obtain the vanishing line of plane Ψ.

It is advisable to draw the intersecting planes in conjunction with ramps, as in Fig. 24, to define their position.

The vertical right triangle ADE of the ramp with the inclined plane Φ is called the supporting triangle. Its vanishing line passes vertically through FP_2, the vanishing point of its side AE, which can be considered the perspective horizontal plan of its hypotenuse AD. Its vertical side DE indicates the height of the side CD of the inclined ramp plane above the base.

A closer look at the hypotenuse of the supporting triangle ADE reveals that this is the vanishing line between ADE and the inclined ramp plane Φ. Therefore FP_5 is the vanishing point of a line that belongs both to the vertical plane of the supporting triangle and to the inclined plane Φ.

Let us consider the supporting triangle of plane Ψ from the same aspect as that of plane Φ, whose vanishing line passes vertically through FP_3. In the construction of the line of intersection of two planes we must pay attention to what is called "visibility"; that is, we must look at the parts of the planes that remain visible and at those that become obscured. The rule governing the construction of the line of intersection of two planes—joining the intersection point of their traces to that of their vanishing lines—also enables us to solve the problem of drawing the lines of intersection of three and more planes. Here it must be kept in mind that three planes intersect in one point, for instance, in the corner of a tetrahedron or in the corner of a room.

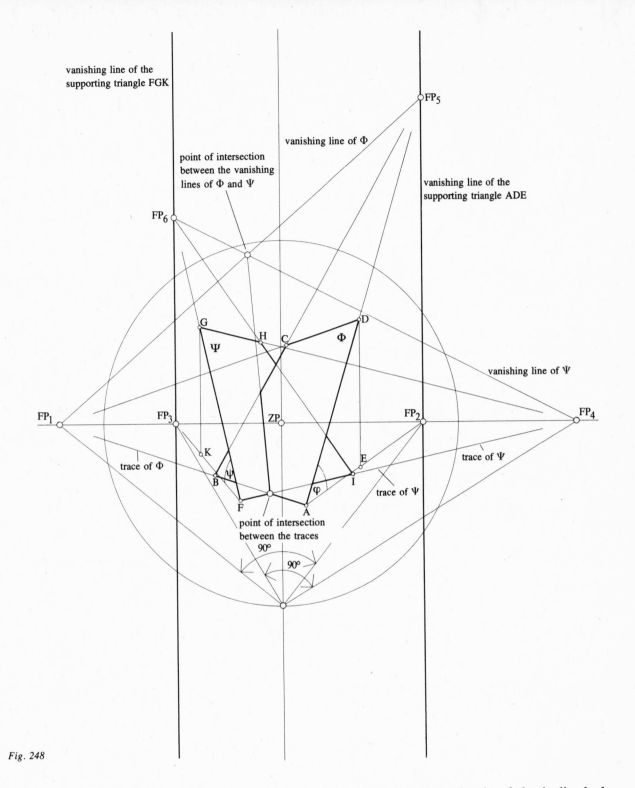

vanishing line of the
supporting triangle FGK

point of intersection
between the vanishing
lines of Φ and Ψ

vanishing line of Φ

FP₅

vanishing line of the
supporting triangle ADE

FP₆

vanishing line of Ψ

G H C Φ D

Ψ

FP₁ FP₃ ZP FP₂ FP₄

K E

trace of Φ trace of Ψ

B ψ I trace of Ψ

F φ A

point of intersection
between the traces
90°

90°

Fig. 248

Constructions with Auxiliary Horizons

*Drawing a Square as an Inclined Plane of a Ramp in
the Diagonal Position*

We recommend the drawing of inclined planes to
define their positions in conjunction with a ramp.
This was not possible in Fig. 249 because the square
of the inclined ramp plane, instead of being given,
had to be found or drawn; only when we have found
this square can we draw the ramp in conjunction with
it.

We are nevertheless able to construct as a first step
the structure A–B–FP₃–FP₂ (Fig. 249), to define the
position of the square to be drawn; it is a ramp in the
diagonal position. The triangle A–B–FP₃ is its in-
clined plane in perspective and the triangle A–FP₂–

FP₃ the supporting triangle of the inclined plane
A–B–FP₃. We obtain its vanishing line with a verti-
cal line drawn through FP₂.

To construct the square ABCD, we determine A
on the measure line from which we mark off the
width of the square. To draw the side AD, the height
of the square, an auxiliary horizon and accordingly
an auxiliary sagittal must be introduced.

Every straight line that passes through the center
of perspective can be regarded as an auxiliary hori-
zon, to which the auxiliary sagittal is related; this
obviously must also pass through the center of per-
spective and be normal to the auxiliary horizon.
Every auxiliary horizon can be treated as a trans-
formed horizon, and every auxiliary sagittal as a
transformed sagittal.

143

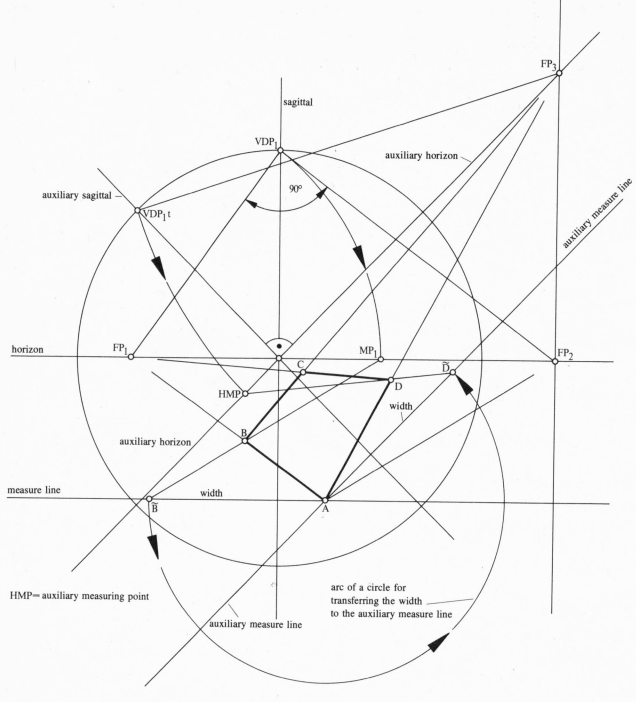

Fig. 249

In Fig. 249 we obtain the auxiliary horizon from a line drawn through FP_3 and the center of perspective. The auxiliary sagittal, which we require for the construction of the auxiliary measuring point HMP for the vanishing point FP_3, is a normal to the auxiliary horizon passing through the center of perspective. The intersection between the auxiliary sagittal and the circle of the horizon produces the point VDP_1 t, the transformed horizontal distance point 1.

The auxiliary measuring point to be drawn, HMP, is the point of intersection between an arc of a circle of radius FP_3–VDP_1 described around FP_3 and the auxiliary horizon.

To determine the side AD of the square, we require the auxiliary measure line, which we draw parallel to the auxiliary horizon through A. The

width of the square to be constructed can now be transferred from A through an arc of a circle, whose intersection with the auxiliary measure line produces \tilde{D}. The connection of \tilde{D} and HMP produces corner D of the square in its intersection with A–FP_3; from here its corner C can be determined.

In the solution of the problem of drawing the lid lifted from a box in a diagonal position as an inclined plane (Fig. 250), the construction described in conjunction with Fig. 249 is used even when the lid of the box is not square. Its width is determined on the measure line as $\tilde{A}D$; from here it is transferred to the auxiliary measure line to become $D\tilde{F}$. With the aid of the auxiliary measuring point HMP we can draw the line DF in perspective by joining \tilde{F} to HMP. The intersection of this connection with D–FP_3 produces

144

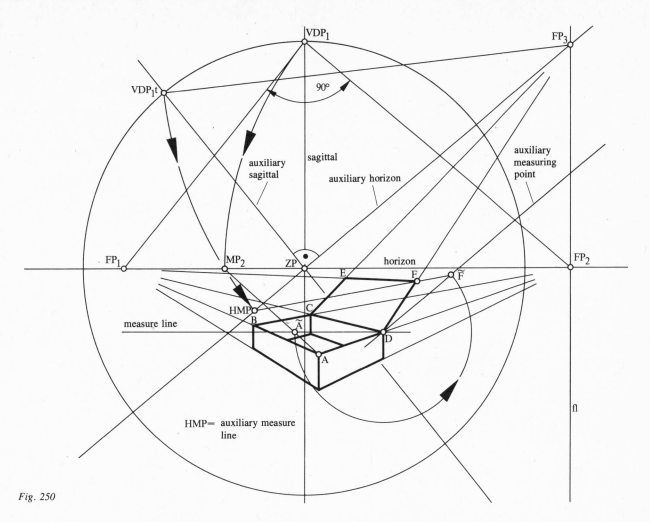

Fig. 250

HMP= auxiliary measure line

Fig. 251

width of box and lid

the corner F of the lid of the box, from which the remaining features of the lid can be drawn.

Figure 251 demonstrates the drawing of eight stages in the rotation of the lid of a box without transformation of the horizon. We start from the assumption that the lid of the box rotates around EF through 360°. With this rotation the box lid describes a horizontal circular cylinder. The side EF of the lid around which it rotates remains fixed during this motion. It can be regarded as a hinge and is the central or body axis of the cylinder. The moving side of the lid, which represents its length, generates the convex surface of the cylinder. At the different stages it becomes the cylinder's generatrix. The base and top planes of the cylinder are generated by the sides of the lid that represent its width. Geometrically they are the radii of the circle of the base and top planes.

We proceed from the fact that the part of the cylinder where these radii or sides are visible is its base plane, which must be constructed as a circle in perspective from the square in perspective ADC°B°. On the inscribed circle of square ABCD we determine those points which must be transferred to the circle in perspective. The square with the inscribed circle should be drawn in the rotated state.

The square ADC°B° has thus been produced by rotating square ABCD around AD. We indicate a turned point with a ° after and above the relevant letter; thus B° = B turned.

The vanishing line of the square in perspective 145

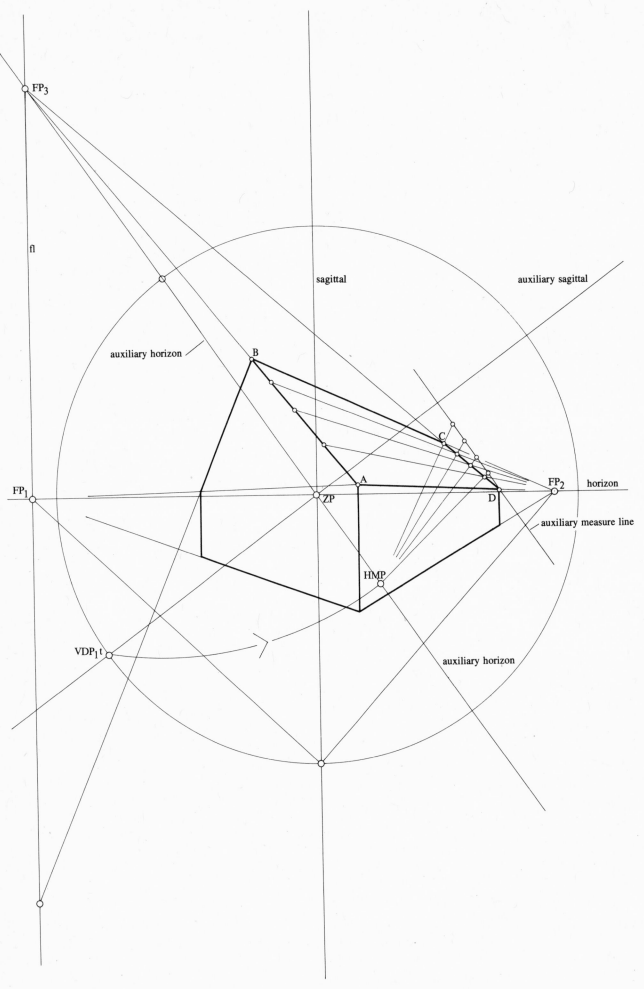

Fig. 252

ADC°B° is a vertical passing through FP_2. We require this vanishing line, the locus of the vanishing points of those sides of the box lid whose motion generates the base plane of the cylinder. We can interpret the base and top planes of the cylinder as wheels, which we must draw. EF could then be regarded as their axle and the sides representing the width of the lid as spokes. With the aid of the vanishing points of the "spokes" of the base plane of the cylinder, the "spokes" of its top plane can be constructed.

The sloping roof of the building in Fig. 252 has been divided by means of an auxiliary horizon, which, of course, always requires an auxiliary sagittal.

Instead of the line AB the shorter line DC was used for this division because if we divide AB, lines intersecting at very small angles are produced between the measure lines and AB, and this results in ill-defined points of intersection.

Cube and Cuboid in Random Positions or Three-Point Perspective

The parallel perspective drawing in Fig. 253, explaining the development of a three-point perspective, shows on the left the perspective model with the observer and on the right a cube in random position. This position is characterized by a spatial diagonal passing vertically through the corner of the ground plane. We can call this position of the cube random, on the one hand, and on the other special in that one of its spatial diagonals is vertical. The horizontal plan of the cube in this position is a regular hexagon. The right-hand drawing in Fig. 253 shows that certain edges of the cube produce the diagonals in the horizontal plan, and others the outline of the hexagon. To visualize this, we can imagine a wire cube in this position that is exposed to vertical parallel light rays, to be interpreted as parallel projection rays. The shadow cast by the wire cube will then form a regular hexagon analogous to the vertical parallel projection. In the chapter "Perspective of a cuboid from its horizontal and vertical plan" we will return to the cube in the position just discussed.

In the corner next to the observer both the edges K_1, K_2, and K_3, and the three faces Φ, X, Ψ of the cube intersect. The three edges represent the three directions of the parallel edges. In Fig. 253 the edges k_1, k_2, and k_3 have been extended and drawn boldly and with arrowheads. Each of these edges is associated with three others, which are parallel to it and therefore have the same direction and vanishing point. We thus obtain three vanishing points for the cube in this position, because this is characterized by three receding directions of the cube edges.

We have an analogous situation concerning the three faces Φ, X, and Ψ of the cube; they represent the other faces of the cube that are parallel to them. None of these faces is parallel to the picture plane.

Each of them is therefore a receding plane with a vanishing line. There are, then, three vanishing lines for the faces of a cube in random position. To begin with, let us determine the vanishing points of the edges K_1, K_2, and K_3 of the cube in a random position by drawing their parallel or vanishing rays fs_1, fs_2, and fs_3 from the center of projection. These vanishing rays pierce the picture plane in the vanishing points FP_1, FP_2, and FP_3. But to find these piercing points, we require the horizontal plans K_1', K_2', K_3' of these edges. In Fig. 253 these plans are shown in bold lines. By erecting and dropping perpendiculars at FP_1', FP_2', and FP_3', the vanishing points of those horizontal plans, on the horizon we obtain FP_1, FP_2, and FP_3, the three vanishing points of the edges of the cube in a random position. They are the points of intersection between these perpendiculars and the vanishing rays fs_1, fs_2, and fs_3.

Through the construction of the vanishing rays of k_1', k_2', and k_3' we obtain PZ–FP_1', PZ–FP_2', and PZ–FP_3' on the horizon plane. They are the horizontal plans of PZ–FP_1, PZ–FP_2, and PZ–FP_3.

By joining the three vanishing points FP_1, FP_2, and FP_3 to each other we obtain an acute triangle. The three vanishing points of a cube or cuboid in random position must therefore be the corners of such a triangle.

The connection of FP_1, FP_2, and FP_3 results in the three lines fl_1, fl_2, and fl_3, which belong to the three vanishing lines of the faces Φ, X, and Ψ of the cube. Because in theory vanishing lines are of infinite length, these lines are only sections of them.

The acute triangle formed by the connection FP_1, FP_2, and FP_3 is the base of a pyramid on the picture plane, whose apex is the center of projection and whose height is D. The vanishing rays fs_1, fs_2, and fs_3 become the edges of this pyramid and form right angles whose apices are in the center of projection. These angles correspond to the angles of the edges of a cube intersecting in, or proceeding from, a corner.

Figure 254 is a graphic illustration of this pyramid. Its partly hatched sides are the vanishing planes of the faces Φ, X, and Ψ of a cube, which generate the vanishing lines of these faces where they intersect the picture plane. These three vanishing planes, intersecting in the center of projection, need not be drawn, because they are generated automatically by the construction of the vanishing rays of the edges of the cube. As two intersecting straight lines the vanishing rays fs_1 and fs_2 form the vanishing plane FE_1, the vanishing rays fs_2 and fs_3 the vanishing plane FE_2, and the vanishing rays fs_1 and fs_3 and the vanishing plane FE_3.

Figure 254 shows that we can treat the pyramid of the three vanishing planes FE_1, FE_2, and FE_3 as the corner of a cube cut off by the picture plane as with a knife.

The cut face thereby produced forms an acute triangle as shown in the cube on the right in Fig. 253. This triangle, too, corresponds to the cut face ob-

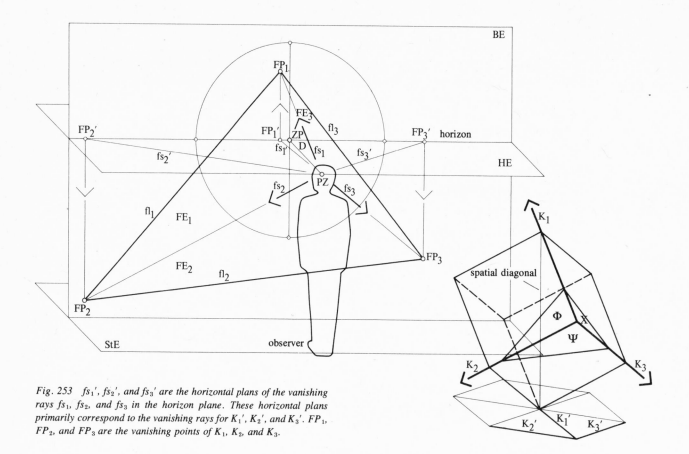

Fig. 253 fs_1', fs_2', and fs_3' are the horizontal plans of the vanishing rays fs_1, fs_2, and fs_3 in the horizon plane. These horizontal plans primarily correspond to the vanishing rays for K_1', K_2', and K_3'. FP_1, FP_2, and FP_3 are the vanishing points of K_1, K_2, and K_3.

tained when a corner is cut off a cube by a vertical plane. The triangle thus produced is similar to the triangle with corners FP_1, FP_2, and FP_3.

In Fig. 255 the perspective model with the pyramid in the horizontal plan is shown so that the picture plane appears as a rectangle, and the ground and horizon planes appear as lines when we trace them. In this horizontal plan PZ', the center of perspective, the apex of the pyramid, the central visual ray, and D, the distance (which is, of course, the radius of the circle of view) all coincide. Figure 255 represents the pyramid, not three-dimensionally but as a plane figure in the form of an acute triangle with its three altitudes. For by extending the lines representing the projections of the edges of the pyramid, that is, $PZ'-FP_1$, $PZ'-FP_2$, and $PZ'-FP_3$ in this acute triangle, we obtain the altitudes of the triangle because these lines join its corners to the opposite sides, to which they are normal.

Figure 256 represents the pyramid three-dimensionally and in parallel perspective. The picture plane with the base of the pyramid, whose altitude D will be vertical, is shown in a horizontal position. By comparing Figs. 255 and 256 we will obtain a better grasp of the significance of the various elements of these figures, especially of the lines $PZ'-A$, $PZ'-B$, and $PZ'-C$, which are extensions of the vanishing rays of fs_1, fs_2, and fs_3. Figure 256 shows that FP_3-PZ' in Fig. 255 is the horizontal plan of the edge of the pyramid FP_3-PZ, and furthermore that $PZ'-A$ is that of $PZ-A$.

Let us first discuss the significance of $PZ'-A$ in Fig. 255, because it is a fall line. This is the line a

drop of water or a ball follows on an inclined plane. The fall line $PZ'-A$ is thus the shortest distance between the center of projection and the trace FP_1-FP_2 of the plane or side of the pyramid FP_1-FP_2-PZ. $PZ'-B$ and $PZ'-C$ are the fall lines of the related sides of the pyramid. We now associate the supporting triangles $PZ-A-PZ'$, $PZ-B-PZ'$, and $PZ-C-PZ'$ with these sides. The fall lines are the hypotenuses of the supporting right triangles. Therefore in Fig. 256 $PZ'-A$, $PZ'-B$, and $PZ'-C$ are the horizontal plans of the three supporting triangles of the sides of the pyramids. But these lines also represent the true dimensions of the verticals of the supporting triangles, and D is the true dimension of the bases.

The supporting triangles can be interpreted as parts of the larger (also right) triangles $PZ'-A-FP_3$, $PZ'-B-FP_1$, and $PZ'-C-FP_2$. In Fig. 255 the ground plans of these triangles are the altitudes $A-FP_3$, $B-FP_1$, and $C-FP_2$ of the acute triangle. The sides of the pyramid, too, are right triangles, which we can correct for distortion by rotating them into the picture plane (Figs. 257 and 258).

The side $FP_1-PZ-FP_2$ of the pyramid in Fig. 257 is shown in the original position, which is rotated into the picture plane through 180° in opposite directions, with PZ describing arcs of a circle or, in the complete rotation, a semicircle. The axis of rotation is the hypotenuse FP_1-FP_2 of the right triangle. $PZ° = PZ$ turned.

In Fig. 258, which shows the horizontal plane of the rotation, the right triangle $A-B-S'$ in the original position can be considered for a turn to the right or to

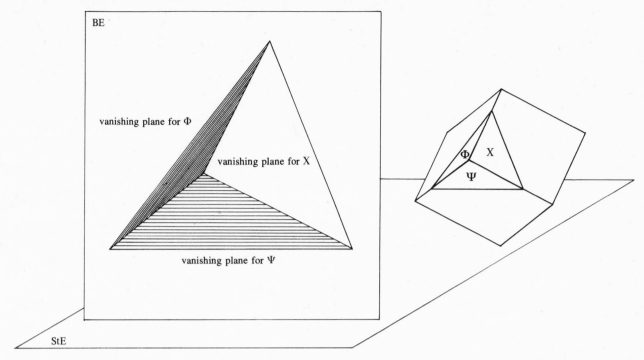

Fig. 254

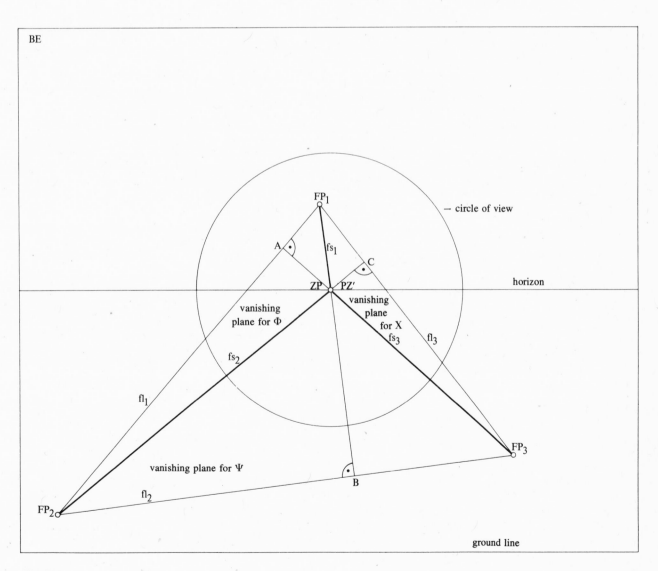

Fig. 255

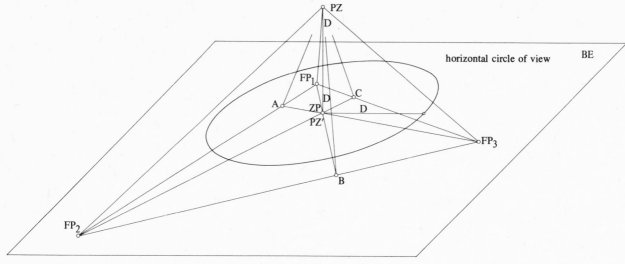

Fig. 256

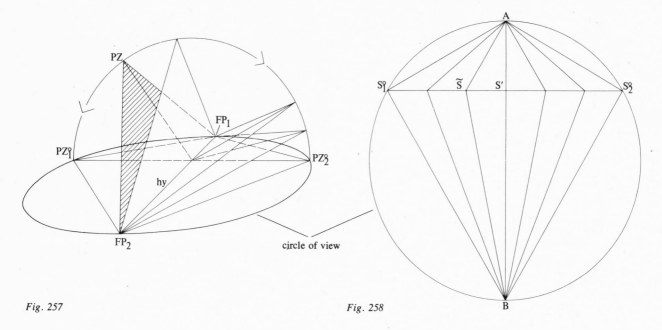

Fig. 257 *Fig. 258*

the left. It becomes the line A–B and in this hori-
zontal plan the diameter of a circle if it is at right
angles to the picture plane into which it can be
rotated. S', the horizontal plan of the corner S of the
right triangle, and its sides A–S̃ and B–S̃, which in
this plan become A–S' and B–S', lie on A–B.

The corner S describes a semicircle as it is being
rotated; in the horizontal plan it appears as $S_1°$–$S_2°$.
This line incorporates the horizontal plans both of
the fall lines and of the supporting triangles of the
triangular plane in the various phases of turning.
$S_1°$–$S_2°$ is the horizontal plan of such a supporting
triangle or fall line. The figure in Fig. 258 can be
constructed with the aid of the semicircle of Thales
on A–B.

Another comparison between a graphic and an
abstract representation (Figs. 259 and 260) explains
the rotation or correction for distortion of the side
FP_1–FP_2–PZ of the pyramid.

We construct this rotation in perspective as shown
in Fig. 260. We obtain the relevant side of the
pyramid rotated into the picture plane as a right
triangle FP_1–FP_2–PZ° by describing the semicircle
of Thales on the axis of rotation FP_1–FP_2 around M.

We now extend PZ'–A and obtain PZ°, the point of
intersection between the extended line and the semi-
circle of Thales, that is, the rotated center of projec-
tion. By joining this point to FP_1 and FP_2 we obtain
the distortion-corrected side of the pyramid rotated
into the picture plane with the fall line A–PZ' as its
true length. We proceed analogously with the correc-
tion of the other sides of the pyramid for distortion.

Construction of a Cube in Three-Point Perspective

We begin with the construction of a square as the
base of this cube. Let us draw a random—but not
equilateral—acute triangle with its three altitudes, as
shown in Fig. 261. Because we treat the vanishing
lines of the sides of the cube as infinitely long, they
are not terminated by the corners of this triangle.
Thus we can extend the sides of the acute triangle
beyond these corners as vanishing lines of the sides
of the cube. The point of intersection of the three
heights of the acute triangle is the center of projec-
tion in the horizontal plan as well as ZP, the center of
perspective.

We start the construction of the cube by drawing
the side A–B of its base, which has its vanishing

150

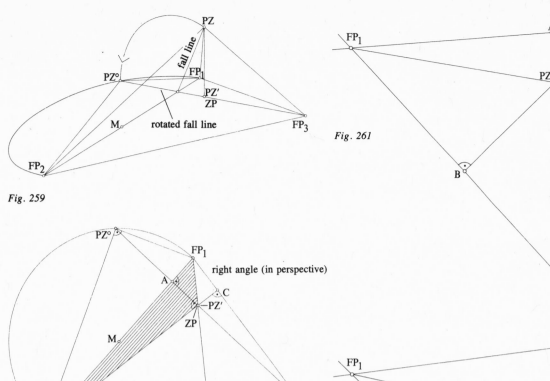

Fig. 259

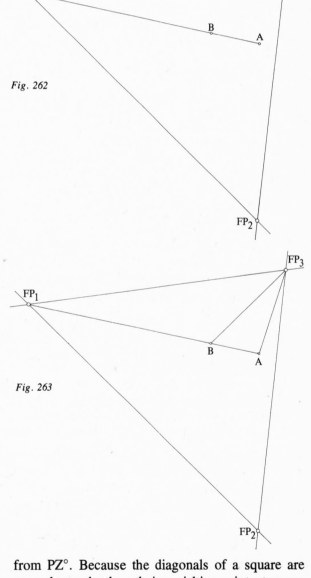

Fig. 261

Fig. 262

Fig. 263

Fig. 260 *Planimetric representation.*

point in FP_1 (Fig. 262). We mark off a random length of this side from A. How the cube is to be constructed according to certain predetermined dimensions will be explained later. However, this side of the square should not be chosen too long, because the larger the perspective picture the more distorted it will be. We must also place the side A–B of the square near the center of perspective, that is, in the zone of least distortion. This requirement has not been met in the construction of Fig. 264; the square ABCD is close to the vanishing line FP_2–FP_3, so that the cube appears rather distorted.

In Fig. 263 the corners A and B have been joined to FP_3, because the corners C and D of the square are located on the connecting lines A–FP_3 and B–FP_3. Figure 264 shows how to find these corners. We first determine C with the aid of the vanishing point D–FP_1 of the diagonal, because it is the point of intersection between the connecting lines A–DFP_1 and B–FP_3. A–C will then be the diagonal of the square that has its vanishing point in DFP_1. We obtain D by drawing a line through FP_1 and C, intersecting the connecting line A–FP_3.

Figure 265 explains the construction of the vanishing point DFP_1 of the diagonal. Because the corner of a square is also the apex of a right angle bisected by a diagonal, we obtain the vanishing point DFP_1 of the diagonal with the bisectrix of the right angle that has its apex in $PZ°$. DFP_1, the vanishing point of the diagonal A–C, is the point of intersection between the bisectrix and the vanishing line f_1.

Figure 266 shows how to construct DFP_1 and DFP_2, the vanishing points of the two diagonals,

from $PZ°$. Because the diagonals of a square are normal to each other, their vanishing points, too, are vanishing points of normals. Therefore, all we have to do is draw the other side of the bisectrix, which we can treat as the side of a right angle, from $PZ°$, intersect the vanishing line f_1 with it, and obtain 151

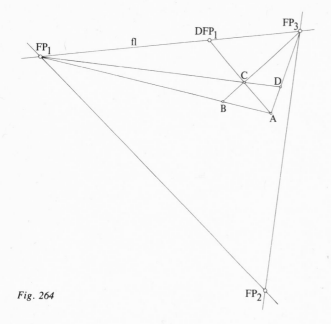

Fig. 264

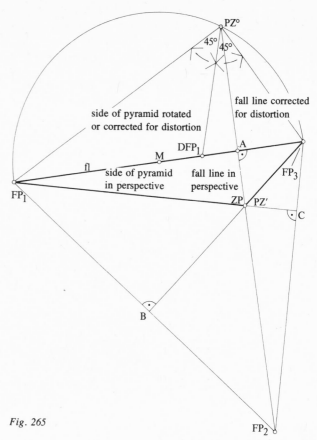

Fig. 265

DFP$_2$, the vanishing point of the diagonal D–B.

In Fig. 267 the construction of the cube from its base ABCD is continued. We draw two lines through its corners and FP$_2$ and from them those edges of the cube which are normal to the base ABCD and have their vanishing point in FP$_2$. Because fl$_1$ is the vanishing line of this base plane, all straight lines converging in FP$_2$ are normal to the planes of which fl$_1$ is the vanishing line.

Therefore, FP$_2$ is the vanishing point for the normal to the vanishing line fl$_1$.

Figure 268 shows how to obtain the side ABFE of the cube from the normals erected at A and B. To do this, it is necessary to construct DFP$_3$, the vanishing point of the diagonal B–E, which lies on fl$_2$, the vanishing line of the side ABFE. Figure 269 bottom explains the construction of DFP$_3$. If this point is known, we obtain E by drawing a line through DFP$_3$ and B, with which we intersect the normal to the base plane of the cube erected at A. The line joining E and FP$_1$ produces F, which is the point of intersection between this line and the normal to the base plane of the cube erected at B.

To complete the construction of the cube in three-point perspective as described in Fig. 270, E and F must be joined to FP$_3$. These connecting lines intersect the normals to the base plane of the cube erected at C and D in the corners G and H of the cube, which, when joined to each other, complete the drawing of the cube.

The sides normal to the base of the cube can obviously be drawn in a different sequence; this is recommended as an exercise.

Figure 271 shows how to add other cubes attached to cube ABCD and EFGH downward and upward from A, with the aid of the vanishing point DFP$_3$ of the diagonal.

We suggest the following problem: Construct other cubes from the original one in depth so that they are located in a space limited by lines that have their vanishing point in FP$_1$.

Construction of the Cube in Three-Point Perspective with the Aid of an Equilateral Triangle

The equilateral triangle is a regular acute triangle, which can be used for the construction of a cube in three-point perspective (Fig. 272). This cube can be drawn with the aid of the vanishing points DFP$_1$, DFP$_2$, and DFP$_3$ of the diagonals, which are the midpoints of the sides of the equilateral triangle. Construction of the cube can start from one of its corners.

Figure 273 also illustrates the construction of a cube in three-point perspective with the aid of an equilateral triangle. Three edges of this cube radiate from the center of perspective or the point of intersection between the three heights of the triangle. Therefore, one corner of this cube coincides with ZP. The angles formed by the vanishing rays of these edges when they pierce the image plane are equivalent.

One of the diagonals of each of the visible sides of the cube coincides with the fall line of the associated side of the pyramid, but the other diagonals are parallel to the corresponding vanishing lines or sides of the equilateral triangle.

Construction of the Circle of View from an Acute Triangle with the Three Altitudes as the Horizontal Plan of a Pyramid

We have constructed the cube without the circle of view and only on the basis of the acute triangle whose corners are vanishing points. How can we find the circle of view from an acute triangle with the three altitudes as horizontal plan of a pyramid?

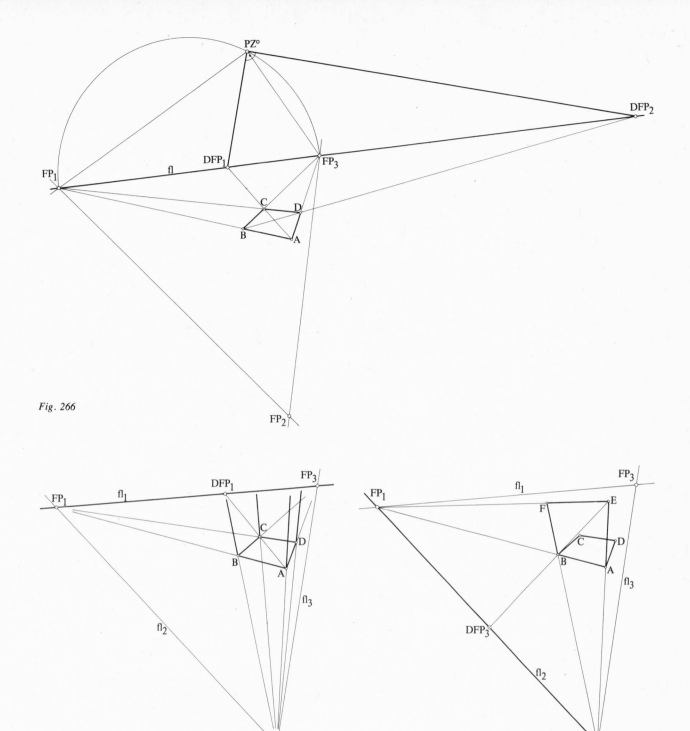

Fig. 266

Fig. 267

Fig. 268

Figure 274 is the spatial rendering of the pyramid with its horizontal base within the picture plane. However, Fig. 275 shows the pyramid's horizontal plan as an acute triangle. Its side FP$_1$–FP$_3$–PZ′ is shown in bold outline.

The graphic drawing in Fig. 274 shows that the distance D we want to find because it is the radius of the circle of view is the vertical side of the supporting triangle PZ–ZP–A. In Fig. 275 this triangle appears as line PZ′–A.

To find D and therefore the radius of the circle of view, with which we can then describe the circle itself, we must rotate the supporting triangle PZ–ZP–A into the picture plane or construct it in the planimetric form.

Figures 276 and 277 reveal that we have two of the pieces of information needed to construct this supporting triangle, namely, its right angle, whose apex is ZP, and its shortest side A–ZP. For the construction of the rotated triangle we therefore need one more piece of information, the hypotenuse, which is the fall line PZ–A and which we obtain, corrected for distortion in its true length, by rotating the side FP$_1$–FP$_3$–PZ of the pyramid. The rotating action is shown graphically in Fig. 276 and planimetrically in Fig. 277.

Figures 278 and 279 explain how to find the rotated supporting triangle with the true length of side D and therefore of the radius of the circle of view. The graphic rendering in Fig. 278 shows the support-

153

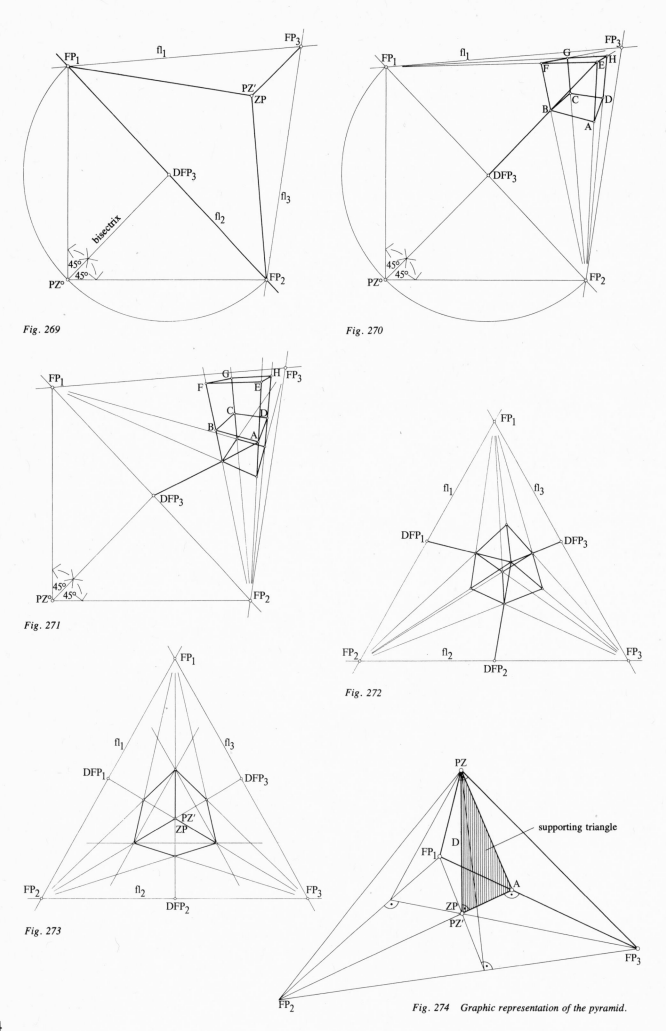

Fig. 269

Fig. 270

Fig. 271

Fig. 272

Fig. 273

Fig. 274 Graphic representation of the pyramid.

154

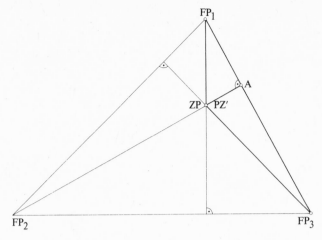

Fig. 275 Planimetric representation of the pyramid.

ing triangle both in the vertical and in the horizontal (that is, rotated) position. The vertical supporting triangle, which can be rotated in opposite directions, is shown in bold outline in Fig. 278.

According to Figs. 277 and 278 we must first draw a normal to A–ZP through the center of perspective, which we regard as the apex of a right angle. This produces the right angle of the rotated supporting triangle. The side A–ZP of this angle is given; as the axis of rotation it is part of both the vertical and the rotated supporting triangle. The other side of the rotated right angle or the normal we have drawn to A–ZP through the center of perspective must be intersected by an arc of a circle with its center in A and radius A–PZ°. We join the resulting point of intersection PZ$^+$ to A to obtain the rotated supporting triangle A–ZP–PZ$^+$; this is also hatched in Fig. 280, and the circle of view of radius D is shown in it.

To summarize briefly: An acute triangle with its three altitudes is given; it is a planimetric figure which we interpret as the horizontal plan of a pyramid for the construction of a three-point perspective. We require the circle of view or its radius D, the distance between the center of projection and the picture plane, which represents the altitude of the pyramid. We regard D as the longer of the legs of the triangle supporting a side of a pyramid. We know the right angle of the triangle and its shortest side, which coincides with its horizontal plan. But we need three pieces of information for the construction of a triangle. The third dimension to be found is its hypotenuse, which is the fall line of the associated side of the pyramid. By rotating this side we obtain the fall line or hypotenuse of the supporting triangle in its true dimension. This enables us to draw the rotated supporting triangle, and with its longer leg D we construct the circle of view.

Construction of an Acute Triangle with Its Three Altitudes from the Circle of View

If it is possible to draw the circle of view from an acute triangle with its three altitudes, then conversely, it must be possible to construct the acute triangle with its three altitudes as the horizontal plan of a pyramid from a given circle of view for the construction, illustrated in Figs. 281 and 282, of a three-point perspective. Comparison of Figs. 281 and 282 shows that by joining PZ to A and FP$_1$ we obtain the right triangle PZ–A–FP$_1$, drawn in bold outline and vertically hatched in Fig. 281, where it is also shown rotated. We must look at it very closely, because it shows that we can construct the vanishing point FP$_1$ and thereby the first corner of the acute triangle from point A on the vanishing line fl$_1$, which we draw at random for the given circle of view. In Fig. 282 the two intersect, but the vanishing line can also be outside the circle of view.

We must now find the point A on fl$_1$ by drawing a line through the center of perspective and at right angles to fl$_1$. We can treat this line as an auxiliary horizon, because it passes through the center of perspective.

We can now construct PZ$^+$ from this auxiliary

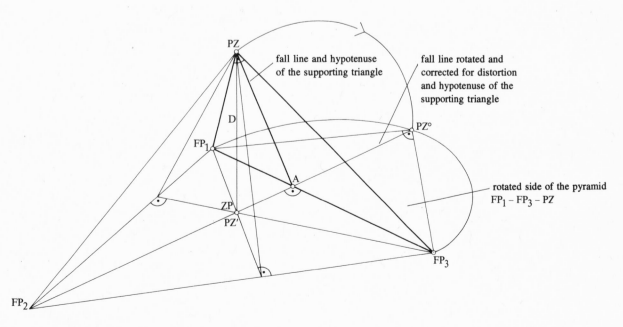

fall line and hypotenuse of the supporting triangle

fall line rotated and corrected for distortion and hypotenuse of the supporting triangle

rotated side of the pyramid
FP$_1$ – FP$_3$ – PZ

Fig. 276 Graphic representation of the pyramid.

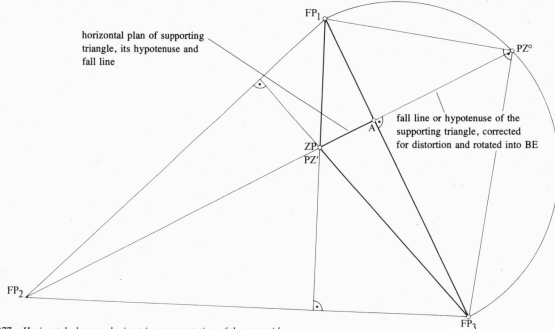

horizontal plan of supporting triangle, its hypotenuse and fall line

fall line or hypotenuse of the supporting triangle, corrected for distortion and rotated into BE

Fig. 277 Horizontal plan or planimetric representation of the pyramid.

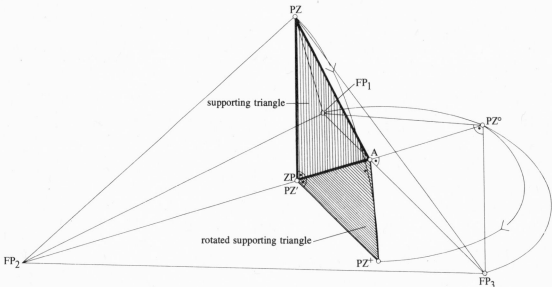

supporting triangle

rotated supporting triangle

Fig. 278 Graphic representation.

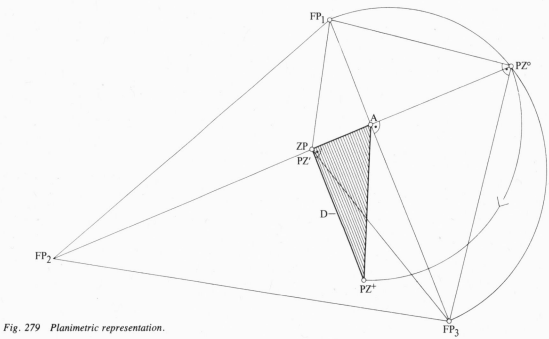

Fig. 279 Planimetric representation.

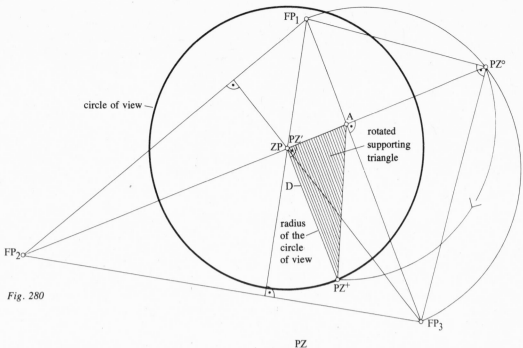

circle of view

A

rotated
supporting
triangle

ZP PZ'

D

radius
of the
circle
of view

PZ°

PZ⁺

FP₁

FP₂

FP₃

Fig. 280

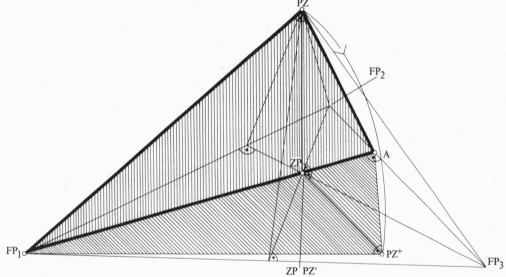

PZ

FP₂

A

ZP

ZP PZ'

PZ⁺

FP₁

FP₃

Fig. 281 Graphic representation.

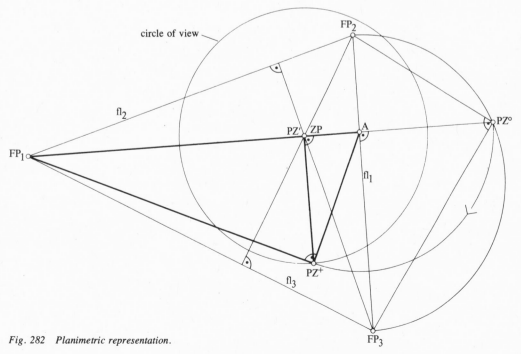

circle of view

FP₂

fl₂

PZ' ZP A

PZ°

fl₁

FP₁

fl₃

PZ⁺

FP₃

Fig. 282 Planimetric representation.

157

horizon, because it is the point of intersection between this and a normal to it passing through the center of perspective and the circle of view. By joining PZ^+ to A we obtain not only the fall line of the side $PZ^°$–FP_2–FP_3 but also the supporting triangle ZP–A–PZ^+, which can be regarded as a part of triangle PZ^+–A–FP_1.

We treat PZ^+–A as one side of a right angle with its apex in PZ^+; we can construct its other side to find FP_1.

Figure 283 shows how to determine FP_1 from A. Point FP_1 is a vanishing point of the normal to A and vice versa, and FP–PZ^+ is parallel to the vanishing line fl_1, which is given and therefore known. Therefore, using a parallel from the center of perspective with which we intersect the circle of view, we are immediately able to construct not only PZ^+ but also the fall line PZ^+–A and the supporting triangle PZ^+–A–ZP of the side of the pyramid, whose vanishing line is fl_1.

If we know A and FP_1, we can draw the rotated triangle PZ^+–A–FP_1 with the aid of the semicircle of Thales constructed on A–FP_1, as Fig. 284 shows. Finally, the vanishing points FP_2 and FP_3 must be constructed as corners of the acute triangle. We can place FP_2 at random on the vanishing line fl_1. We

join it to FP_1, which gives us the vanishing line fl_2; on this we construct a normal that passes through the center of perspective and intersects the vanishing line fl_1 in the third vanishing point FP_3 or corner of the acute triangle.

Joining FP_3 with FP_1 results in the vanishing line fl_3. A line drawn through FP_2 and ZP must intersect the vanishing line fl_3 at right angles. We give a brief summary based on the discussion of Figs. 285–291: The circle of view is given. The acute triangle with its three heights is required for the construction of a three-point perspective.

Fig. 285: Let us draw a random vanishing line fl_1 for the circle of view with ZP as center; it need not intersect the circle and can pass outside it.

Fig. 286: A is the result of a line drawn through the center of perspective and intersecting fl_1 at right angles. PZ^+ is obtained by means of a parallel to fl_1, which passes through the center of perspective and intersects the circle of view.

Fig. 287: If we know A and PZ^+, the line joining A and PZ^+ will be one side of a right angle, to which we add the other side from PZ^+ as its apex; its point of intersection with the normal to fl_1 passing through ZP is the vanishing point FP_1.

Fig. 288: We place FP_2 on fl_2 at random. The

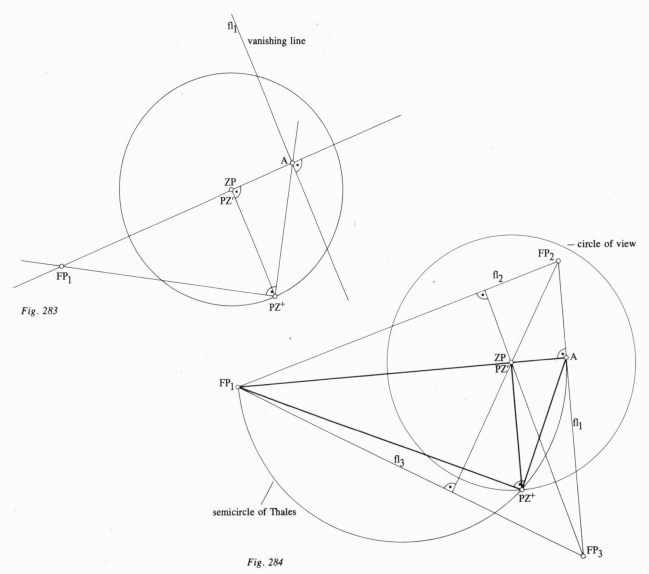

Fig. 283

Fig. 284

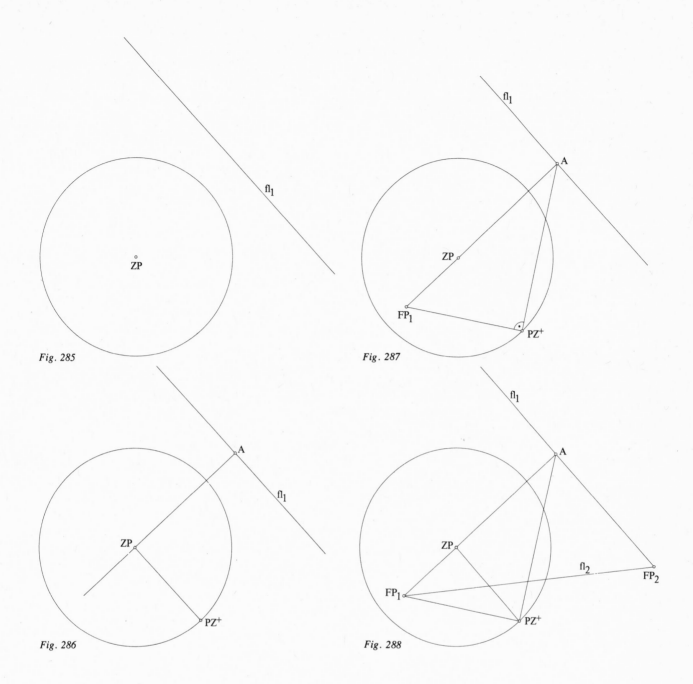

Fig. 285

Fig. 286

Fig. 287

Fig. 288

connection between FP_1 and FP_2 results in the vanishing line fl_2.

Fig. 289: FP_3 is the point of intersection between a normal to fl_2 passing through the center of perspective and fl_1.

Fig. 290: The connection between FP_1 and FP_3 produces the vanishing line fl_3. A line passing through FP_2 and ZP must be normal to fl_3.

Fig. 291: Having found the fall line $A–PZ^+$, which we rotate from A into $A–FP_1$, we obtain the turned side $FP_2–FP_3–PZ°$ of the pyramid.

Construction of a Cube in Three-Point Perspective from a Given Edge Length

We first construct the base square of the cube, erecting normals on its corners A, B, C, and D; their vanishing point is FP_3. We draw the edges AE, BF, CG, and DH from the normals to the base square. Figure 292 shows that we can treat the altitude $X–FP_1$ of the acute triangle $FP_1–FP_2–FP_3$ as the auxiliary horizon hh_1; on this lies the measuring point to be constructed from FP_1; this enables us to transfer into perspective the side A–B of the square, which starts in A and is laid down on a measure line parallel to the auxiliary horizon; we do this on $A–FP_1$, where it becomes the side A–B of the square.

We proceed analogously with the determination of corner D of the square (Fig. 293), drawing through A a parallel to the auxiliary horizon hh_2, which is the altitude $Y–FP_2$, on which we determine the side $A–\tilde{D}$ of the square from A and transfer it into perspective on $A–FP_2$, where it becomes the side A–D of the square. We find corner C of the square as the point of intersection between the connecting lines $D–FP_1$ and $B–FP_2$.

Figure 294 completes the construction of the cube: To obtain A–E, B–F, C–G, and D–H from the normals to its base erected on its corners, we first draw A–E. The measure line or parallel to the auxiliary horizon hh_3 must pass through A. We mark off the

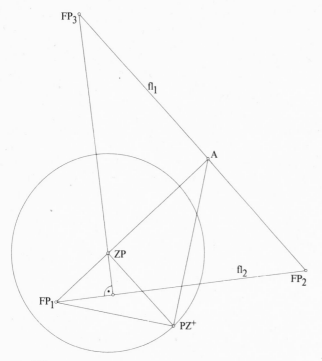

Fig. 289

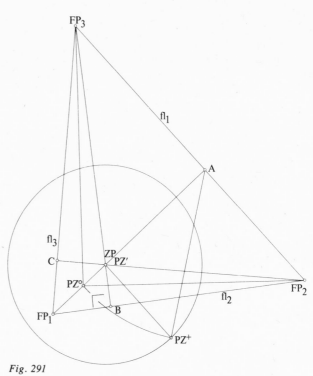

Fig. 291

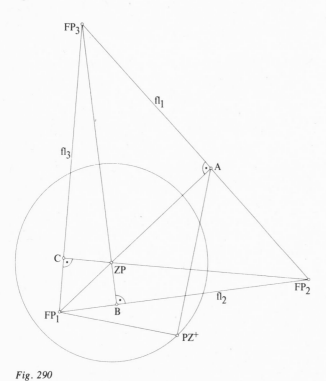

Fig. 290

length of edge A–Ẽ on this measure line from A. We draw a line through MP₃ and Ẽ, which intersects the normal to the base square erected at A, resulting in the corner E of the cube. The other corners F, G, and H are the result of the connections with the normals to the base square of the cube erected at B and D. We thereby obtain, to start with, F and H. G results from joining F and FP₂ or H and FP₁.

These explanations should provide an understanding of Figs. 295 and 296, which illustrate cuboid building structures with structured elevations. When we structure the front of a building, we begin with the division of an edge divided into eight equal parts (Fig. 295). The measure lines, on which we mark off

the length, width, and height of a cuboid or building block in their true dimensions, must all pass through 0. In the construction of Fig. 296 this requirement has not been met for technical reasons in that the measure line or parallel to the auxiliary horizon hh_1 has been displaced. It passes through the point on a line that has the same vanishing point FP₃ as the edge to be subdivided.

Construction of a Cube in Three-Point Perspective with the Aid of Measuring Points on the Vanishing Lines fl_1, fl_2, and fl_3

The chapters about the measuring point have taught us that by rotating the line connecting the vanishing point with the center of projection into the horizon, which is a vanishing line in the picture plane, we can construct measuring points.

In three-point perspective we obtain measuring points by rotating the line connecting the vanishing point and the rotated center of projection into a vanishing line (Fig. 297).

This illustration shows that it is possible to construct two measuring points on two different vanishing lines, so that we can correlate six measuring points with the vanishing points FP₁, FP₂, and FP₃. Figure 298 shows us how to use them; the base of the cube is constructed, from which the cube itself is developed.

The undistorted edge of the cube or side of the square A–B̃ on the parallel to fl_1, which is drawn to A, is given. A–B̃ can be marked off on this parallel to fl_1 or measure line from A also in the opposite direction, so that it will be the undistorted side A–D̃ of the square. We now join A to FP₁ and FP₂. To obtain the side A–B of the square, we must join B̃ to MP₁ because A–B has its vanishing point in FP₁,

160

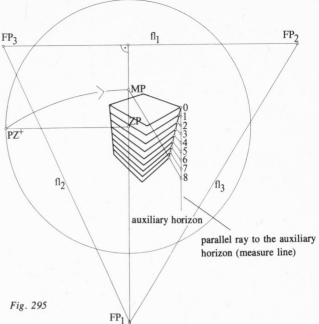

Fig. 292

Fig. 295

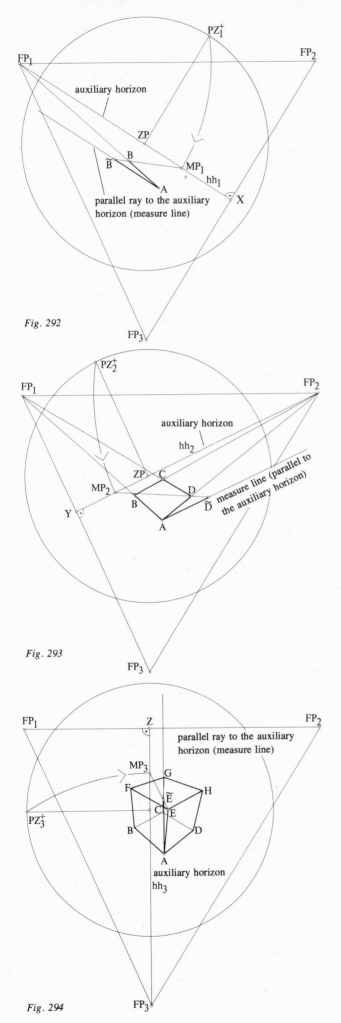

Fig. 293

Fig. 294

from which we construct MP_1. The point of intersection between \tilde{B}–MP_1 and A–FP_1 produces the corner B of the square. Analogously, D is the point of intersection between the connecting lines \tilde{D}–MP_2 and A–FP_2. Point C is the point of intersection between B–FP_2 and D–FP_1.

Figure 299 shows how to draw the cube from its base square by erecting normals to the base on the corners A, B, C, D; their vanishing point is FP_3, because all lines that converge in FP_3 are normal to planes of which fl_1 is the vanishing line. Edges A–E, B–F, C–G, and D–H lie on the normals to the base square. We first construct A–E by finding the corner E of the cube with the aid of a parallel to fl_2 or measure line drawn through A. We now mark off A–\widetilde{E}, the real edge length of the cube, on the measure line from A. We also draw a line through MP_3 and \widetilde{E}, which intersects the normal to the base erected at A; this produces the corner E of the cube. F and H are obtained from E through the connection of E with FP_1 and FP_2. G can be constructed from F or H by connecting either F with FP_2 or H with FP_1.

Figures 300 and 301 illustrate the construction of building blocks or multistory buildings in three-point perspective from the bird's-eye view.

Representation of a Rotated Cube on an Inclined Plane of a Ramp whose Trace is Parallel to the Horizon

Figure 302 clarifies the construction of the base of a cube placed diagonally on an inclined ramp whose trace is parallel to the horizon. We start the construction by drawing the side A–B of the base of random dimension. The vanishing point of A–B lies on the vanishing line fl_1 of the inclined ramp and is obtained by the production of the side A–B of the square to be constructed until it intersects fl_1.

Now the normal vanishing point to FP_1, FP_2, must be constructed (Fig. 303), for which we require

161

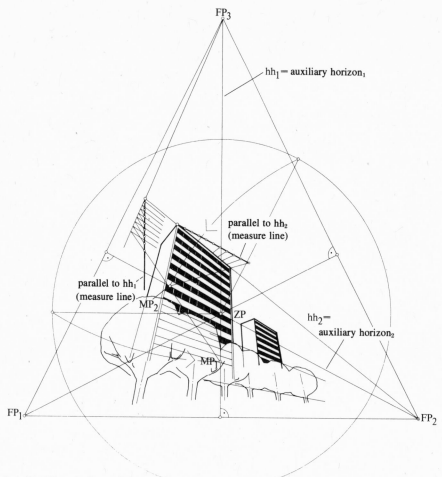

Fig. 296 *Construction of buildings in three-point perspective from below.*

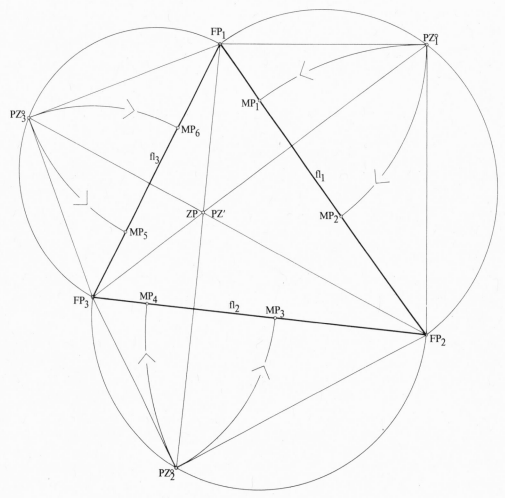

Fig. 297

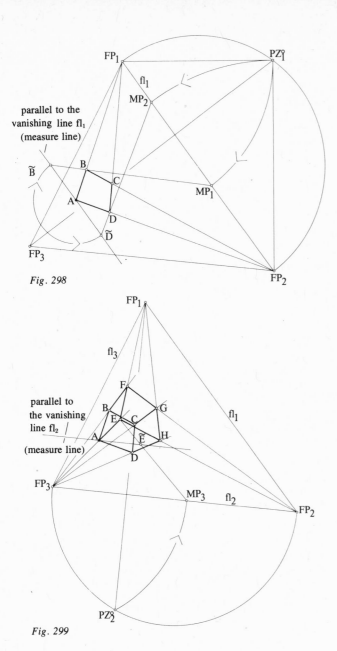

Fig. 298

Fig. 299

we construct first with the aid of the diagonal D–E with its vanishing point in DFP₂, lies on the line through A and FP₃. Because fl₂ is the vanishing line of the side ADHE of the cube, the vanishing point of the diagonal D–E lies on it. Figure 305 demonstrates how DFP₂, the vanishing point of this diagonal, is found. The corner E of the cube is the result of a line drawn through DFP₂ and D, which intersects the normal to the base erected in A. The corners F and H of the cube are obtained with the connections of E with FP₁ and FP₂. G is produced by the connection of H with FP₁ or F with FP₂. We suggest the following problem: Construct the cube on the inclined ramp with a given edge length with the aid of measure lines and measuring points.

Construction of a Cube on an Inclined Plane of a Ramp in the Diagonal Position

We first draw the base of the ramp (Fig. 306) with the aid of the circle of view and the two vanishing points FP₁ and FP₂ lying on the horizon. The inclined sides of the sloping ramp have their vanishing point in FP₃, which we join to FP₁ to obtain the vanishing line fl₁ of the inclined ramp and the base ABCD of the cube; this we construct by means of the vanishing point DFP₁ of the diagonal A–C of the square, produced by the intersection of the bisectrix of the right angle FP₁–PZ°₁–FP_II fl₁.

We choose the direction and length of the side A–B at random, and accordingly the vanishing point FP₁ on fl₁, to which we construct the vanishing point FP_II of the normal. This requires the hypotenuse PZ⁺–I of the supporting triangle PZ⁺–I–ZP. By drawing a parallel to fl₁ through ZP and intersecting it with the circle of view we obtain PZ, which we connect with I to produce the supporting triangle.

We obtain I with a normal to fl₁, which passes through the center of perspective. The extension of this normal to fl₁ is intersected by the arc of a circle of center I and radius PZ⁺–I. This provides PZ°₁. The connection of PZ°₁ with FP₁ produces one side of the right angle, to which we add the other side in PZ°₁ to intersect fl₁, which yields the vanishing point of the normal FP_II to FP_I. If we want to draw the edges A–E, B–F, C–G, and D–H of the cube, we must first construct the vanishing point FP_III in which all the lines converge that are normal to the inclined ramp and to the base of the cube. We obtain FP_III by intersecting the line passing through I and ZP with the side of the right angle whose apex is PZ⁺ and which we complete by drawing the other side PZ⁺–I. By drawing a line through DFP₂ and D with which we intersect the normal to the base of the cube erected in A we obtain the corner E of the cube, from which we can find its other corners F and H by joining E to FP₁ and to FP₂.

G is obtained by joining H with FP_I or F with FP_II.

The point DFP₂ on fl₂ is the point of intersection of the bisectrix of the right angle whose apex is PZ°₂ with fl₂, which is the vanishing line of the side

the turned supporting triangle ZP–I–PZ⁺, whose hypotenuse I–PZ⁺ is the radius of an arc of a circle with the center in I; with this arc we intersect the sagittal and its extension so that we obtain PZ°₁ and PZ°₂. The lines joining FP₁ with PZ°₁ and PZ°₂ each yield a side of a right angle with apices PZ°₁ and PZ°₂, from which we draw the other sides of the right angles so that they intersect the vanishing line fl₁. This produces FP₂, the vanishing point of the normal for FP₁.

The base square ABCD of the cube can be constructed with the aid of the vanishing point DFP₁ of the diagonal (Fig. 304).

Figure 305 shows how to develop the cube on the inclined ramp from its base square. To I–PZ⁺, which we interpret as a side of a right angle, we add the other side with PZ⁺ as the apex so that it intersects the sagittal, which gives us the vanishing point FP₃, where all lines converge that are normal to the inclined ramp and therefore to the base square of the cube. To obtain A–E, B–F, C–G, and D–H, which are normal to the base, we first draw lines through A, B, C, D, and FP₃. The corner E of the cube, which

163

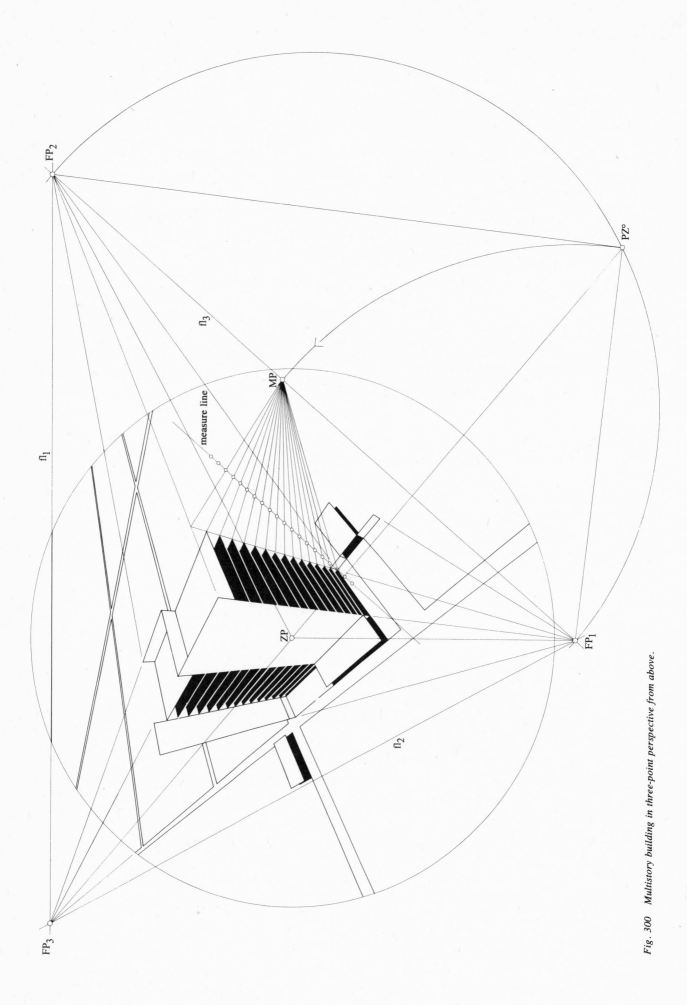

FP₂

PZ°

fl₃

MP

fl₁

measure line

FP₁

ZP

fl₂

FP₃

164

Fig. 300 Multistory building in three-point perspective from above.

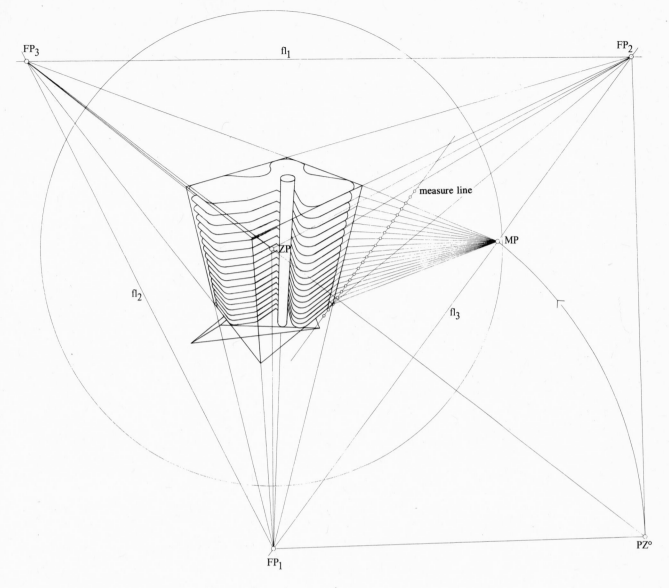

Fig. 301 Multistory building with curved fronts in three-point perspective.

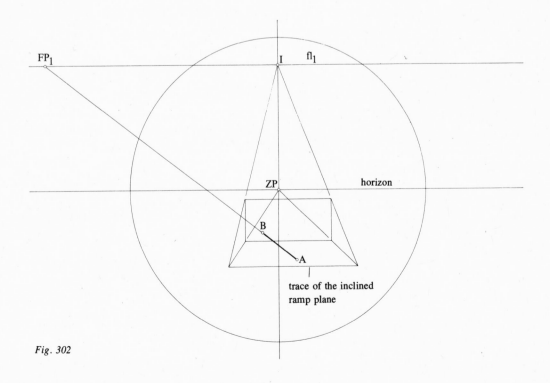

Fig. 302

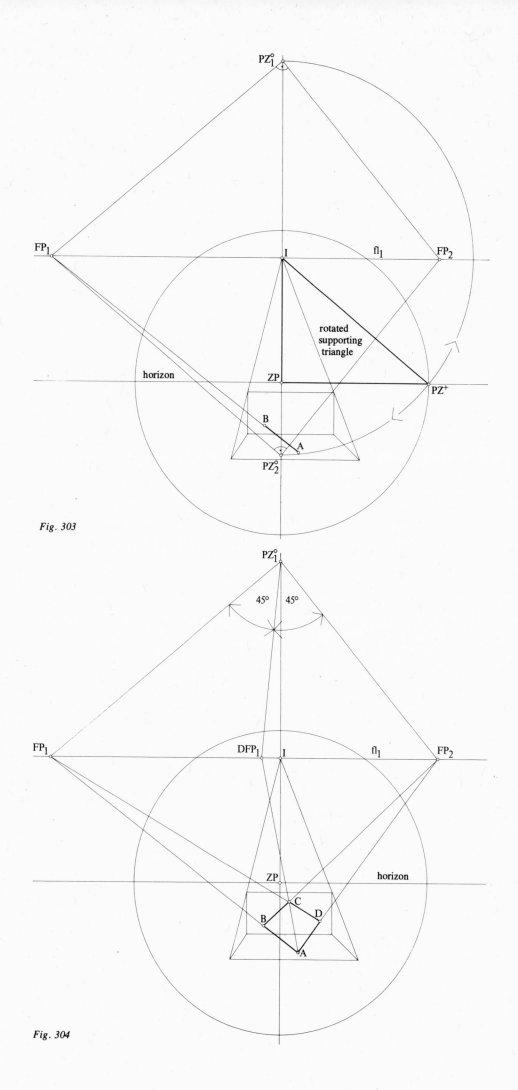

Fig. 303

Fig. 304

166

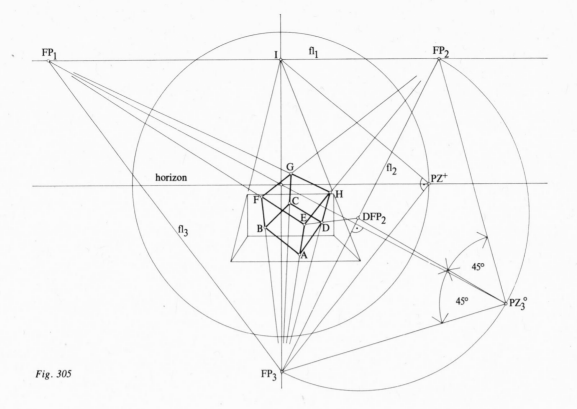

Fig. 305

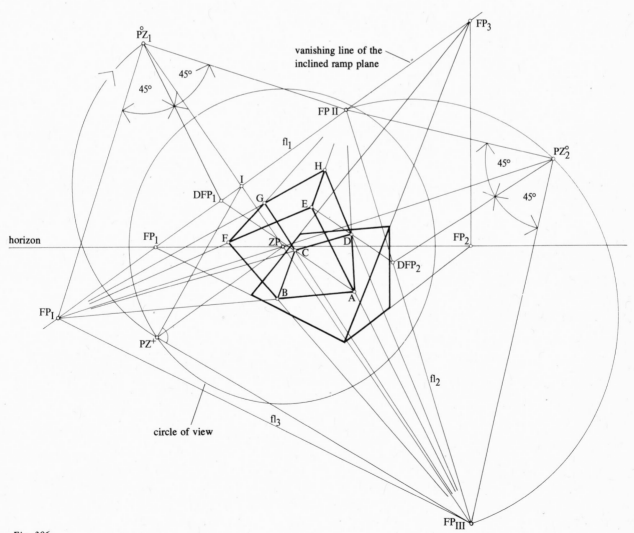

Fig. 306

ADHE of the cube. We therefore construct the semi-circle of Thales over FP_{II}–FP_{III}, with which we obtain the right angle FP_{II}–PZ°_2–FP_{III} and thereby the rotated side of a pyramid.

Construction of a Three-Point Perspective from a Given Viewpoint

We proceed from the horizontal and vertical plans of a cuboid in diagonal position, whose picture appears on an inclined picture plane in three-point perspective.

As we can move the cuboid into a random position relative to the vertical picture plane, so conversely we can incline the picture plane relative to a cuboid in the diagonal position. Figure 307 shows the observer facing a cuboid in this position. The inclined picture plane with the picture of the cube in three-point perspective is situated between the cuboid and the observer. Figures 308 and 309 explain how to obtain this picture.

Figure 308 shows the horizontal and vertical plans of the cuboid. In these plans we must find the center of projection, StP, the station point, and the visual ray at right angles to the picture plane. This requires the representation of the picture plane at a random inclination. The width of the angle of inclination formed by the inclined picture plane and the ground plane is shown in the vertical plan. Rotated, it could also be shown in the horizontal plan.

It is also possible to draw the inclined picture plane in the horizontal plan in the form of its trace and a height line parallel to this.

The trace of the picture plane passes through the corner A of the cuboid. One point of the cuboid is therefore situated in the picture plane. We must now construct the vanishing rays of the receding edges of the cuboid from the center of projection or from its projections in the horizontal and the vertical plan. To begin with we can find FP_1''. This vanishing point is the point of intersection of the vanishing ray of the vertical edges of the cuboid and the inclined picture plane.

To determine the vanishing points FP_2 and FP_3 or their projections in the horizontal and the vertical plan, we imagine the vanishing plane of the top and base planes of the cuboid passing through the center of projection. Its intersection with the picture plane produces the vanishing line of the top and bottom planes of the cuboid. On this vanishing line, which we will later use as the axis for rotating the picture plane, we find the vanishing points FP_2 and FP_3. In the vertical plan these two points coincide. By means of a collator or a vertical line drawn through this point, the vanishing line in the horizontal plan on which FP_2' and FP_3' lie can be found. We obtain them as the points of intersection of the related vanishing rays from PZ'.

To find $FP_1^{\circ\prime\prime\prime}$, we rotate the picture plane in the vertical plan around the axis of rotation, which here appears as a point, into the horizontal position. In Fig. 308 this point is marked both FP_2'' and FP_3''. The rotation is indicated by the arc of a circle that describes the path along which FP_1'' travels during rotation. Observe this rotation process and the related change of position of ZP'' and A''. Again with the aid of collators we can find the corresponding points in the horizontal plan. Here rotation has the effect of displacing the individual points. A comparison of the horizontal and vertical plans shows that A moves from left to right.

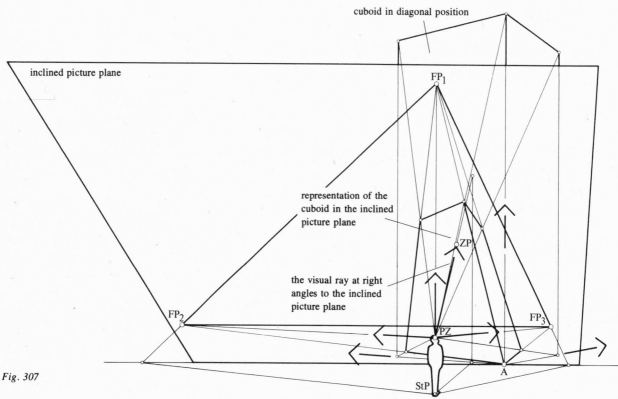

cuboid in diagonal position

inclined picture plane

FP_1

representation of the cuboid in the inclined picture plane

ZP

the visual ray at right angles to the inclined picture plane

FP_2

FP_3

PZ

A

Fig. 307

StP

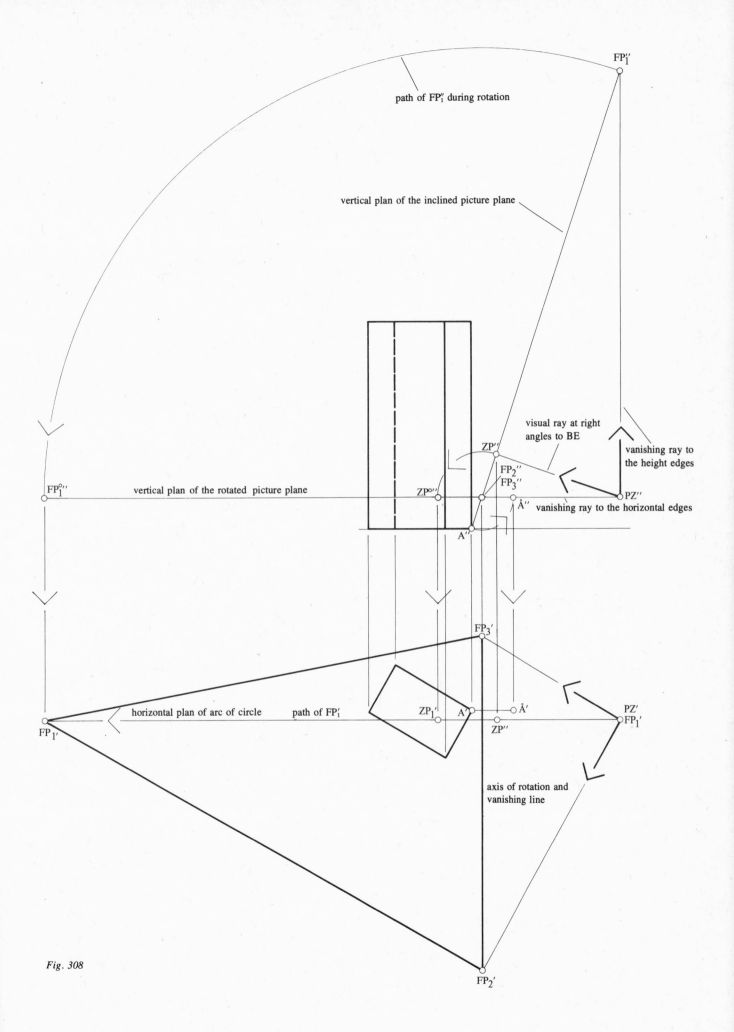

path of FP''₁ during rotation

vertical plan of the inclined picture plane

FP''₁

visual ray at right
angles to BE

ZP''

FP''₂
FP''₃

vanishing ray to
the height edges

FP°''₁ vertical plan of the rotated picture plane ZP°'' Å'' vanishing ray to the horizontal edges PZ''

A''

FP'₃

horizontal plan of arc of circle path of FP'₁ ZP'₁ A' Å' PZ'
FP'₁ ZP'' FP'₁

axis of rotation and
vanishing line

FP'₂

Fig. 308

169

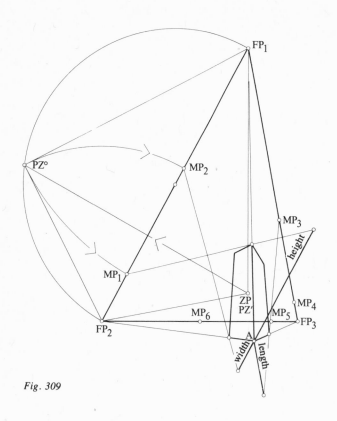

Fig. 309

To construct the perspective of the cuboid as illustrated in Fig. 309, FP_1, FP_2, FP_3, and A are taken over from the horizontal plan of Fig. 308. With the aid of the measuring points on the vanishing lines, the length, width, and height of the cuboid, indicated in the horizontal and vertical plan, can be translated into perspective.

Reconstruction of Three-Point Perspectives of Cities with Skyscrapers

Pictures or photographs of skyscrapers in three-point perspective are characterized by their expressive impact produced by the strong distortion, which changes and "alienates" the shapes of objects.

Because a photograph can reproduce objects only as they appear, the appearance or effect of a three-point perspective can be experienced most strikingly in suitable photographs of skyscrapers.

Reversing the problem of developing appearance from three-point perspectives, we now reconstruct the geometric structure on which the visual appearance of three-point perspectives is based. The center of Fig. 310 is occupied by a skyscraper which dominates—towers over—other skyscrapers. This is where we start, adding the others in the same position.

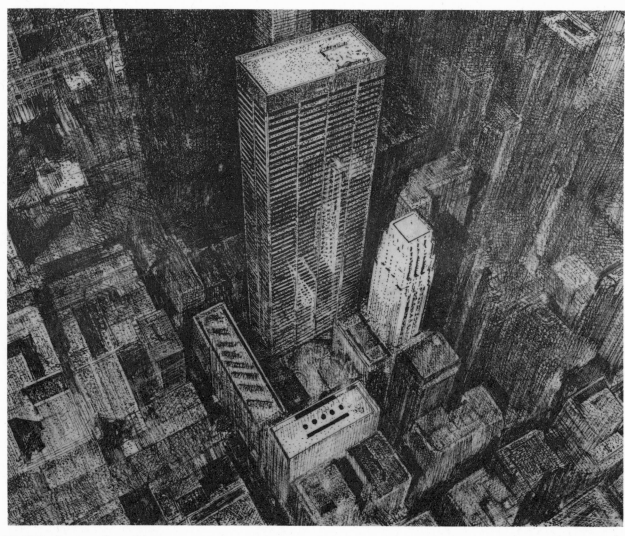

Fig. 310 Commerce Court, Toronto.

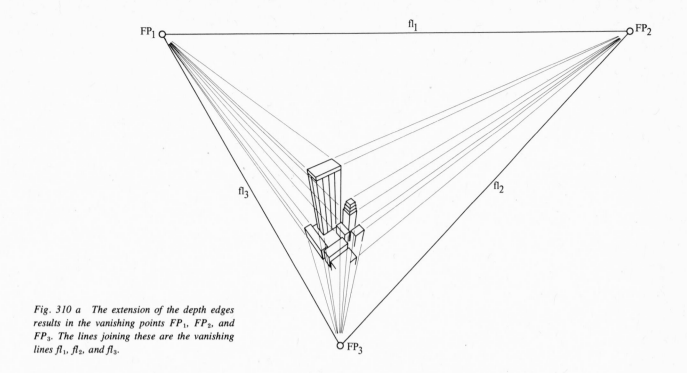

Fig. 310 a The extension of the depth edges results in the vanishing points FP_1, FP_2, and FP_3. The lines joining these are the vanishing lines fl_1, fl_2, and fl_3.

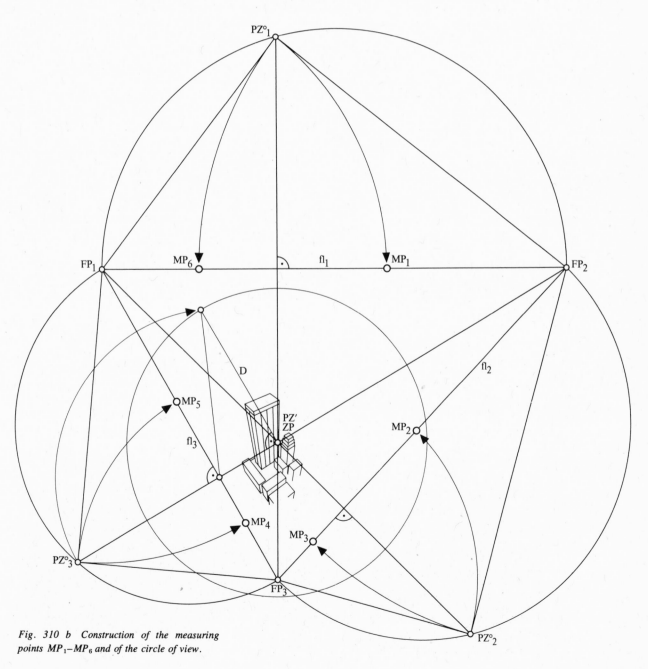

Fig. 310 b Construction of the measuring points MP_1–MP_6 and of the circle of view.

171

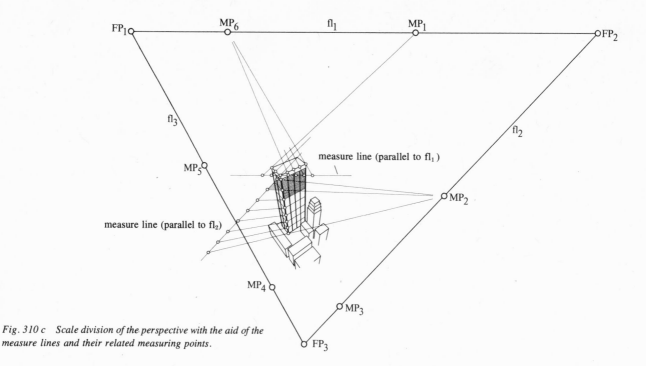

Fig. 310 c Scale division of the perspective with the aid of the measure lines and their related measuring points.

By extending the receding edges of this skyscraper we obtain the three vanishing points FP_1, FP_2, and FP_3. Joining them to each other will result in an acute triangle whose sides are the vanishing lines fl_1, fl_2, and fl_3 of the lateral planes of the skyscraper. The vanishing points of the receding edges of the same plane are on its vanishing line.

The legends of Figs. 310a, b, and c explain in detail the procedure for reconstructing the geometric-perspective structure from the appearance of Fig. 310.

The perspective construction on which Fig. 311 is based is illustrated more explicitly in Fig. 311a. To determine this construction, we start from the skyscraper in the left foreground of Fig. 311. The extension of the relevant edges yields the vanishing points FP_1, FP_2, FP_3; these apply to those building blocks which occupy the same position as the skyscraper. To draw the structures which diverge from the position of the skyscraper, we can start from the vanishing line fl_1 of the plane of the skyscraper which supports all the building blocks of Fig. 311. But fl_1 is also the vanishing line of the flat roofs of these buildings. Their height edges have their vanishing points in FP_3; here all the lines converge which are normal to the plane whose vanishing line is fl_1, the

Fig. 311
Christian Science
Center, Boston.

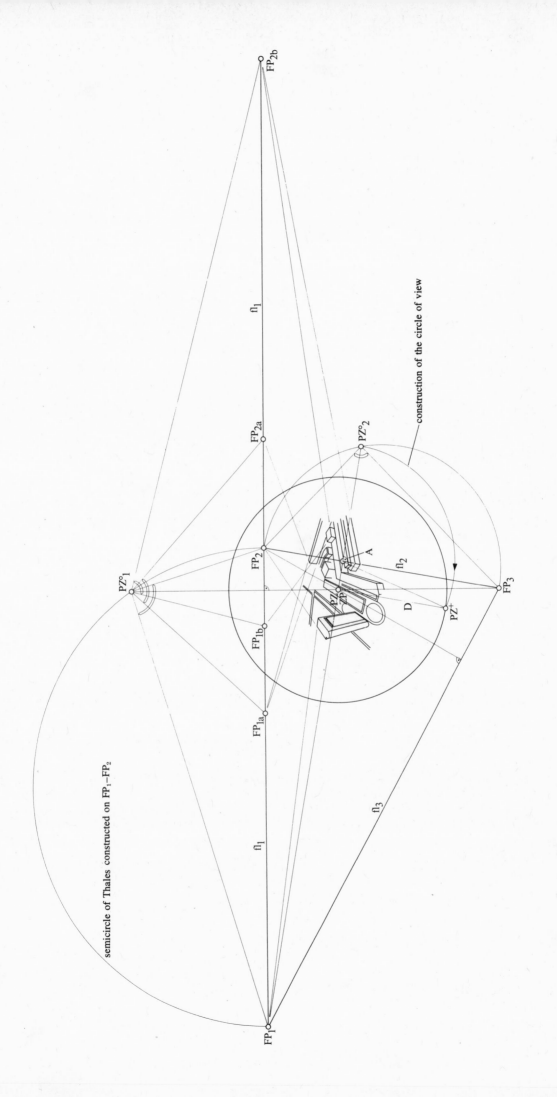

semicircle of Thales constructed on FP$_1$–FP$_2$

construction of the circle of view

Fig. 311 a Reconstruction of the circle of view and of the vanishing points from Fig. 311.

173

Fig. 312 Manhattan, New York City. Appearance of a three-point perspective.

locus of the vanishing points of the edges of all building blocks parallel to the ground plane. Figure 311a shows how to construct these vanishing points. For this we require the point PZ_1°, which we treat as the apex of right angles, to be used for their construction because the points of intersection between their sides and the vanishing line are the vanishing points FP_{1a} and FP_{2a} as well as FP_{1b} and FP_{2b} of the nor-

mals, used in drawing the building blocks that are not in the same position as the skyscraper. To construct the circle of view, we must find its radius D, which is the vertical side of the supporting right triangle A–ZP–PZ^+.

If we want to draw the perspective construction on which the picture of a cityscape is based, we represent the building blocks as cuboids, from which we

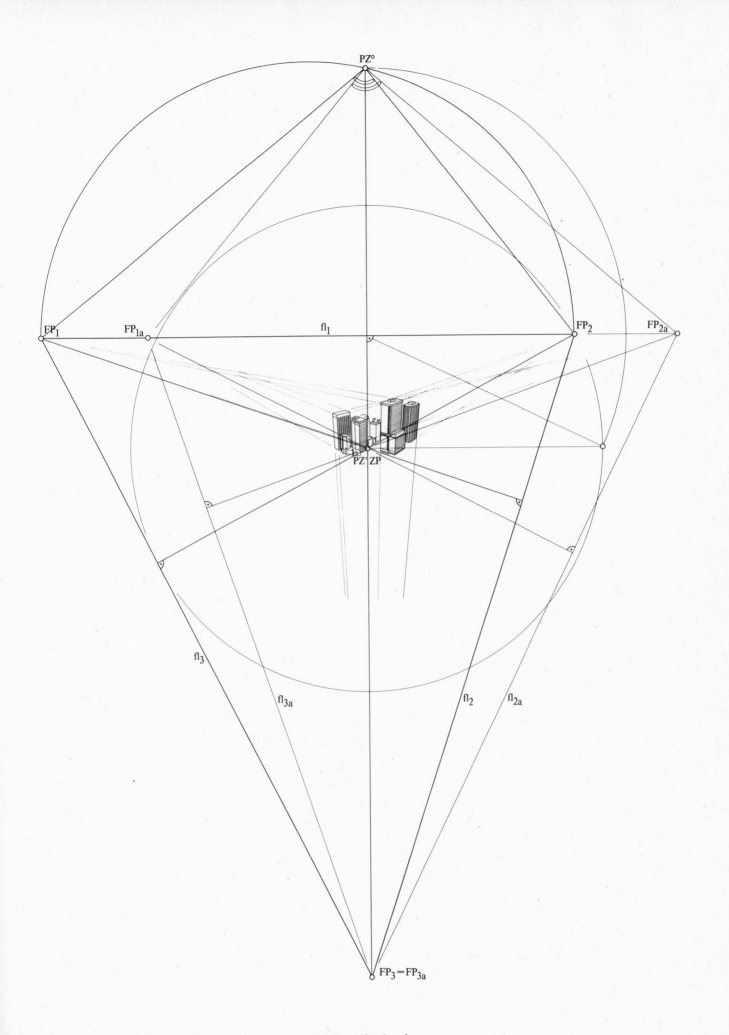

PZ°

FP₁ FP₁ₐ fl₁ FP₂ FP₂ₐ

PZ′ ZP

fl₃

fl₃ₐ fl₂ fl₂ₐ

FP₃＝FP₃ₐ

Fig. 312 a Reconstruction of the geometric structure on which Fig. 312 is based.

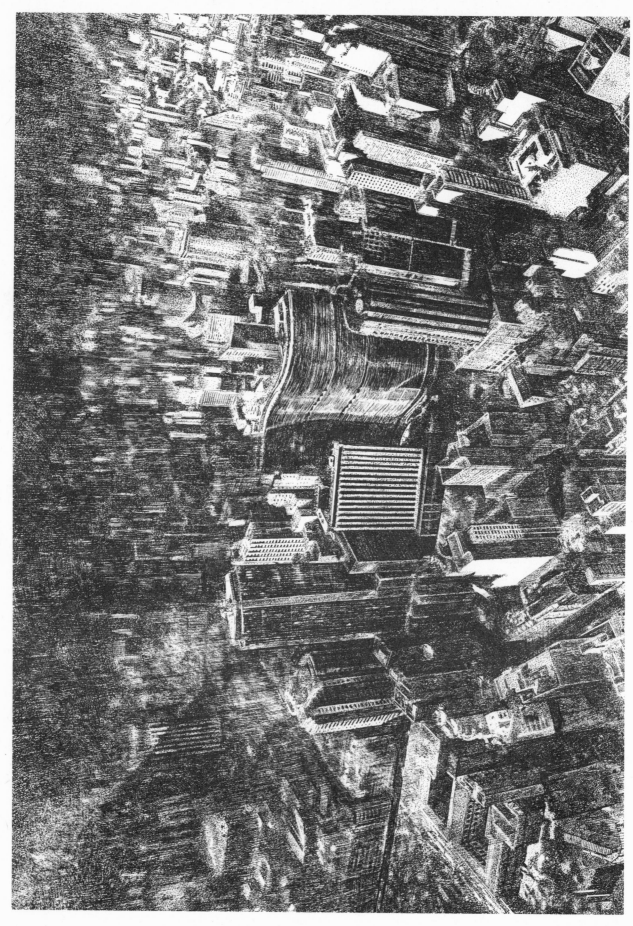

Fig. 313
Sao Paulo.

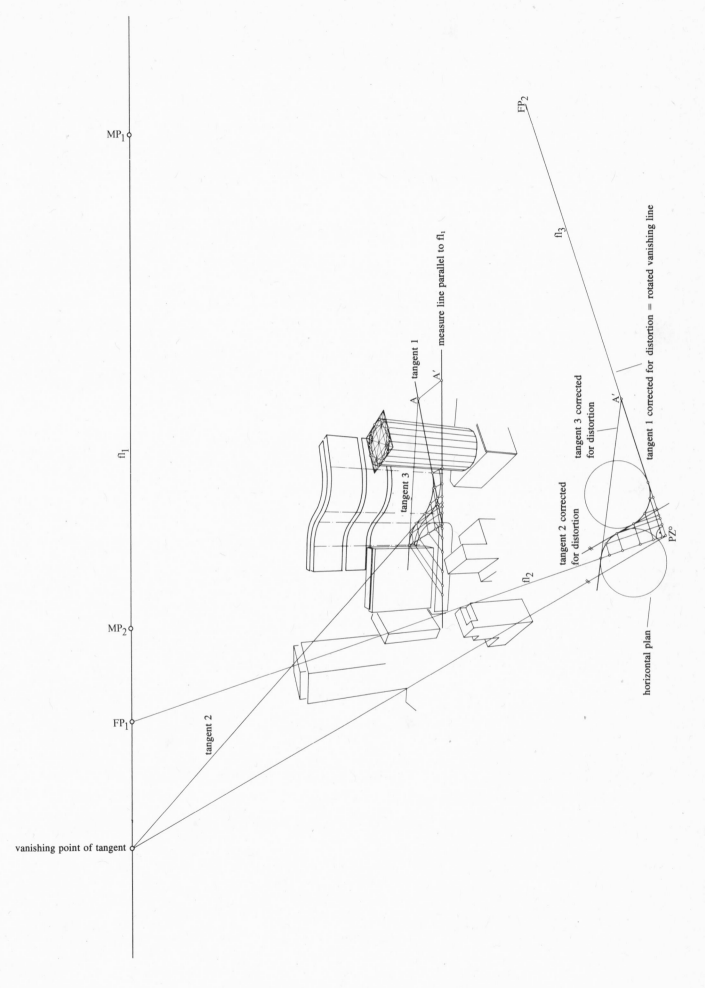

MP$_1$

fl$_1$

MP$_2$

FP$_1$

vanishing point of tangent

tangent 2

FP$_2$

fl$_3$

A tangent 1

A' measure line parallel to fl$_1$

tangent 3

tangent 3 corrected for distortion

tangent 1 corrected for distortion = rotated vanishing line

A'

tangent 2 corrected for distortion

fl$_2$

PZ°

horizontal plan

Fig. 313 a Reconstruction of the curved building structure through transfer of the coordinates to the above drawing.

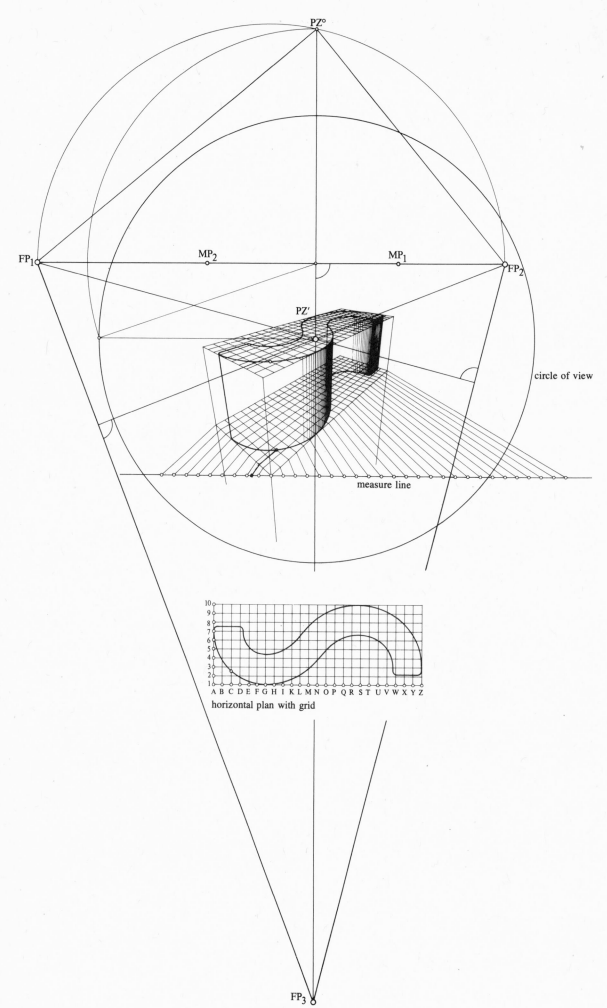

PZ°

FP₁ MP₂ MP₁ FP₂

PZ'

circle of view

measure line

10
9
8
7
6
5
4
3
2
1
A B C D E F G H I K L M N O P Q R S T U V W X Y Z

horizontal plan with grid

FP₃

178 *Fig. 313 b Free forms can be rendered in perspective only with the aid*
of a grid.

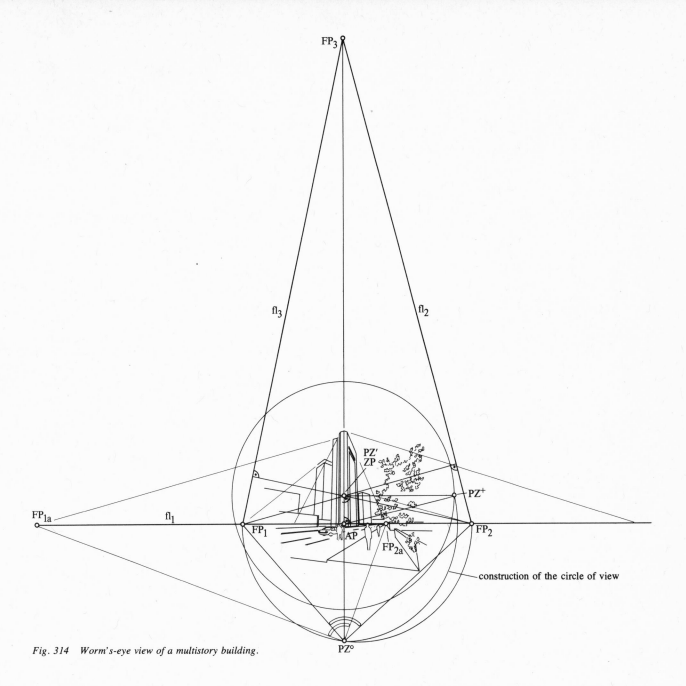

Fig. 314 Worm's-eye view of a multistory building.

can develop the buildings whose geometric shapes are different. We adhere to this principle also in reconstructing the perspective of Fig. 312. We therefore start from a certain dominant building in the foreground, whose edges extend so that they intersect to obtain the vanishing points FP_1, FP_2, and FP_3. In Fig. 312 it is the skyscraper in the right foreground from whose edges we find the previously mentioned three vanishing points, as shown in Fig. 312a. With the aid of these vanishing points we must draw all the buildings in the same position as the skyscraper from which we started. But for the construction of buildings that are at an angle to the skyscraper we must determine the vanishing points FP_{1a} and FP_{2a}, which are the points of intersection of the sides of a right angle whose apex is $PZ°$ with the vanishing line fl_1.

By joining FP_{1a} and FP_{2a} to FP_3 we obtain the acute triangle FP_{1a}–FP_{2a}–FP_{3a}, provided FP_3 and FP_{3a} coincide. The altitudes of the two triangles must intersect in the same point PZ' or ZP. A succession of new triangles can be constructed from normal vanishing points on fl_1 if buildings in other positions

additional to those already existing are to be drawn. The reconstruction of the perspective picture in Fig. 313 involves, among other actions, the representation of a cylindrical and of a curved building structure of an S-shaped longitudinal section and thereby the solution of a new problem. Figure 313a shows the construction of the cylindrical building to the right of the S-shaped skyscraper. The principle of the perspective rendering of a building with a curved point is explained in Fig. 316b. The curved line must be divided into individual coordinates. In Fig. 313a the position of the coordinates has been constructed with the aid of the vanishing points FP_1 and FP_2 (FP_3 lies off the drawing sheet) and their corresponding measuring points MP_1 and MP_2 on the measure line. The transfer of the coordinates into the rotated triangle FP_1–FP_2–$PZ°$ produces the horizontal plan of the curved line.

Here the side $ZP°$–FP_2 of the triangle is also tangent 1. Tangent 2 has its vanishing point on the vanishing line fl_2. Tangent 3 is fixed by the point of intersection A.

179

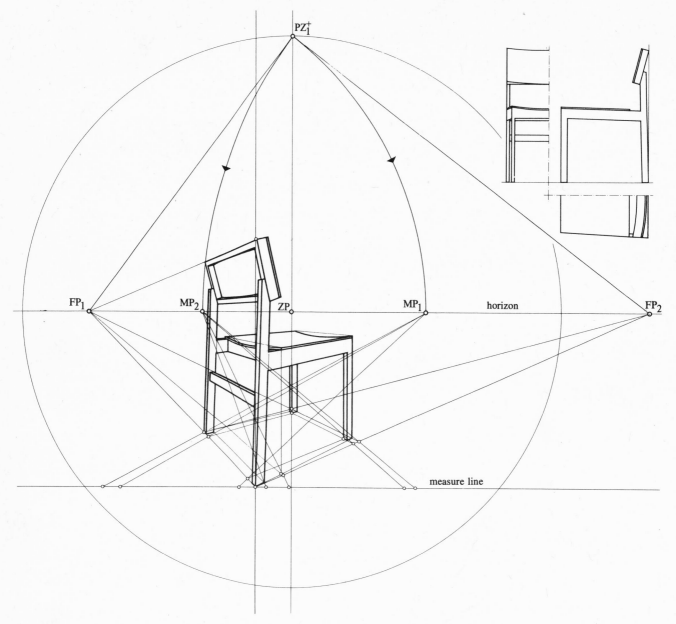

Fig. 315 Chair, designed by W. Guhl, in perspective.

The coordinate method must always be used for geometrically undefinable forms as distinct from the cylindrical building.

Figure 313b shows how to construct free curved forms by means of the coordinate method and to translate them into three-point perspective.

In Fig. 314 buildings are shown from the worm's-eye view (from below). One group has been constructed with the aid of the vanishing points FP_{1a} and FP_{2a} of the normals. Line fl_1 is the vanishing line of the flat roofs of the buildings, which are, of course, parallel to the ground (the vanishing points of the edges of the roofs are thus located on fl_1). The construction of the supporting triangle $ZP–A–PZ^+$ establishes $ZP–PZ^+$, the radius of the circle of view; this leads to the construction of the circle of view itself.

Figure 315 illustrates a chair, designed by Willy Guhl, in diagonal position. It is dealt with in this chapter on three-point perspective because the part of its back as shown in Fig. 315a must be constructed with the aid of three vanishing points.

For a better understanding of the structure of this chair we must study the plans that appear both in Fig. 315 and in Fig. 315a next to its perspective drawings. They reveal that the back legs of the chair are not vertical and are further apart than the front legs. The back of the chair is therefore wider than the front and its horizontal plan trapezoid instead of rectangular. Accordingly, the seat has the same shape; it also slopes slightly downward to the rear.

But we construct the chair from a basic square form in the diagonal position with the two vanishing points FP_1 and FP_2, as if its horizontal plan were a rectangle from which the trapezoid of the horizontal plan can be determined.

Figure 315a illustrates in detail how to construct the slightly concave and inclined seat. The trapezoidal seat, which to begin with should be regarded as a plane, must be drawn from a rectangle whose vanishing line is the locus of the vanishing points of the nonparallel sides of the trapezoid.

The backrest can be developed from a cuboid in random position by means of the three vanishing

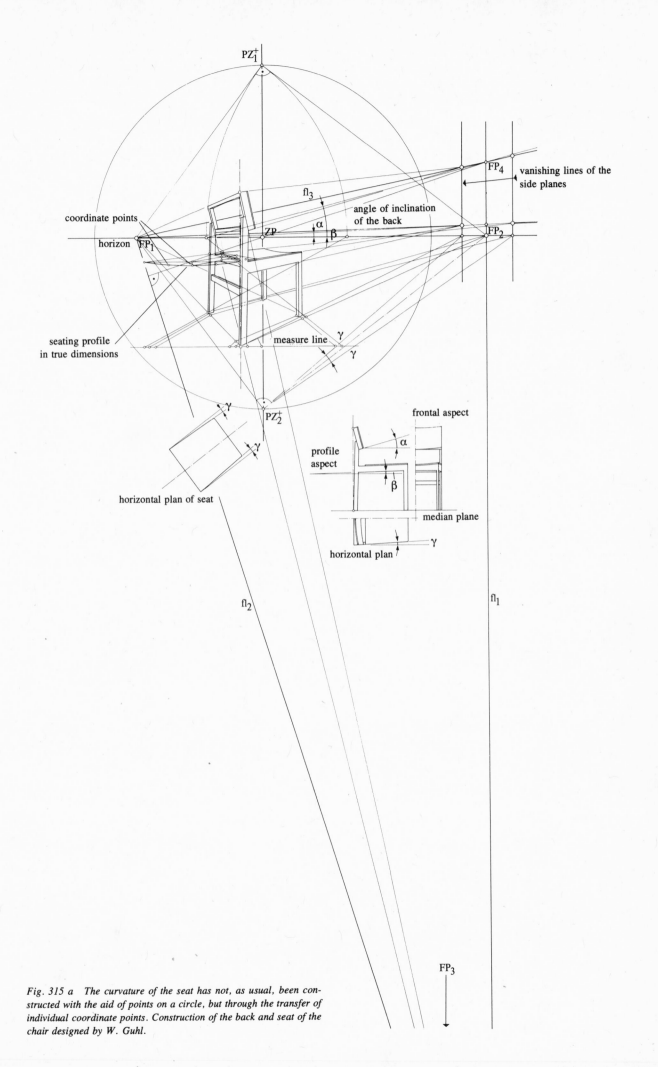

PZ$_1^+$

FP$_4$

vanishing lines of the side planes

fl$_3$

coordinate points

angle of inclination of the back

ZP

α

β

horizon

FP$_1$

FP$_2$

seating profile in true dimensions

measure line

γ

γ

frontal aspect

γ

PZ$_2^+$

profile aspect

α

horizontal plan of seat

β

median plane

horizontal plan

γ

fl$_2$

fl$_1$

FP$_3$

Fig. 315 a The curvature of the seat has not, as usual, been constructed with the aid of points on a circle, but through the transfer of individual coordinate points. Construction of the back and seat of the chair designed by W. Guhl.

181

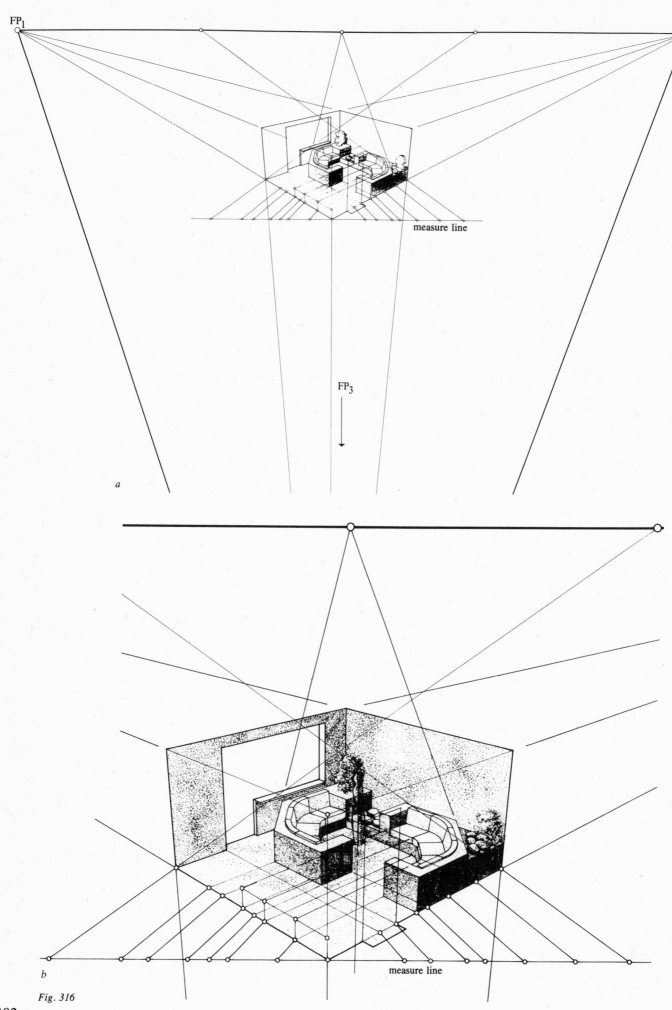

FP$_1$

FP$_2$

measure line

FP$_3$

a

measure line

b

Fig. 316

points FP_1, FP_3, and FP_4.

To find these vanishing points, we first draw the horizontal edges of the backrest, whose vanishing point is FP_1. The vanishing points FP_3 and FP_4 lie on the vanishing line fl_1, for the edges of the backrest whose vanishing points are FP_3 and FP_4 are in a plane which has fl_1 as its vanishing line. The edges of the backrest which characterize its position inclined to a vertical plane intersect fl_1 in the vanishing point FP_3; this is off the sheet of drawing paper. We find the vanishing point FP_4 through a normal to fl_2 that passes through the center of perspective and intersects fl_1 in FP_4.

The angles of inclination of the sloping components are rendered undistorted in the profile of the chair and play a part in the perspective construction. The angle of inclination of the seat, which is only $5°$ to $7°$, can be drawn so that the measuring point MP_2 forms its apex. When the slightly inclined back legs of the chair, whose upward extensions form the supports of the backrest, are being drawn, their divergence from a horizontal plane must be allowed for in the same way as in the drawing of the backrest. We must therefore consider the angle which the backrest forms with a horizontal plane. This angle, too, can be represented corrected for distortion on the horizon with the aid of measuring point MP_2.

Figure 316 shows an interior in three-point perspective. Here, too, the oblique lines have been drawn not with the aid of vanishing points but through the connection of points resulting from the relevant horizontal and vertical coordinates.

Reflection

In modern planimetry, where it plays a very important role, reflection is a method of reproduction based on a straight line or axis of symmetry about which a figure is reflected. Reflection in this context corresponds to the congruent reproduction of a figure that can be demonstrated by rotating it around a straight line or axis of symmetry. In Fig. 317 an original point P is reflected about an axis. We obtain its reflection P′ by means of a straight line passing through P and intersecting the axis at right angles. P′, the mirror image of P, lies on the straight line and is the same distance as P from the axis, as shown by the following drawings, which also illustrate the reflection of a triangle produced by reflection of its corners.

But here we are dealing with reflection not about a straight line but from a plane, where we conceive the mirror image of an object as a representation of its perspective image symmetrical to the axis of reflection. A reflecting surface can be a reasonably calm sheet of water or an artificial mirror. Unlike the former, which can only be horizontal, the latter can be set up in any position. If we touch the surface of a mirror with a pencil, we find that there is a distance between the tip of the pencil and its mirror image,

which indicates twice the thickness of the mirror; however, this can be ignored in the construction of mirror images because here we proceed from an ideal reflector of thickness 0, where the tip of the pencil and its mirror image would be in contact. But even in an ordinary mirror we can observe that the tip of the pencil and its mirror image are opposite each other; we also note that as we withdraw the pencil from the mirror surface, its mirror image seems to move in the opposite direction. Conversely, the tip of the pencil and its mirror image approach each other when we move the pencil toward the mirror. If we rotate the pencil clockwise in a horizontal position in front of a vertical mirror, its mirror image will move counterclockwise. But if we turn it so that it is parallel to the mirror, object and mirror image will move in the same direction. We can further observe that in the mirror real objects that are invisible to us become visible and vice versa; for instance, the mirror will show us the palm of a hand held in front of it so that we face the back of the hand. We can also see that the right side of a face becomes the left side in the mirror and vice versa and that a person's mirror image in the water seems to stand on its head (Fig. 334c). We therefore speak of mirror inversion, which also applies to our hands, feet, and shoes, which are in symmetrical planes.

Reflection by Water

A sheet of water reflects the light rays incident on it at an angle equal to that of their incidence. In other words, the angle of incidence is equal to the angle of reflection according to Fig. 318, which demonstrates the reflection of the vertical AB.

The mirror image of the top end of the vertical is as far below the mirror plane as the top end is above it. If we want to construct the mirror image of a point P located above a horizontal reflecting plane, we must drop a perpendicular from this point onto this plane. From the foot of the perpendicular we mark off its distance from P downward on the perpendicular to obtain P′, the mirror image of P. This also explains the reflection of a vertical if we treat the perpendicular from P to the reflecting surface as a line whose mirror image is LF–P′ (Figs. 319 and 319a).

If the bottom end of the perpendicular does not touch the reflecting surface, the ensuing distance must also be reflected, as Fig. 320 shows. We also make use of perpendiculars in the reflection of oblique lines. The illustrations in this chapter show that we can understand the reflection from a horizontal reflecting surface in planimetric terms. For the reflection of an oblique line the axis of symmetry can be constructed from the projection of this line on the reflecting surface (Figs. 321 and 322). Our previous explanations should interpret Fig. 323, which shows the reflection of a building structure, a bridge with a semicircular arch, in the water of a canal with sloping banks, whose reflection must be included.

axis of symmetry

P — P′

a

Fig. 317

axis of symmetry

A — A′
B — B′
C — C′

b

PZ

StP — α — α — sheet of water or reflecting surface — B

A

A′

α = angle of incidence and reflection
A′–B= mirror image of A–B

Fig. 318

ZP — horizon

P
LF
P′ — reflecting surface

Fig. 319 Reflection of a point.

ZP — horizon

A
B=B′
A′ — reflecting surface

Fig. 319 a Reflection of a vertical with its foot in the reflecting surface.

Fig. 320 Reflection of a perpendicular above the reflecting plane.

Artificial Mirrors

Unlike sheets of water, which can only be horizontal, artificial mirrors can be vertical or inclined to a wall. Here we construct the mirror images on the same principle as with sheets of water (see Fig. 324).

If we want to reflect the point of an object whose mirror image we construct point by point, we must drop a perpendicular from this point onto the mirror plane. From the foot of this perpendicular the reflected point seems situated as far behind the mirror as the real point is in front of it. It depends on the position of the mirror whether the light rays producing the mirror image are parallel to the picture plane or not. In the latter case we must construct the vanishing point of the perpendicular for the vanish-

Fig. 321

Fig. 322

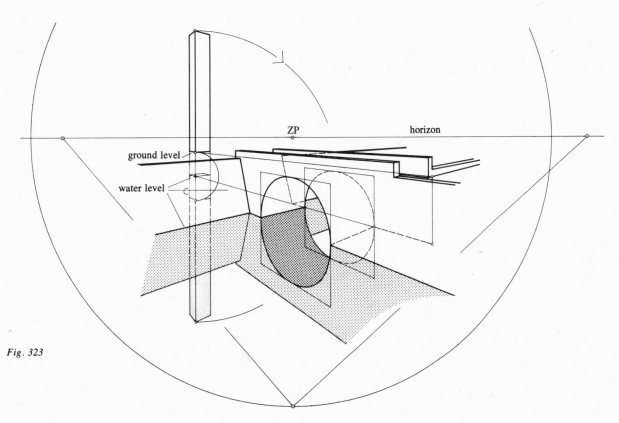

Fig. 323

185

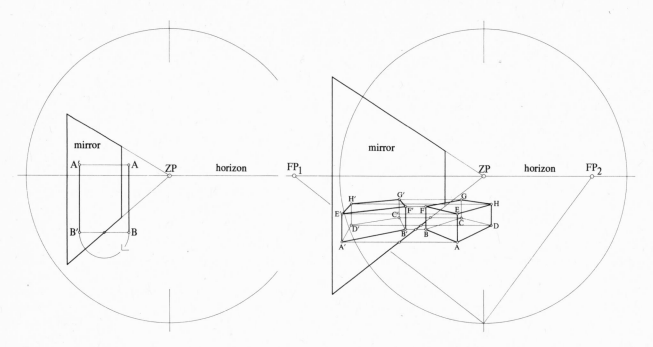

Fig. 324 Reflection of a perpendicular in a mirror at right angles to the picture plane.

Fig. 325 Reflection of a cuboid in diagonal position in a mirror at right angles to the picture plane.

ing line of the mirror plane in which the light rays forming the mirror image converge. The line from the original point to be reflected to the mirror plane must also be corrected for distortion, so that, as the distance of the reflected point from the mirror plane, it can be rendered in perspective behind it.

We first draw the mirror image of a vertical AB in a vertical mirror that is at right angles to the picture plane. The solution of this problem shows that the light rays forming the mirror image are parallel to the picture plane, so that they remain parallel in the perspective picture; their vanishing point is therefore at infinity. It is also evident that the distance between the vertical and the mirror plane is not shortened. We appreciate this when we turn the book or the drawing through 90° and find that the problem is solved in the same way as with a horizontal mirror plane.

In Fig. 325 the reflection of the cuboid is produced by its vertical edges AE, BF, CG, and DH.

In the next problem to be solved (Fig. 326) the vertical mirror plane for the reflection of the vertical AB is skew to the picture plane. Two solutions to this problem are possible. The first involves correcting the distortion of the line from B to the mirror plane with measuring point MP_1 to render it in perspective behind the mirror plane and to obtain B'. Point A' will then be the point of intersection of a perpendicular on the mirror plane from A with the perpendicular erected in B'. The perpendicular on the mirror plane has its vanishing point in FP_1, the vanishing point of the perpendicular for the vanishing line of the mirror plane.

The next illustration explains the second method of constructing the mirror image of AB. The point of intersection of a line drawn through A and M with B–FP_1 is B', the corner of the rectangle ABB'A'.

AB' is the diagonal of this rectangle.

We can solve the problem of Fig. 327 by first drawing the perpendiculars or visual rays on the mirror plane from A and B, which converge in FP_1, the vanishing point of the perpendicular for the vanishing line of the mirror plane. These perpendiculars pierce the mirror in DP_1 and DP_2; we join these points to bisect the resulting connecting line and to find the center M. A line drawn through A and M so that it intersects the perpendicular on the mirror plane from B produces B'. Analogously we obtain A', the mirror image of A, with a line through B and M intersecting the perpendicular on the mirror plane from A. The lines are diagonals of a rectangle whose required corners A' and B' are found by means of its diagonals whose vanishing line passes through FP_1.

In a mirror standing vertically in front of, or hanging on the facing wall of, a room, the mirror image of a vertical AB is to be drawn, which we treat as a thin rod (Fig. 328). All perpendiculars on the mirror plane converge in the center of perspective. To correct the distance of B from the mirror plane for distortion, we use the corresponding measuring point, which also serves for the transfer of the corrected distance into perspective and therefore for the determination of the mirror image of B.

The mirror plane, which for reasons of constructing the mirror image of AB is shown to extend to the ground, can subsequently be reduced at will, for instance, so that only part of the line is reflected by the mirror.

A table and a window in a room are to be mirrored in a vertical mirror on a wall (Fig. 329).

We can treat the wall on which the mirror hangs as the mirror plane on which we construct the mirror images of the objects mentioned. By drawing the

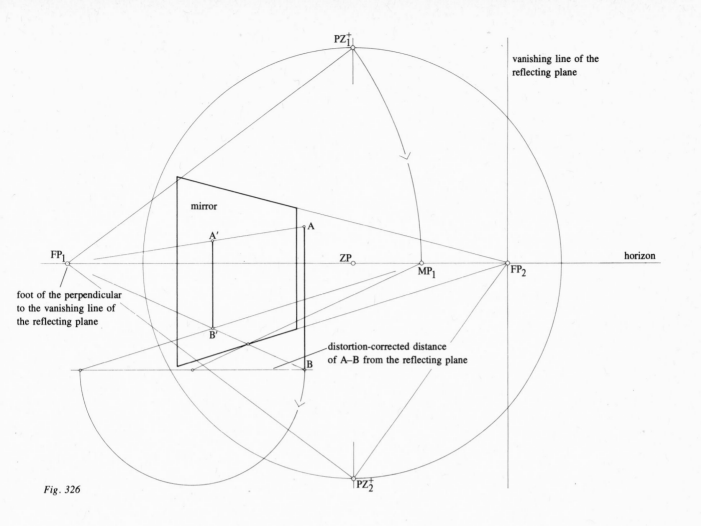

Fig. 326

Fig. 326 labels:

PZ₁⁺ → PZ_1^+

vanishing line of the
reflecting plane

mirror

A′ → A'

A

FP₁ → FP_1

ZP

MP₁ → MP_1

FP₂ → FP_2

horizon

foot of the perpendicular
to the vanishing line of
the reflecting plane

B′ → B'

B

distortion-corrected distance
of A–B from the reflecting plane

PZ₂⁺ → PZ_2^+

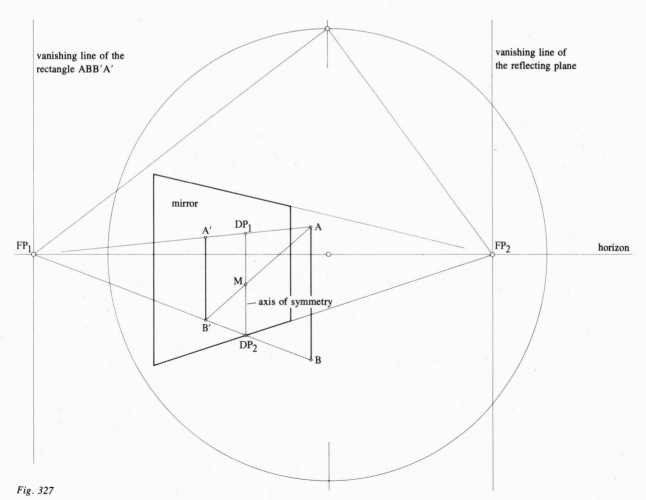

Fig. 327 labels:

vanishing line of the
rectangle ABB′A′

vanishing line of
the reflecting plane

mirror

A′ → A'

DP₁ → DP_1

A

FP₁ → FP_1

FP₂ → FP_2

horizon

M

axis of symmetry

B′ → B'

DP₂ → DP_2

B

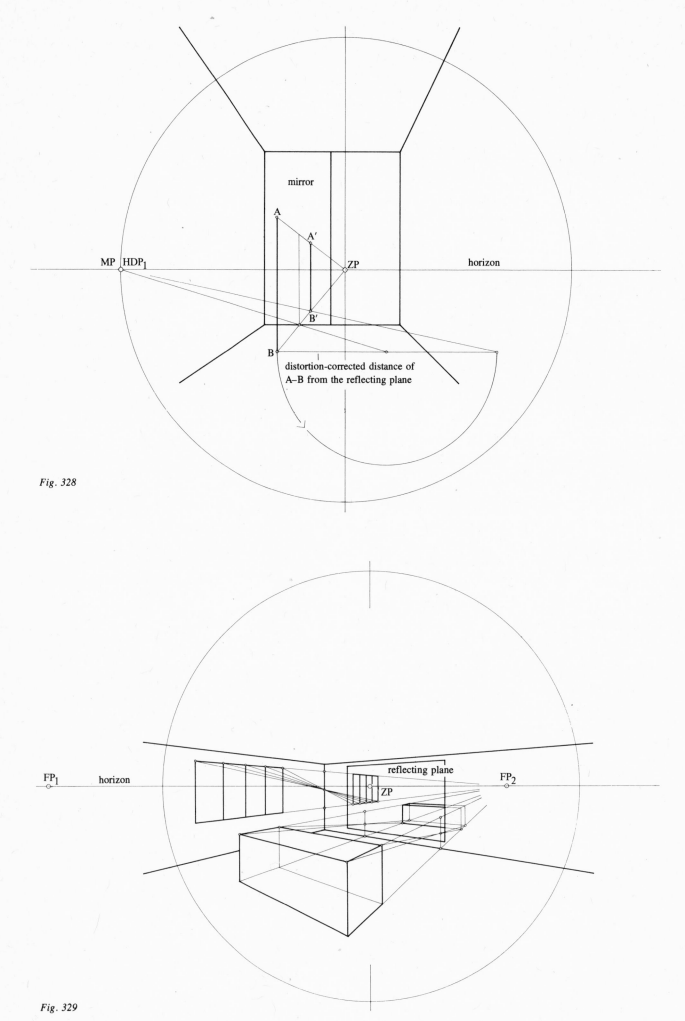

mirror

A

A′

MP HDP₁ ZP horizon

B′

B

distortion-corrected distance of
A–B from the reflecting plane

Fig. 328

FP₁ horizon reflecting plane FP₂

ZP

Fig. 329

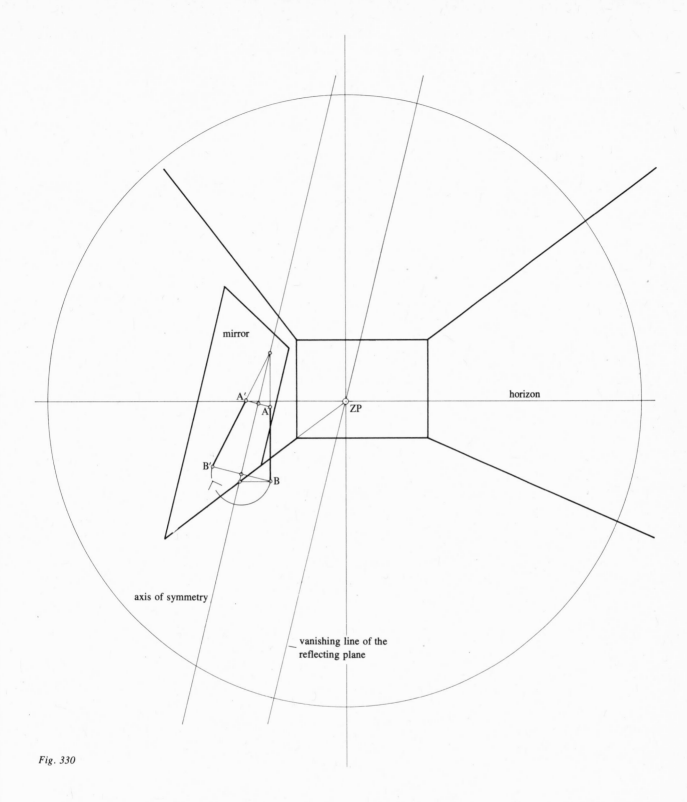

Fig. 330

mirror on the wall at a later stage we will be able to show either the entire mirror image of an object or only a part of it in the mirror. The mirror image of the window thus appears in full but that of the table in the foreground of the drawing only in part. However, we can assume a position of the mirror in which the situation is reversed.

In the oblique mirror in Fig. 330, whose trace coincides with the wall to which it is fixed and which is at right angles to the picture plane, the mirror image of a vertical line AB is to be drawn.

The bottom end B of the vertical is on the floor of the room in which the mirror is set up.

To solve this problem, it is useful to know that the

vanishing line of the mirror plane passes through the center of perspective and is parallel to the associated edges of the mirror. This is true because by turning the drawing or the book so that the vanishing line is horizontal and becomes a horizon, we can basically solve the problem as with the—always horizontal—sheet of water.

A vertical from B intersects the trace of the reflecting plane in a point, through which we draw a line parallel to the vanishing line of the mirror, which is the reflecting axis or axis of symmetry of the reflection. The piercing points of the light rays in the plane of reflection are situated on it; from these the mirror images of A and B are constructed. They

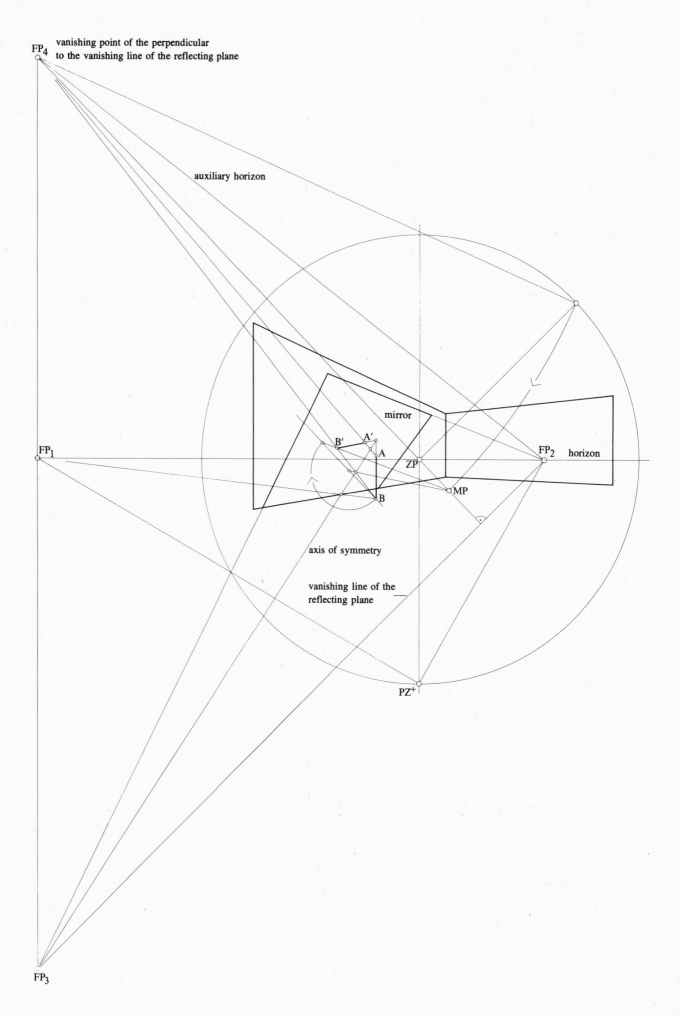

vanishing point of the perpendicular
to the vanishing line of the reflecting plane

FP₄

auxiliary horizon

mirror

B′ A′
 A
FP₁ ZP FP₂ horizon
 B
 MP

axis of symmetry

vanishing line of the
reflecting plane

PZ⁺

FP₃

Fig. 331

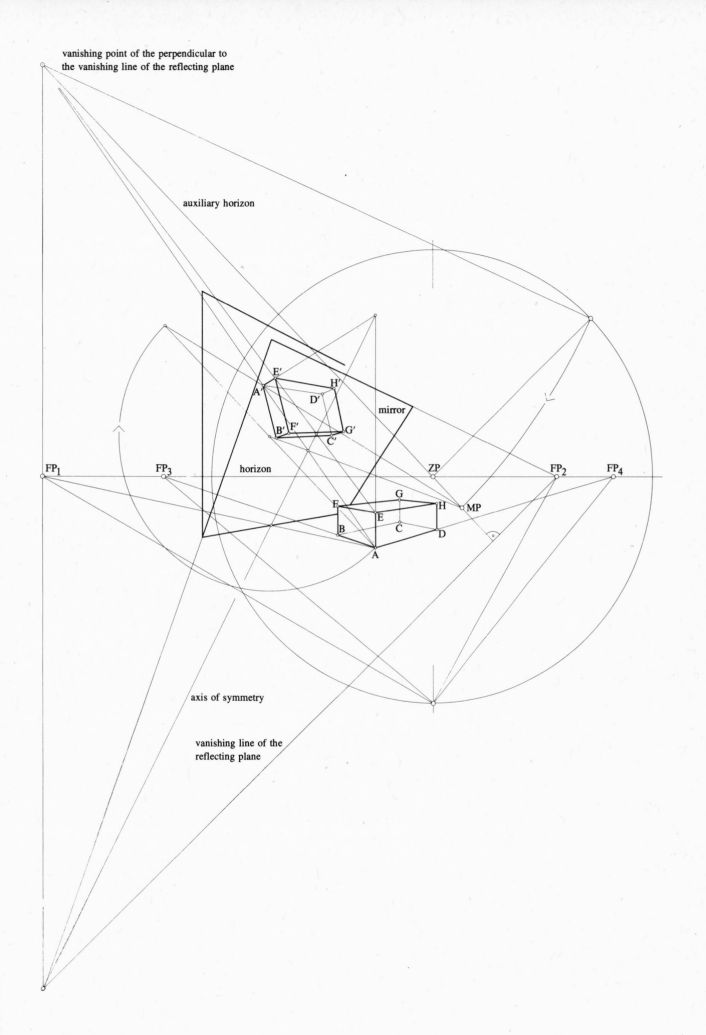

vanishing point of the perpendicular to
the vanishing line of the reflecting plane

auxiliary horizon

E'
H'
A'
D'
mirror
B' F'
G'
C'

FP₁ FP₃ horizon ZP FP₂ FP₄
MP

G
E H
E
B C
D
A

axis of symmetry

vanishing line of the
reflecting plane

Fig. 332

191

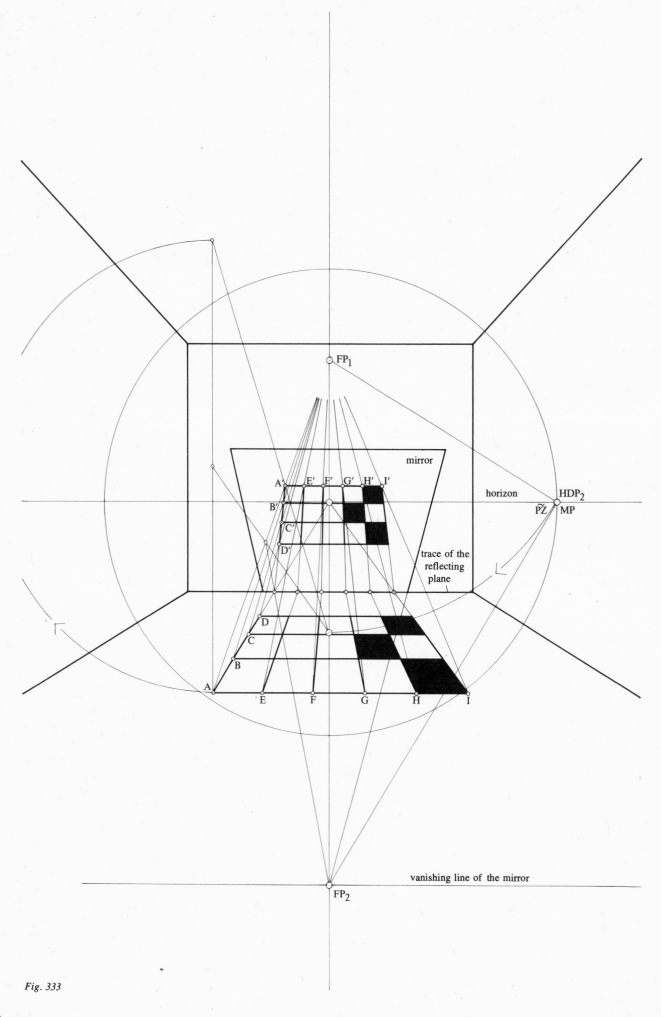

mirror

A' E' F' G' H' I'

B'

C'

D'

horizon HDP₂

P̃Ž MP

trace of the
reflecting
plane

D

C

B

A E F G H I

vanishing line of the mirror

FP₂

FP₁

Fig. 333

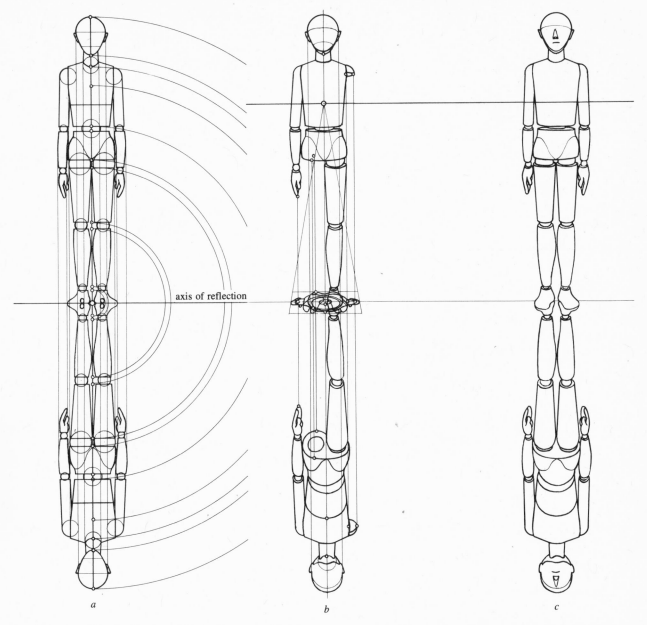

axis of reflection

a b c

Fig. 334 Use of the reflection construction for the representation of a human figure in the form of a dummy.

are centers of circular arcs, with which we are able to transfer the real distances between A and B and the mirror to the reflection.

The interior represented in two-point perspective in Fig. 331 contains a tilted mirror, whose trace coincides with that of a wall of the room. The mirror image of a vertical AB is to be drawn in this mirror. It is useful to treat this vertical as a thin rod, which is extended so that its top end C touches the mirror. The mirror image of C is then coincident or identical with C. This sleight of hand facilitates the solution of this problem in that all we need to do is join B′, the mirror image of the bottom end of the rod, to C to obtain A′, the mirror image of A, which results from the intersection of the connecting line B′C with the connecting line A–FP_4.

To construct the mirror image of the vertical AB in detail, FP_4, the vanishing point of the perpendicular

for the vanishing line of the reflecting plane, must be drawn. We find it with a perpendicular to be erected on the vanishing line of the reflecting plane so that it passes through the center of perspective and intersects the vanishing line we already know as the vertical through FP_1. We use this perpendicular also as auxiliary horizon for the construction of the measuring point MP, through which we correct the distance of P from the reflecting plane for distortion to be able to represent it in perspective for finding B′. The solution calls for the knowledge of the construction of a three-point perspective. We realize this when we join FP_4 to FP_2 and FP_3, for these points are the corners of an acute triangle of a three-point perspective.

In Fig. 332 a cuboid with the corners ABCD and EFGH is to be reflected in a tilted mirror.

If we treat the height edges AB, BF, CG, and DH 193

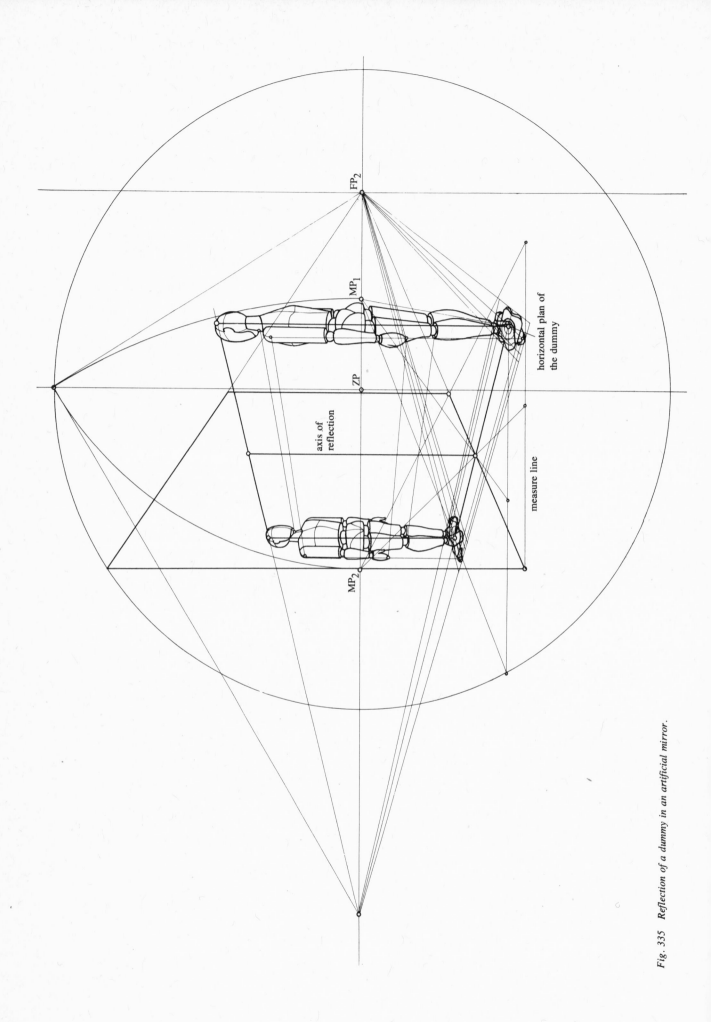

Fig. 335 Reflection of a dummy in an artificial mirror.

as verticals, we can find the mirror image of the cuboid in the reflection of these lines, because the endpoints of the mirror images of these lines have only to be connected to obtain the mirror image of the cuboid.

Part of the floor has a chessboard pattern whose geometric form represents a net of squares (Fig. 333). The mirror image of this net is to be drawn in a tilted mirror mounted on the facing wall of a room so that its trace coincides with that of the wall.

For the reflection of important points of the net such as ABCD and EFGHI, FP_1, the vanishing point of the vertical for the vanishing line of the reflecting plane, must be drawn.

To find the mirror image of the net of squares, we extend the receding lines of this net so that they intersect the trace of the reflecting plane. With the points of intersection we obtain their mirror images, because the trace belongs to the reflecting plane. The mirror images of the extended receding lines of the net originate in the mirror images of these points. The mirror images of EFGH and I are located on a horizontal drawn through A'. If we know this, the mirror images of the receding lines of the net are produced by connecting them with the points on the trace of the reflecting plane.

Fig. 336 The three possible positions of the cube

a Frontal position.
The single direction of the parallel receding edges produces one-point perspective.

b Diagonal position.
The two directions of the parallel receding edges produce two-point perspective.

c Random position.
The three directions of the parallel edges produce three-point perspective.

Reflection of the Human Figure in the Form of a Dummy

If, as in Fig. 334a, the dummy is reproduced in vertical plan and therefore as a planimetric figure, its reflection in the water can be drawn as that of any other plane figure would be. More difficult is the construction of the reflection of a three-dimensionally or perspectively represented dummy (as in Fig. 334b), because this requires a thorough knowledge of the construction of the dummy and its horizontal plan must be represented in perspective. The points of this horizontal plan can be treated as the feet of perpendiculars dropped from the dummy to the floor on which it stands. With the aid of these perpendiculars the dummy can be reflected point by point.

We use the same principle when drawing the mirror image of a dummy in an artificial mirror, as shown in Fig. 335. If we turn Fig. 335 clockwise through 90°, we obtain the mirror image of a figure in the horizontal position in a tilted mirror.

The chapter on reflection concludes the discussion of the perspective of the circle of view. It will be combined with other methods of perspective construction later. Figures 336–339 represent merely a survey of the perspective construction of the cube in the three possible positions with the aid of the circle of view; the captions of the illustrations contain the necessary explanations.

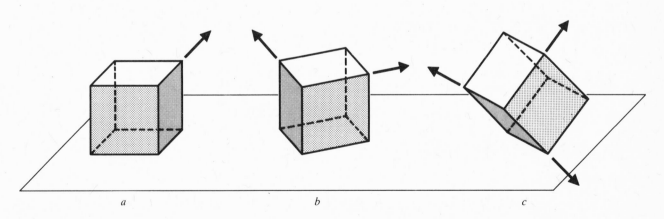

a b c

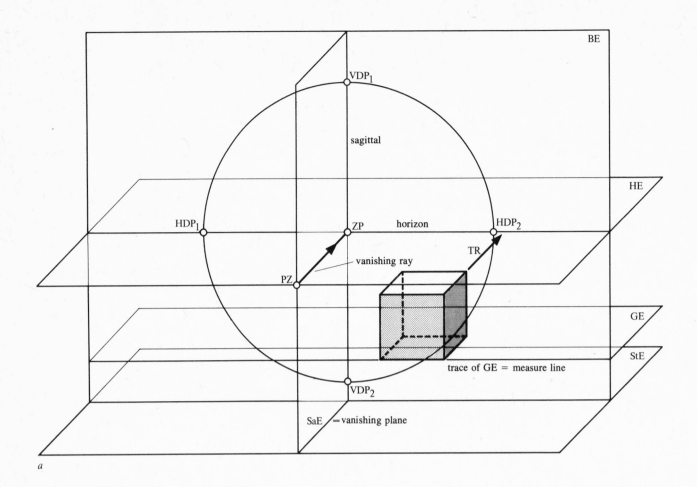

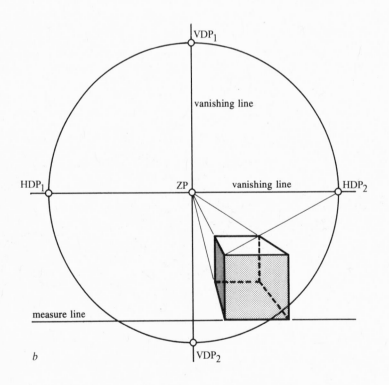

Fig. 337 One-point perspective.
a Horizon and sagittal are the vanishing lines of the faces of the cube
that are not parallel to the picture plane.
b Perspective picture of the cube in the frontal position.

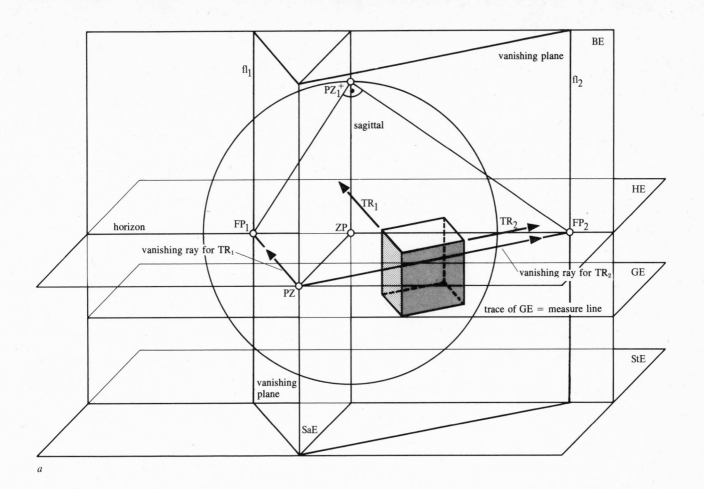

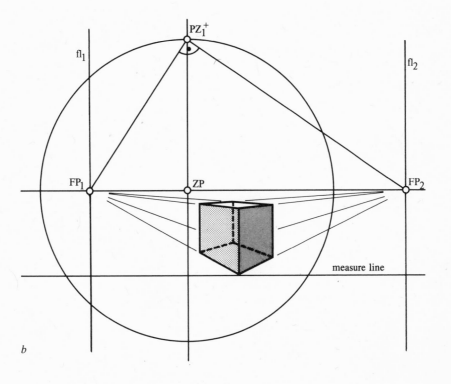

Fig. 338 Two-point perspective.
a The horizon, fl_1, and fl_2 are the vanishing lines of the faces of the
cube in the diagonal position.
b Perspective picture of the cube in the diagonal position.

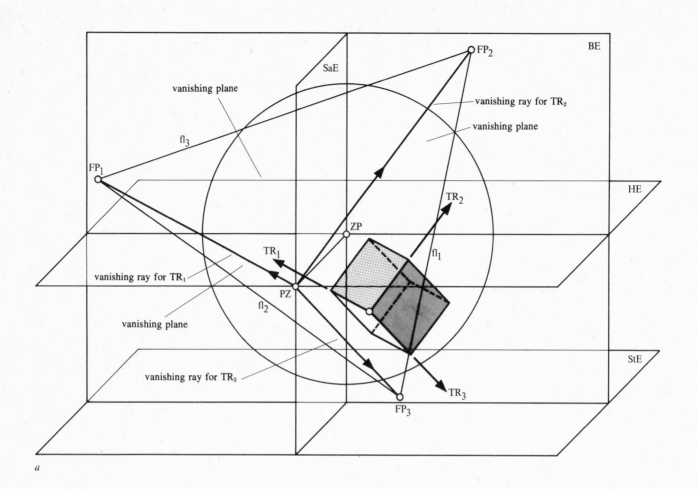

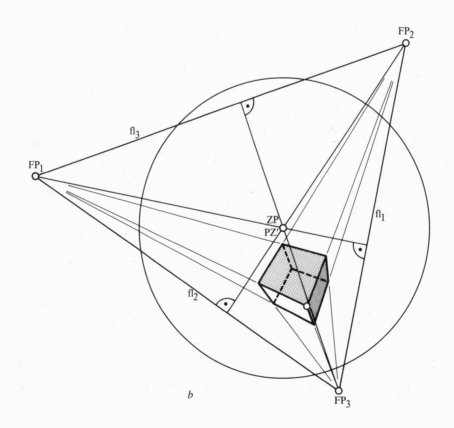

Fig. 339 Three-point perspective.
a fl_1, fl_2, and fl_3 are the vanishing lines of the faces of the cube in
random position.
b Perspective picture of the cube in random position.

The Horizontal/Vertical Plan Method

Perspective Construction of a Cuboid from Its Horizontal and Vertical Plans without Vanishing Points

The method of construction of the perspective of a cuboid as explained below requires the horizontal and vertical plans of this cuboid. We must first discuss how the horizontal and vertical plans of a cuboid are produced. The method is also characterized by the fact that no vanishing points need to be constructed for the drawing of a perspective picture of an object.

The Nature of the Plans

The horizontal and vertical plans and the profiles of an object are its normal projections onto three projection planes that are normal to each other. These plans and profiles are produced by the projection rays that are parallel and normal to the projection planes. We therefore call this type of projection orthogonal or right-angled parallel projection. This differs from the oblique parallel projection, in which the projection rays are oblique to the projection plane. We must remember that central projection, on which perspective is based, is distinct from parallel projection.

Horizontal and Vertical Plans of a Point

The origin of the horizontal plan of point P on the ground plane (Fig. 340) is explained as follows: Let us draw a straight projection ray normal to the ground or the first projection plane. It meets or intersects the projection plane in P′ or the horizontal plan of P, which we distinguish by adding ′ to P. The vertical plan or the second projection of P is produced analogously: A projection ray normal to the elevation plane is drawn through P; it produces the vertical plan of P where it meets the second projection plane of the vertical plan. Because it is the second projection, we designate the vertical plan of P as P″.

In Fig. 340a, PP′ is the distance between P and the ground plane, which we also call Π_1, and PP″ is that between P and the plane of the vertical plan, called Π_2.

We now rotate the ground plane around the reference line of projection RA, which we can compare to a hinge, downward so that it coincides with the plane of the vertical plan; all we are doing is rotating the first plane into the second to obtain the horizontal and vertical plans in one and the same plane. Because the reference line of projection belongs to both the first and the second projection plane, it can also be treated as the line of intersection between the two planes; we therefore call it $X_{1,2}$. A comparison of Figs. 341a and 341b shows the situation after the plane has been rotated. Points P′ and P″ are the endpoints of a vertical that really consists of two parts, the one above and the one below the reference line of projection RA.

The line between P′ and the reference line of projection provides information about the distance of the original point P from the ground plane. The line between P″ and the reference line of projection, on the other hand, indicates the distance between P and the vertical plane; but it is also the projection of the quadrant that P′ describes as the plane is being turned. It must also be remembered that the line between P′ and the reference line of projection represents the horizontal plan of the projection ray, which produces the vertical plan of P, and furthermore that the line between P″ and the reference line of projection reproduces the vertical plan of the projection ray, which results in the horizontal plan of P.

Horizontal and Vertical Plans of a Cuboid

Figures 343a and b illustrate the production of the horizontal and vertical plan of a cuboid in the diagonal position, whose edges we treat as the connecting lines between its corners ABCD and EFGH. Therefore we project the cuboid by reproducing important points of it (that is, its corners), which we must then join according to the original to obtain its horizontal and vertical plans.

Figure 343a graphically explains the origin of the horizontal and the vertical plan of a cuboid. The horizontal plan can also be seen as the profile of its shadow cast when the sun's rays are vertically incident. We can accordingly interpret the vertical plan of the cuboid as the profile of its shadow cast on the

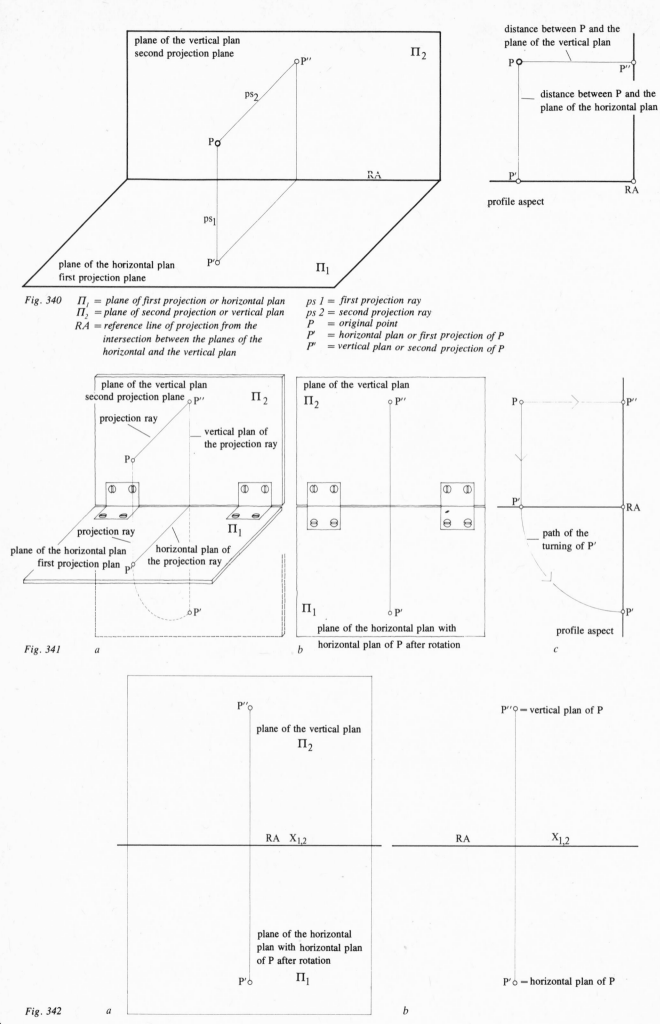

plane of the vertical plan
second projection plane

Π₂

P''

ps_2

P

ps_1

P'

plane of the horizontal plan
first projection plane

Π₁

RA

distance between P and the
plane of the vertical plan

P P''

distance between P and the
plane of the horizontal plan

P' RA

profile aspect

Fig. 340 Π₁ = plane of first projection or horizontal plan ps 1 = first projection ray
 Π₂ = plane of second projection or vertical plan ps 2 = second projection ray
 RA = reference line of projection from the P = original point
 intersection between the planes of the P' = horizontal plan or first projection of P
 horizontal and the vertical plan P'' = vertical plan or second projection of P

plane of the vertical plan
second projection plane P''

Π₂

projection ray

P

vertical plan of
the projection ray

projection ray

Π₁

plane of the horizontal plan
first projection plan P'

horizontal plan of
the projection ray

P'

plane of the vertical plan

Π₂ P''

Π₁ P'

plane of the horizontal plan with
horizontal plan of P after rotation

P P''

P' RA

path of the
turning of P'

profile aspect

P'

Fig. 341 a b c

P''

plane of the vertical plan
Π₂

RA X₁,₂

plane of the horizontal
plan with horizontal plan
of P after rotation

P' Π₁

P'' = vertical plan of P

RA X₁,₂

P' = horizontal plan of P

Fig. 342 a b

200

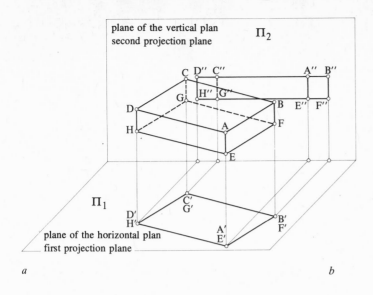

Π_2

C D'' C'' A'' B''

G H'' G''

D B E'' F''

H A F

E

Π_1

plane of the horizontal plan
first projection plane

C'
G'

D'
H' B'
F'

A'
E'

a

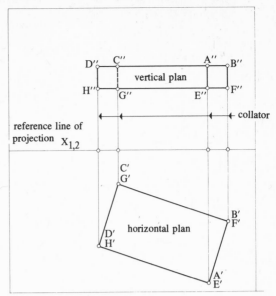

D'' C'' A'' B''

vertical plan

H'' G'' E'' F''

reference line of
projection $X_{1,2}$ ← collator →

C'
G'

D'
H' horizontal plan B'
F'

A'
E'

b

Fig. 343 *The plane of the horizontal plan with the horizontal plan of the cuboid after rotation.*

plane of the vertical plan when the sun's rays are normal to it.

Figure 343b shows the plane of the horizontal plan after it has been rotated—when, in other words, it coincides with that of the vertical plan or with our sheet of drawing paper. The associated points of the cuboid are joined by so-called collators or verticals.

The cuboid or any other structure can be projected not only onto two but onto several planes. All we have to do is imagine the cuboid inside a hollow cube whose sides are projection planes made of glass. This will enable us to project the cuboid six times, onto each side of the cube, or produce six projections of it. But the number of plans of an object that can be obtained depends on its shape and structure. Thus two plans of a glass or a vase are enough to characterize it. Five plans are necessary to describe the exterior of an automobile.

The Profile Plan of a Cuboid

To explain the production of three plans of a cuboid on three planes normal to each other, it is necessary to describe the origin of its profile clearly and to demonstrate the relation that exists between the horizontal, vertical, and profile plans of an object.

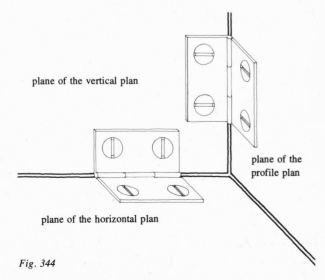

plane of the vertical plan

plane of the
profile plan

plane of the horizontal plan

Fig. 344

The planes of the horizontal, vertical, and profile plans form the corner of a space, as illustrated in Fig. 344. These three planes are joined by means of hinges so that the planes of the horizontal and of the profile plans can be moved into the same position as the plane of the vertical plan, which remains fixed. The parts of the hinges are in the same position as the boards or planes they join (Fig. 345).

This corner of space may be made of thin plywood, stout paper, or cardboard. This model can be designed as follows: An oblong piece of paper of any size is folded so that both its length and its width are halved. We can treat the longer fold as the longitudinal and the shorter one as the transverse axis of the paper rectangle (Fig. 346a).

We now cut the longitudinal fold in half from the right as shown by the bold horizontal line in Fig. 346b, thereby separating the part representing the profile plane from that representing the plane of the horizontal plan. We can cut the profile plan so that its length corresponds to the width of the plane of the horizontal plan. The paper rectangle from which we form the corner of the space represents a plane figure from which we produce a three-dimensional structure, as shown in Fig. 346c. Conversely, the corner of the space must again be reduced to a single plane as follows: The plane of the vertical plan is left in its original position, the plane of the horizontal plan rotated downward, and the plane of the profile plan rotated clockwise through 90°; they are now all in the plane of our drawing paper. This operation is graphically illustrated in Fig. 347; Fig. 348a shows the three planes as a result of it, in the same plane as the plane of the vertical plan and the sheet of drawing paper, symbolized by the hinges.

Figure 348b shows that the intersection of planes Π_1 and Π_3 results in a line that becomes the reference line of projection $X_{1,3}$. But it must be kept in mind that the axis $X_{1,3}$ coincides with the vertical axis $X_{2,3}$ through the turning of the plane of the horizontal plan and with the reference line of horizontal projec-

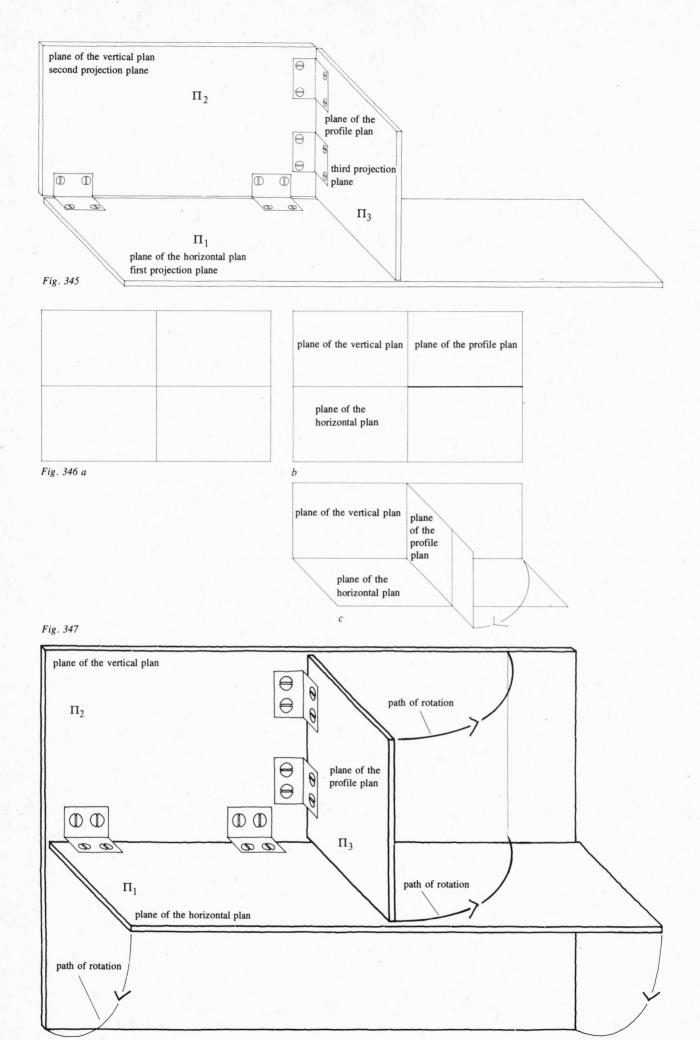

plane of the vertical plan
second projection plane

Π_2

plane of the
profile plan

third projection
plane

Π_3

Π_1

plane of the horizontal plan
first projection plane

Fig. 345

Fig. 346 a

plane of the vertical plan | plane of the profile plan

plane of the
horizontal plan

b

plane of the vertical plan | plane
of the
profile
plan

plane of the
horizontal plan

c

Fig. 347

plane of the vertical plan

Π_2

path of rotation

plane of the
profile plan

Π_3

Π_1

plane of the horizontal plan

path of rotation

path of rotation

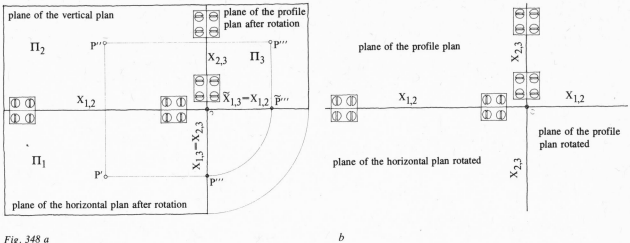

plane of the vertical plan

plane of the profile
plan after rotation

Π_2 P''

$X_{2,3}$ Π_3 P'''

$X_{1,2}$ $\widetilde{X}_{1,3} = X_{1,2}$ \widetilde{P}'''

$X_{1,3} = X_{2,3}$

Π_1 P'

P'''

plane of the horizontal plan after rotation

Fig. 348 a *b*

plane of the profile plan

$X_{2,3}$

$X_{1,2}$ $X_{1,2}$

plane of the horizontal plan rotated

plane of the profile
plan rotated

$X_{2,3}$

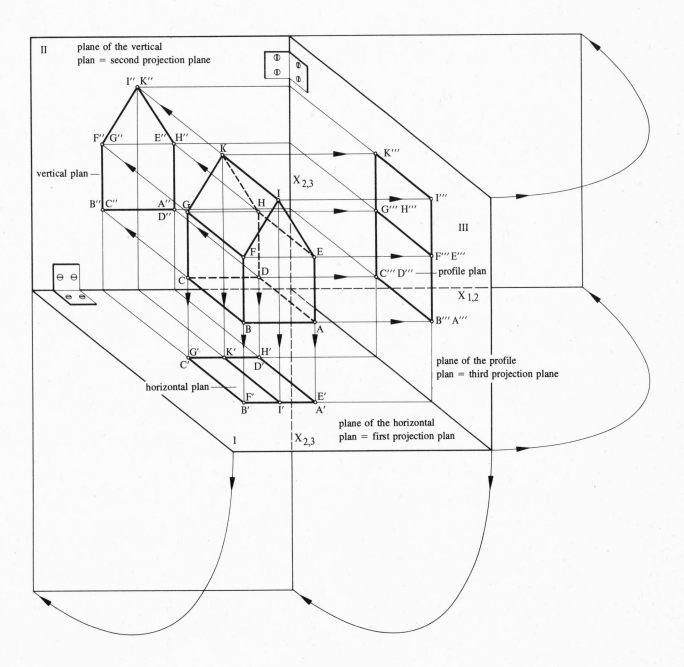

II plane of the vertical
plan = second projection plane

I'' K''

F'' G'' E'' H''

vertical plan —

B'' C'' A'' G H I G''' H'''

D'' $X_{2,3}$

K'''

I'''

III

F''' E''' — profile plan

C''' D'''

$X_{1,2}$

B''' A'''

G' K' H'
C' D'
horizontal plan —
F' E'
B' I' A'

plane of the profile
plan = third projection plane

plane of the horizontal
plan = first projection plan

I $X_{2,3}$

Fig. 349 a

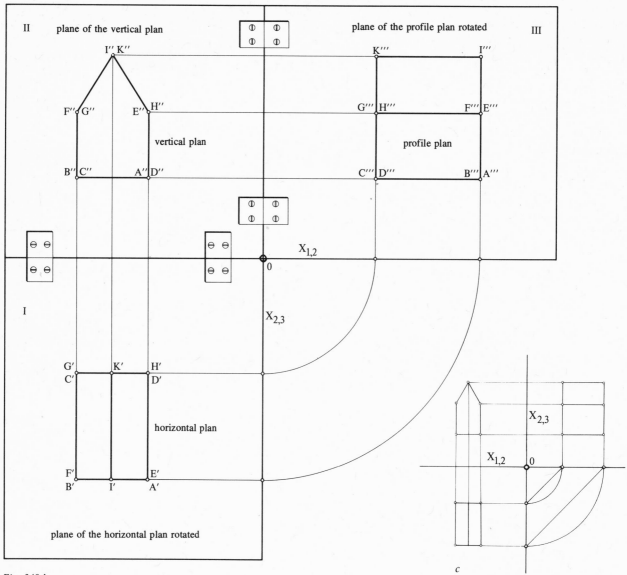

Fig. 349 b

c

tion $X_{1,2}$ through the turning of the plane of the profile plan. We therefore call the reference line of horizontal projection $X_{1,2}$ and the vertical one $X_{2,3}$.

If we imagine Fig. 348b without the hinges, only the intersecting reference lines of horizontal and vertical projection remain. We call their point of intersection O. The horizontal, vertical, and profile plans of a point can be constructed with this simple figure of intersecting axes. Figure 348a shows the intersecting axes in conjunction with the framed projection planes and their hinges. This explains the construction of the profile plan or third projection of P.

It further shows that the profile of P, P''', is first produced on the reference line of projection $X_{2,3}$ and transferred to the reference line of projection $X_{1,2}$ with a quarter-circle. With its center in O this represents the rotation of the plane of the profile plan into that of the vertical plan. During this turn all points in the plane of the profile plan describe quarter-circles.

The point P''' rotated onto the reference line of projection $X_{1,2}$ is called P̃'''. To obtain P''' in the rotated plane of the vertical plan, we erect a perpendicular at P̃''' and intersect the perpendicular with a

horizontal drawn through P''. The resulting point of intersection corresponds to the profile plan of P or P'''. The perpendicular erected at P̃''' and the horizontal through P'' are called collators.

The Horizontal, Vertical, and Profile Plans of a Building

If we know how to construct the horizontal, vertical, and profile plans of a cuboid, we will be able to do the same for a building (Fig. 349a), because it involves its point-by-point reproduction in the three projection planes with the aid of parallel projection rays. In other words, we project the points of the building called ABCD, EFGH, I and K and join them according to the original to obtain the horizontal, vertical, and profile plans of the building. Figure 349a explains the production of these plans with the aid of the spatial model discussed. In Fig. 349b the planes of the horizontal and profile plans are reproduced after they have been turned; Fig. 349c shows the three projections of the building in their relation to the intersecting axes.

Figure 349a gives us the opportunity to compare the original points of the building with the picture

points. We note that those original points located on a projection ray produce only one picture point each. Thus, for instance, the original points B and F are on the same vertical projection ray and therefore produce only the one picture point on the plane of the ground plan. That, conversely, the projecting ray must be correlated with two original points we can see only because of the designations B′ and F′ for this picture point. An analogous situation exists in the case of the two original points A and B, which are located on the same horizontal projection ray for the production of a picture point on the profile plane.

The horizontal and vertical plans and profile of an object are also called the "three-side aspect," because they show the object projected from three different directions and, accordingly, three different sides of it. In other words, the horizontal, vertical, and profile plans of an object produce three different pictures of it, whose dimensions are, however, interdependent and agree with each other and recur in the individual projections.

The Perspective Projection of a Point from Its Horizontal and Vertical Plans

Another model, shown in Fig. 350, explains the origin of the perspective picture of P from its horizontal plan P′ and its vertical plan P″. The planes Π_1 of the horizontal plan and Π_2 of the vertical plan are used to produce the horizontal and vertical plans of P. We use the picture plane, called Π, to construct

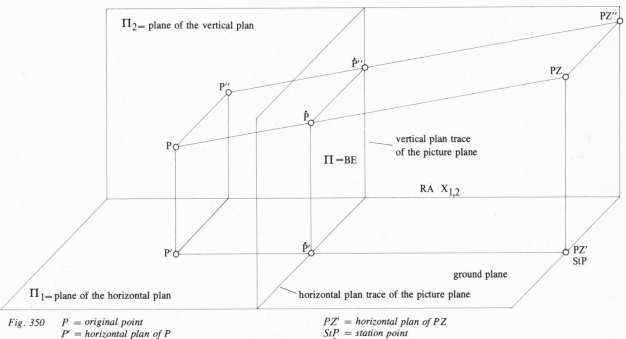

Fig. 350 P = original point
 P′ = horizontal plan of P
 P″ = vertical plan of P
 P̊ = central projection or perspective
 representation of P

 PZ = center of projection

PZ′ = horizontal plan of PZ
StP = station point
P̊′ = horizontal plan of the perspective representation of P
P̊″ = vertical plan of the perspective representation of P

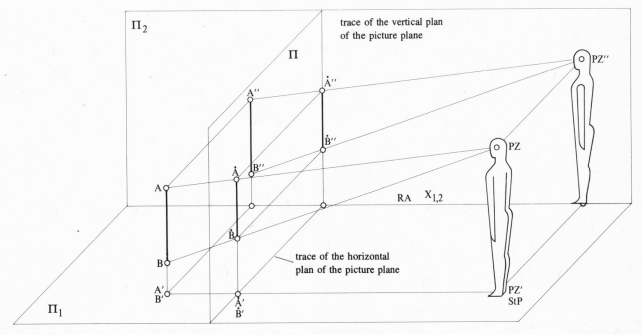

Fig. 351

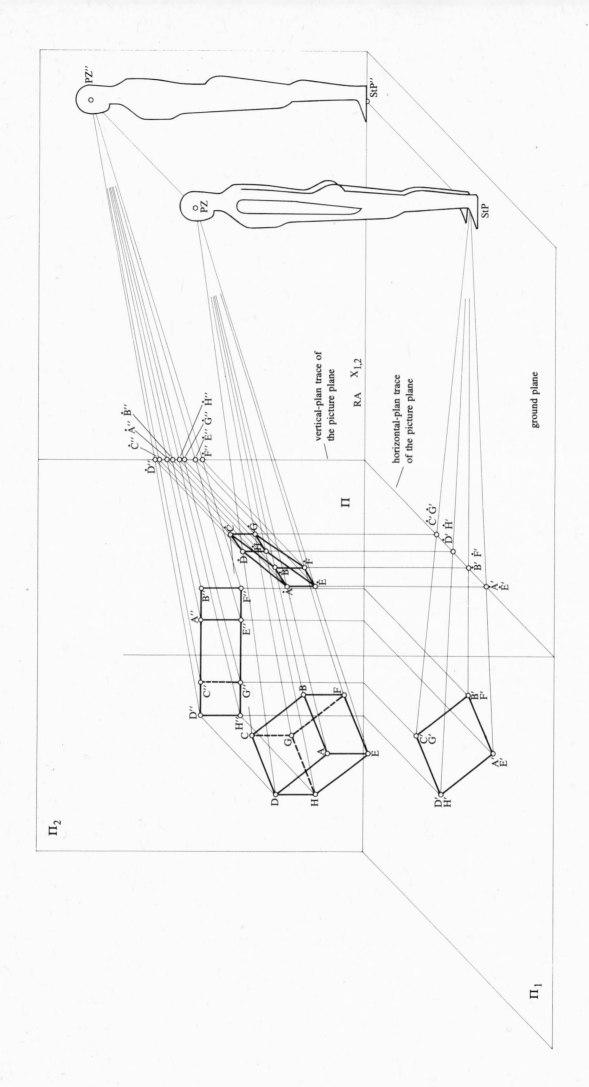

Fig. 352

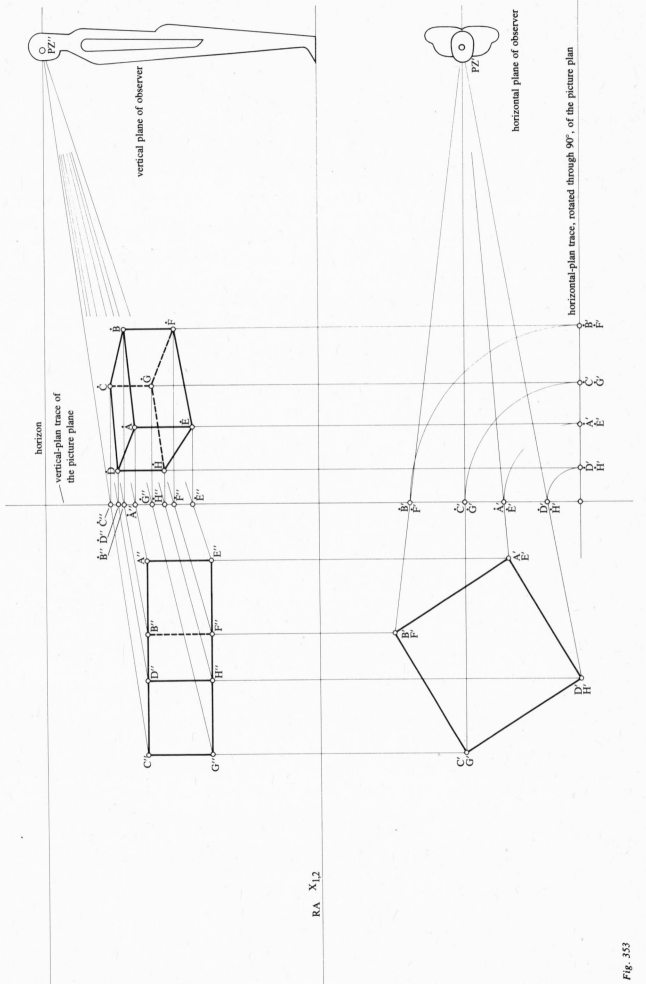

vertical plane of observer

horizontal plane of observer

horizontal-plan trace, rotated through 90°, of the picture plan

horizon

vertical-plan trace of the picture plane

RA X$_{1,2}$

Fig. 353

the perspective picture of P. The plane of the horizontal plan is also the ground plane on which the observer is standing. In Fig. 350 it is represented by the vertical PZ–PZ'.

However, the intersection lines between the projection planes are of special significance; the intersection between Π and Π₂ produces the reference line of projection $X_{1,2}$. The intersection of Π and Π₂ produces the horizontal plan trace of the picture plane.

To obtain the perspective picture (that is, P̊) in the graphic drawing of Fig. 350, P' would actually be enough, because from the intersection of the connecting line P'–PZ' with the horizontal-plan trace of the picture plane results P̊', the horizontal plan of the perspective picture of P. From P̊' we obtain P̊, the perspective picture of P, by erecting a perpendicular at P̊' and intersecting it with the projection ray PZ–P. Point P̊ is really the point where this projection ray pierces Π; but the horizontal plan of the projection ray (that is, P'–PZ) is required to construct P̊. Figure 350 further demonstrates that we can determine P̊ also from P'', its vertical plan, because this is where the connecting line PZ'–P'' intersects the vertical-plan trace of the picture plane. The projection ray PZ–P must intersect a parallel to the horizontal plan trace of the picture plane from P̊' to obtain P̊.

The Perspective Projection of a Vertical from Its Horizontal and Vertical Plans

Figure 351, which includes the observer, graphically demonstrates how the perspective projection of a vertical AB is obtained. The vertical plan of the observer can also be treated as his cast shadow produced on the plane of the vertical plan when the sun's rays are normal to it. If we imagine the two visual rays PZ–A and PZ–B as thin wires, we could likewise treat their vertical plans as their cast shadows. If the sun's rays are perpendicularly incident, the cast shadows of the two wires will produce only one straight line, PZ'–A', which will be coincident with PZ'–B'.

The initial point and endpoint of the vertical AB produce only one picture point on the plane of the

horizontal plan, because they are located in a vertical projection ray.

The perspective projections of these points are obtained according to the method used for finding P̊ in Fig. 350.

The Perspective Projection of a Cuboid in the Diagonal Position from Its Horizontal and Vertical Plans

Figure 352 shows the construction of the perspective picture of a cuboid ABCD and EFGH through point-by-point central projection.

This illustration of how the perspective picture of a cuboid in the diagonal position is constructed from its horizontal and vertical plans should be considered together with Fig. 353. It is significant in that it explains how the perspective projection of an object can be drawn from its horizontal and vertical plans.

To understand this drawing, let us imagine that the ground plane or plane of the horizontal plan is rotated downward. We are now interested in the traces of the picture plane, which contain the piercing points of the horizontal and vertical plans of the projection rays. From these points we determine the perspective picture of the cuboid.

We see in the graphic illustration Fig. 352 that the horizontal-plan trace of the picture plane forms a right angle with its vertical-plan trace. But after the plane of the horizontal plan has been rotated, the horizontal-plan trace of the picture plane together with its vertical-plan trace forms a vertical. However, we cannot leave the horizontal-plan trace of the picture plane in this position, in which it coincides with its vertical-plane trace. It is necessary to draw the horizontal-plan trace of the picture plane normal to its vertical-plan trace, that is, as it was before the plane of the horizontal plan was rotated.

The piercing points must be transferred from the vertical horizontal-plan trace of the picture plane to the horizontal-plan trace normal to it by means of quarter-circles or by simply marking them off with a pair of compasses.

The corners of the cuboid in perspective are the points of intersection between verticals and horizontals. The verticals begin from the piercing points

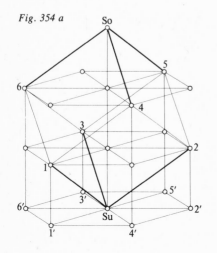

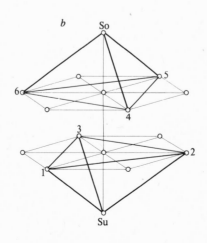

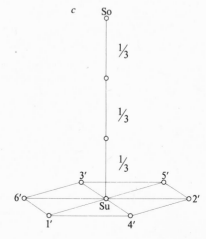

Fig. 354 a b c

on the horizontal horizontal-plan trace of the picture plane; the horizontals begin from the piercing points on the vertical-plan trace of the picture plane. The perspective picture of the cuboid can therefore be constructed point by point and without vanishing points, which may, however, be found subsequently and for checking purposes by extending the receding edges of the cuboid.

The station point or horizontal plan of the center of projection should be chosen so that the central visual ray passes roughly through the center of the object, which should be centrally projected. The angle of view within which the observer sees the object should be strictly between 60° and 30° to avoid excessively distorted perspectives.

The distance of the object from the picture plane should be chosen so that the piercing points on the horizontal- and vertical-plan traces of the picture plane are not too close together.

The Perspective Picture of the Cube in a Random and in a Special Position

With the aid of the method just described let us discuss the construction of the perspective picture of the cube from its horizontal and vertical plans; the cube stands on a corner so that the body diagonal passing through it is vertical. The position of the cube, which produces three vanishing points, may either be random or special. The horizontal plan of the cube in this position is a regular hexagon drawn from a circle on which its radius is marked off six times. This position can be visualized with the aid of a wire cube, because when the sun's rays are vertically incident on it in this position, its cast shadow produces a regular hexagon with its diagonals.

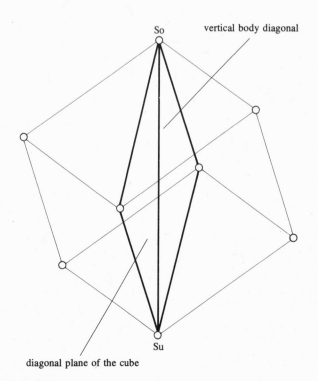

Fig. 355

To be able to draw the vertical plan of the cube determined from its horizontal plan, the structure of the cube in the relevant position will be explained with the aid of Figs. 354a, b, and c.

Let us first examine Fig. 354a. The endpoints 1, 2, and 3 of the edges starting from the bottom corner Su are situated in the horizontal plane of the hexagon of the horizontal plan. This hexagon contains the points 1, 2, and 3, which when joined to each other form an equilateral triangle. The corners 5, 6, and 7 of the three edges coming from the top corner So likewise lie in a horizontal plane. The equilateral triangle formed when points 5, 6, and 7 are joined appears rotated through 180° with reference to the triangle with the corners 1, 2, and 3 (Fig. 354b).

The distance between the two hexagonal planes is the same as between these planes and the top and bottom corners of the cube. To draw the vertical spatial diagonal with the centers of the horizontal planes, we must divide the spatial diagonal into three equal parts as in Fig. 354c. We must now find the height of the vertical spatial diagonal. We therefore have to remember that a spatial diagonal of a cube is also a diagonal of a diagonal plane of the cube (Fig. 355).

This illustration shows that a diagonal plane can be arranged through a spatial diagonal of a cube. Conversely, the length of a spatial diagonal can be determined from a diagonal plane. This diagonal plane is a rectangle, which we can draw from an edge and a plane diagonal of the cube.

Let us now consider the horizontal plan of the cube, as shown in Fig. 356a. The edges coming from the top corner with the corners 5′, 6′, and 7′ in the horizontal plan are drawn in bold lines. This illustration will also reveal that no edge of the cube appears in its true size; in other words, all edges are shortened. The plane diagonals, on the other hand, are not. They result from the connection of 4′, 5′, 6′, and 7′. Thus it is possible to construct the length of an edge and therefore of a side from the horizontal plan of the cube in the given position through one of its nonshortened plane diagonals.

Because in a square the diagonals are normal to and bisect each other, a square can be constructed from its diagonals (Fig. 356b). From a nonshortened plane diagonal of the cube and the side of the square or edge of the cube found, we can construct the rectangle whose diagonals correspond to the required spatial diagonal of the cube (Fig. 356c). The rectangle of Fig. 356c is a diagonal plane of the cube.

Figure 357 shows once again how to find the spatial diagonal of the cube, with which the vertical plan of the cube can be drawn. It also indicates that we must divide the vertical spatial diagonal into three equal parts so that we can draw through the division points between Su″ and So″ horizontal lines on which the points 1″, 2″, 3″, 4″, 5″, and 6″ lie. These are produced by the intersections between the

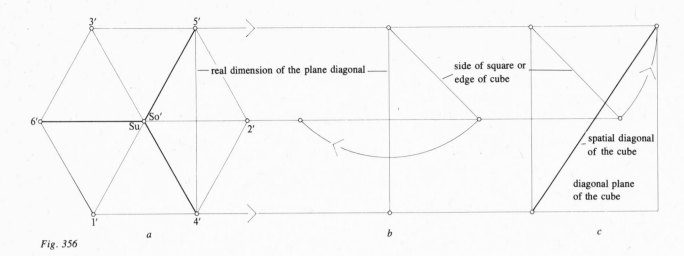

real dimension of the plane diagonal

side of square or edge of cube

spatial diagonal of the cube

diagonal plane of the cube

Fig. 356

a b c

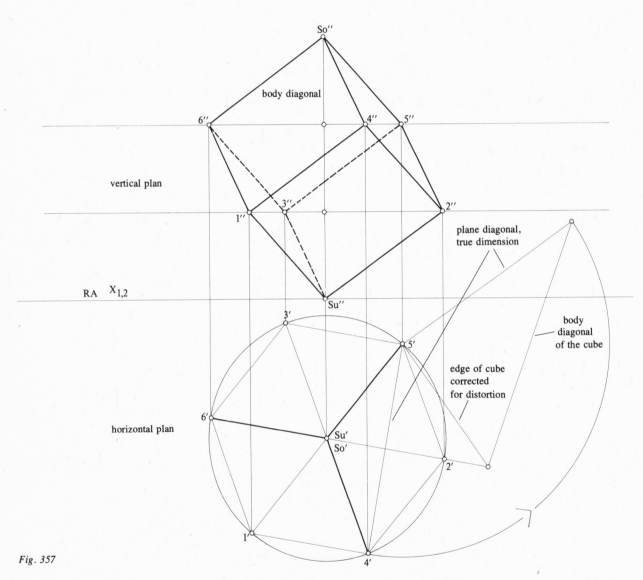

So''

body diagonal

6'' 4'' 5''

vertical plan

1'' 3'' 2''

Su''

RA X$_{1,2}$

plane diagonal, true dimension

3' 5'

body diagonal of the cube

edge of cube corrected for distortion

6' Su'
 So'
 2'

horizontal plan

1' 4'

Fig. 357

collators from the horizontal plan and the related horizontals. How must we join 1″, 2″, 3″ and 4″, 5″, 6″ to obtain the vertical plan of the cube as a whole? This problem is solved with the aid of the horizontal plan of the cube: The points joined in this plan must also be joined in the vertical one.

Figure 358 shows how to construct the perspective projection of a cube from its horizontal and vertical plans in the given position. The method to be used has been explained on the basis of Figs. 352 and 353.

To understand the concept of "visibility" requires close scrutiny of Fig. 352, which characterizes a figure from the aspect of its visible and its invisible elements; invisible lines are dashed as in the perspective picture of the cube in Fig. 358, to define its true position as seen by the observer. In the determination of visibility it must be kept in mind that the parallel projection of the cube for the drawing of its horizontal and vertical plans is executed from a direction different from that of central projection,

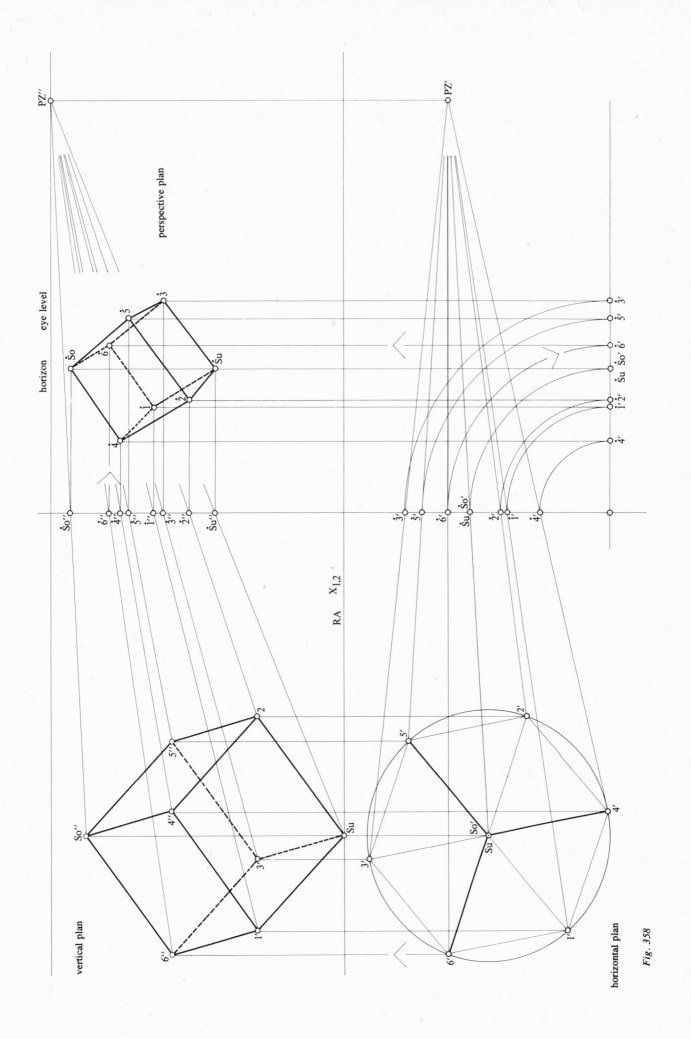

perspective plan

eye level

horizon

vertical plan

RA $X_{1,2}$

horizontal plan

Fig. 358

211

which produces its perspective picture, according not only to Fig. 358 but also to Figs. 352 and 353.

In Fig. 359 the same method as in Fig. 358 for the construction of the perspective picture of the cube has been used for the representation of the horizontal plan of this cube in perspective. To check the correctness of the construction used in Fig. 359, the vanishing points of the sides and of the diagonals of the regular hexagon (which is, of course, the horizontal plan of the cube) have also been drawn. These vanishing points are on the vanishing line of the hexagon or horizon.

In Fig. 360 the same cube has been drawn, this time with the assumption of a somewhat different aspect, which accordingly results in a perspective picture different from that in Fig. 358. The significance of Fig. 360 consists, however, in the establishment of a connection between the horizontal/ vertical plan method and the circle of view method. Although the circle of view is not reproduced in Fig. 360, it could be subsequently constructed with the aid of an acute triangle formed by connecting the vanishing points FP_1, FP_2, and FP3, which could be easily found from the extensions of the edges of the cube.

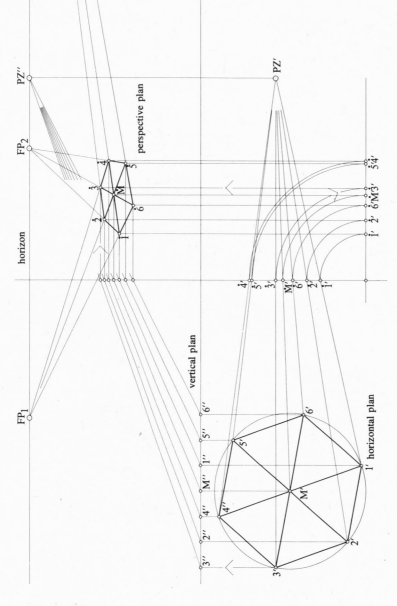

Fig. 359

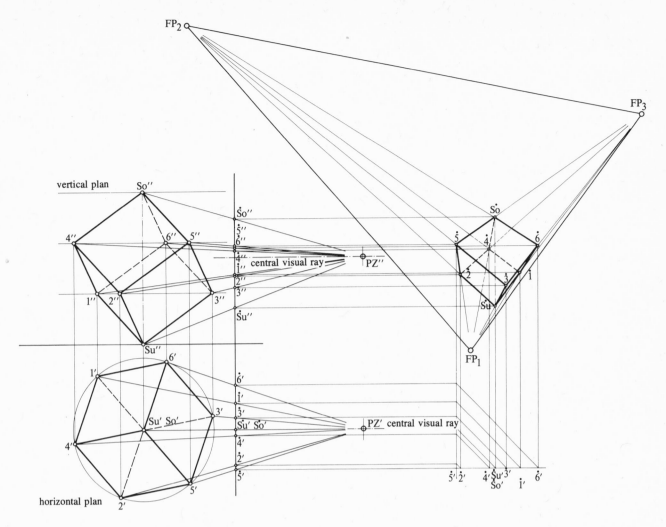

vertical plan

horizontal plan

Fig. 360

Perspective Construction of a Cuboid from Its Horizontal and Vertical Plans with Vanishing Points

This method, too, is explained with the aid of a model shown in Fig. 361a, consisting of three horizontal and three vertical planes, which in Fig. 361b and c are in the plane of the drawing sheet.

In this construction method we must begin by drawing the perspective picture of an object from its horizontal and vertical plans as the starting feature. We must therefore look first at that part of the model in Fig. 361a in which the horizontal and vertical plans of the cuboid ABCD and EFGH in the diagonal position are produced. Its base ABCD is in the object plane GE, which intersects the picture plane BE I to produce the measure line. The distance between GE and the plane Π_1 is that between the cuboid and Π_1, on which its horizontal plan is produced. The plane Π_2 with the vertical plan of the cuboid intersects Π_1, producing the reference line of projection.

The part of the model in Fig. 361a discussed so far involves the parallel projection of the cuboid; we now enter the field of central projection, which is connected with the picture plane BE. Whereas the base of the model in Fig. 361a is the plane of the horizontal plan in parallel projection, in central projection it represents the ground plane on which the

observer stands; his head coincides with the center of perspective, which at the observer's eye level, lies in the horizon plane. PZ′, or the horizontal plan of PZ, is identical with the station point, StP.

For the central projection of the cuboid a relation must be established between the cuboid and the picture plane, which can be done in various ways.

In Fig. 361 this relation consists in the contact between the edge AE of the cuboid with the picture plane. AE is therefore in the picture plane, where it appears in its true dimension. This explains why we require contact between the cuboid and the picture plane. Figure 361b shows that the horizontal plan of the measure line coincides with the trace of the picture plane, and its vertical plan with the reference line of projection RA.

After the alignment of the picture plane with the cuboid we must determine the center of projection in the head of the observer. This raises the question where and at what distance from the picture plane the observer is to be assumed to produce a good perspective picture of the cuboid. There is no simple answer. According to one rule of thumb for determining the distance between the center of projection and the picture plane, it should be three times the height of the object to be rendered in central projection. But this rule is based only on the height of the object, whereas its width and depth must also be considered.

213

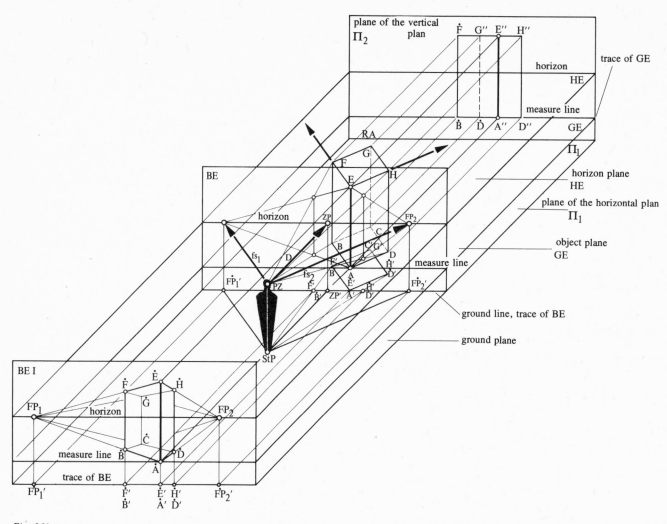

Fig. 361 a

Another problem that requires detailed discussion is that of the distance D between the center of projection and the picture plane (Fig. 373): With this distance we also know the size of the circle of view, which we are able to construct in both the horizontal and the vertical plans, so that we can judge whether and to what extent the object or cuboid to be reproduced in central projection lies within or outside it. We can superimpose the 60° sector of view or the zone of least distortion within the 90° sector of view on the construction of the circle of view in the vertical plan so that the object of central projection appears within this zone. The distance should therefore be determined according to the size of the circle of view resulting from it and of the zone of least distortion situated within it.

In the perspective model the distance coincides with the line of intersection between the horizon and the sagittal planes; the latter is not shown in Fig. 361a. Because the line of intersection between two planes is the locus of all the points these planes share, the distance between the center of projection and the picture plane can be associated with either plane. The same applies to MS, the central visual ray, which starts from the center of projection and with which the distance coincides; it, too, can be associated either with the horizon or with the sagittal plane. But we now see MS in conjunction with the

vertical sagittal plane, so that we can better define its course related to the picture plane and to the cuboid. Because the sagittal plane is not represented in Fig. 361a, we must imagine this vertical plane of the central visual ray as having been generated from the latter and its horizontal plan, in that it extends between these two elements. We call it the "plane of the central visual ray." The fact that it, and with it the central visual ray, must be normal to the picture plane is important and obvious from what has been said earlier.

We must now determine the position of the plane of the central visual ray relative to the cuboid; we can move it to the left or to the right (it must always be normal to the picture plane) so that it either intersects or passes outside the cuboid.

To obtain a good perspective picture of the cuboid, it is best to adjust the plane of the central visual ray relative to it so that the trace of this plane or the horizontal plan of the central visual ray passes roughly through the center of the horizontal plan of the cuboid, as in Fig. 361.

Figures 361a and b show that the cuboid through whose horizontal plan the trace of the plane of the central visual ray passes produces a good perspective picture.

Having determined the central visual ray, we can draw the vanishing points FP_1 and FP_2 by construct-

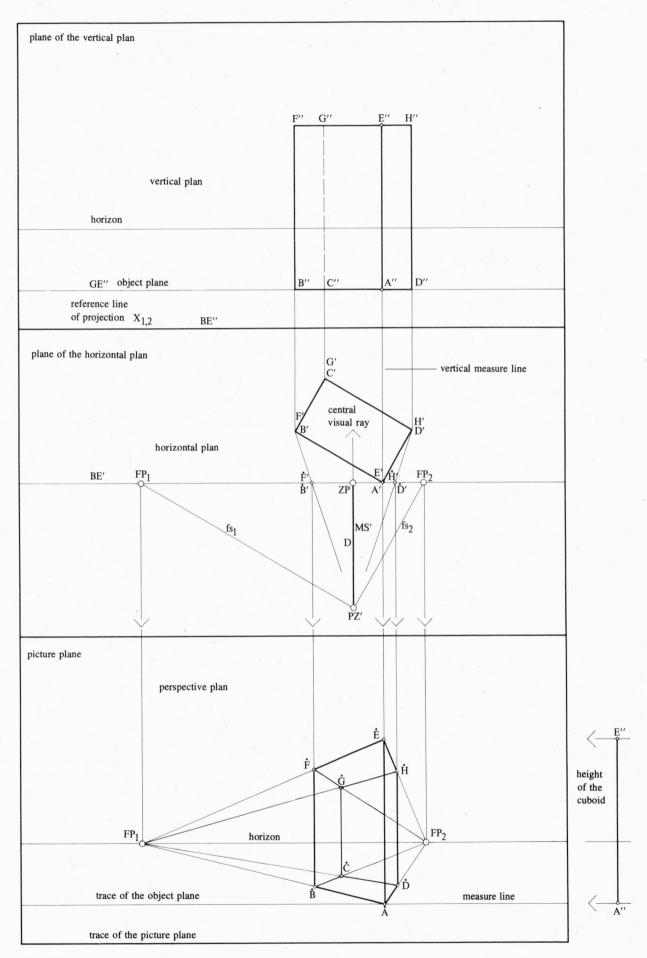

plane of the vertical plan

vertical plan

horizon

GE″ object plane

reference line
of projection $X_{1,2}$ BE″

plane of the horizontal plan

vertical measure line

central
visual ray

horizontal plan

BE′ FP$_1$

fs_1

F″ G″ E″ H″

B″ C″ A″ D″

G′
C′

F′
B′ H′
D′

F′ E′ H′
B′ ZP A′ D′ FP$_2$

MS′ fs_2

D

PZ′

picture plane

perspective plan

É

Ḟ Ḣ
Ġ

FP$_1$ horizon FP$_2$

Ċ

trace of the object plane Ḃ Ḋ measure line

A

trace of the picture plane

E″

height
of the
cuboid

A″

Fig. 361 b

215

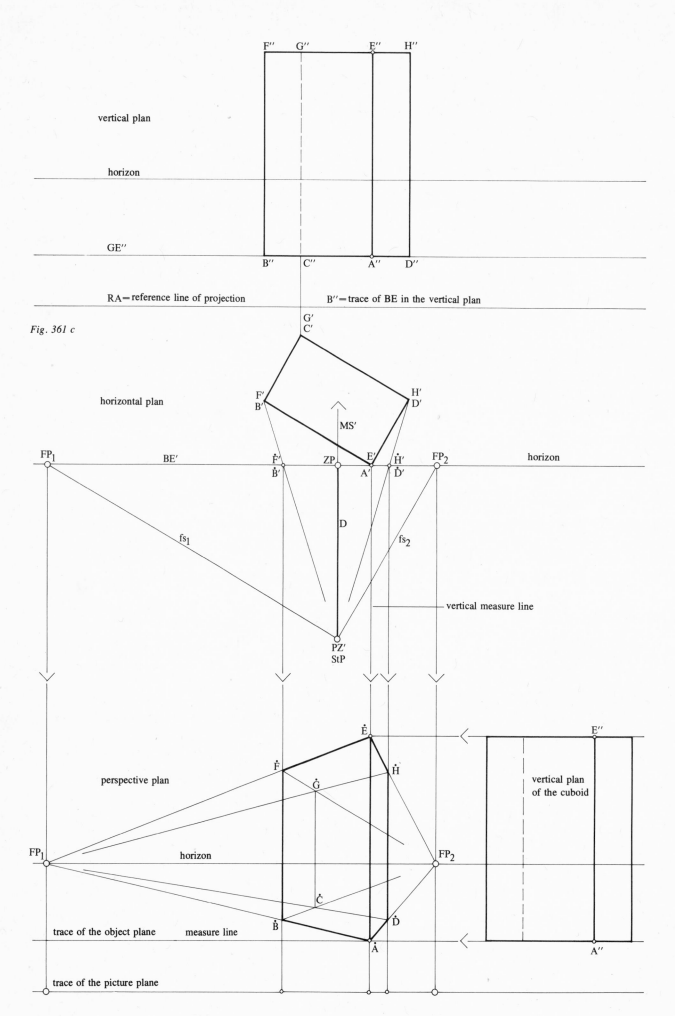

vertical plan

horizon

GE''

F'' G'' E'' H''

B'' C'' A'' D''

RA = reference line of projection B'' = trace of BE in the vertical plan

Fig. 361 c

G'
C'

horizontal plan

F' H'
B' D'

MS'

FP₁ BE' F' ZP E' H' FP₂ horizon
 B' A' D'

fs₁ fs₂

D

vertical measure line

PZ'
StP

E

F H

perspective plan G vertical plan
 of the cuboid

FP₁ horizon FP₂ E''

C

B D

A A''

trace of the object plane measure line

trace of the picture plane

Fig. 361 d

ing the vanishing rays of the receding edges of the cuboid.

Now the eight corners or original points of the cuboid can be projected from the center of projection; they produce eight picture points in the picture plane. By joining them according to the original we obtain the perspective picture of the cuboid. We do not really need these vanishing points for its construction any more than the planes of the horizontal and vertical plans of the model in Fig. 361a. The situation is different when we have only projections to work on, as is explained with the aid of this graphic model. Central projection of the horizontal plan of the cuboid thus produces not the picture points of the cuboid but only their horizontal plans, which is expressed by the prime after the dotted letters. \mathring{B}', for instance, indicates the perspective picture of B in horizontal plan.

We are now able to draw the perspective picture of the cuboid on the picture plane BE I. To do this we transfer the points obtained for this from the horizontal and the vertical plans of the cuboid to the picture plane BE I with horizontals. Planes can be extended between these horizontals and their horizontal plans as shown in the model of Fig. 361a.

In the projection representations in Figs. 361c and d these planes become verticals, with which these points are to be transferred.

Figures 361b and c show that we can transfer the following elements unchanged from the vertical plan of the cuboid to the picture plane BE I to construct from them the perspective picture of the cuboid: (1) the trace of the picture plane; (2) the measure line; (3) the horizon; (4) the edge AE and therefore the height of the cuboid.

It is advisable to construct the perspective projection of the cuboid by drawing these elements in this order.

In the picture plane BE I its trace, the measure line, and the horizon can be treated as intersections between horizontal planes with this plane. In other words, these horizontal planes, which do not appear in the abstract representation in Fig. 361c, serve for the transfer of these elements to the picture plane BE I.

The edge AE can be transferred to the picture plane BE I through a vertical plane, which in Fig. 361c appears as a vertical line called the vertical measure.

The elements taken from the vertical plan of the cuboid for the construction of its perspective picture lie in the picture plane BE. To complete the drawing of this perspective picture, the points of the cuboid in the horizontal plan, which were centrally projected into the picture plane in the horizontal plan, must be transferred to the picture plane in addition to the vanishing points FP_1 and FP_2, which are best transferred first, because when we join \mathring{A} and \mathring{E} to them we obtain the lines on which the corners \mathring{B} and \mathring{F}, and the corners \mathring{D} and \mathring{H} of the cuboid lie. These points in

the picture plane in the horizontal plan enable us to complete the construction of the perspective picture of the cuboid, because the connection of \mathring{B}, \mathring{F}, \mathring{D}, and \mathring{H} with FP_1 and FP_2 produces the missing corners as points of intersection of the relevant connecting lines. In other words, we do not depend on transferring \mathring{C}' and \mathring{G}' from the picture plane in the horizontal plan; however, we can transfer them to the picture plane BE I as controls—they must coincide with the points of intersection of the relevant connecting lines.

Brief summary on the basis of Fig. 361c:

Given: Horizontal and vertical plans of a cuboid ABCD and EFGH in the diagonal position.

Required: The perspective picture of this cuboid.

Solution:

1. Draw the horizontal BE′ as horizontal plan of the picture plane through A′E′.

2. Construct MS′ normal to BE′ as horizontal plan of the central visual ray so that it passes roughly through the center of the horizontal plan of the cuboid.

3. Determine PZ′ on MS′.

4. Construct the vanishing points FP_1 and FP_2 from PZ′. Central projection of B′F′ and D′H′, which produce \mathring{B}'' \mathring{F}' and $\mathring{D}'\mathring{H}'$ on BE′.

5. Begin construction of the perspective picture of the cuboid by drawing the trace of the picture plane, the measure line, and the horizon at a random distance below the horizontal plan of the cuboid.

6. Transfer the edge AE or the height of the cuboid to the measure line by means of the vertical measure line.

7. Transfer the vanishing points FP_1 and FP_2 through verticals to the horizon.

8. Connect \mathring{A} and \mathring{E} with FP_1 and FP_2.

9. Construct the corners \mathring{B} and \mathring{F} as well as \mathring{D} and \mathring{H} by transferring \mathring{B}', \mathring{F}', \mathring{D}', and \mathring{H}' to the connecting lines \mathring{A}–FP_1 and \mathring{A}–FP_2 as well as \mathring{E}–FP_1 and E–FP_2 by means of verticals from the horizontal plan of the picture plane BE.

10. Construct the corner \mathring{C} of the cuboid as point of intersection between the connecting lines \mathring{B}–FP_2 and \mathring{D}–FP_1.

11. Construct the corner \mathring{G} of the cuboid as point of intersection between the connecting lines \mathring{F}–FP_2 and \mathring{H}–FP_1.

12. Connect the still unconnected points according to the original.

Construction of the Perspective Picture of a Cuboid in the Frontal Position from Its Horizontal and Vertical Plans

This construction is based on the same principle as that of the cuboid in the diagonal position.

Figure 362 shows three cuboids, Q_1, Q_2, and Q_3, in conjunction with the perspective model in the frontal position; their front faces touch the picture plane and therefore appear in their true size. Cuboid Q_1 stands on the ground plane StE as object plane

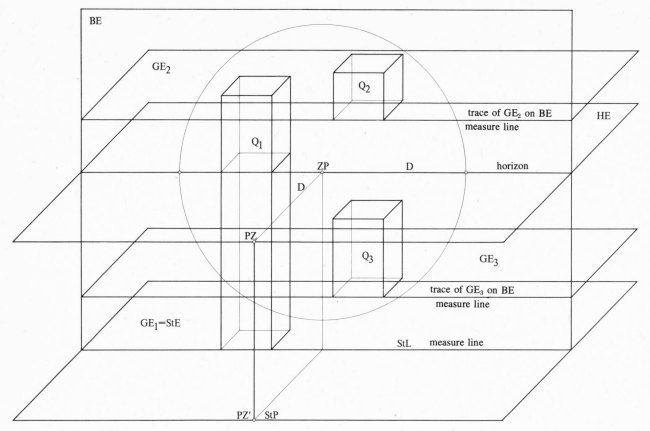

Fig. 362

GE; the former can therefore be treated and used like the latter or any other plane that is parallel to it. Cuboid Q_1 intersects the horizon plane HE; this produces a cross section of the cuboid, which can, however, also be imagined as the bottom face of its upper section. When we look at the cuboid Q_1 as a whole, we see its bottom face from above and its top face from below.

Cuboid Q_2 stands on the object plane GE_2, which is above the horizon plane and therefore above the observer's eye level. As a result, the whole cuboid is seen from below.

Cuboid Q_3 stands on the object plane GE_3, situated below the horizon plane. Because its top face is below the horizon plane, the whole cuboid is seen from above. The construction of the three perspectives of the cuboid in the frontal position as represented in Figs. 363–365 is best begun from the measure line, on which the height of the cuboid is to be erected. The distance between the measure line and the horizon must also be considered.

In Fig. 363 the circle of view, too, is constructed in the perspective projection of the cuboid, whose bottom face appears in the top and whose top face in the bottom view; its radius is identical with the line PZ'–ZP' and therefore known so that the circle of view can be drawn also in the horizontal and vertical plans. With the aid of PZ'–ZP', the radius of the circle of view, the two horizontal distance points HDP_1 and HDP_2 have also been drawn in Fig. 363. Whereas in the horizontal plan MS′ the horizontal plan of the central visual ray intersects that of the cuboid, in Figs. 364 and 365 MS′ bypasses the cuboid, in Figs. 364 and 365 MS′ bypasses the

horizontal plans of the cuboids; this does not affect the perspective picture of the cuboid adversely.

The Separate Position of the Picture Plane Relative to the Object

Thus far we have proceeded with the construction of the perspective picture of the cuboid from the assumption that the picture plane is situated in front of the cuboid so that the edge AE of the cuboid touches it. But we can also draw the perspective picture of an object so that the picture plane is either in front of or behind this object or cuboid without touching it, or that it intersects it.

Figures 367–369 show the perspective pictures of the cuboid in the various positions of the picture plane.

Figure 366 illustrates a model in parallel perspective, where the picture plane is at a certain distance in front of the cuboid. When, as here, no connection or contact exists between the picture plane and the object, it must be established for the construction of the latter, whose dimensions are determined by its horizontal and vertical plans.

In cuboid a in Fig. 366 the connection between the cuboid and the picture plane has been established by the extension of the face ABFE to its line of intersection with the picture plane. In the cuboid b in Fig. 366 four of its faces have been extended so that they intersect the picture plane. The cuboid c in Fig. 366 has been enlarged so that its height edge makes contact with the picture plane.

In Fig. 367 the cuboid in the diagonal position has been represented at a certain distance behind the

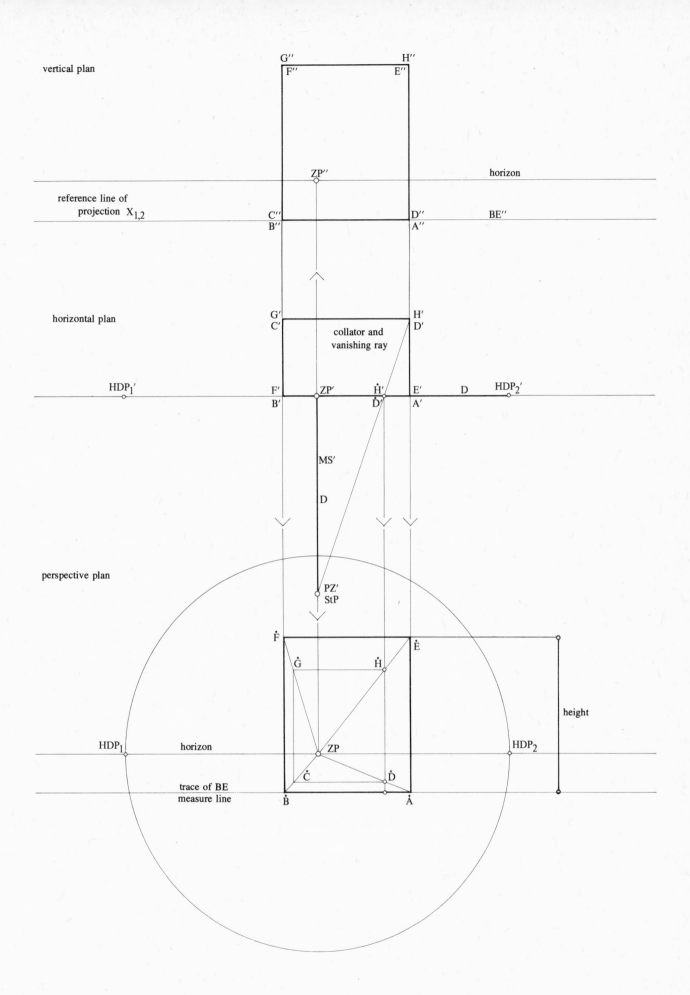

vertical plan

horizon

reference line of
projection $X_{1,2}$

horizontal plan

collator and
vanishing ray

HDP_1'

HDP_2'

MS'

D

perspective plan

height

horizon

HDP_1

HDP_2

trace of BE
measure line

Fig. 363

219

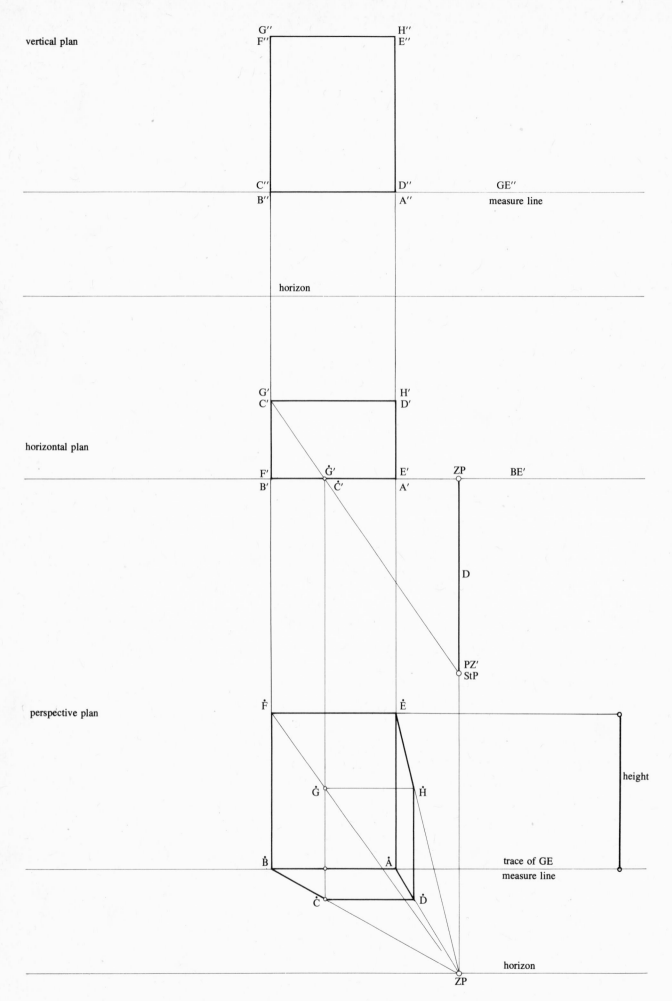

vertical plan

G''
F''

H''
E''

C''
B''

D''
A''

GE''
measure line

horizon

G'
C'

H'
D'

horizontal plan

F'
B'

Ġ'
Ċ'

E'
A'

ZP

BE'

D

PZ'
StP

perspective plan

Ḟ

Ė

Ġ

Ḣ

Ḃ

Ȧ

trace of GE
measure line

Ċ

Ḋ

height

horizon

ZP

Fig. 364

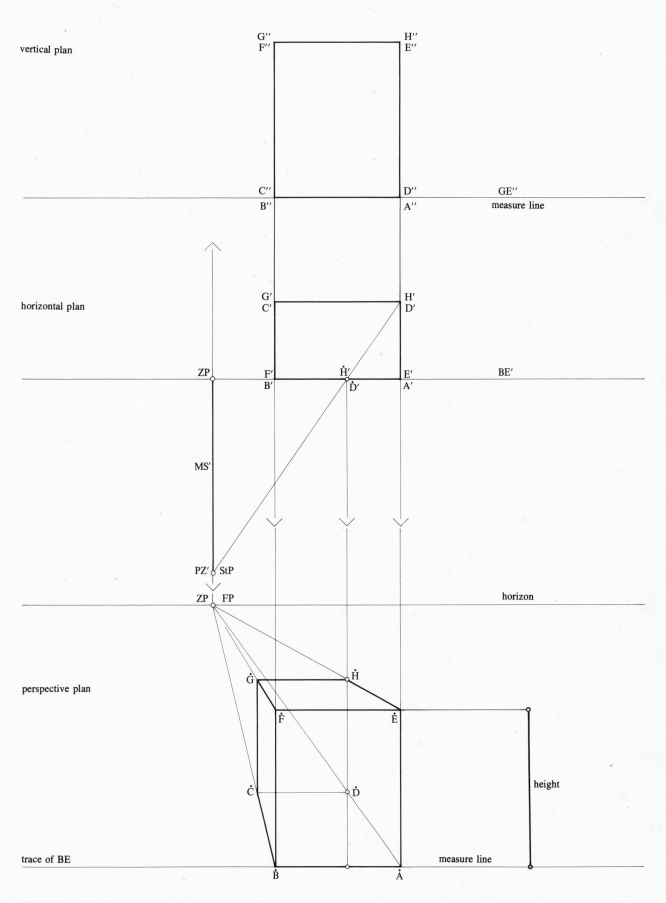

horizon

vertical plan

G''
F''

H''
E''

C''
B''

D''
A''

GE''
measure line

horizontal plan

G'
C'

H'
D'

ZP

F'
B'

Ḣ'
Ḋ'

E'
A'

BE'

MS'

PZ' ○ StP

ZP | FP

horizon

perspective plan

Ġ

Ḣ

Ḟ

Ė

Ċ

Ḋ

height

trace of BE

Ḃ

Ȧ

measure line

Fig. 365

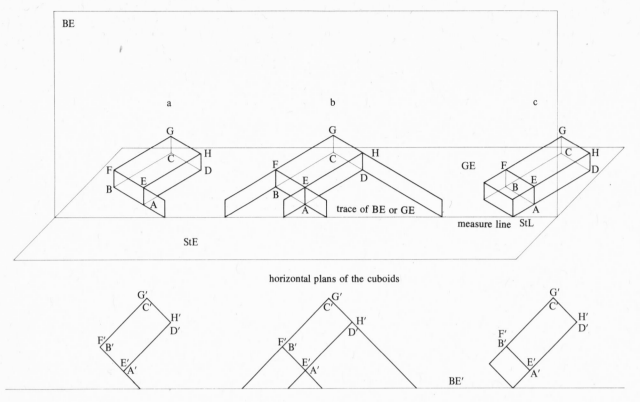

BE

a b c

GE

trace of BE or GE

measure line StL

StE

horizontal plans of the cuboids

BE'

Fig. 366

picture plane. To do this, two sides of the cuboid have been extended to their intersection with the picture plane. In BE' this produces I' and K' as well as L' and M', which have also been transferred into the perspective projection so that the sides extended to the picture plane are also reproduced there. In the construction of this perspective projection of the cuboid we would, incidentally, have been able to manage with the extension of one side of the cuboid only.

In the example shown in Fig. 368 the picture plane intersects the cuboid so that part of this is in front of this plane. This intersection produces the rectangle L″I″K″M″ in the vertical plan of the cuboid, which has been drawn in bold lines in perspective projection. This rectangle can be used to construct the cuboid in perspective.

If we want to obtain a large perspective picture of an object or cuboid, we draw the picture plane as in Fig. 369, that is, behind it. The greater the distance between the object and the picture plane BE, the larger this perspective picture becomes. As in any other arrangement of the picture plane, the relevant points of an object or corners of a cuboid must be projected onto it and transferred from there into perspective projection. As with Fig. 367, the cuboid and the picture plane can be related through the extension of its sides CBFG and CDHG until they intersect the picture plane BE.

Figures 370a and b show that it is possible to combine in the same drawing those examples which in this chapter are dealt with separately on the basis of Figs. 367–369. One cuboid in Fig. 370 is therefore situated in front of the picture plane and another one intersected by it. The other three cuboids are behind the picture plane and detached from it. As

already mentioned, only one cuboid is intersected by the plane of the central visual ray.

In the horizontal plan of the cuboids in Fig. 370a the angle of view is represented at 60°, which is not enough for the determination of D, the distance between the center of projection and the picture plane, because it does not allow for the height of the cuboids. But the representation of this angle of view draws attention to the problem of distance when the perspective projection of several cuboids is to be drawn from their horizontal and vertical plans.

Construction of Measuring Points

Figure 371 illustrates the construction of measuring points of certain vanishing points when the perspective projection of an object is drawn from its horizontal and vertical plans. Basically, this construction is identical with the circle of view method: To find the measuring point for a certain vanishing point, we describe a circular arch of radius FP–PZ$^+$ around this vanishing point as center; the measuring point is the point of intersection between this arc and the horizon. In other words, we rotate the line connecting the vanishing point with the center of projection into the horizon. To construct the measuring points for the two vanishing points FP$_1$ and FP$_2$ of the sides of the rectangle ABCD in Fig. 371, FP$_1$–PZ' and FP$_2$–PZ' must also be rotated into the horizon or into the picture plane. These lines are, accordingly, identical with the radii of circular arcs whose points of intersection with BE', the picture plane in the horizontal plan, containing the horizon produce the measuring points MP$_1$ and MP$_2$.

The same result is obtained with the other method of determining the measuring points MP$_1$ and MP$_2$: The construction of the vanishing rays of the mea-

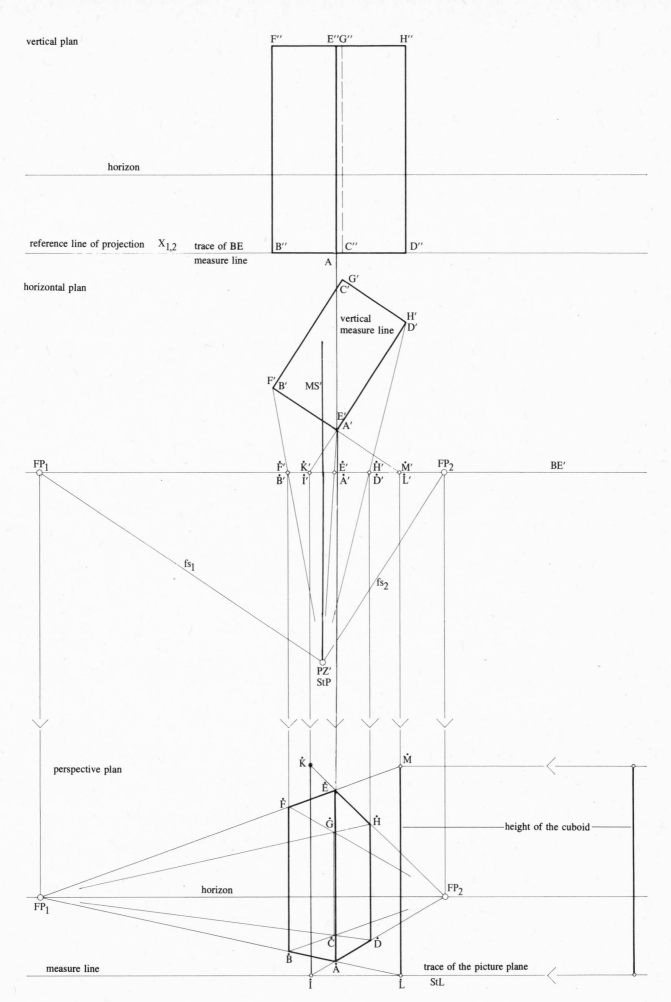

Fig. 367 In this drawing the ground plane has been used as object plane, which in its intersection with the picture plane produces the ground line StL as well as the measure line. Now study Fig. 366.

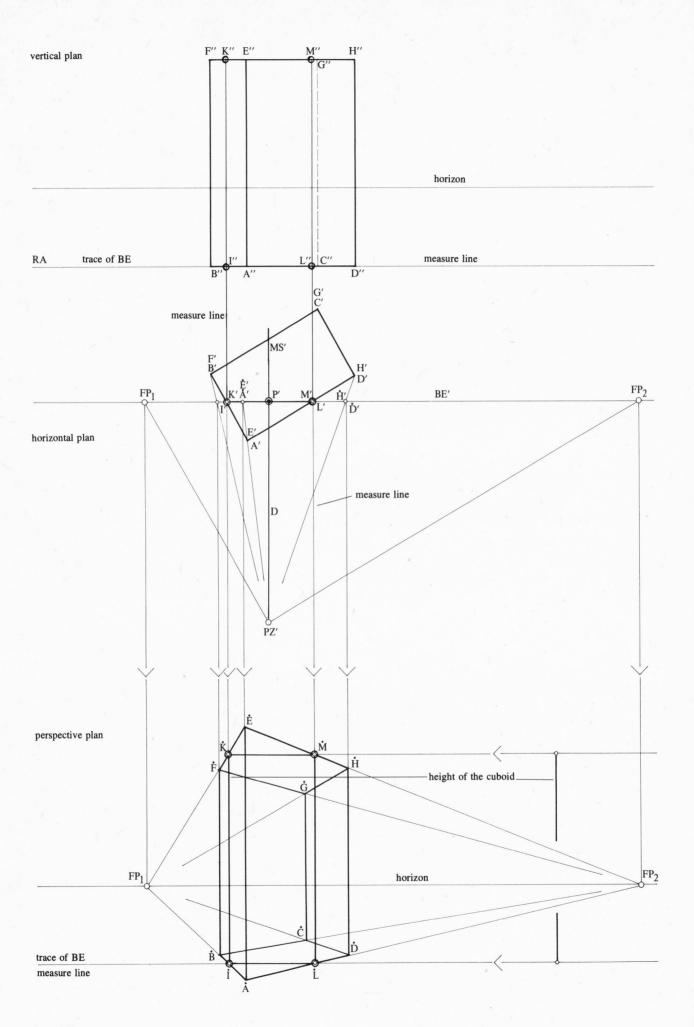

vertical plan

F″ K″ E″ M″ H″
 G″

horizon

RA trace of BE measure line
 I″ L″ C″
 B″ A″ D″

 G′
 C′
measure line

 F′ H′
 B′ D′
FP₁ K′ A′ P′ M′ H′ BE′ FP₂
 I′ L′ D′
 E′
 A′
horizontal plan

 measure line
 D

 PZ′

perspective plan
 E

 K M
 F H
 height of the cuboid
 G

FP₁ horizon FP₂

 C

trace of BE B D
measure line I L
 A

Fig. 368

224

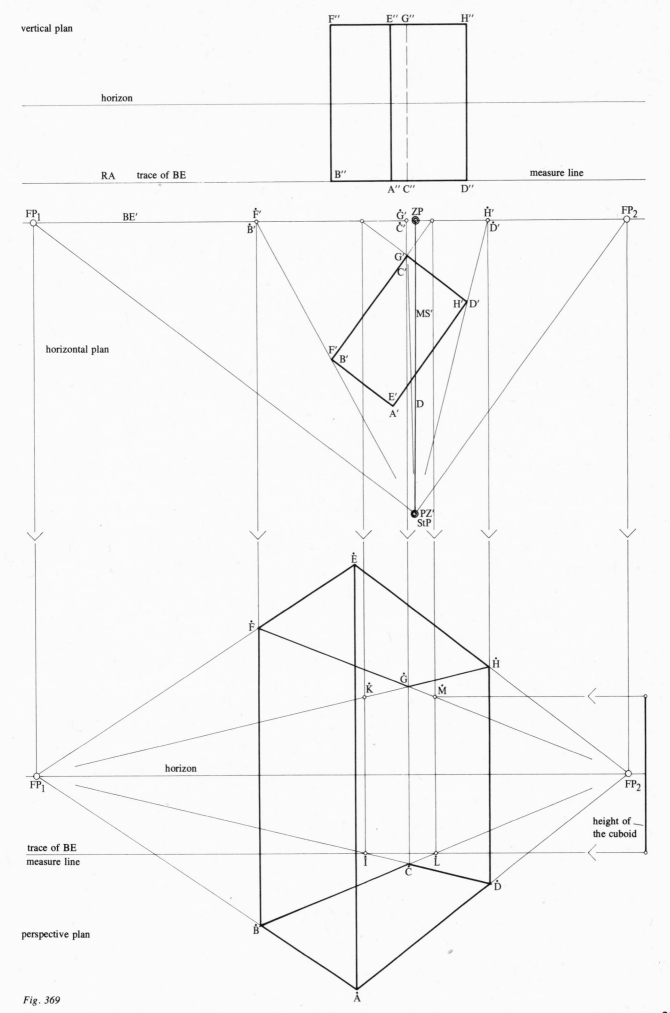

vertical plan

horizon

RA trace of BE

F'' E'' G'' H''

B''

A'' C'' D''

measure line

FP₁ BE' Ḟ' Ġ' ZP Ḣ' FP₂
Ḃ' Ċ' Ḋ'

G'
C'
H' D'
MS'
F'
B'

horizontal plan

E'
A' D

PZ'
StP

Ė

Ḟ Ḣ

K̇ Ġ Ṁ

horizon

FP₁ FP₂

height of
the cuboid

trace of BE
measure line

İ L̇
C Ḋ

perspective plan

Ḃ

Ȧ

Fig. 369

225

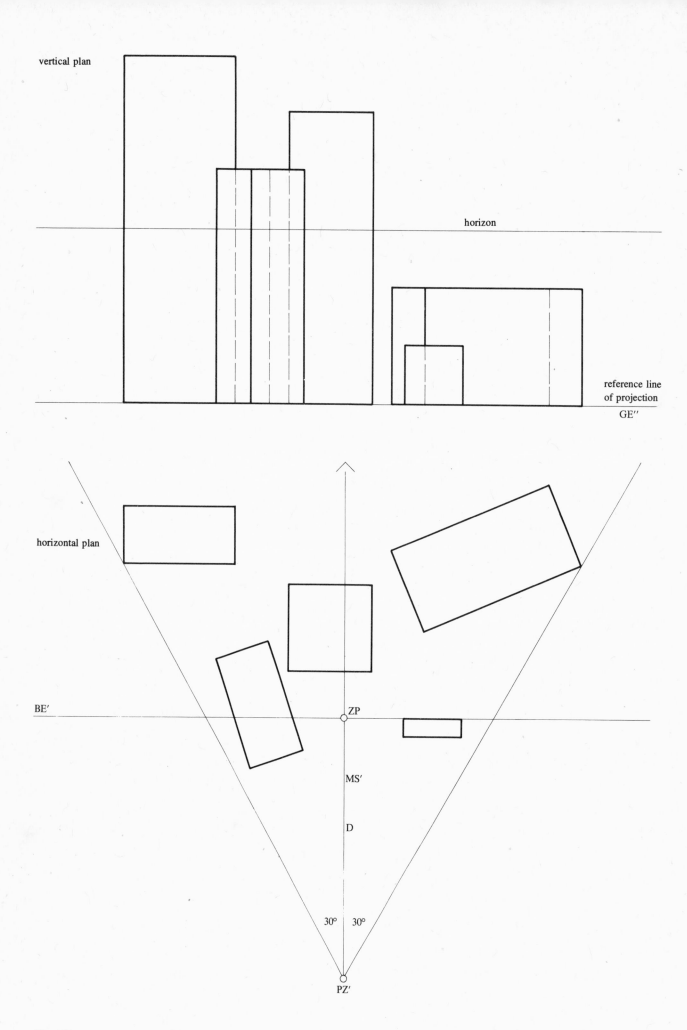

vertical plan

horizon

reference line
of projection

GE''

horizontal plan

BE'

ZP

MS'

D

30° 30°

PZ'

Fig. 370 a

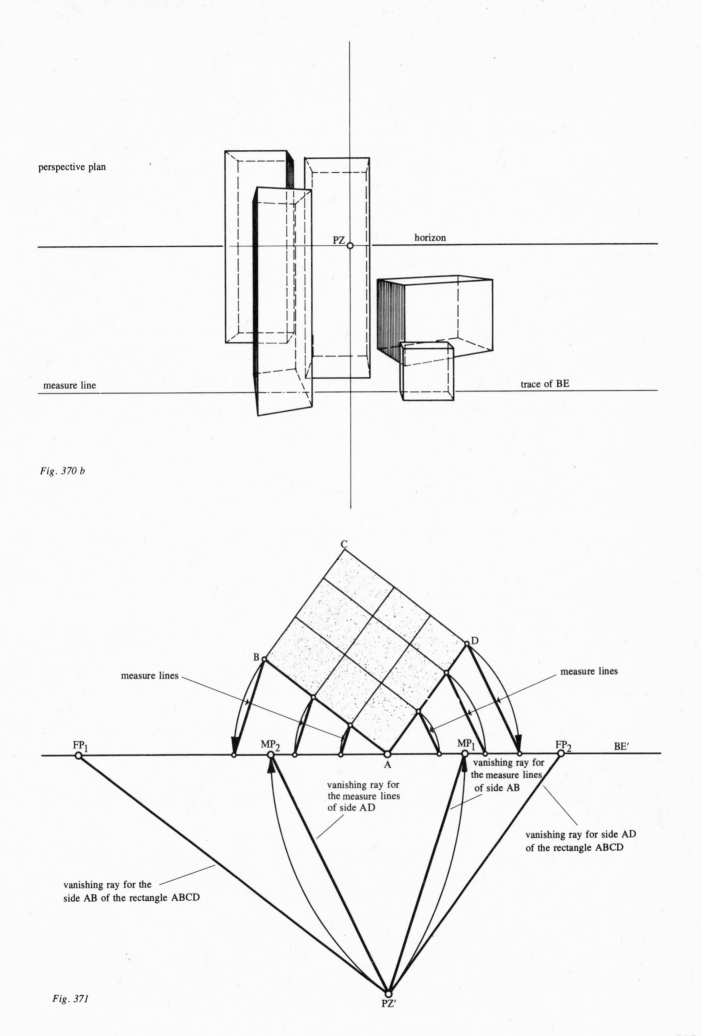

perspective plan

PZ○ horizon

measure line trace of BE

Fig. 370 b

C

B

measure lines

D

measure lines

FP₁ ○ MP₂ ○ MP₁ ○ FP₂ ○ BE'
A

vanishing ray for
the measure lines
of side AD

vanishing ray for
the measure lines
of side AB

vanishing ray for side AD
of the rectangle ABCD

vanishing ray for the
side AB of the rectangle ABCD

Fig. 371

PZ'

227

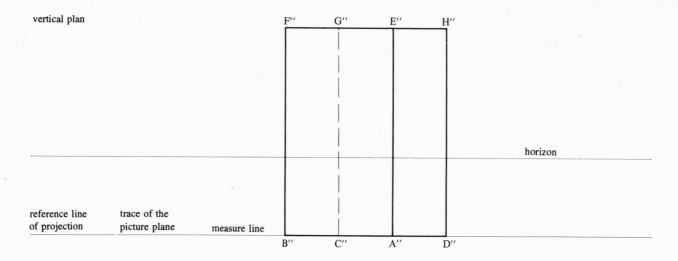

vertical plan

F″　　G″　　E″　　H″

horizon

reference line	trace of the
of projection	picture plane	measure line

B″　　C″　　A″　　D″

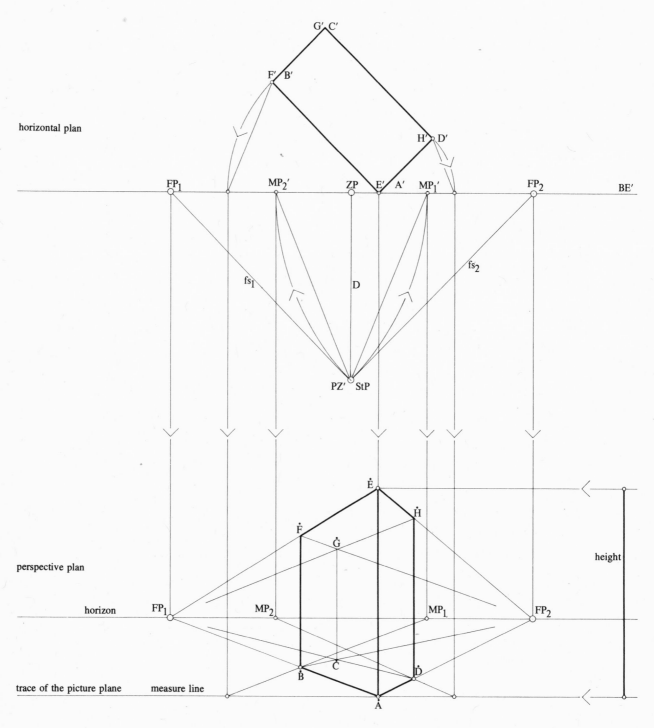

G′ C′

F′ B′

horizontal plan

H′ D′

FP₁　　MP₂′　　ZP　E′ A′　MP₁′　　FP₂　　BE′

fs₁

D

fs₂

PZ′ StP

Ė

Ḣ

Ḟ

Ġ

perspective plan

height

horizon　FP₁　　MP₂　　MP₁　　FP₂

Ḃ　Ċ　Ḋ

trace of the picture plane　　measure line

Ȧ

Fig. 372

228

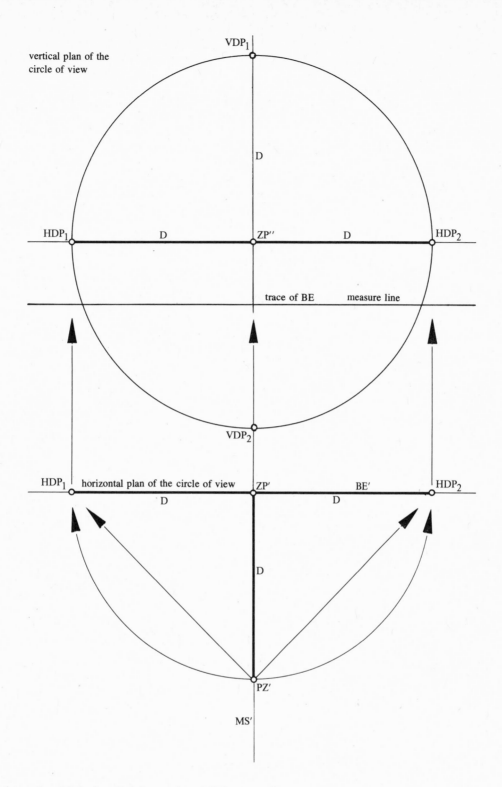

vertical plan of the circle of view

VDP₁

D

HDP₁ — D — ZP″ — D — HDP₂

trace of BE measure line

VDP₂

HDP₁ horizontal plan of the circle of view ZP′ BE′ HDP₂
 D D

D

PZ′

MS′

Fig. 373

sure lines through which the division points of the sides AB and AD of the rectangle ABCD were transferred to BE′ (Fig. 371). Because these measure lines are horizontal, their vanishing points lie on the horizon, which, as we have said before, is in BE′.

Figure 372 shows how the perspective picture of a cuboid in diagonal position can be drawn with the aid of the measuring points MP₁ and MP₂, which were constructed in the same way as in Fig. 371.

The Circle of View in the Horizontal/Vertical Plan Method

It has already been mentioned that we can construct the circle of view by the method of drawing the perspective projection of an object from its horizontal and vertical plans as soon as we know D, the

distance between the center of projection and the picture plane. In other words, this enables us to draw the horizontal and vertical plans of the circle of view from those of the object.

When Fig. 373, which illustrates the construction of the horizontal and vertical plans of the circle of view, was drawn, BE′, the picture plane in horizontal plan, and MS′, the horizontal plan of the central visual ray, were given. With the determination of PZ′ on MS′, D and therefore the radius of the circle of view was known, so that it was possible to construct the circle of view first in the horizontal and then in the vertical plan.

The construction of the circle of view in the horizontal and the vertical plan and in perspective projection (Fig. 374) must start from the cuboid, the pic-

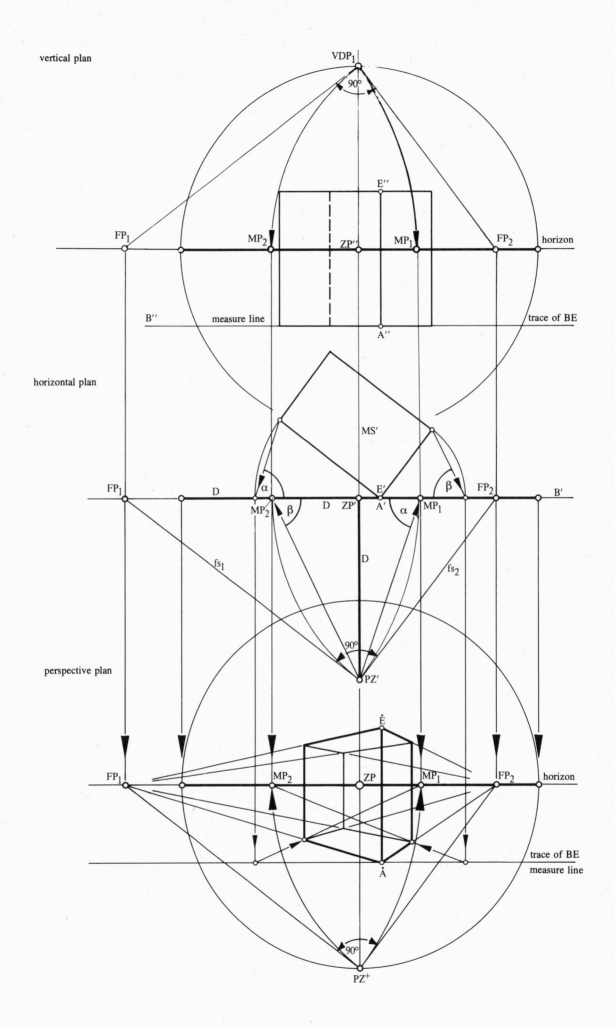

vertical plan

VDP₁

90°

E''

FP₁ MP₂ ZP'' MP₁ FP₂ horizon

B'' measure line trace of BE

A''

horizontal plan

MS'

FP₁ D α E' β FP₂ B'

MP₂ β D ZP' A' α MP₁

fs₁ D fs₂

90°

PZ'

perspective plan

Ė

FP₁ MP₂ ZP MP₁ FP₂ horizon

Ȧ trace of BE
 measure line

90°

PZ⁺

Fig. 374

230

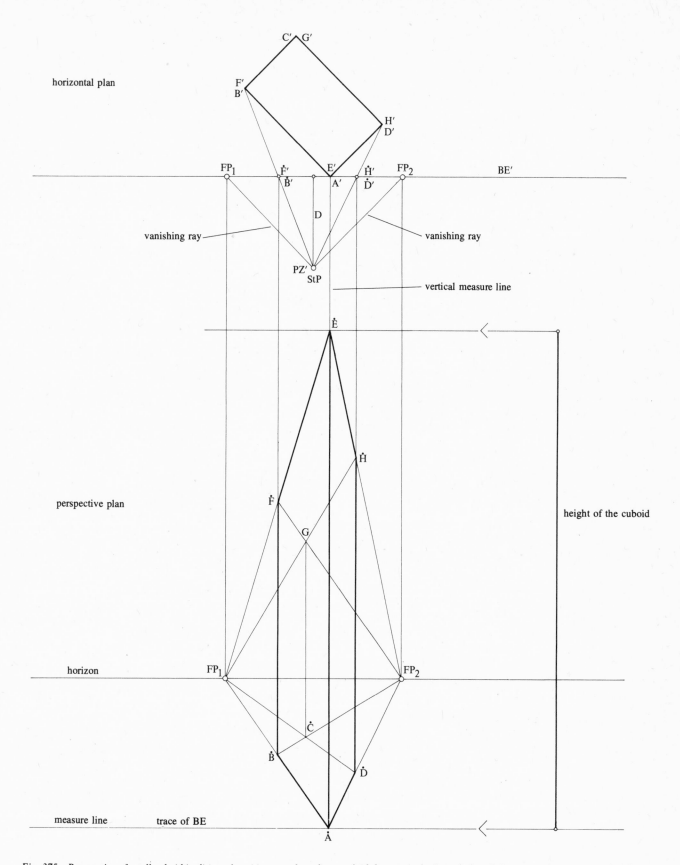

horizontal plan

C′ G′

F′
B′

H′
D′

FP₁ F′ E′ H′ FP₂ BE′
 B′ A′ D′

D

vanishing ray vanishing ray

PZ′
StP

vertical measure line

Ė

perspective plan

Ḣ

Ḟ

G

height of the cuboid

horizon FP₁ FP₂

Ċ

Ḃ Ḋ

measure line trace of BE

À

Fig. 375 Perspective of a tall cuboid in diagonal position at a short distance laid down in its horizontal plan. In its perspective representation the vanishing points FP₁ and FP₂ approach each other.

FP₁ horizon FP₂

Fig. 376 Perspective of a low cuboid at comparatively long distance. Here the vanishing points FP₁ and FP₂ move apart. When the center of projection is assumed to be at infinity, FP₁ and FP₂ will also be at infinity, with the cuboid appearing in parallel perspective.

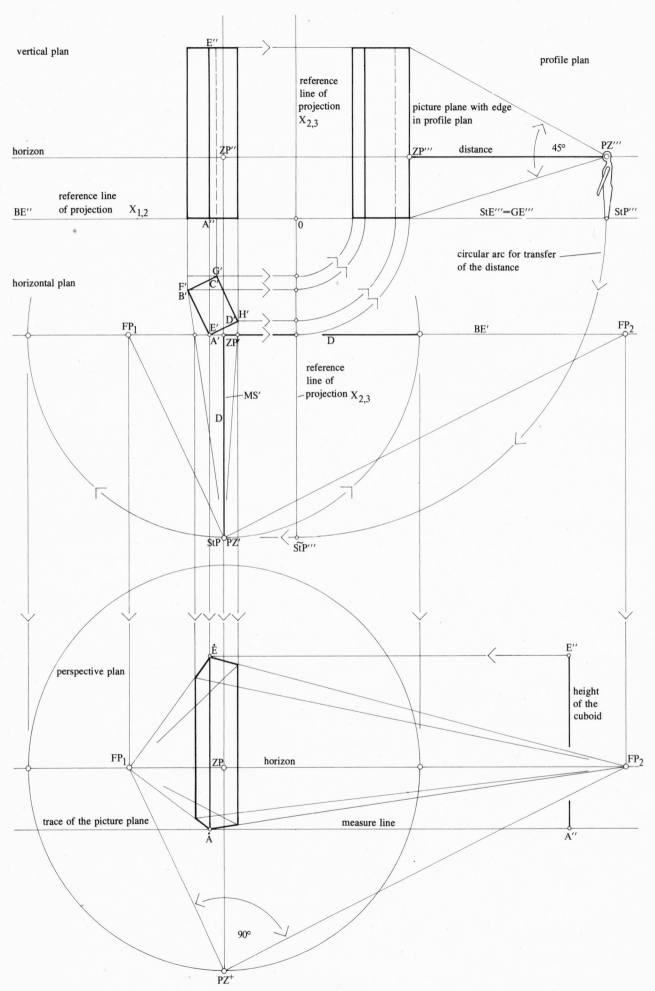

vertical plan

horizon

reference line
of projection X$_{1,2}$

BE''

horizontal plan

reference
line of
projection X$_{2,3}$

perspective plan

trace of the picture plane

Fig. 377

E''

ZP''

A''

0

reference
line of
projection
X$_{2,3}$

picture plane with edge
in profile plan

profile plan

ZP''' distance 45° PZ'''

StE'''=GE''' StP'''

circular arc for transfer
of the distance

G'

F'
B' C'

D' H'

E'
A' ZP'

MS'

D

D

BE'

FP$_1$ FP$_2$

StP PZ' S̃tP'''

E''

height
of the
cuboid

Ė

FP$_1$ ZP horizon FP$_2$

measure line

A''

Å

90°

PZ$^+$

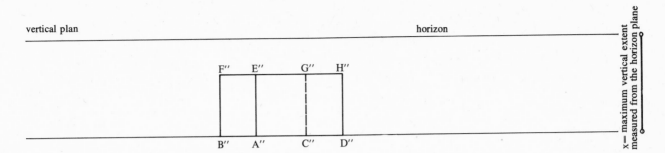

vertical plan horizon

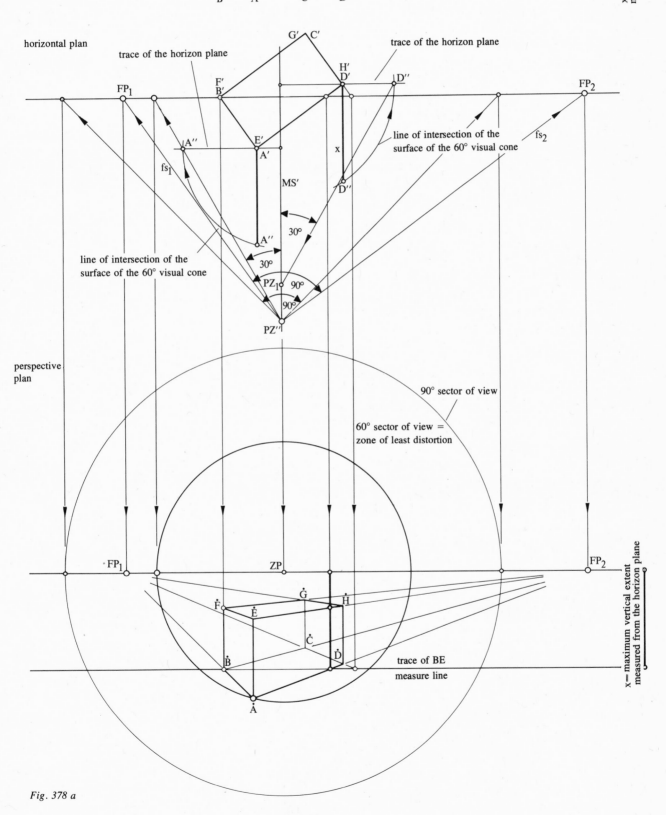

x = maximum vertical extent measured from the horizon plane

horizontal plan

trace of the horizon plane

trace of the horizon plane

FP$_1$

F'
B'

A''

fs$_1$

A'
E'

MS'

x

D'
H'

D''

D''

line of intersection of the
surface of the 60° visual cone

fs$_2$

FP$_2$

30°

30°

90°

90°

line of intersection of the
surface of the 60° visual cone

PZ$_1$

PZ''

perspective
plan

90° sector of view

60° sector of view =
zone of least distortion

FP$_1$

ZP

FP$_2$

F

G

E

H

C

B

D

trace of BE

A

measure line

x = maximum vertical extent measured from the horizon plane

Fig. 378 a

233

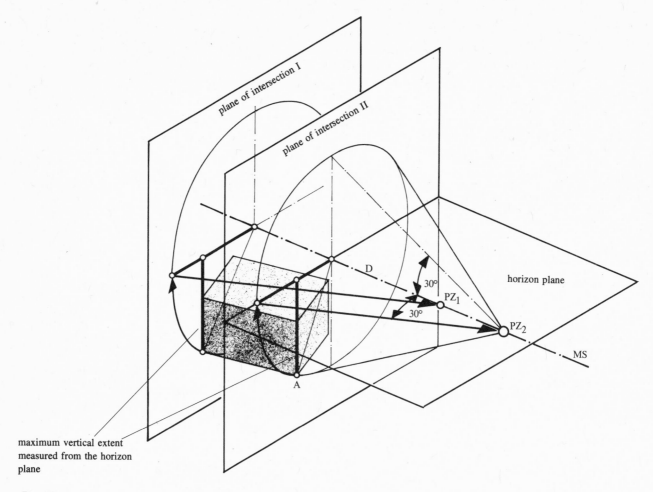

maximum vertical extent
measured from the horizon
plane

Fig. 378 b

ture plane, MS, and D in the horizontal plan; that is, the circle of view can first be represented in the horizontal plan and its vertical plan drawn from it.

Figure 374 confirms that the construction of the measuring points MP_1 and MP_2 of the vanishing points FP_1 and FP_2 agrees in the three projections. This must be so because in all three projections the measuring points must be constructed with circular arcs whose radii are the lines joining the vanishing points to PZ or PZ^+. Of course, the circle of view and the horizontal/vertical plan methods must also agree in other respects so that one method can be used as a control of the other.

The Problem of the Distance Between the Center of Projection and the Picture Plane

Various authors of textbooks on perspective give different methods for determining the distance between the center of perspective and the picture plane, which indicates the difficulty of determining absolutely valid dimensions for it. Yet the draftsman needs guidelines for the dimension of D.

The distance D should be such as not to produce too distorted a perspective picture of the object. But the draftsman may want to choose a short distance for reasons of dynamic expression to obtain a strongly distorted perspective picture, as shown in Fig. 375.

In contrast with this, the distance is long for the construction of the cuboid in Fig. 376. The two

vanishing points FP_1 and FP_2 are consequently far apart and the perspective picture of the cuboid shows little distortion and appears very similar to a parallel perspective representation. Where the distance is infinitely long (or, in other words, when the center of projection is at infinity), parallel perspective is produced. We obtain a yardstick of the length of the distance to be chosen when we combine the circle of view method with the horizontal/vertical plan method. Here we are able to check whether the perspective picture to be drawn of an object will be within or outside the circle of view. But this method also enables us to determine the distance in view of the construction of the 60° sector of the horizon, the zone of least distortion, within the 90° sector. But before discussing the construction with the aid of Fig. 378, we must explain, on the basis of Fig. 377, yet another method of determining the distance between the center of projection and the picture plane when drawing perspective pictures of tall objects, such as multistory buildings or skyscrapers.

For the determination of this distance not only the height but all the other dimensions of an object must be considered.

In Fig. 377 it is the profile plan of the cuboid from which we start for the determination of the distance in the construction of its perspective picture. Here we determine the horizon and thereby the observer's eye level and the center of projection so that the angle of view at which the observer sees the cuboid is

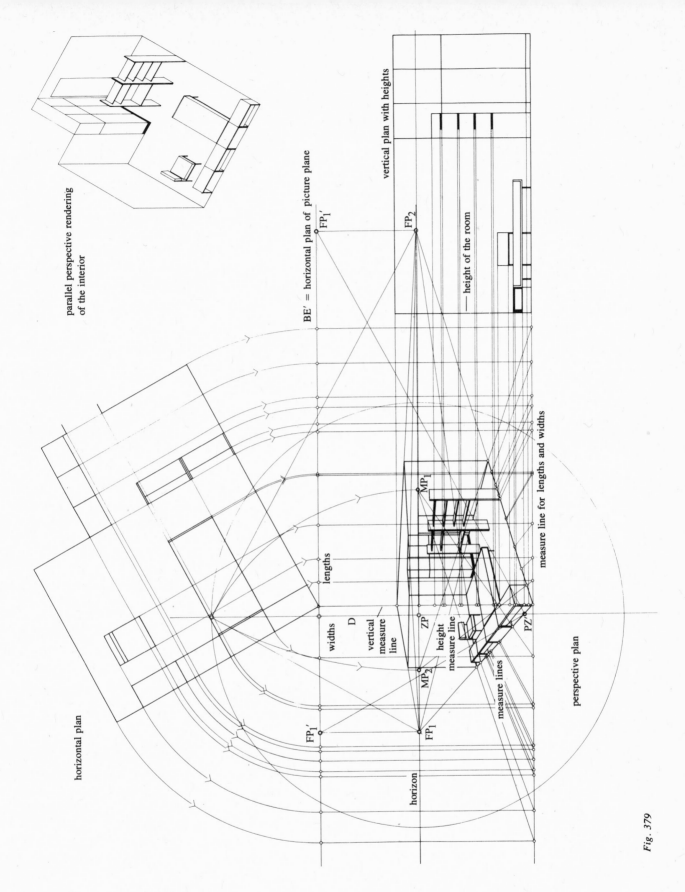

parallel perspective rendering of the interior

BE' = horizontal plan of picture plane

vertical plan with heights

height of the room

horizontal plan

measure line for lengths and widths

lengths

widths

D

vertical measure line

ZP

height measure line

MP₁

MP₂

FP₂

FP₁'

FP₁'

FP₁

horizon

measure lines

PZ''

perspective plan

Fig. 379

45°. Once PZ″ as the apex of this 45° angle has been laid down, X₁,₂ StP‴, the station point in profile plan can be determined with a perpendicular from PZ‴ onto the reference line of projection. By means of a quarter-circle around the center O we transfer StP‴ to the reference line of projection X₂,₃ to obtain StP‴. We then intersect MS′ with a horizontal passing through StP‴, which provides PZ′, StP, and therefore the distance between the center of projection and the picture plane.

The Construction of the Distance between the Observer and the Object to be Reproduced

This construction, demonstrated in Figs. 378a and b, also involves the determination of the 60° sector of view as the zone of least distortion within the 90° sector. Let us first explain the construction of the distance between the observer and the object visually.

When taking a photograph of the object, we as-

235

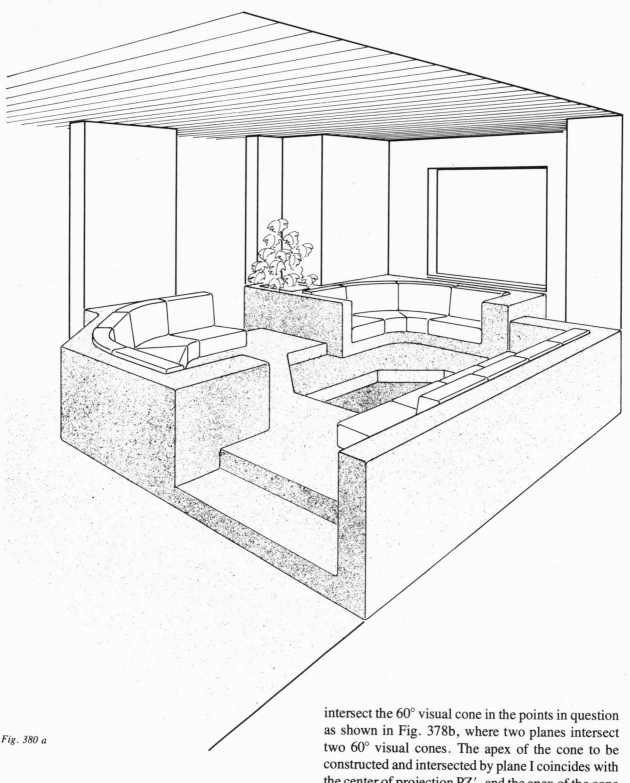

Fig. 380 a

sume that this is seen through a viewfinder of 60°
angle of aperture. We move toward and away from
the object until it lies within the 60° field of view or
sector of view. This determines the distance between
us and the object. Basically, the procedure is similar
when we construct the 60° visual cone to determine
the center of projection on the central visual ray and
thereby the distance required. We examine what
maximum vertical distance seen from the horizon
plane appears as peripheral point on the 60° sector of
view.

Because the vertical distance determining this
point is rarely known with any certainty, planes at
right angles to the central visual ray are made to

intersect the 60° visual cone in the points in question
as shown in Fig. 378b, where two planes intersect
two 60° visual cones. The apex of the cone to be
constructed and intersected by plane I coincides with
the center of projection PZ′, and the apex of the cone
intersected by plane II produces PZ₂ and thereby the
distance required.

The method illustrated in Fig. 378b shows the
construction of the conical sections in the vertical
plan. Comparison between Figs. 378a and b indi-
cates that we need only the part of the circle between
the peripheral point and the trace of the horizon line.
A line is drawn through these points as the side of a
30° angle, with the central visual ray as the other
side. Its apex is the center of projection. The point of
intersection of the sides of this angle farthest from
the object is the required center of projection PZ,
which also determines the distance D.

After this distance the picture plane is determined,

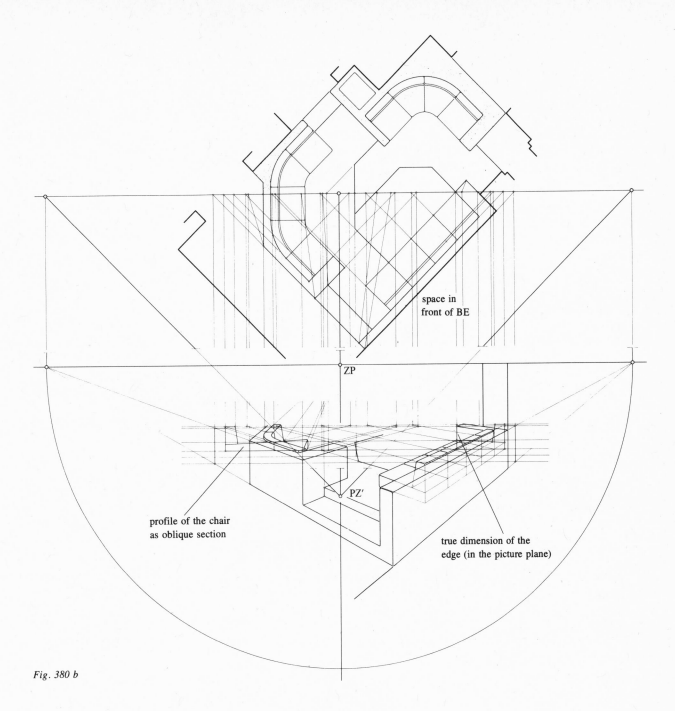

Fig. 380 b

space in
front of BE

ZP

PZ'

profile of the chair
as oblique section

true dimension of the
edge (in the picture plane)

on which we construct all the points we need for drawing the 60° sector of the horizon within the 90° sector.

Applications

The representations of interiors in Figs. 379 and 380 have been constructed with the circle of view method in combination with the horizontal/vertical plan method.

Drawing the perspective picture of an object is made easier if the object is first reproduced in parallel perspective, as in the top right-hand corner of Fig. 379.

With arcs of circles, the lengths and widths of this interior in the horizontal plan were transferred to BE′ and from there to the measure line in perspective projection. The vertical plan of the interior on the right has been drawn at the level of the perspective projection, which technically offers the advantage that the heights of the interior could be conveniently

transferred to the height measure line in perspective projection.

The vanishing points FP_1 and FP_2 as well as the measuring points MP_1 and MP_2 were determined from the circle of view.

Figure 380a shows the perspective picture of an interior as the result of the combination of its two halves, whose construction is listed in Fig. 380b, showing its front, and Fig. 380c, showing its rear half.

With complex rooms it is often useful to place the picture plane as plane of intersection through the center of the room, so that its perspective picture can be developed from the two halves, as in Fig. 380.

Here the interior has been constructed within a 45° angle of view. The method is based on extending the various edges until they intersect the picture plane and on the section profiles thus provided.

Except for the back of the chair, the interior of Fig. 379 has been constructed from horizontals and 237

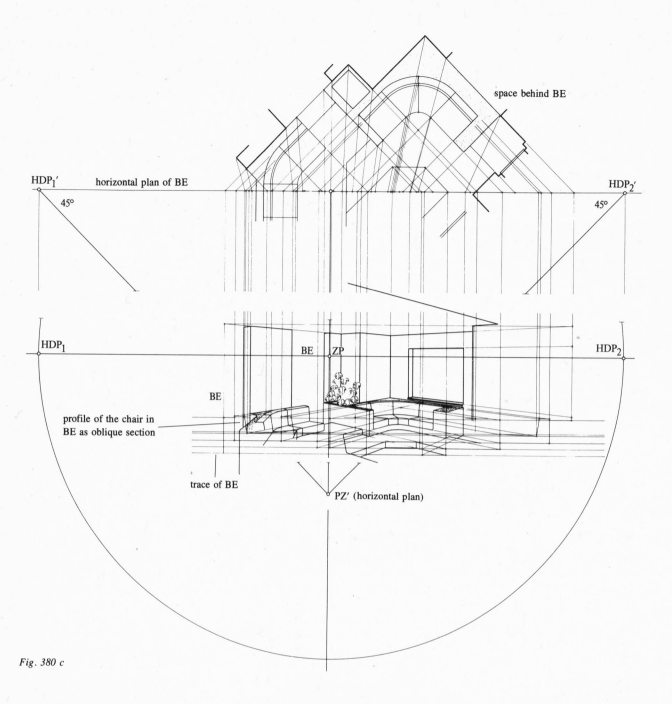

HDP₁ BE ZP HDP₂

BE

profile of the chair in
BE as oblique section

trace of BE

PZ′ (horizontal plan)

Fig. 380 c

verticals. In contrast, the interior of Fig. 380 has oblique lines in the seating elements which have not been drawn with the aid of vanishing points; they are the result of joining points at different levels.

The Cylinder from a Cube or from a Cuboid in the Frontal Position

In this context the cylinder is defined as a right circular cylinder represented by a circular column or roller. Its surface consists of the top, the bottom, and the cylindrical surface, which contains the generatrices, normal to the top and the bottom planes. A drop of water running from the upper rim of a cylindrical vessel down its cylindrical surface produces a trace which is a generatrix, the shortest distance between the starting and the end point on the cylindrical surface. The generatrices are the only straight lines on the cylindrical surface. We can imagine them as thin rods. If we place such rods of the same length side by side without a gap, we obtain a rectan-

gular surface, which we can consider the developed cylindrical surface. If we wrap such a rectangle around a roller of circular cross section, we obtain a cylindrical surface. The generatrices or rods are arranged so that they form a curved surface, which can thus be generated entirely from straight lines.

A circular cylinder can be drawn from a cube or cuboid of square cross section. We can proceed by constructing from its top and bottom planes circles which in perspective become ellipses representing these planes. A separate problem, which we shall discuss in the following chapter, is presented by the drawing of (vertical) contour generatrices of a cylinder.

We draw such contour lines when we construct the vertical plan of a cylinder, which represents a cylinder developed from a cube as a rectangle or a square. The vertical sides of the rectangle or square are the contour generatrices of the cylinder; its horizontal sides represent the top and bottom planes.

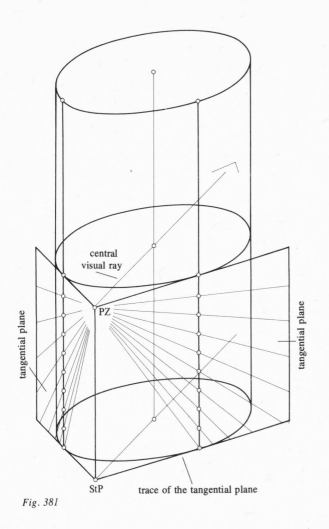

central
visual ray

tangential plane

PZ

tangential plane

StP trace of the tangential plane

Fig. 381

The cylinder shown in Fig. 170 has been developed from a cuboid, whose bottom plane appears in top view and top plane in bottom view. We accordingly see the cross sections of the cylinder below the horizon from above and those above the horizon from below. The representation of the cuboid of the cross sections as shown in Fig. 169 can be conceived as the picture of an open cabinet with shelves. The choice of method of drawing the ellipses from the squares in perspective is left to the draftsman. The contour generatrices of the cylinder must touch these ellipses, too, at the right points, which for the time being we draw according to our own judgment and by sight.

The Establishment of the Contour Generatrices of the Cylinder

Figure 381 in which the observer is represented by the perpendicular PZ–StP, explains the establishment of the contour generatrices of a cylinder. Let us imagine this observer to be standing in front of and looking at a circular column. He will then see the cylinder laterally outlined by two defined contour generatrices. Whenever he changes his point of view, the contour generatrices will also change. We must therefore know the point of view if we want to construct the contour generatrices of the cylinder strictly from a geometric approach rather than according to our own discretion.

Figure 381 shows that the observer's visual rays, which pass through the points of the two contour generatrices representing for him the contour of the cylinder, are situated in two tangential planes touch-

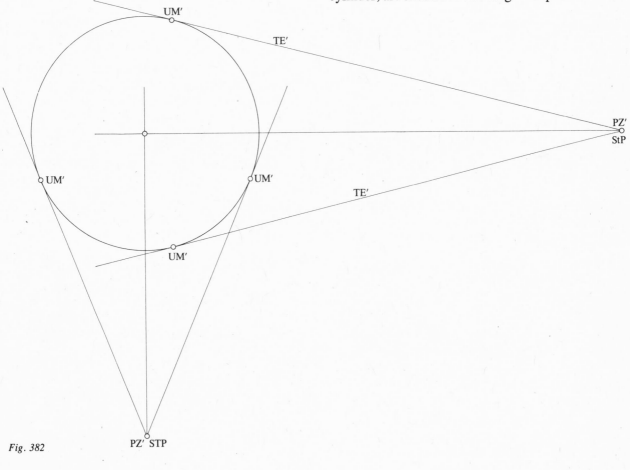

UM′

TE′

PZ′
StP

UM′ UM′

TE′

UM′

Fig. 382 PZ′ STP

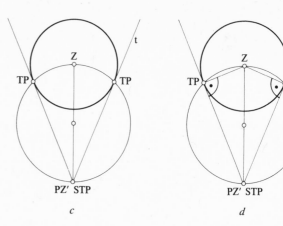

Fig. 383 a b c d

ing the cylindrical surface along a generatrix. One
generatrix is the straight line common to the cylinder
and to the tangential plane. We can look on such a
plane as a rolling pin lying on a table. Tabletop and
rolling pin are in contact along a straight line when
both their surfaces are flat.

The two tangential planes in Fig. 381 for the
determination of the vertical outlines of the cylinder
intersect in a perpendicular, which we limit so that
its top end is the center of projection and its bottom

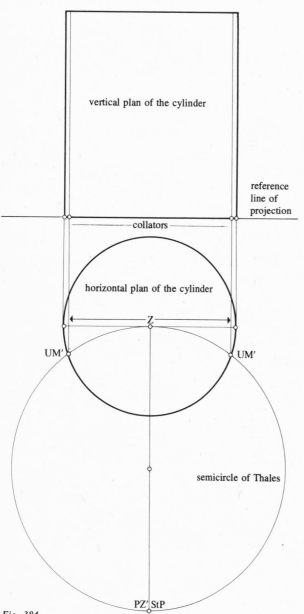

vertical plan of the cylinder

reference
line of
projection

collators

horizontal plan of the cylinder

Z

UM′ UM′

semicircle of Thales

PZ′ StP

end the station point. For the observer the straight
lines common to the tangential planes and to the
cylinder form the contour generatrices.

Figure 382 illustrates the already mentioned con-
dition that the two contour generatrices of a cylinder
change as soon as we change our point of view. It
also shows that the visual rays PZ′–UM′ form an
angle that decreases as the observer moves away
from the cylinder. If he were able to move infinitely
far away from it, his visual rays would be parallel
and he would see the cylinder as represented by its
vertical plan, that is, in parallel projection, in which
the projection rays are parallel. In the horizontal plan
in Fig. 382 the tangential planes appear as rays or as
tangents originating in PZ′. The tangent points UM′
are the horizontal plans of the contour generatrices.
If we want to draw these in the horizontal plan, we
must therefore draw the tangents from PZ′ to the
circle as the horizontal plan of a cylinder.

The procedure is explained by the drawings a, b,
c, d in Fig. 383. The semicircle of Thales is de-
scribed above PZ′–Z. It intersects the circle repre-
senting the horizontal plan of the cylinder in the
required tangent points TP, with which we found the
horizontal plans of the contour generatrices. Be-
cause according to Thales' theorem, angles in-
scribed in a semicircle such as PZ′ − Z are right
angles, Z–TP must be normal to the tangent t.

The contour generatrices in the horizontal plan in
Fig. 384 have been constructed according to this
method. They can be drawn in the vertical plan by
means of collators or verticals from the horizontal
plan. Note that the picture of the cylinder in the
vertical plan is a rectangle whose vertical sides do
not coincide with the contour generatrices. They
therefore represent the horizontal and the vertical
plan of the cylinder in parallel projection, but not in
central projection, which applies when we subse-
quently draw tangents from a center PZ′ to the hori-
zontal plan of the cylinder, thus doing something
that amounts to central projection, because here the
tangential planes, which appear as tangents in the
horizontal plan, intersect in the body axis of the ob-
server. In parallel projection, however, the tangen-
tial planes are parallel.

We can develop the perspective picture of the
cylinder as in Fig. 365 from its horizontal and verti-

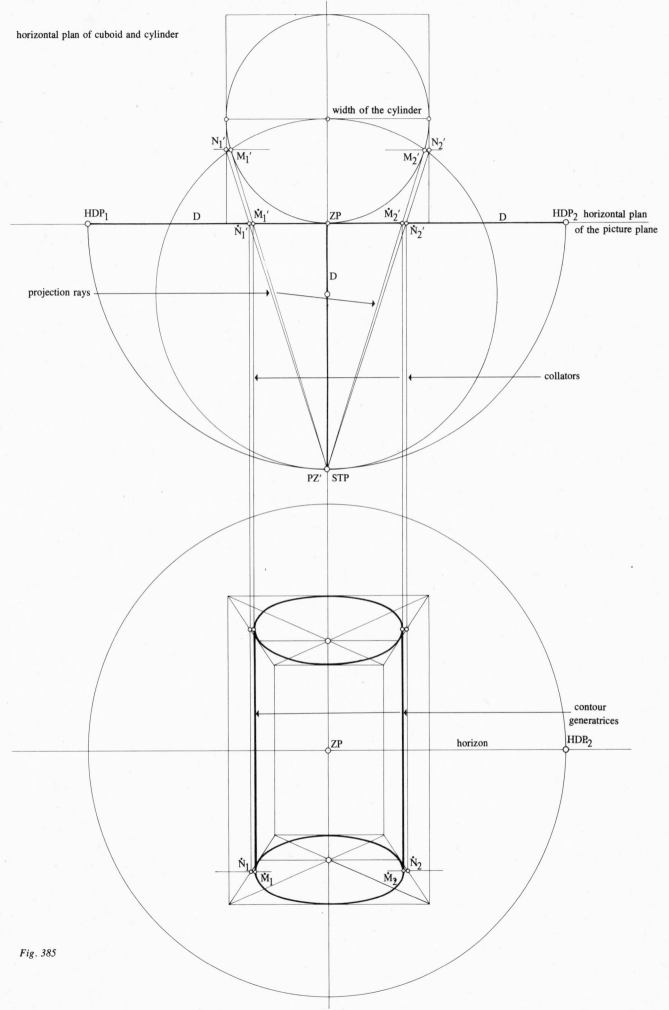

horizontal plan of cuboid and cylinder

width of the cylinder

N$_1$'
M$_1$'

N$_2$'
M$_2$'

HDP$_1$ D Ṁ$_1$' ZP Ṁ$_2$' D HDP$_2$ horizontal plan of the picture plane

Ṅ$_1$' Ṅ$_2$'

D

projection rays

collators

PZ' STP

contour generatrices

ZP horizon HDP$_2$

Ṅ$_1$ Ṅ$_2$

Ṁ$_1$ Ṁ$_2$

Fig. 385

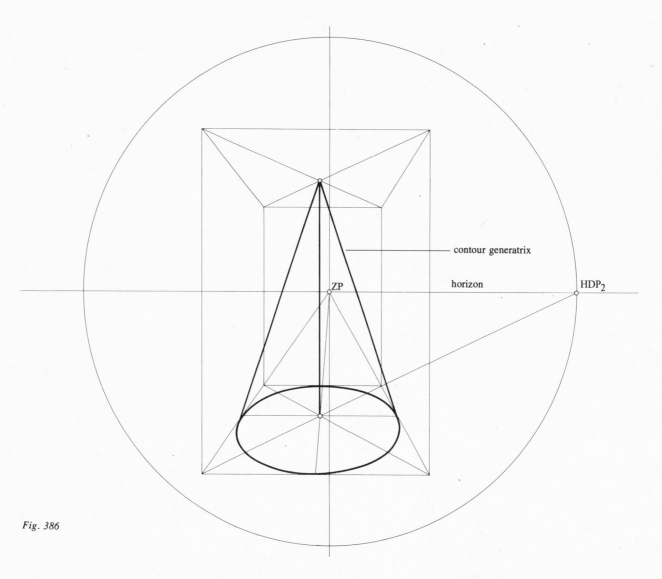

contour generatrix

ZP horizon HDP_2

Fig. 386

cal plans with the contour generatrices as seen from a certain assumed point of view. Here again we draw the cylinder from a cuboid of square cross section, represented in the horizontal plan by a square. In the vertical plan, on the other hand, cuboid and cylinder appear as the same rectangle. The picture plane, which the front face of the cuboid touches, is also reproduced in the horizontal plan in Fig. 385. We require it for the projection of important points in the horizontal plan, which we translate from here into perspective projection.

We determine the contour generatrices M_1' and M_2' again with the aid of the semicircle of Thales. We project these points by joining them to PZ'. This results in projection rays that coincide with the tangents we draw from PZ' to the horizontal-plan circle of the cylinder. Where these projection rays intersect the picture plane in the horizontal plan we have the horizontal plans of the central projections of the contour generatrices produced with \dot{M}_1' and \dot{M}_2'. We transfer them by means of collators to the perspective projection, where they are situated on the peripheries of the top and bottom planes of the cylinder.

We can indirectly transfer M_1' and M_2' to the perspective projection as follows: We draw a horizontal through these points, which intersects the

relevant sides of the square. We imagine M_1' and M_2' transferred to these sides, on which we obtain N_1' and N_2', which, by projection, produce \dot{N}_1' and \dot{N}_2' in the horizontal plan of the picture plane; from there we transfer them by means of collators to the receding sides of the top and of the bottom square, resulting in \dot{N}_1' and \dot{N}_2'. A horizontal drawn through them intersects the periphery of the bottom and top planes of the cylinder in the required points \dot{M}_1' and \dot{M}_2', through which the contour generatrices pass. We again point out that in practice the draftsman constructs the contour generatrices not in the way discussed, which is rather cumbersome, but by sight.

Construction of a Cone from a Cube or from a Cuboid

This cone is defined as a right cone of circular base and a vertical body axis or altitude connecting the center of the circle and the apex of the cone. The oblique circular cone differs from it in that its body axis is inclined, and its altitude does not represent the connection between the center of the circular base and the apex of the cone or body axis as in the right circular cone. In the oblique cone, which does not interest us here, the altitude is the distance between apex and base.

The right and the oblique cones are not the only types of cone. Bases of cones may be elliptical or even irregular instead of circular in outline. The concept of a conical surface is therefore very ill-defined; in our context, a cone is always a right circular cone.

Here, too, we can treat the conical surface as consisting of straight lines, or, in concrete terms, taut threads or thin rods. We can therefore construct a model of a cone as follows: we cut a circular disk from a sheet of stout cardboard; it forms the bottom or base of the cone. We make holes parallel and as close as possible to the periphery, and pass electric threads representing the generatrices of the cone through them. The number of the holes depends on the number of elastic threads or generatrices we want to use for the construction of the conical surface. We now tie up the threads coming from the periphery of the base so that they are of equal length and the knot is in the center of the base. If we now pull the knot away from the base and at right angles to it, we obtain cones of heights that vary with the distance between the knot and the base.

This model shows that the generatrices of the cone, which strictly ought to start from the edge of the base, are the shortest connection between a point on the periphery of the base and the apex of the cone.

We can draw the right cone in perspective from a cube or cuboid of square cross section by determining the apex of the cone in the point of intersection between the diagonals of the top face of the cube or cuboid. The base of the cone can be constructed from that of the cube or cuboid; as we have seen, the former is circular but in perspective becomes an ellipse. The connection between the center of the base and the apex of the cone is the height of the cone, as in Fig. 386; here the contour generatrices have not been specially constructed but drawn by sight, because we must first discuss how they are generated.

Generation of the Contour Generatrices of the Right Circular Cone

We can construct the contour generatrices not only of the cylinder but also of the cone. The geometric aspects from which we can proceed are shown in the following illustrations. In Fig. 387 we see an observer looking at a cone taller than himself; this must be kept in mind, because in the construction of the contour generatrices of the cone the height of the cone compared with the observer's is an important feature that must not be ignored. In Fig. 387 a plane E parallel to the base of the cone at the observer's eye level is shown. It divides the cone into an upper and a

Fig. 387

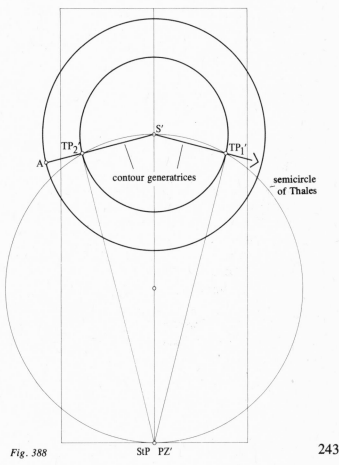

Fig. 388 StP PZ'

243

lower, truncated, one. We proceed to determine the contour generatrices of the original whole cone from the cone above plane E by imagining the observer's visual rays to the cone proceeding in two tangential planes. The traces of these planes are in plane E and represent tangents of the base of the cone in this plane. The tangential planes intersect in a straight line, which coincides with the observer's visual ray to the apex of the cone. The tangents common to the tangential planes and to the cone are the required contour generatrices, which we extend from the upper part of the cone to its lower part.

Figure 388 shows the procedure illustrated in Fig. 387 in the horizontal plan; the cone appears in the form of two concentric circles with the center in S', which is also the horizontal plan of the apex of the cone. The larger of the circles represents the base of the original whole cone, and the smaller one the important plane of intersection between the cone and plane E, which can also be treated as the base of the cone above E and as the top face of the truncated cone below this plane.

Figure 387 has already shown that the contour generatrices are determined on the top part of the cone (that is, the smaller cone) and extended from there to the bottom part, the truncated cone. We conceive these contour generatrices as the lines common to the tangential planes and the smaller cone.

In Fig. 388 these planes are represented by three lines: first in the form of the two traces PZ'–TP$_1$' and PZ'–TP$_2$', and second by PZ'–S', which represents the horizontal plan of the line of intersection between the two tangential planes; this plan also includes the horizontal plan of the central visual ray. But PZ'–S' is also the diameter of the semicircle of Thales to be constructed for the determination of the two tangent points TP$_1$' and TP$_2$'. By joining these points to S' we obtain the contour generatrices of the small cone, which we extend to derive those of the bottom cone and thus of the whole cone. S'–A is therefore a contour generatrix of the whole cone. Figure 389, top, shows not only the cone with the picture plane but also the circle of view in the horizontal and vertical plans, whose radius is of course the distance D between picture plane and center of projection. This illustration shows in addition that in the vertical plan we can use the trace of the picture plane also as the reference line of projection, and that in the horizontal and vertical plans the plane of intersection of the cone must be located at eye level or on the horizon. Analogously to Fig. 388, the contour generatrices are constructed in the horizontal and vertical plans, corresponding to M$_1$'–S' and M$_2$'–S'. To be able to draw these contour generatrices in

perspective construction, we must project M$_1$' and M$_2$' centrally, which gives us \dot{M}_1' and \dot{M}_2' on the horizontal plan of the picture plane, from where they are transferred to the periphery of the base of the cone in perspective, and \dot{M}_1 and \dot{M}_2 are obtained. Both joined to \dot{S} produce the contour generatrices in perspective.

In the perspective picture the height of the cone must be determined from the trace of the picture plane, which we can also treat as a measure line. On the front corner of the square from which we draw the base of the cone we erect a perpendicular, on which we mark the height of the cone taken from the vertical plane. From the height thus shown on the trace of the picture plane we construct the altitude of the cone in the perspective picture.

Top View of the Contour Generatrices of a Cone

The height of the cone in question is less than that of the observer, who looks down on it. But Fig. 390 shows two cones, a bottom, larger one and a top, smaller one. The two cones touch in a point or have a common apex through which the body axes of both of them pass. The altitudes of both cones add up to the eye level of the observer in plane E with the base of the small cone.

But where are the contour generatrices of the bottom cone, from which we start, situated for the observer? And how do we construct these generatrices of this cone? To answer these questions we introduce the auxiliary top cone, whose contour generatrices we construct to transfer them from there to the other cone.

The observer's visual rays to the contour generatrices of the auxiliary cone are in two tangential planes, whose traces are tangents to the base of the auxiliary cone in plane E.

Figure 391 shows the procedure in the horizontal plan, which we construct by describing the semicircle of Thales on PZ'–S' to determine the tangent points TP$_1$' and TP$_2$' on the periphery of the base of the small cone. TP$_1$'–S' and TP$_2$'–S' will then be the contour generatrices of the small top cone. The production TP'–S' produces the contour generatrix TP$_4$'–S' of the larger bottom cone. Analogously we obtain the contour generatrix TP$_3$'–S' of this cone from the production of TP$_2$'–S'.

Figure 392 tells us that we can determine the contour generatrices in perspective at first with the aid of a horizontal and a vertical plan of the two cones, to transfer them from there to the perspective projection.

We suggest the following problem: Construct the contour generatrices of a cone of the same height as the observer.

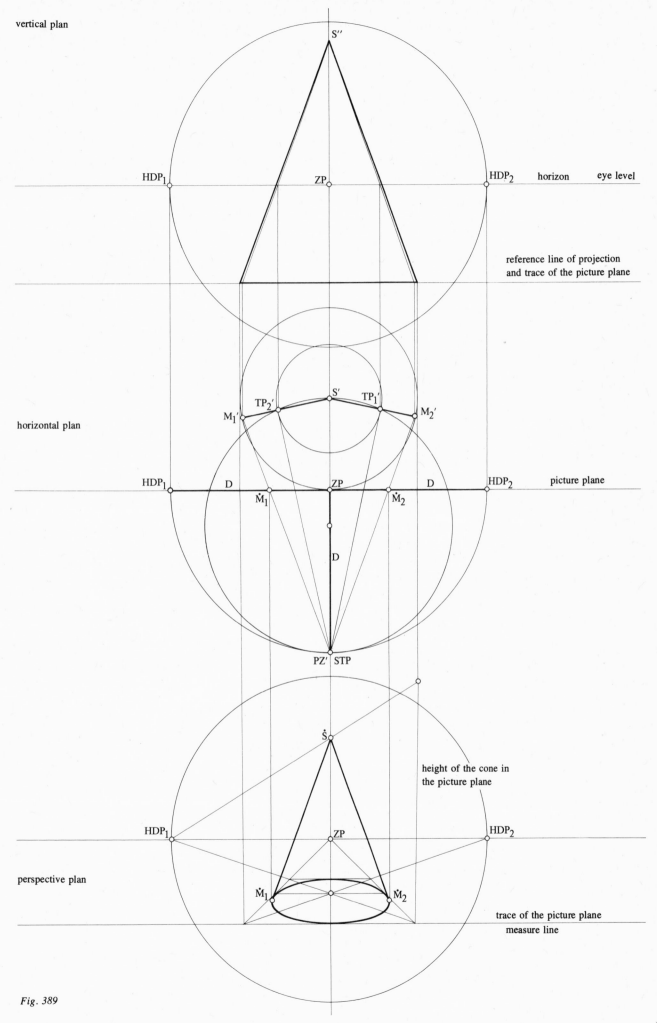

vertical plan

S''

HDP₁ ZP HDP₂ horizon eye level

reference line of projection
and trace of the picture plane

horizontal plan

M₁' TP₂' S' TP₁' M₂'

HDP₁ D Ṁ₁ ZP Ṁ₂ D HDP₂ picture plane

D

PZ' STP

height of the cone in
the picture plane

HDP₁ ZP HDP₂

perspective plan

Ṡ

Ṁ₁ Ṁ₂

trace of the picture plane
measure line

Fig. 389

245

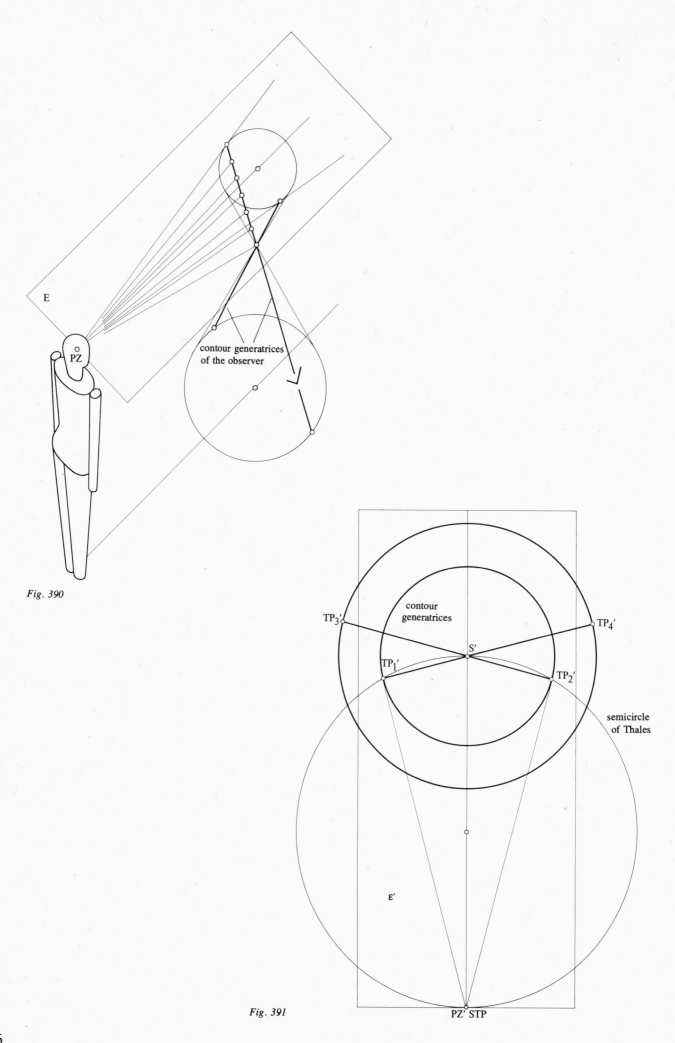

E

contour generatrices
of the observer

Fig. 390

contour
generatrices

TP₃′

TP₄′

S′

TP₁′

TP₂′

semicircle
of Thales

ε′

Fig. 391

PZ′ STP

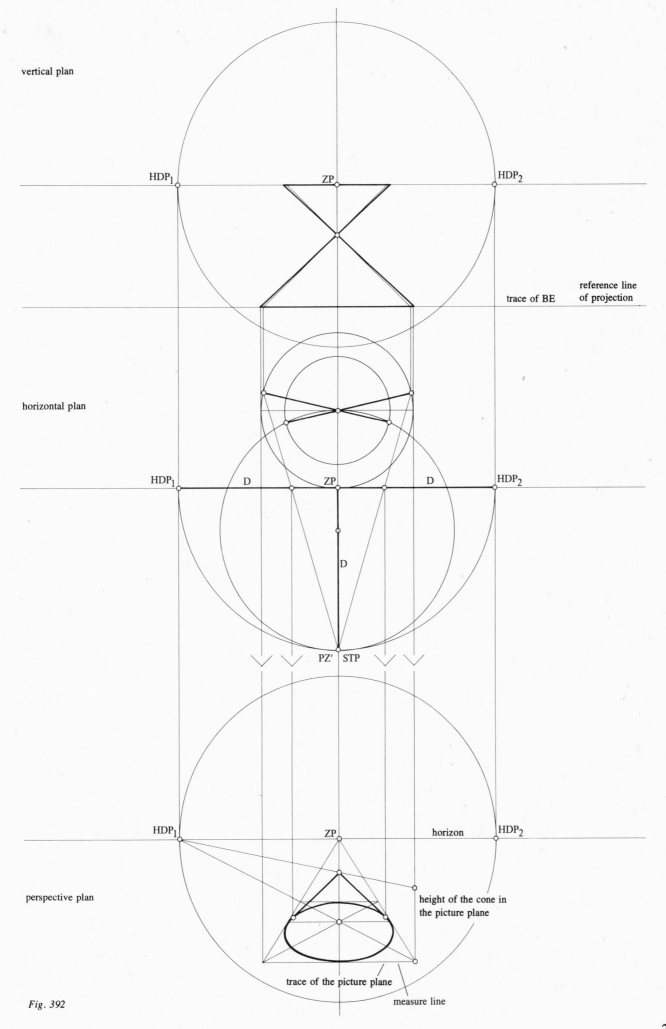

vertical plan

HDP$_1$ ZP HDP$_2$

trace of BE reference line
of projection

horizontal plan

HDP$_1$ D ZP D HDP$_2$

D

PZ′ STP

HDP$_1$ ZP horizon HDP$_2$

perspective plan

height of the cone in
the picture plane

trace of the picture plane

measure line

Fig. 392

247

Postscript by
F.G. Winter*

On page 15 of this book we find one of Albrecht Dürer's well-known woodcuts explaining the construction of the perspective picture. This series also contains the representation of a reclining nude, expression of burgeoning life; seen through a vertical net of squares, the picture is transferred through a marked fixed point to a corresponding net on the drawing table. Dürer's translation of Piero della Francesca's description of the subject reads as follows: "The first (component) is the eye, which sees, the second is the object being seen, the third is the space in between." Subject, object, and space were the three constituents of the discovery. The picture and the text convey an idea of the fascination Renaissance man must have felt when he had found in perspective a geometric, rational system of comprehending the incomprehensible coming to life of the environment and nature. The passionate urge to objectivize (that is, to master) everything has up to now remained the impulse that dominated the last five hundred years. But today this orientation is no longer fully accepted. We must therefore define questions and answers more closely and briefly sketch the origin of perspective and its effect on art, music, science, and the Western concept of the world to appreciate its indispensability. Willy Bärtschi's cross section through the history of perspective in painting and mathematics, its significance in our own days and his lucid analyses of pictures derive their special importance to the understanding of the upheaval we are witnessing from the fundamental role, which can be only briefly outlined here, played by perspective in the history of thought of the last five hundred years. His own contribution, the coordination of the old methods of construction with that of the circle of view, which he developed further and made comprehensible in its inexhaustible applications, confirms the claim for the topicality of perspective advanced in this postscript.

More than 25 years ago Jean Gebser published his *Ursprung und Gegenwart* (Origin and the Present Time), an interpretation of our age in terms of its history, whose validity has since been increasingly confirmed by events. The work describes the foundations and manifestations of an "aperspective world" as the history of the development of awareness, becoming the clue to the understanding of our age, whereas "perspective," vision referred to the individual object, was the decisive invention that left its imprint on the epoch we have just left behind. As an aperspective world the present time is replacing a perspective era which, based on rational science and thinking in causal sequences, regarded the eye, the brain, measurement, the three dimensions of space as decisive factors. This process of change is manifesting itself in innumerable phenomena. The new aperspective world, on the other hand, thinks in four dimensions, ignoring space and time, universally: An integrated level of consciousness is replacing the perspective-mental one in the same way as this in its time replaced its three predecessors, the archaic, the magic, and the mythical level of consciousness.

In modern physics, in Einstein's Theory of Relativity, the factor of time as the fourth dimension appeared on the scene decades ago, at the same time as or after relevant new developments in the fine arts. Additional knowledge about the nature of light and the perspective vision that depends on its relativizes perspective, which (although it was discovered also by artists) was regarded as the herald of the scientific age, as a typically anthropocentric phenomenon: Only a very narrow range of all the wave lengths emitted by the sun is able to penetrate the gaseous envelope of our planet. This comparatively minute section of the solar spectrum is for man the visible part (that is, light) of a much broader frequency range of all the sun's radiation. This minute section is used by the life process of the creatures of the Earth to provide them with the necessary orientating optical information; vision as the perception of colors and shapes in a geometric reference system adapted for the eye was evolved. The Arab mathematician Alhazen gave a precise description of a bundle of light: a pyramid of rays extending from the object to the eye became the basis of perspective, which in turn became the fundamental idea of mathematics and of all the thought processes of the modern age.

But only now is the unprecedented decision which this perspective-mental thought process as a seemingly successful combination of economics and science-based technology forces us to make today being realized. The analyses of the future published by the Club of Rome challenge our generation to oppose what is economically and technologically feasible if it is prepared to accept responsibility for future generations. These analyses demand integral, perspective thinking, which is not confined to individual detail. In this situation a fundamental book on perspective, its history, how to construct it, and its various manifestations in the environment and in the fine arts is written. The question arises about the purpose of such a book in our day and age.

The author points out, much too modestly, that even today the construction of perspective views and

*Prof. F.G. Winter, Dip.Eng., architect BDA, DWB. Head of the College of Arts and Crafts, Krefeld 1949–1971. Born 1910 in Düsseldorf. Studied architecture under Clemens Holzmeister in Düsseldorf 1928–1933 and Hans Poelzig in Berlin, under Arthur in Toronto 1934–1935. Freelance architect in Berlin since 1936, in the Rhineland since 1946. Numerous publications and guest lectures abroad.

spatial pictures is indispensable to the architect and to interior and other designers, whereas it no longer plays any part in contemporary art. Here we must contradict him in both his own and his book's interest. In the surprising revival enjoyed by, for instance, the graphic arts, academic drawing and therefore perspective has been reintegrated into contemporary art. We need only think of the cycles of drawings by Ungerer, Oldenburg, and, if we include painting, of Klaphek's "object magic," photorealism, Nesbitt, and Colville. Such a reintegration of perspective in the contemporary art scene reflects the slow unfolding of the aperspective world as a level of awareness which, far from discarding the preceding perspective level, includes it as an important constituent. Only those can understand the new aperspective world who are able to comprehend not only the original novelty but also the limitations and inadequacy of the perspective world in the face of the political and cultural problems of the twentieth century.

Perspective can be described as the most striking symptom of the new cosmic spirit which during the early Renaissance brought about a basic transformation of mankind. In the nonperspective era of antiquity and the Middle Ages man felt himself to be part of the world; in the era of perspective he confronts it as an independent individual and begins to take increasing possession of the Earth in many ways.

Francesco Petrarca's famous letter of 1336 about his ascent of Mont Ventoux describes how there came about this crossing of the frontier between a nonperspective existence and perspective awareness, from a rather irrational dream world to rational truth, from spiritual imagination to abstracting reflection, from the two-dimensional pane of the Byzantine gold background to the depth of the three-dimensional space and the shock associated with it and the inner struggle this initiated. His vision detached for the first time a part from the whole as space and took possession of it; space and landscape had been discovered.

Let us quote his own words: ". . . shaken by the unaccustomed wind and the wide and free spectacle, I was at first as if frozen in fright. To my gaze the clouds were at my feet. . . . I turned my eye toward Italy and my soul turned toward it even more than my eye . . . and then a fresh thought took hold of me, which carried me from space to time. . . ." Still on the summit, confronted by the space that captivated his soul, he read in the *Confessions* of Augustin, who pronounced the word, aptly characterizing the old world, "that time is in the soul." Petrarca's first experience of space was the germ of Leonardo's scientific theory of perspective 150 years later. What had thus begun during the fourteenth century, the gradual replacement of the soul by space, a change from a view of the world in which all decisive events took place in the soul to a philosophy which was felt to be the very discovery and conquest of the world, in time degenerated into an increasingly materialistic atrophy of the spiritual substance.

From a modern point of view, Vasari's concept of rinascità is only partially correct because it is perspective more than any other aspect that distinguishes the Renaissance from Antiquity. Seeming similarities with the Greek ideal, definitive bodies, drawing, and clear contours, in the rinascimento distinguish perspective space from the object; in ancient Greece the objects remain isolated. Although the beginning of the era of perspective is also called the Renaissance, its source is nevertheless the power and depth of the Gothic style, which mysteriously radiates from its perspective spaces. After the artist's first spontaneous enthusiasm aroused by the linear perspective they had just discovered, clear edges soon merge into the background, light and aerial perspective become more important. Masaccio's frescoes in the Brancacci Chapel, Raphael's Stanze, Leonardo's *Last Supper* are composed in space, but in measure and rhythm they possess the hidden musicality of Gregorian Chant. And the seemingly rational invention of perspective, mentally aiming at the secular aspect of life, soon serves the purpose of striving for infinity, beyond all material barriers, to shift the center of gravity of pictorial composition into the perspective distance and to conquer the atmosphere and space with colors fading into twilight.

The fascination with perspective which dominated and left its imprint on the late fifteenth century explains the status as the Eighth Art it was accorded, at first in an inscription on the tomb of a pope, and then as plastic art, and an almost executive function ascribed to it. Gebser places particular emphasis on the symbolic significance of the sacred number seven being exceeded by the number eight, which he interprets as the affirmative, clear, and bright opposite of the nonperspective, negative night.

After Leonardo's *Theory of Perspective,* which made awareness of space commonplace, the artistic experience of space developed—outstanding examples are analyzed in this book—at the beginning of the sixteenth century with a downright exuberant abundance of landscapes, interiors, and painted architectures from Altdorfer through the sixteenth- and seventeenth-century Dutch Masters, Poussain, Lorrain, Watteau, Constable, Corot, C. D. Friedrich, the French Impressionists to Van Gogh and Rousseau, to name only a few.

The development of music is an instructive parallel to perspective in painting. In his *Gespräche über Musik* (Talks about Music) (Zurich, 1948) Wilhelm Furtwängler, arguing against Oswald Spengler's *The Decline of the West,* made some enlightening observations on the subject of perspective: "Music finds its realization in the dimension of time. The tonal cadence affords a musical sequence, which up to the time of the Renaissance proceeded from one

note to the next, on a plane as it were, the opportunity of dominant, integrating relations and therefore a previously unknown arrangement in depth. It is not inapt to follow Spengler in claiming the existence of a parallelism between tonality and the invention of perspective. It is to the dimension of time, in which music finds its realization, what the third dimension, the dimension of depth, is to space in the fine arts. Both tonality and perspective owe their invention to the same vital consciousness. . . ." Whereas our contemporary, aperspective music looks for forms without time through using several meters or tempos simultaneously, our Western classical music adheres to the given rhythm in contrast with the nonperspective, two-dimensional, primeval music.

Perspective with its sectorlike vision demonstrates more clearly than any other phenomenon how the all-embracing God-relatedness of the nonperspective past became a man-related partial aspect. From that moment onwards vision is concerned less and less with the whole; in fact the sector examined and investigated ever more closely stakes an absolute claim on our attention. It is again Gebser who points out the significant ambivalence of the original word "totus," which can mean either "all" and "whole" or "nothing." But regardless of whether the Latin word "perspicere," from which perspective is derived, is translated as "to look through" (by Dürer) or "to see clearly" (by Erwin Panofsky), the discovery of perspective is the most striking manifestation of an entire epoch and through its separation of the ego from space, subject from object, makes possible the particularization of our environment and thereby its objectivization and its scientific comprehension, which is still increasing in depth. Leonardo's clarification and establishment of the laws of perspective not only concluded a process lasting two thousand years (described in this book), but also initiated, with the introduction of the technical drawing, a development which has produced the gigantic and at the same time threatening results of our own age. Leonardo's most important observations are: "Perspective is evidence, and experience confirms, that all objects send their images to the eye in pyramidal lines." And concerning the correlation between eye and object, ego and space: "In the distances perspective uses two opposed pyramids. One of them has its apex in the eye and its base far on the horizon. But the first refers to the general situation because it covers all the sizes of the objects facing the eye. . . . However, the second pyramid refers to a special spot . . . and this second pyramid is derived from the first."

With its reference to anatomy Bärtschi's *Linear Perspective* indicates how the space that has acquired self-awareness through perspective of the human body manifests itself also in other important fields. Besides Vesalius's *Anatomy* as the spatial rendering of the body and Harvey's discovery of the blood circulation, we must mention above all Copernicus, who regarded the sun instead of the Earth as the center of the universe, Johannes Kepler, who proved that Michelangelo's elliptical dome of St. Peter was preformed in the orbits of the planets (even Copernicus still thought they were circular), Columbus as the discoverer of the Western Hemisphere, Galilei as that of the stellar regions, and lastly once again Leonardo as the designer of the first airplanes and submarines, prepared to conquer the space of the air and under the sea.

The conquest of space was reflected not only in colonial imperialism, in new forms of an increasingly personal right of ownership, but above all in its compartmentalization of all spaces, even the intellectual ones. With the religious schism in the West began the era of the conquests of power politics, of a steadily progressive technological and materialistic invasion of human life. The age of perspective ends in a polar confrontation between ego and space. An overemphasis on space, on the objective superficial aspect, cannot but lead to an everemphasis on the ego, which becomes more and more inflexible and isolated until the independent personality disintegrates in the general loss of individuality.

But we must today acknowledge perspective in the wider sense, described here as an indispensable means of perceiving our environment. This applies not only to the field covered by this book. Perspective thinking as rational scientific approach must not have the total hold on our lives it still has. It must become related to the environment and included in the vast phenomena which point to a change to thinking in terms of integration. Our present age is thus tied to perspective in a twofold manner, by its permanent, but in future only partial, dependence and by its contradiction.

Recent research in the psychology of consciousness has come to the conclusion that at least Western man thinks mainly with the left half of his brain. According to these investigations the left hemisphere, which controls the right half of the body, is responsible for perspective, discursive, rational-verbal consciousness, and the right hemisphere for intuitive, formal consciousness which perceives interconnections and is typical of Eastern thought. But "the devil is found in the detail." We can no longer exist in our environment, which depends on a highly sophisticated technology, perspective-particularistic thinking. In spite of the increasingly catastrophic nature of perspective-rational thinking, life today is impossible without this perspective. Although our knowledge is made up of individual sectors, innumerable successive theoretical and practical experiments of object-oriented, perspective thinking, it nevertheless becomes more and more integrated in a synopsis, an increasingly denser network of noncontradictory relations, a homogeneous whole.

Perspective is indispensable. The question "Why perspective today?" demands a positive answer.

List of Names

References

Ching, Frank. *Architectural Graphics*. New York: Van Nostrand Reinhold, 1975.

Coulin, Claudius. *Step By Step Perspective Drawing for Architects, Draftsmen and Designers*. New York: Van Nostrand Reinhold, 1971.

Doblin, Jay. *Perspective: A New System for Designers*. New York: Watson-Guptill, 1956.

Doyle, Michael. *Color Drawings*. New York: Van Nostrand Reinhold, 1981.

Martin, C. Leslie. *Architectural Graphics*. New York: Macmillan, 1971.

Oles, Paul Stevenson. *Architectural Illustration*. New York: Van Nostrand Reinhold, 1979.

Richter, Gisela. *A Handbook of Greek Art: A Survey of the Visual Arts of Ancient Greece*. New York: Dutton, 1980.

Vero, Radu. *Understanding Perspective*. New York: Van Nostrand Reinhold, 1980.

Watson, Ernest W. *How to Use Creative Perspective*. New York: Van Nostrand Reinhold, 1955.